Anecdotes of Modern Art

Anecdotes
of Modern Art

From Rousseau to Warhol

DONALD HALL

PAT CORRINGTON WYKES

New York Oxford Oxford University Press 1990

Oxford University Press

Oxford New York Toronto
Delhi Bombay Calcutta Madras Karachi
Petaling Jaya Singapore Hong Kong Tokyo
Nairobi Dar es Salaam Cape Town
Melbourne Auckland

and associated companies in
Berlin Ibadan

Published by Oxford University Press, Inc.
200 Madison Avenue, New York, New York 10016

Oxford is a registered trademark of Oxford University Press

Library of Congress Cataloging-in-Publication Data
Hall, Donald, 1928–
Modern art anecdotes : from Rousseau to Warhol
Donald Hall, Pat Corrington Wykes.
p. cm. Bibliography: p. Includes index.
ISBN 0-19-503813-4
1. Art, Modern—19th century—Anecdotes. 2. Art, Modern—20th century—Anecdotes.
3. Artists—Anecdotes. I. Wykes, Pat. II. Title.
N6447.H34 1990 709.04—dc20 89-9330 CIP

9 8 7 6 5 4 3 2 1

Printed in the United States of America
on acid-free paper

Selections from works by the following authors
were made possible by the kind permission of
their respective publishers.

Ernest Harms "Paul Klee As I Remember Him." Reprinted from *Art Journal*, Vol. 32, No. 2 (1972–73), p. 178, with the permission of the College Art Association of America.

Marsden Hartley The selection from "Farewell, Charles: An Outline in Portraiture of Charles Demuth" by Marsden Hartley is reprinted from *The New Caravan*, edited by Alfred Kreymborg, Lewis Mumford, and Paul Rosenfeld. With the permission of W. W. Norton & Company, Inc. Copyright 1936 by W. W. Norton & Company, Inc. Copyright renewed 1964 by Lewis Mumford.

Barbara Haskell *Charles Demuth*. Harry N. Abrams, Inc., N.Y., and Whitney Museum of American Art, N.Y., 1987. Copyright © Whitney Museum of American Art.

Margaret Calder Hayes *Three Alexander Calders*. Eriksson, 1977. Reprinted by permission of Calder Hayes and Kenneth Hayes, Trustees, Margaret Calder Hayes Fund.

MacKinley Helm *John Marin*. Institute of Contemporary Art, Boston (in association with Pellegrini and Cudahy).

Gordon Hendricks From *The Life and Works of Thomas Eakins* by Gordon Hendricks. Copyright © 1974 by Gordon Hendricks. All rights reserved. Reprinted by permission of Viking Penguin, a division of Penguin Books USA, Inc.

Hayden Herrera Excerpts from *Frida: A Biography of Frida Kahlo* by Hayden Herrera. Copyright © 1983 by Hayden Herrera. Reprinted by permission of Harper & Row, Publishers, Inc.

Thomas B. Hess *Barnett Newman*. Copyright © 1969 by Thomas B. Hess. Reprinted by permission of M. Knoedler & Company. *Willem de Kooning*. Copyright © 1959 by Thomas B. Hess. Reprinted by permission of George Braziller, Inc.

J. P. Hodin *Edvard Munch*. Copyright © 1972 by J. P. Hodin. Reprinted by permission of Thames & Hudson Ltd. *Oskar Kokoschka: The Artist and His Time*. Little, Brown and Company, 1966.

Michael Holroyd *Augustus John: A Biography*. Copyright © 1975 by Michael Holroyd. By arrangement with Lescher & Lescher, Ltd.

Harry Holtzman "Piet Mondrian: The Man and His Work," in *The New Art—The New Life: The Collected Writings of Piet Mondrian*, G. K. Hall, 1986.

Thomas Hoving (ed.) From *Two Worlds of Andrew Wyeth: A Conversation with Andrew Wyeth*, by Thomas Hoving, published by Houghton Mifflin Company. Copyright © 1978 by Thomas Hoving. By arrangement with Lescher & Lescher, Ltd.

Richard Huelsenbeck From *Memoirs of a Dada Drummer* by Richard Huelsenbeck. English language translation copyright © 1974 by The Viking Press, Inc. Reprinted by permission of Viking Penguin, a division of Penguin Books USA, Inc.

Juliette Huxley "Une Petite Fumée de Souvenirs," *Paris Review* 101, Winter 1986.

Marcel Jean From *The Autobiography of Surrealism* by Marcel Jean. Copyright © Marcel Jean, 1980. All rights reserved. Reprinted by permission of Viking Penguin, a division of Penguin Books USA, Inc.

Augustus John *Chiaroscuro: Fragments of an Autobiography*. Published by Pellegrini and Cudahy, 1952. *Finishing Touches*. Published by Jonathan Cape, 1964, and reprinted by permission of David Higham Associates Ltd.

Otto Kallir Excerpt from *Grandma Moses: My Life's History*. Copyright © 1952 (renewed 1980), Grandma Moses Properties Co., New York.

Daniel-Henry Kahnweiler *My Galleries and Painters*. Copyright © Editions Gallimard 1961.

Wassily Kandinsky *In Memory of Wassily Kandinsky*. Solomon R. Guggenheim Foundation, 1945.

X. J. Kennedy "Nude Descending a Staircase." Reprinted from *Cross Ties*, copyright © 1985 X. J. Kennedy. Repritned by permission of the author.

Joan Kinneir (ed.) *The Artist By Himself*. Copyright © 1980 by Joan Kinneir. Reprinted by permission of St. Martin's Press, Inc., New York, and Grafton Books (a division of William Collins Sons & Co. Ltd.).

Felix Klee (ed.) *The Diaries of Paul Klee 1898–1918*. University of California Press, 1968.

Stephan Lackner *Max Beckman—Memories of a Friendship*. University of Miami Press, 1969.

Preface

Arshile Gorky hanged himself from a beam on which he had written "Goodbye my 'loveds." The old Douanier Rousseau courted with ardor but without success a young lady of fifty-four. When an aging Picasso brought Françoise Gilot to meet an aging Braque, he determined to be invited for lunch—and Braque out-stubborned Picasso. After Stanley Spencer divorced his wife to marry another woman, he could not understand their unwillingness to share him. Brancusi was a superb cook. Kokoschka, losing the love of Alma Mahler, had a life-sized doll constructed to resemble her. Juan Gris patted dogs with his left hand so that if he were bitten he would still have his right hand to paint with.

When we began reading for *Anecdotes of Modern Art*, we thought the book would be *Anecdotes of Art*. We collected stories from Plutarch and Pausanias about Phidias and other Greeks; Pliny the Elder and Cicero supplied Roman stories. Heaven knows Vasari's pages were thick with anecdotes of the Renaissance, and Cellini's *Autobiography* assembles *The Oxford Book of Cellini Anecdotes*. When we had accumulated a ton and a half of photocopies, several anxieties converged: We worried how to select and organize. It is always true that some periods, some people, and some genres provide more anecdotes than others. Eighteenth-century England was prolix of story and thin of genius; with the earlier Dutch masters, our predicament was opposite. Cogent arguments raised themselves against any organization based on chronology, geography, or topic.

Then we realized that the modern period, a century and a quarter of stories, provided a particular richness of documentation and would allow us a chronological order artist-by-artist. We seized upon this segment of art—for the shape of its brilliance and for the variety and scope of its anecdotal history. Henri

Rousseau provided us entrance into its universe, especially the long anecdote of the banquet to celebrate Rousseau prepared by some younger friends including Picasso and Braque. A century later, we depart our subject by way of a celebrity-machine, as modern art erected Andy Warhol's Factory.

• Along the way we find amusement and we find dolor. Suzanne Valadon together with her child Maurice Utrillo and his friend Amedeo Modigliani provide anecdotes of dissipation, melancholy and risible together; but they also provide the moment of the bohemian life, conditions from which great work sprouted and grew. This book is gossip for the sake of amusement—but it is gossip about people worth our attention. In their work they found pleasure, pain, and a reason to live; from their work we take pleasure, pain, and a reason to live. Maybe Stanley Spencer speaks for all artists when he said that he was grateful not to have been born a worm or a rat "because they have such a rough time without the pleasure of painting."

Topical approaches are difficult, because the same story fits under so many categories. But an index can cross reference the same tale—obeying doctrines of human ambivalence and diversity—under Generosity and Selfishness, Drunkenness and Sobriety, Profligacy and Fidelity.

Pat Wykes read more books than Donald Hall, who read a good many. Donald Hall wrote most of the connective prose. Pat Wykes made the indexes and did the permissions. (Some publishers from time to time vanish from the face of the earth. We have tried diligently to contact everyone, and apologize when we have failed.) At the Oxford University Press, our excellent copyeditor was Stephanie Sakson-Ford. Our editors have been Sheldon Meyer and Leona Capeless, to whom we are grateful.

January 1990 D.H. & P.C.W.

Contents

Anecdotes of Modern Art

Henri Rousseau
(1844—1910)

Remembered as "le Douanier Rousseau," he wasn't a douanier. From 1871 to 1885 he worked for the municipal toll service in the City of Paris, and it was this office that was miscalled customs. In *Il y a* the poet and art critic Guillaume Apollinaire mythologized him:

❏ Rousseau had so strong a sense of reality that when he painted a fantastic subject, he sometimes took fright and, trembling all over, had to open the window.

When he did a portrait of someone, he was much calmer. Before anything else he carefully measured his model and inscribed on the canvas the measurements reduced in proper proportion. All the time, in order to keep his spirits up, the Douanier sang songs of his youth and of the time he had spent in the toll service.

—ROGER SHATTUCK, *The Banquet Years.*

Before he became a painter he lost his wife and seven of his nine children. He painted in poverty, sometimes begging by playing his violin in the streets.

People spoke of his naïveté. When someone told him that his work was as beautiful as Giotto's, he asked, "Who is Giotto?" At a Cézanne exhibition Rousseau admired a *Bathers*, but regretted that Cézanne ". . . had left so many places unfinished. I wish I had it in my studio, I could finish it nicely!" Once a friend found him painting with a wreath of leaves tied around the thumb that stuck through the palette; there were no leaves in the painting.

3

The friend asked why he wore the bouquet. "One must study nature," said Rousseau.

People remembered him as simple, and, as Roger Shattuck says,

❑ . . . so great a simplicity, so great a purity of heart, often excites in others a desire to do hurt. We look for some flaw or vice, we scoff at what we cannot understand. That is just what happened. "Friends" and strangers who merely knew his reputation played a thousand tricks on him. The victimization which had started while he was in the toll service now became a standing joke. Gauguin told him once that he had been awarded a government commission for a painting. Rousseau went happily to the appropriate office to find out the details and was sent scornfully away. A stranger called on him and introduced himself as Puvis de Chavannes, the academic painter then at the peak of his fame. Rousseau, believing that such a tribute was natural and deserved, politely showed the impostor around his studio. Another time, a group of friends arrived with a man who resembled the Minister of Fine Arts; a ceremony was performed in which Rousseau was awarded a decoration while the concierge's daughter stood holding flowers.

—SHATTUCK.

Another time someone told him that the President of the Republic had invited him to dinner. When he returned, without dinner, he told a story:

❑ I went up to the front door, but they told me I couldn't get in without a card of invitation. When I insisted, the president himself came out, patted me on the back and said, "Sorry, Rousseau, but you see you're wearing an ordinary suit. Since everybody else is in formal dress, I can't very well receive you today. But come again some other time."

—SHATTUCK.

Fernande Olivier recollects the first time she and Picasso, invited by Apollinaire, paid a call.

❑ The *douanier* lived in a sort of studio, near to the Rue Vercingétorix. He was a nice, slightly stooping man, who pottered rather than walked, with gray hair still thick despite his sixty-five years and with the appearance of a small-time tradesman. His startled face shone with kindness, though he could easily get quite purple in the face if he was annoyed or put out. He generally agreed with everything that was said to him, but one had the feeling that he was holding himself back and hadn't the courage to say what he was thinking.

When we arrived at about nine, two or three couples, dressed in their

best clothes, were sitting bolt-upright on chairs packed into rows as if they were in some lecture-hall. They were the bakers, grocers and butchers of the neighborhood. At the back of the room was a platform.

The guests began to arrive one by one. To avoid a bottleneck Rousseau insisted that they sat down as soon as they came in. He sat on a chair near the door, like a program-seller in a theatre. When everybody had arrived the evening began.

There were lots of painters, writers and actors there: Picasso, Duhamel, Blanche Albane, Max Jacob, Apollinaire, Delaunay and a few Germans were crushed amongst the local tradesmen and Rousseau's personal friends. Suddenly Rousseau leapt onto the platform and played a little tune on the violin to get things going. Immediately after this other people appeared and sang ridiculous songs accompanied by theatrical gestures, or recited interminable monologues. Rousseau was absolutely delighted with it all and as we left he said:

"There's a successful evening for you!"

—FERNANDE OLIVIER, *Picasso and His Friends.*

He called all foreigners "Americans." The younger painters of the School of Paris admired him. Once he told Picasso, "We are the two great painters of the age, you paint in the 'Egyptian' style, I in the modern." Picasso bought a huge Rousseau portrait from a junk dealer for five francs. It was the *Femme au Rideau de Karamanie,* Rousseau's first wife; the junkman said to Picasso, ". . . you can always paint over it."

In 1908 Picasso worked up a banquet in Rousseau's honor at the Bateau Lavoir, an occasion that has been described by Maurice Reynel, André Salmon, Gertrude Stein and her brother Leo, as well as by Fernande Olivier:

❑　Picasso decided to organize, at his own expense and in his studio, a banquet in honor of Henri Rousseau. The project was received enthusiastically by the gang, who were overjoyed at the prospect of pulling the *douanier's* leg.

They planned to invite thirty people, and all those who wanted to come after dinner would be allowed to.

Unforeseen incidents were to add to the effect of this party. The decorations were ready, branches concealed columns and beams and covered the ceiling. At the end of the room, opposite the big high window, was the seat intended for Rousseau: a sort of throne, made from a chair built up on a packing case and set against a background of flags and lanterns. Behind this was a large banner bearing the words: "Honor to Rousseau."

The table was a long board set on trestles. The chairs, plates and

cutlery had been borrowed from our local restaurant, Azon's. Thick glasses, small, heavy plates and tin knives and forks; but nobody bothered about such things.

Everything was ready, the guests crowded into the studio, which was soon far too small to hold them all; but at eight o'clock the dinner, which had been ordered from a caterer's, was still not there. It didn't arrive until the next day, at noon!

We went off to rustle up something from the cake shops and restaurants round about, while the guests, who had gone back to the bar, drank more apéritifs to the encouraging sounds of the pianola.

It was at that point that poor Marie Laurencin ("Coco" to her friends), who was just making her début in this artists' world, became the object of determined attentions from some of the guests who had decided to make her drunk.

It was not difficult. The first thing she did when she came back into the studio was fall onto the jam tarts which had been left on a sofa, and, with her hands and dress smothered in jam, start kissing everybody. She got more and more excited, and then found herself quarreling with Apollinaire, until finally she was rather brutally packed off to mother.

At last we all sat down.

Rousseau, who thought the food had arrived, installed himself gravely and tearfully on the dais that had been erected for him. He drank more than he was used to and finally fell into a peaceful sleep.

There were speeches and songs composed especially for the occasion; then a few words from Rousseau, who was so moved that he spluttered with pleasure. Indeed, so happy was he that he accepted with the greatest stoicism the regular dripping of wax tears on to his brow from a huge lantern above him. The wax droppings accumulated to form a small pyramid like a clown's cap on his head, which stayed there until the lantern eventually caught fire. It didn't take much to persuade Rousseau that this was his apotheosis. Then Rousseau, who had brought his violin, started to play a little tune.

What a colorful evening that was! Two or three American couples, who had got there by accident, had to make the most excruciating efforts to keep a straight face. The men in their dark suits and the women in pale evening-dresses seemed a bit out of their element amongst us.

The wives and mistresses of the painters were wearing simple little dresses of undeniable originality. Madame Agero looked like a schoolgirl in a black smock. Her husband hadn't a care in the world, and though he probably imagined he was taking it all in he seemed to be oblivious of everything. There were the Pichots, the Fornerods, André Salmon and Cremnitz, who at the end of the evening did an imitation of *delirium tremens,* chewing soap and making it froth out of his mouth,

which horrified the Americans. Jacques Vaillant, Max Jacob, Apollinaire and Leo and Gertrude Stein were there, and many, many others.

After dinner, most of Montmartre trooped into the studio, and those of them who simply couldn't stay consoled themselves with snaffling the *petits fours* and anything else within easy reach. I actually saw one man stuffing his pockets, although my eyes were glued to him. Rousseau had sung his favorite song:

Aïe, aïe, aïe, que j'ai mal aux dents . . . but he couldn't finish it and dozed off, snoring gently. Occasionally he woke up with a jerk and pretended to take an interest in what was going on around him, but he couldn't keep it up for long, and his head would flop back onto his shoulder. He was charmingly weak and naïve, and touchingly vain. He remembered that dinner with emotion for a long time afterwards, and the good man took it in good faith as homage paid to his genius. He even sent a sweet letter to Picasso, thanking him.

It was some time after that that Rousseau, twice a widower, became engaged to be married for the third time. His self-respect was greatly wounded by his future father-in-law, who thought him too old for his daughter. She was, in fact, fifty-nine. Rousseau must have been a little over sixty-six. As for the father-in-law, he was eighty-three. Rousseau was desolated by the fact that his fiancée would not act against her father's wishes. He was quite cast down by this:

"One can still be in love at my age without being ridiculous. It's not the same sort of love as you young people go in for, but must one resign oneself to living alone, just because one's old? It's dreadful going back to lonely lodgings. It's at my age that one most needs one's heart warmed up again and the knowledge that one won't have to die all alone and that perhaps another old heart will help one's passing to the other side. It's not right to laugh at old people who get married again; you need the company of someone you love when you're waiting to die."

He said all this in a soft, tearful voice. He hadn't the time, as it turned out, to put all this into practice: he died alone, in hospital, a few months later.

One more story to illustrate his naïveté: I was talking to him one day about the canvas which Picasso had bought from Père Soulier—the woman at the window, which I described earlier. As I'd always thought that that window looked out on to a mountain landscape in Switzerland, I said to Rousseau, "I suppose you were in Switzerland when that picture was painted?"

He looked reproachfully at me as if I were laughing at him.

"Oh, come on," he said. "Don't you recognize the fortifications of Paris? I did that when I was working in the customs and I was living near the . . . gate." I've forgotten which gate it was.

—OLIVIER.

When the widower fell in love, it was not without anxiety, as the art dealer Ambroise Vollard remembered.

❏ One afternoon Rousseau arrived at my shop in a *fiacre*. He had in front of him a canvas two meters high. I can see him now, battling with the wind. When his work was under shelter, he stood contemplating it with satisfaction.
"You seem pleased with your work, M. Rousseau," I said to him.
"And you, M. Vollard?"
"That will go to the Louvre!"
His eyes glistened.
"Since you admire my painting, couldn't you give me a certificate to say that I'm getting on?"
"Absurd! A testimonial of that kind would cover us both with ridicule. But why do you want my certificate?"
"I must tell you that I want to get married. . . . At the Customs I was in the outdoor service, whereas my future father-in-law is in one of the offices . . . of course those gentlemen look down on us mere *gabelous*. Besides, to give one's daughter to a man who takes his pictures round to his customers himself . . ."
"Don't let that stand in your way, M. Rousseau! I'll go and fetch them from you, if you like that better."
"Yes, but then, if my bride's family should hear that I'm no longer seen about the streets with my pictures under my arm, they will think I haven't any work. . . . I thought a testimonial from someone with a shop . . . a certificate from a licensed dealer. . . . My situation is becoming difficult. The father of my betrothed is threatening me because he knows that his daughter and I are still meeting in spite of his prohibition."
"Take care, M. Rousseau! If your future wife is under sixteen, her father may prosecute you for abduction of a minor."
"Oh! M. Vollard! She is fifty-four. . . ."
And as this struck me dumb:
"You know, I wish I were called Léon and not Henri. . . ."
"Why Léon?"
"Well, my fiancée is called Léonie. So you see, Léonie . . . Léon . . ."
—AMBROISE VOLLARD, *Recollections of a Picture Dealer.*

Vollard told about another occasion.

❏ The *"Douanier"* Rousseau read me one of his poems in which a ghost was concerned:
"Ghosts! Come, M. Rousseau! A sensible man like you!"
"So then you, M. Vollard, don't believe in ghosts?"

"No, I don't believe in them."

"Well, I do. I've seen some. There was actually one that pursued me for quite a long time."

"You don't say so! And what was he like?"

"Just an ordinary man. Nothing special about him. He used to come and defy me when I was on duty at the *octroi*. He knew I couldn't leave my post. So he would put out his tongue or cock snooks at me, and then let off a great fart."

"But what makes you think he was a ghost?"

"It was M. Apollinaire who told me so."

—VOLLARD.

Thomas Eakins
(1844—1916)

When he was twenty-two he started study in Paris with Jean-Léon Gérôme. He wrote about rites of hazing in a letter to his father.

❏ When I got my card of admission the officers told me I could go now into the studio, and they seemed to have a little fun amongst themselves. Asking my way of the employees, I was passed along, and the last one, looking very grave, took me in. All the way that I went along I was making up a neat little address to Professor Gérôme explaining to him why I appeared so tardy. Unfortunately for French literature, it was entirely lost, as is every trouble you take to imagine what you ever are going to say when such and such a thing arrives.

The man took me into the room and said, "I introduce to you a newcomer," and then he quickly went out and slammed the door. There was nobody in there but students. They gave a yell which would have lifted an ordinary roof up, and then crowded around me, "Oh, the pretty child!" "How gentle!" "How graceful!" "Oh, he is calling us *Musheers*, the fool!" "Isn't he tall?" "Give us twenty francs!" Half of them screamed, "Twenty francs!" and the other half, "The welcome breakfast!" When I could get them to hear me I asked what it was. Several tried to explain but their voices were drowned. They all pushed each other and fought and yelled all at once. . . . "Where do you come from? England?" "My God no, gentlemen, I'm an American." (I feel sure that raised me a peg in their estimation.) "Oh, the American!" "What a savage!" "I wonder if he's a Huron or an Algonquin?" "Are

you rich?" "No." "He lies; he's got a gold mine." They began at last to sit down one by one. I was invited by one to do the same thing. I did so, looking to see the stool was not jerked from under me. No sooner was I sat down than one of the students about thirty years old, a big fellow with a heavy beard, came and sat down with his face within a foot of mine and opposite me. Then he made faces, and such grimaces were never equalled. . . . Each new contortion of course brought down the house. I looked pleasantly on and neither laughed nor got angry. I tried to look merely amused. Finally he tired himself out. . . . Then he insisted that I should put my bonnet on to see how I looked in it. Not being a model I resisted and wouldn't until I would be ready to go away. . . . I had determined to keep my temper even if I should have to pitch into them, and to stay there and have as much of it through with as possible. When they got not quiet but comparatively quiet, I took my leave. I thanked them for their kind attention, and giving warning to the big fellow that I was now about to put on my bonnet, I thanked him for his politeness and then left. I think the last was a good stroke, and the first thing I did next day was to make friends with the big booby.

There was a dispute in the studio between two of the fellows as to which was the strongest. It was decided they should wrestle as soon as the model rested. So they stripped themselves and fought nearly an hour, and when they were done, they were as dirty as sweeps and bloody. Since then there has been wrestling most every day, and we have had three pairs all stripped at once, and we see some anatomy. The Americans have the reputation of being a nation of boxers. Max Schmitt taught me a little about boxing, which I have forgotten. A French student squared off at me, offering to box; I jumped in nothing loth for a little tussle, but another student jerked my opponent away, saying, "My good man, let me give you a piece of counsel: never box with an American."

<div align="right">

—GORDON HENDRICKS, *The Life and Works of Thomas Eakins.*

</div>

Adam Emory Albright (father of Ivan and Malvin), who was Eakins's student in later years, repeated a story he heard from Eakins.

❏ He always leaned toward the wild west and in the Paris school hazing was started by a group of French students. When it came Eakins's turn they called him from an upper floor. A group waited for him below. He came down sliding on the bannister,—I have seen him do this trick, from the dissecting room to the hall a dozen times, only this time he had two revolvers. I don't know that either one was loaded. Down he came yelling like an Indian, but quick as his descent was, that

group of Frenchmen were equally quick. There wasn't a Frenchman there when he landed with a Comanchee yell. The students went into a huddle and made all Americans exempt from initiations.

—HENDRICKS.

Apparently Eakins enjoyed pulling a gun. Another student told about Eakins's visit to the Bonheur establishment.

❏ I should have mentioned another companion of Tom's—Germain Bonheur. From this acquaintance we were invited to his parent's home. His sister Rosa Bonheur was there on a visit from her home in Fontainebleau and as she sat at the table she strikingly resembled Henry C. Carey the political economist of Philadelphia. Below she wore skirts but her upper attire resembled that of a man. She was very bossy and dictatorial, with the family, and when Germain differed from her on any point she would tell him to go to bed! Tom was speaking of our national mechanical skill and to illustrate his point he pulled out from his pocket his Smith & Wesson revolver. (I know of no other person in Paris who carried one!) Rosa put *her* hand into her pocket and pulled out one of the same make. She acquired the habit of carrying it during her sketching at Fontainebleau.

—HENDRICKS.

When Eakins returned to Philadelphia, he returned to a country which had not accepted the notion of nude models, not even partial, medical nudity.

His *The Gross Clinic* showed an operation on a man's thigh, complete with blood. The thigh was judged obscene, all the more because of a woman's presence in the picture. At the Pennsylvania Academy of the Fine Arts in Philadelphia, female models had always been recruited from houses of prostitution. When Eakins wanted to advertise for *respectable* nude models, he made a shocking and unrespectable suggestion.

Eakins's students drew from cadavers and *parts* of cadavers. Adam Emory Albright remembered a story.

❏ One episode certainly lowered our status and created an entirely false notion of our characters. Carried outside [the rumor] was spread by a plumber, after cleaning out a clogged toilet. To prepare a male stiff for the women's dissecting class, we removed the part that made a man a man. We all declared it was an accident that the part was found in some fellow's smock pocket as he took it down before leaving. Be that as it may, it had to be dodged several times and finally followed

some one down the back stairs and into the washroom, landing in the flush toilet. "Say," said the plumber, and his assistant verified the story, "some of those artists are rotten and I know what I am talking about. . . ."

—HENDRICKS.

But nudity was the great issue.

❑ According to a legend that has the ring of truth, the final straw that broke the directors' back was the protest someone had made when Eakins removed the loincloth from a male model in the ladies' life class. He wanted to show the origin of a muscle, it is said, perhaps the oblique, and how else could he show it than to take off the model's covering?

—HENDRICKS.

In 1886 Thomas Eakins resigned his position at the Pennsylvania Academy of the Fine Arts, as he was requested to do.
 In 1888 he painted Walt Whitman.

❑ Of all the portraits of me made by artists [Whitman wrote], I like Eakins's best. It gets me there—fulfills its purpose, sets me down in correct style, without feathers, without fuss of any sort. I like the picture always—it never fades or weakens. It is not perfect, but it comes nearest being me. . . . Eakins errs just a little—a little—in the direction of the flesh.

—HENDRICKS.

The poet said of the painter: "I never knew of but one artist, and that's Tom Eakins, who could resist the temptation to see what they thought ought to be rather than what is." When Whitman died in 1892, Eakins made the death mask.
 His portraits—like so many portraits by the best painters—often shocked his sitters. At least one prospective subject declined the honor because, as he declared, he did not wish to discover the flaws of his own character.

❑ Some of the less courageous were thoroughly annoyed by Eakins's honesty. "How beautiful an old woman's skin is!" he once exclaimed. "All those wrinkles!" But the women who posed for him could happily have done without them. They blushed to hear their daughters explaining to visitors that "mother was sick when this was painted."

—ALEXANDER ELIOT, *Three Hundred Years of American Painting.*

Inevitably enough, the Academy which neglected him at the height of his powers attempted to honor him when he was old.

❏ In 1904 the Pennsylvania Academy offered him a gold medal. He appeared with a disciple, both in bicycling costume, to pick it up. Commenting that the Academy had "a heap of impudence" to give him a medal, he promptly cycled on to the Philadelphia mint where he derisively turned the gold emblem into cash.
—JAMES THOMAS FLEXNER, *America's Old Masters.*

Albert Pinkham Ryder
(1847–1917)

❏ Ryder was completely unworldly. He cared nothing for money, social prestige, or even the ordinary comforts of living. He never married, he lived in disorder, dressed shabbily and ate poorly. He existed only for his art. As he said: "The artist needs but a roof, a crust of bread and his easel, and all the rest God gives him in abundance. He must live to paint and not paint to live. He cannot be a good fellow; he is rarely a wealthy man, and upon the potboiler is inscribed the epitaph of his art."

Money matters never seemed to worry him. With no responsibilities, not even that of keeping up appearances, he needed little to live on. . . . Financial affairs were a deep mystery to him. Checks and cash were left lying around his rooms. Once Horatio Walker asked him if he had any money, and Ryder replied that "there was some on a paper in the cupboard." After rummaging around he produced a check in four figures, months old. Walker explained the wisdom of cashing checks and took him to a bank and helped him open an account. Later Ryder told Albert Groll that Walker was not only a fine painter but a great financier.

In the middle 1890s he settled at 308 West Fifteenth Street, which was his home for fifteen years or so. In this drab, crowded neighborhood he had two rooms in an old house, where he lived and worked, without a regular studio—not even a north light. He was utterly unable to cope with housekeeping, and the place soon reached a condition of incredible disorder and dirt. The house agent came once a year to see about repairs and painting, but Ryder would never let him in, so that the rooms were never painted or papered, and rarely cleaned, all the

years he was there. Wallpaper hung in long streamers from the ceiling. He never threw anything away, and the rooms were piled waist-high with every conceivable kind of object—furniture, trunks, boxes, old newspapers and magazines, canvases, frames, painting materials, soiled clothes, food, unwashed dishes, milk bottles, ashes. There were paths through his rubbish to the door, to the easel, to the fireplace. Over all lay the dust of years. Ryder did cooking of a kind on an open grate or a small stove, except when he went out for cheap meals in the neighborhood. Being unable to keep his cot clean, he slept on a piece of carpet on the floor.

This was the reality; but he said to Marsden Hartley, "I never see all this unless someone comes to see me." He described how it appeared to him: "I have two windows in my workshop that look out upon an old garden whose great trees thrust their green-laden branches over the casement sills, filtering a network of light and shadow on the bare boards of my floor. Beyond the low roof tops of neighboring houses sweeps the eternal firmament with its everchanging panorama of mystery and beauty. I would not exchange these two windows for a palace with less a vision than this old garden with its whispering leafage."

—LLOYD GOODRICH, *Albert P. Ryder.*

His unworldliness extended to the materials he worked with.

❏ The bits of professional instruction Ryder accepted in New York City had no appreciable effect on his work. His technique, indeed, remained almost tragically faulty. Whereas most untrained artists at least used permanent sign painter's colors, Ryder's passionate urge for self-expression made him employ whatever best enabled him to externalize his vision at the instant. To a friend who expressed horror at finding him painting with candle grease, Ryder replied defensively that he had used only one small candle. Further argument over his method would elicit from him the statement that only beauty mattered. If a composition had beauty, that would remain, however much the picture deteriorated physically. This has proved true to some degree—Ryder's pictures are still moving—but old photographs reveal they were often much more beautiful when they left his easel.

—FLEXNER, *America's Old Masters.*

❏ He used alcohol, candle wax, and varnish as well as oil, mixing them indiscriminately. He changed some compositions scores of times, moving the center of interest all about the canvas. In the evening he would put a thin layer of quick-drying glaze over his day's work, and next morning paint on top of that, locking in the wet undersurface, which consequently took years to dry. As a result, almost his entire

production (about 150 canvases) has already cracked, yellowed, or blackened horribly.

He loved his work in a fashion that transcended egotism.

❏ A painter friend once praised a canvas he saw in Ryder's studio and was gratified to be offered it as a present. "But after [Ryder] had washed the picture's face in a basin of very dirty water and dried it with a dirty towel, he stood gazing at it with a faraway look in his eyes, a look of fondest love. He had forgotten that I was there. When I gently recalled him to earth, he turned to me and, with the simplicity of a child, said kindly and regretfully: 'Come again next year and I think you can have it, if I find I can do what more it needs. I have only worked on it a little more than ten years.' "

—ALEXANDER ELIOT, *Three Hundred Years of American Painting.*

He became a famous Manhattan eccentric.

❏ In the evenings he was a familiar figure on Eighth Avenue, walking slowly, his hands behind his back, oblivious of the noise of wagons and streetcars. More than once kindhearted people stopped to give him money. But when he went up to Fifth Avenue "to see the pictures" or when he was invited out to dinner, he wore an old frockcoat or ancient evening clothes and high hat.

—GOODRICH.

His studio was also famous.

❏ When callers came, it took him a quarter of an hour to clear a path to his door. Dead mice lay all about in the traps that had caught them, and live ones scampered near the ancient stew that simmered year in and year out on his stove. He slept on a window shade on the floor to avoid bedbugs. Fat and shambling, he puttered mainly with his old pictures, as often as not doing them more harm than good. Pictures, reading matter, junk, food, nothing would he let go. Everything must be saved and kept, a wealth of useless treasure that closed in around him at the end with the weight of tombstones.

—ELIOT.

Painting was everything.

❏ To one importunate collector, he wrote, "Have you ever seen an inch worm crawl up a leaf or twig, and then clinging to the very end,

revolve in the air, feeling for something to reach something? That's like me. I am trying to find something out there beyond the place on which I have a footing."

—FLEXNER.

John Singer Sargent
(1856–1925)

The young American studied in Paris with Carolus Duran, then kept his own studio in that city.

❑ In the great ceiling painting in the Luxembourg Palace, on which Carolus Duran was engaged at the time, he introduced the heads of several of his favorite American students, among others Sargent, Carroll Beckwith, and Frank Fowler. The likenesses of Beckwith and Fowler, more or less idealized, are still there, but not so Sargent's. It was painted out. The story goes that the French master especially liked to paint Sargent's hands. Long after Sargent had finished studying with him, he used to send for him to come over and pose for hands. The time came when Sargent could no longer respond to his beck and call. He, Sargent, was beginning to get work of his own to do which would not allow him to leave his studio at a moment's notice to go and pose for his domineering old master. One day, Carolus sent a hurry call to him, and Sargent was obliged to refuse the request. This was too much for Carolus. A few days later one of his friends who had heard of the episode met him and asked him, "Well, how is it with Sargent? Have you made up?" "Ah, no!" replied the French artist, *"C'est fini!* I have been to the Luxembourg; I went and I got a ladder, and I painted out his head."

—WILLIAM HOWE DOWNES, *John Sargent: His Life and Work.*

Because he was the great portrait painter of his era, there are a thousand stories confronting painter and sitter.

❑ There is the tale of the fashionable lady who was so concerned about the way her mouth was going to look in the picture that she sat from hour to hour twisting and turning her lips into all sorts of unnatural positions, until Sargent said, "Well, madam, perhaps we had better leave it out altogether."

—DOWNES.

❑ It is said of one portrait of Sargent's that so accurately was the tell-tale bearing and expression of a sitter painted, that a physician diagnosed from it an incurable malady from which the man did not know that he suffered and of which he was afterwards to die.

—JAMES LAVER, *Portraits in Oil and Vinegar.*

❑ Sometimes Sargent would, with his vast facility, finish a portrait quickly but go on painting a sitter for a day or two because he could not bear to say he had done all he could. At the same time, there was something in him "which made it impossible to lessen the imperfections and give complete satisfaction." He could paint only what he saw and felt.

—BURKE WILKINSON, *Uncommon Clay: The Life and Works of Augustus Saint Gaudens.*

When the time came to paint Secretary of State John Hay, Sargent saw that he looked like a shrimp and painted him as such—all the while wishing that he *could* make him less shrimplike. Like Saint Gaudens, he had a healthy awareness of his own mastery. Nevertheless, he much preferred to be complimented on his piano playing, which was somewhat less than masterful.

Osbert Sitwell recalled a casualty.

❑ I recollect, too, another incident of the visit. Sargent one morning, in the upper drawing room, executed a watercolor of my mother, Sacheverell, and myself which was said to be astonishing in its virtuosity and swift, breath-taking resemblance, and then gave it to her. When they went down to luncheon, my mother left it, for safety, between the pages of one of the weekly social papers of the epoch, *Tatler* or *Sketch* or *Onlooker,* and then forgot all about it. By the time she remembered its existence again, a few days later, a new journal had arrived to replace the old, and one of the housemaids, in the fatal process of "tidying up the room," had taken the old to use for lighting the fires.

—SIR OSBERT SITWELL, *Left Hand, Right Hand.*

Usually his American sitters sat for this American painter in a European city. In 1900 he returned to the United States and made a famous portrait of a Spanish dancer.

❑ "Carmencita was a lovely creature who had just been brought over from Europe, and whose dancing had set the town on fire in that Age of Innocence of New York," wrote H. I. Brock in the *New York Times.* "Sargent had a studio for a while in Twenty-third Street. The Spanish

jade was a very difficult subject. She would not keep still or pay atten-
tion to her pose. Sargent used to paint his nose red to rivet her childish
interest upon himself, and when the red nose failed he would fascinate
her by eating his cigar. This performance was the dancer's delight. . . .
There is another story about a grand party given at the much grander
studio of William M. Chase, in Tenth Street, where there were Oriental
hangings and all the artistic trappings of the period. Carmencita came
to dance with her hair fearfully frizzled and much powder and paint.
Sargent took a wet brush and brushed the hair as flat as he could get
it, and then used a washrag upon the lady's make-up, while Carmencita
scratched at his face like a tigress. After the job was done, Carmencita
danced, and the guests threw not only their flowers but even their pearls
at her feet. She kept the pearls."

—DOWNES.

A few years later he visited Dublin where he found a special
treat.

❏ He had a special liking for ears, and it was said that he particularly
enjoyed painting ears that were red, and which stuck out. Despite an
otherwise handsome and distinguished appearance Hugh Lane had the
incongruous physical peculiarity of a pair of ears that were large and
red and stuck out from the sides of his head. Sargent was enthralled.
He sat him down and commenced a head and shoulders portrait in oil
which he worked at with steadily mounting enthusiasm, canceling other
sittings and bringing Lane back several times in order to get the por-
trait exactly right. It was presented on January 11, 1907; Lane kept it
on the staircase at Lindsay House in Chelsea, and on his death it passed
to the Municipal Gallery in Dublin where it now hangs.

—BRUCE ARNOLD, *Orpen: Mirror to an Age.*

Osbert Sitwell, who was a child when Sargent painted the Sitwell
family group, described the master at work.

❏ He was always dressed in a conventional blue-serge suit, for in those
times fashionable portrait painters never indulged in the overalls or
semi-fancy dress which they would adopt today, and no doubt the tight,
starched white collar was responsible for the rather plethoric appear-
ance of his face as he painted, for work of an esthetic and intellectual
order is as difficult as manual labor in such constricting fetters. . . . I
can see him even now, if I shut my eyes, as, when something he had
done displeased him, he would lower his head and, as it were, charge
the canvas with a brush in his hand to blot out what the minute before
he had so rapidly created, bellowing, at the same time, in his deep

voice, the words, "It's pea green, pea green, pea green—it's all pea green!" . . .

The sittings began on March first, as planned, and I remember the day because we heard in the morning that Ladysmith had been relieved. . . . Every second day for five or six weeks we posed to the famous portrait painter in his studio, and no picture, I am sure, can ever have given the artist more trouble, for my father held strong views concerning the relationship of the patron to the painter, who ought, he inwardly maintained, to occupy the same position as a bone to a dog—or, as for that, of a mouse to a cat—being created and placed before him to be worried, gnawed, and teased. That my father believed this painter to be a great artist at his greatest in no wise relieved him of his duty as patron, which was to offer an opinion upon every matter, whether of taste, of feeling, or of technique, with an air of absolute and final authority, and to distract him by starting a new theory every instant, and then swiftly abandoning it or, alternatively, by suddenly behaving as though it were Sargent's theory and not his own at all, and by consequently opposing it with startling vigor just as the artist had agreed to accept it. At moments that became steadily more frequent as the picture progressed, he played a very strong hand and became positively dictatorial.

In some ways a man of gentle temperament, despite his full-blooded, energetic, resolute appearance, Sargent exhibited under this treatment a remarkable mildness and self-control. Notwithstanding, albeit difficult to provoke, there were enacted from time to time considerable scenes, though, even then, the sudden outbursts of the artist, his rushing bull-like at the canvas and shouting, were in reality the expression more of tremendous physical vitality than of rage. And, in any case, my father himself enjoyed these exhibitions very much, for, according to his code, a show of temperament was expected of every artist—who ought, indeed, to be goaded daily by the patron until he gave it, that being part of the contract, as it were, existing between them, and a guarantee that the work would be of the highest quality. . . .

—SITWELL.

The poet Edith was a young girl with a distinctive nose. Osbert continues:

❏ I remember, too, another incident. My father, who, as I have said, only admired in a female small du Maurier-like features, pointed out to the painter that my sister's nose deviated slightly from the perpendicular, and hoped that he would emphasize this flaw. This request much incensed Sargent, obviously a very kind and considerate man; and he showed plainly that he regarded this as no way in which to speak of her personal aspect in front of a very shy and supersensitive child of eleven. Perhaps, too, he may already have divined in her face

and physique the germ of a remarkable and distinguished appearance which was later to appeal particularly to painters. At any rate, he made her nose straight in his canvas and my father's nose crooked, and absolutely refused to alter either of them, whatever my father might say.

—SITWELL.

Sacheverell was two years old for this painting. (Davis was nurse.)

❏ After a quarter of an hour, it would be impossible for either Davis or me any longer to restrain his childish impatience, or to cajole him into posing; but Sargent could always contrive to hold his attention for a few extra minutes, either by indulging in a peculiar and elaborate whistling he had cultivated, like that of a French *siffleur* upon the music-hall stage, or by incessantly intoning a limerick, which ran:—

> There was a Young Lady of Spain
> Who often was sick in a train,
> Not once and again,
> But again and again,
> And again and again and again.

With an air of rapt amazement and delight, Sacheverell would listen to this recitation, rooted throughout the performance of it to the right spot. . .

—SITWELL.

There were many tales of Sargent's kindness.

❏ Sargent had an especial affection for Spain, Spaniards, Spanish painting and music. It will therefore be no surprise to the reader that he was a friend of Rubio whom I have previously described. Indeed, that extraordinary old musician seemed to sum up in his person much of the contradictory, chivalrous, exuberant, austere, religious character of his land. It will be remembered, too, that Rubio liked to spend the few shillings he kept for himself on buying pictures. His rooms in Fulham Road were covered with them, and all of them boasted great names; the saints and virgins he attributed mostly to Greco, Murillo, and Ribera, the portraits to Velásquez and Goya. None of them, of course, were genuine. His friends used to tease him affectionately about these works of art, but it would only infuriate him; and never prevented him from acquiring more.

One day, however, he added a hypothetical Sargent which he had found—blatantly spurious—to his collection. He was immensely pleased with this atrocious landscape, in water color; lacking in brilliance of any sort. His friends laughed at him more than ever, and more openly, about it. They pointed out that the artist in question always signed his watercolors. . . . A week or so later, Sargent arrived to see him upon

an afternoon when he was being chaffed about it again, and Rubio had grown very angry. As Sargent entered the room, Rubio waved the landscape at the artist and roared out, with his Spanish lisp:—

"This is by you, *by you,* isn't it?"

Sargent at once comprehended what had happened and sprang gallantly to the rescue of his old friend.

"Of course it is!" he said.

"Then sign it for me now, here!" Rubio demanded triumphantly, pointing at a corner of it.

This was something for which even the kindness of Sargent had not been prepared, but, in spite of the pride of craft which he undoubedly possessed, he did as he was asked. . . .

—SITWELL.

It was not surprising that he gave up portrait painting or, as he called them in mockery of an upper-class accent, "paughtruts."

❑ To Lady Radnor he was as emphatic: "Ask me to paint your gates, your fences, your barns, which I should gladly do, *but not the human face.*" His disenchantment reached its most cogent form with the terse declaration, "No more mugs!" and later settled down in the definition he inscribed on the flyleaf of the French edition of reproductions of his work: "A portrait is a picture in which there is just a tiny little something not quite right about the mouth."

—STANLEY OLSON, *John Singer Sargent: His Portrait.*

During the 1914–18 war he drew in the trenches of France.

❑ He was discovered by a watchful guardsman. With leveled gun the little soldier demanded, "And who are you?" "Sargent—" replied the artist. "The hell you are! I know the sergeant. Come along," he insisted, and it was not until he brought his giant captive before a superior officer that the confused Tommy learned to distinguish sergeants from the one and only Sargent.

—MARTIN BIRNBAUM, *John Singer Sargent: A Conversation Piece.*

He made murals for the Boston Public Library, denigrated in later years.

❑ When the Boston art critics were invited to a press view of the mural paintings in the Museum, in 1921, the assistant director handed to each writer present a succinct typewritten description of the panels with a semiofficial explanation of the symbolism. It chanced that one of the minor panels, depicting three graceful female figures in dancing postures, was without a title. Some one asked who these personages

were supposed to be. "Ah, that I cannot tell you," said the assistant director; "I asked the artist that same question myself the other day, and he answered, 'Oh, they're three blokes dancing!' "

<div align="right">—DOWNES.</div>

He grew old.

❑ Many years later, in the summer of 1921, during lunch in Bar Harbor, Maine, his attention was drawn to an unsigned portrait in the dining-room, and he was amazed when his host told him that he, Sargent, had done it many years before in Paris. He could remember neither the sitter nor the portrait, and after examining it through the glass he carried in his pocket he mused, " 'Well . . . it *looks* like me! . . . It is me!" and pointed to the white handkerchief as proof. "Do you see that green line around the white?' " he asked. " 'That settles it for me. I recognize my own style, of course, but the handkerchief is conclusive as far as I am concerned. . . . I have an astigmatism . . . that makes me see a red or green line around white objects. Often I paint it in. I have done so here. That green border obviously is not part of the handkerchief. It is a sort of penumbra. By it I can absolutely identify this portrait as mine . . .' " With that, he rolled up his sleeves, signed the painting, and added the incorrect date.

<div align="right">—OLSON.</div>

He died.

❑ People knew that he had been ill and newspapers from hour to hour were issuing optimistic bulletins, as they do during a king's last illness. In front of the Tite Street house reporters were waiting, as they would have done at Buckingham Palace—but the gondolier, John Sargent's Cerberus, would not open the door. His master was dying, peacefully, reading one of Voltaire's *Contes*.

<div align="right">—JACQUES-EMILE BLANCHE, *Portraits of a Lifetime*.</div>

James Ensor
(1860—1949)

The fantastic painter grew up in a curio shop among

❑ . . . a heterogeneous mixture of seashells, chinoiseries, porcelains from the East Indies, glass trinkets, beach toys, comical or peasant-made

statuettes, stuffed animals, three-masted ship models in bottles, vases, dolls, and "souvenirs of Ostend," objects made to astonish, to intrigue, or to scare, and for the Mid-Lent holiday, masks and tinsel ornaments. The child's imagination was fed by all this rich trumpery. He tells us himself how impressed he was by "a certain dark and frightening attic"—where, probably, damaged and unsold objects were relegated—"full of horrible spiders, curios, shells, plants and animals from exotic climes, fine porcelains, old clothing the color of rust and blood, red and white corals, monkeys, turtles, dried mermaids, and stuffed Chinamen."

—PAUL HAESAERTS, *James Ensor.*

His memories were fantastic.

❏ One night, when I was lying in my cradle with the light on and all the windows open in my room overlooking the sea, a large sea-bird was attracted by the light and swooped down towards me, knocking my cradle as it did so. The sensation was unforgettable. I was crazy with terror. I can still see the horrible sight and I can still feel the shock occasioned by the fantastic black bird greedy for light.

—ROGER VAN GINDERTAEL, *Ensor.*

At the academy his eccentricity introduced itself immediately.

❏ As soon as I started at the Académie I was overcome with boredom. I was told to paint the bust of Octavius, the most august of the Roman emperors, from a brand-new plaster cast. The snow-white plaster made my flesh creep. I turned it into bright pink goose-flesh and made the hair red, horrifying the other students, though their initial alarm was followed by cat-calls, grins and punches. The teachers were so taken aback by my impudence that they didn't dwell on the fact and from then on I painted freely from living models.

—VAN GINDERTAEL.

Late in Ensor's life, Jean Stevo visited him, still housed among the curios.

❏ You came to a souvenir shop with mother-of-pearl brooches in the shape of a prawn or a ship, inkwells set in shells, peculiar ashtrays decorated with turn-of-the-century figures, crucifixes set in shells, incredible boxes decorated with yet more colored shells.

In a glass case in the window there was a mermaid with a herring's tail and a monkey's head, with shining eyes fixed on the horizon for all eternity. You pushed open the door, a bell jangled away and behind

the counter appeared the melancholy Ernestine and the rigidly polite August. "Have you come to see the Master? Wait here, I'll go and find out." The minutes ticked by. Eventually Auguste would come back, walk ahead of you, knock on the door. Wait. Then make up his mind to go in, announcing: "Monsieur, there's a gentleman to see you." Then you had your reward. You forgot the shop, the stairs, the corridor, as the palace, the enchanter's magic grotto were revealed. Light streaming in here and there, clusters of colors, masks, lengths of silk, exquisite and delicate things, paper flowers, fantastic dolls, a silver-spangled evening slipper, a woman's hat covered with flowers. And in the midst of all these a skull, a grinning death's head with a flower clenched in its jaws. The whole place was in a charming muddle. You couldn't take everything in at a single glance and the confusion was increased by the ochre-colored blinds, which were modestly lowered to ward off the brutal shock of the immodest daylight, creating little pockets of shadow. A sort of music, very gentle, delicate and faded, seemed to waft out of all these objects. A quick glance towards the canvases; masks, skulls, shells. The images conjured up in the room reappeared in the paintings. . . . And in the center of this motley throng, of all these presences, a calm, smiling, relaxed and handsome old man with curly white hair and a pink complexion . . . Ensor.

The first time I saw him I was a little bit afraid of him: I felt I was in the presence of a magus. He had the same superb tranquility and the same sovereign authority.

Ensor showed me his paintings. Then he asked questions about me, asked me if I painted as well and suggested I should show him my paintings. He sat down at the harmonium and improvised a gentle, old-fashioned melody, rather like a fairground tune, but so fragile and dreamy that it seemed to be a reflection of some other tune you'd heard before, in your childhood.

—VAN GINDERTAEL.

Grandma Moses
(1860—1961)

❏ One time I was papering the parlor, and I ran short of paper for the fire board. So I took a piece of paper and pasted it over the board, and I painted it a solid color first, then I painted two large trees on each side of it, like butternut trees. And back in it I did a little scene

of a lake and painted it a yellow color, really bright, as though you were looking off into the sun light. In the front, to fill in that space, I brought in big bushes. I daubed it all on with the brush I painted the floor with. Dorothy's grandfather, when he saw it, he made a great to-do, "Oh, isn't that beautiful, that's the most wonderful thing I ever see, don't let anything happen to that!" he said. It run on three or four years, and we re-papered the parlor and papered over the picture. When we re-papered the room again a few years ago, Dorothy remembered the picture, and we took the paper off the fire board, but the colors had faded somewhat.

That was my first large picture.

—OTTO KALLIR, *Grandma Moses: My Life's History.*

It was 1918.

❑ I had always liked to paint, but only little pictures for Christmas gifts and things like that. Thomas had never talked about my painting, he thought it was foolish. But one night, a few weeks before his death, he came in, it was after candlelight, and he asked, "Who did that painting?" And I thought it was one of my sister's paintings, so I said, "I don't know, must be one of my sister's." He said, "That's really good, that behind the stove." Then I knew that it was the one I had just painted for Edward, "A little blue boy beside the fence." "Oh," I said, "that isn't much." "No, that's real good." And then he just couldn't keep away the last few weeks, when I started to do a little painting, he was right there watching and liked it so much.

—KALLIR.

Her husband Thomas died in 1927, the year Anna Mary Moses turned sixty-seven.

❑ As for myself, I started to paint in my old age, one might say, though I had painted a few pictures before. My sister Celestia came down one day and saw my worsted pictures and said: "I think you could paint better and faster than you could do worsted pictures." So I did, and painted for pleasure, to keep busy and to pass the time away, but I thought of it no more than of doing fancy work.

When I had quite a few paintings on hand, someone suggested that I send them down to the old Thomas' drug store in Hoosick Falls, so I tried that. I also exhibited a few at the Cambridge Fair with some canned fruits and raspberry jam. I won a prize for my fruit and jam, but no pictures.

And then, one day, a Mr. Louis J. Caldor of New York City, an en-

gineer and art collector, passing through the town of Hoosick Falls, saw and bought my paintings. He wanted to know who had painted them, and they told him it was an old woman that was living down on the Cambridge Road by the name of Anna Mary Moses. So when I came home that night, Dorothy said: "If you had been here, you could have sold all your paintings, there was a man here looking for them, and he will be back in the morning to see them. I told him how many you had." She thought I had about ten, something like that.

Well, I didn't sleep much that night, I tried to think where I had any paintings and what they were, I knew I didn't have many, they were mostly worsted, but I thought, towards morning, of a painting I had started on after house cleaning days, when I found an old canvas and frame, and I thought I had painted a picture on it of Virginia. It was quite large, and I thought if I could find frames in the morning I could cut that right in two and make two pictures, which I did, and by so doing I had the ten pictures for him when he came. I did it so it wouldn't get Dorothy in the dog house. But he didn't discover the one I had cut in two for about a year, then he wanted to know what made me cut my best picture in two. I told him, it's just Scotch thrift.

—KALLIR.

She lived long and kept on painting.

❏ When I paint, I study and study the outside lots of times. Often I get at loss to know just what shade of green, and there are a hundred trees that have each three or four shades of green in them. I look at a tree and I see the limbs, and then the next part of the tree is a dark, dark black green, then I have got to make a little lighter green, and so on. And then on the outside, it'll either be a yellow green, or whitish green, that's the way the trees are shaded. And the snow—they tell me that I should shade it more or use more blue, but I have looked at the snow and looked at the snow, and I can see no blue, sometimes there is a little shadow, like the shadow of a tree, but that would be grey, instead of blue, as I see it. I love pink, and the pink skies are beautiful. Even as a child, the redder I got my skies with my father's old paint, the prettier they were.

—KALLIR.

"If I didn't start painting," she said late in life, "I would have raised chickens."

Walter Sickert
(1860–1942)

As a young man he acted in the company of Sir Henry Irving, and some of his painting has a theatrical provenance. He admired Ellen Terry.

❏ A propos of Miss Terry, he told me how, when a youngster, on the occasion of a first night or some special performance, wishing to pay honor to the great actress, he had drawn on his slender resources to purchase a bouquet of roses, and wishing to make sure that at the appropriate moment this should reach her, he loaded the end of the bouquet with lead. The roses, thrown from the gallery, fell with a violent thud on the hollow stage, narrowly missing Irving, surprised and indignant at this outrage. A loud ha! ha! rang through the house. Whistler had observed the scene. If my memory does not play me false, this was the occasion which led to the close association between him and Sickert.
—WILLIAM ROTHENSTEIN, *Men and Memories.*

He became a follower.

❏ Discipleship to Whistler was a mixture of bliss and servitude. Thus in the evening the Master would whistle up a cab and Walter was charged with a weighty lithographic stone in case inspiration should come during or after dinner. At the Café Royal or elsewhere the waiter was enjoined to place an extra table for the stone, and Walter, bearing it again, untouched, went forth when the evening ended.
—D.S. MACCOLL, *Life, Work and Setting of Philip Wilson Steer.*

With his friend Wilson Steer he was known as an English Impressionist. When Steer sprained his ankle, Sickert sent him a telegram: "Do be careful—I have no desire to be the greatest living painter." Steer liked to paint things pretty in themselves, or conventionally beautiful; Sickert liked to make ugly things handsome by his paintings. Walking together the two men passed a rag-and-bone shop. "That's how I should like my pictures to look," said Sickert.

"They do," said Steer.

❏ I recollect with what apparent delight he related to me how his eye
had been attracted to a certain picture in the window of a shop in the
neighborhood of Holborn. He was on the other side of the road, but
the vaguely familiar aspect of the canvas caused him to cross and ex-
amine it. It was like something he knew, and yet different. . . . Then
he saw, stuck above the picture, to the glass of the window, a piece of
paper. Printed on it in large letters was the name SICKERT. . . . And,
in fact, when he came nearer, he recognized the canvas as one aban-
doned, when only half completed, some years before. Since he had last
seen it, it had been beautifully finished, and had acquired, with every
appearance of verisimilitude, his signature.
 —*A Free House,* ed. Osbert Sitwell.

❏ . . . When some distance out to sea, Sickert suddenly recognized
in another swimmer, who had not seen him, a dealer. This young man,
of a nervous temperament, had proposed a year or two before to pur-
chase some of Sickert's pictures, but had in the end failed to do so. He
appeared to be by no means at home in the water, and Sickert suddenly
burst out of a wave at him, with the words:
 "*Now* will you buy my pictures?"

 —SITWELL.

Although he chose painting over acting, he did not forswear the
theatrical.

❏ His sense of theatre was as keen as that of his idols, Hogarth,
Degas and Dickens; he loved to invent fresh disguises, cropping his
head like a convict on Monday or producing a vast square beard on
Friday, which seemed to grow as fast as Jack's beanstalk. Fortunately,
he soon wearied of these pranks and would reappear suddenly clean-
shaven and fastidiously groomed, lordly as a portrait by Van Dyck. His
dress varied accordingly; at one moment, the painter in open shirt with
carpet slippers, at another the farmer with Norfolk jacket and leggings,
again the man about town with morning-coat, striped trousers, gloves
and cane. If he was making a public appearance somewhere he always
shampooed his hair at the last minute, plunging his head under the tap
in a lather of soap and water, rubbing it vigorously and planting his
bowler on his wet curls, all at lightning speed. We never knew, when
we met him in hall or passage, what fresh quirk had overtaken him,
whether we should see the artist, the *homme du monde,* the farmer, the
professor, the Tichborne claimant. . . !
 —MARJORIE LILLY, *Sickert: The Painter and His Circle.*

A friend called on him unexpectedly.

❏ I saw the familiar leonine head, now cropped, with beard in full spate, looking through the banisters with an expression of acute apprehension.

"It's all right, who did you think I was?" I enquired.

"I thought you must be Lady Oxford. I met her at dinner last week and she asked where my studio was and I said nowhere. She said, 'But you must paint somewhere,' and I said 'No I don't,' and she said 'I shall find you, never fear! *One day you'll open the door and I shall be on the doorstep.*' "

Seeing that he was genuinely scared, I forbore to laugh and followed him upstairs, but he was still full of Lady Oxford.

"It's like Cézanne," I said. "When his friends pursued him, do you remember, he told them: 'I live a long way off, down a street.' But they never found him, did they?"

"Ah, but you don't know Lady Oxford. She's a very determined woman."

—LILLY.

He lived to be old and forgetful. Thérèse was Sickert's third wife.

❏ Sickert had been failing rapidly. He was suffering from a succession of small strokes, which had culminated in a more serious attack so that he was now upstairs, unable to leave his room. But until recently he had persisted in his old way, disappearing suddenly into Bath to potter among the second-hand bookshops as he had liked to do at Brighton, to search for subjects that he would never paint again. She was not worried about these flittings, as he was well known to every taxi-driver in Bath; matter-of-fact, efficient, benign, these men had adopted him long ago and soon discovered him as he wandered, confused and weary, along the great gray streets; one of them would cruise beside him, swoop him into the hovering cab without more ado and bring him home.

"And they never cheated him of sixpence," said Thérèse. "Even when Walter twice produced a fiver, he was given the right change."

She thought he had been happy at Bath, as he believed that he was still working. Sometimes he pleaded to be taken back to Fitzroy Street but that was part of the old restlessness that nothing could assuage. And until his final collapse he thought that he was still teaching. Every morning, he would start off gaily to the old barn in the gardens to "take his class."

"When I went after him, I would find him waiting for the students who never came. I tried to cheer him with promises that they would be

there next day, and take his mind off the subject by talking of something else. He seemed contented for the time being but next day he always went back to the barn to look for them again."

—LILLY.

Marjorie Lilly visited him for a last time.

❏ I tried to interest him in his supper, which was getting cold, but he brushed the tray aside; his attention wandered back to the window and suddenly he started to tell me about the picture he saw there in a torrent of words, moving in its broken vehemence. Then he pointed to the foot of the bed; he wanted a figure in the composition. I seated myself on the bed and his face lit up, he had now got what he needed, the fall of light on the object. "Yes, yes, that's it!" then he fell back in his chair:
 "But I can't do it today."
 "Never mind, you'll do it tomorrow."
 "Yes tomorrow," he agreed eagerly, "tomorrow."

—LILLY.

Aristide Maillol
(1861–1944)

The dealer Ambroise Vollard remembered Renoir telling him:

❏ One day when I had been to see Maillol at Marly-le-Roi, I found him in his garden, hammer and chisel in hand, before a block of stone. So many modern sculptors merely plagiarize the ancients, but Maillol is such a true descendant of the Masters, that as I watched him disengaging his forms I was reminded of a Greek. I caught myself looking for the olive trees.

—AMBROISE VOLLARD, *Recollections of a Picture Dealer.*

The art dealer Georges-Michel remembered a conversation between Maillol and Picasso: a difference of opinion.

❏ A follower of the classical French tradition, Maillol gave this advice to the artist who had just broken with academic form:
 "You must do as everyone else does."

To which Picasso replied,

"You must do differently from everyone else. You must do everything afresh."

"You must do better than anyone else: that is the way to do it differently."

"You must do it differently, and do it better."

"It is more difficult to do as everyone else does, and yet do it better."

They went on this strain, but ended by embracing.

—MICHEL GEORGES-MICHEL, *From Renoir to Picasso: Artists I Have Known.*

Everyone describes him as innocent, benign, and absent-minded. Vollard sent a messenger to Maillol, to pick up some plates.

❏ "I did not find M. Maillol at Banyuls itself," my messenger told me on his return; "I had to go five kilometers beyond it to dig him out at his farm; five kilometers that I had to do bent double, almost on all fours, not to be carried up into the air."

"Ah!" said Maillol absent-mindedly when I repeated this to him, "probably there was a wind that day."

—VOLLARD.

❏ One day in Edouard Vuillard's studio he admired a canvas which the latter was finishing. "I will take it to the Louvre at once," said Maillol. He was very disappointed and angry when he learned of all the rigmarole which accompanies the acceptance of a work of art; and that the Louvre doesn't belong to artists, but to the civil servants of the Arts. He was scandalized. One loves him at first sight; one values and admires him on better acquaintance.

"When I have spent a couple of hours with Maillol," an anxious painter told me, "I go away entirely reassured, I feel a security and a serenity which stays with me for days."

—*The Artist By Himself,* ed. Joan Kinneir.

André Gide said, "Maillol talks with animation, graciousness, and innocence. He looks like an Assyrian from Toulouse." Elsewhere Gide reports a story: Maillol exclaims, "A model! A model; what the hell would I do with a model? When I need to verify something, I go and find my wife in the kitchen; I lift up her chemise; and I have the marble."

Maillol received a commission. As chairman of the committee that gave it to him, Clemenceau asked him, "How do you see your monument?" Reportedly, Maillol answered, "I see a fine woman's bottom."

He saw them all his life but Madame Maillol did not remain his standard. John Rewald noticed the change.

❏ The meal was served by the plump young maid I had met in the garden. She wore a black dress covered with grease spots; underneath she wore nothing. Whenever she presented a dish and had to lean slightly forward, a generous portion of her natural assets was revealed. Maillol lost nothing of the spectacle, though his eyes did not confine themselves to the decolleté; they followed the girl around, appreciating as well her sturdy bare arms and the movements of her portly hips.

When I returned the next morning, Madame Maillol opened the door for me. She was in a foul mood and made no bones about it. "I can't stand it anymore!" she exclaimed. "I have to do everything myself! Impossible to find decent help in this godforsaken place. I must cook, wash the dishes, do the shopping and clean the house. And all this for . . ." (Here followed a few heartfelt appreciations of her husband.) I told her how much I sympathized with her and hurried down the stairs to the comparative safety of the studio, where the artist was cleaning his brushes.

Having heard his wife's angry voice, he shook his head. "Sorry, you had to get mixed up in this," he said. "It must be tough on her to be without servants," I replied. "Don't you believe it," he shot back. "She only has herself to blame. Elderly women around here won't work for her because of her nasty disposition. As for the young ones, well, the minute I so much as look at them, they are fired. That's what happened to the girl who served dinner last night."

—JOHN REWALD, in *Aristide Maillol 1861–1944*.

❏ Clotilde Maillol, a plump old woman, bitter and without any grace, once had played an important role in her husband's work. . . . Now she looked with a sour face at many of the photographs I showed her. Although at the beginning the majority of her husband's works had represented her, she had been slowly dislodged from his creative activity. *La Nuit, La Méditerranée, L'Action enchaînée* had been posed for by her, and so had innumerable drawings that he still used. Probably more acutely than most married women, she had helplessly watched her man lose interest in her and, what is worse, had also been *replaced* in his work. The many pieces not representing her did not—as far as she was concerned—carry the titles under which they had become famous (titles often provided by Maillol's literary friends): *Ile de France, Flore, Pomone, Les Trois Nymphes,* but were merely the bodies of rivals, and she would spit out designations such as *"une Parisienne," "une gamine de Banyuls," "une voisine de Marly," "Marie,"* etc. A tragic victim of her advancing age, she had lost her husband in more than one way. It was true that Maillol did not help when he once tried to appease her by saying:

"But you can still pose for me . . . from the back!" She never forgave him for that.

—REWALD.

Behind his abstraction, especially as he aged, there was a growing misanthropy. Rewald again:

❑ On the way we discussed the difficult question of the extent to which the public at large understands art. Maillol was convinced that it didn't and once more expressed his disdain for most people. "I hate them," he repeated, "they are wretched beings. I prefer my cat or a frog. My cat at least understands when I talk to him." As he said this, he drew my attention to the white-tailed blue swallows flying low over the road ahead of us. He showed me trees, stopped to look at flowers, spoke of the vine-stocks, of fertilizers and of the advantage of manure, of droughts and rains; all this in the most natural tone, like a man who has always been close to the soil.

—REWALD.

When he was old the young Dina modeled for him three hours a day. Rewald visited a last time when Maillol was in his eightieth year in 1941.

❑ Maillol then played some records of Basque folk music, *Sardanas*, to which people dance wherever Catalan is spoken, from Barcelona to Perpignan. It is a music composed of variations of an initial theme, played by wind instruments—not unlike bagpipes—as well as by brass and drums. The captivating rhythms of these simple melodies prompted me to ask him what kind of steps were executed to these cadences. He rose and, with a smile, performed a Catalan *Sardana*. There, by the gleam of the fire, with little steps forward and backward almost on the point of his toes, slightly bending now to the right, now to the left, he moved with an amazing naturalness. Far from being ridiculous, his movements were proud and noble, his gestures sparse, even grave, and infinitely harmonious. Thus the tall old man with the white beard sketched dance steps in which his entire youth lived again. An indescribable joy spread over his wrinkled face, his eyes were laughing; he himself seemed surprised by the ease with which he could resurrect the movements of a dance that once had animated every local feast. Then, after indicating a reverence with the inclination of his head and a gesture of his hand, he sat down.

"You see," he said happily, "I still remember the rounds of my country."

—REWALD.

Gustav Klimt
(1862—1918)

Friederike Beer had her portrait painted by both Egon Schiele and Gustav Klimt. (Her maid reported of the Schiele portrait, "My mistress has been painted and she looks as though she lies in the tomb!")

❏ When I went out to Klimt's garden house in Hietzing I was really prepared for anything, because I knew how eccentric he was with that beard and always going about in a sort of monk's robe and sandals. But when he opened the door for me I wasn't prepared for one thing! He wore a big monocle in one eye and looked me sedately up and down without saying anything! That was rather unsettling. Finally he said to me: "What do you want to come to me for? You have just had your portrait done by a very good painter." I was afraid he was going to turn me down and so I answered quickly that yes, this was certainly true, but that through Klimt I wanted to be made immortal, and he accepted that.

—ALESSANDRA COMINI, *Egon Schiele's Portraits.*

She summed him up.

❏ The most striking quality about him was perhaps his animalism. He was actually "animalisch"; he even *smelled* like an animal!

—COMINI.

Rodin visited Vienna in 1902 and sat with Klimt at an afternoon coffee party. The hostess remembers:

❏ I had the coffee served on the terrace. Klimt and Rodin seated themselves beside two remarkably beautiful women—Rodin gazing enchantedly at them . . . Alfred Grünfeld sat down at the piano in the big drawing-room, whose double doors were opened wide. Klimt went up to him and asked, "Please play us some Schubert." And Grünfeld, his cigar in his mouth, played dreamy tunes that floated and hung in the air with the smoke of his cigar. Rodin leaned over to Klimt and said: "I have never experienced such an atmosphere—your tragic and

magnificent Beethoven fresco; your unforgettable, temple-like exhibi-
tion; and now this garden, these women, this music . . . and round it
all this gay, childlike happiness . . . What is the reason for it all?" And
Klimt slowly nodded his beautiful head and answered only one word—
"Austria."

—FREDRIC V. GRUNFELD, *Rodin: A Biography.*

Edvard Munch
(1863–1944)

Munch's Oslo was prudish. He was twenty for the opening of
the Christiania Museum of Sculpture—at which an art history
professor swore with his hand on the Bible, during a lecture,
that no one should feel shame when observing a nude portrait.
When Munch showed *Puberty*, his first nude, knowing that his
father would visit the exhibition, he "had a cloth put over the
picture in order to spare the feelings of the old man"
 He was poor as a young student in Paris.

❏ His landlord kept watch on the front door because Munch owed
him money. But Munch had to get some pictures to the exhibition at
the Indépendants. He solved the problem simply by throwing the pic-
tures from the window of his studio down into the street over which
his landlord was unable to command a view, where we caught them. A
hole was made in one of the pictures in the process—the one showing
three women under a tree which I think he called *The Flutes* [*The Three
Stages of Woman*], but we repaired it on the way. According to French
law, a landlord may not seize a debtor's property if it is outside his
house.

—J.P. HODIN, *Edvard Munch.*

The playwright August Strindberg was his compatriot and friend.
At one time they loved the same woman, married to yet another
friend. Once as Munch painted a portrait outdoors, a wind sud-
denly rose and knocked his easel over. He stopped work, ex-
plaining that the wind was Strindberg, disrupting him. Troubled
with insomnia, he used to reserve a berth on a sleeper from Oslo
to Stockholm—because he could sleep better on a train, not in
order to go to Stockholm.

Strindberg himself did some painting—and in 1893 showed with Munch in a Berlin *salon des refusés*—while Munch, like Oskar Kokoschka and many Expressionists, tried his hand at writing. His words paraphrase his painting.

❏ A mother who died early gave me the germ of consumption—an overly nervous father—pietistically religious bordering on fanaticism— from an old family—gave me the seeds of insanity—
From birth—they stood by my side—the angels of anxiety—sorrow— death followed me outside when I played—followed me in the spring sun—in the beauty of the summer—They stood by my side in the evening when I closed my eyes—and threatened me with death hell and eternal punishment—
And then it often happened that I woke up at night—and stared in wild terror into the room
 —BENTE TORJUSEN, *Words and Images of Edvard Munch.*

And the life paraphrased the work.

❏ When he was forty he was involved with a girl who had herself laid out, as if on her deathbed, in an attempt to prevent him from leaving her; and when she threatened to shoot herself and Munch tried to restrain her, the gun went off accidentally and he lost one of his fingers in the struggle.
 —JOHN RUSSELL, *The Meanings of Modern Art.*

He called his paintings his "children," and said, "I have nobody else."
In 1913 Christian Gerloff described Munch at work:

❏ He has no less than forty-three studios altogether in his four houses at Kragerø, Ramme, Åsgårdstrand and Grimsrød on Jeløya: all his rooms are studios. He does not possess very much more furniture than he had twenty years ago, when he was a penniless young artist; a few cane chairs are the most luxurious items. His rooms are his workshops, for pictures, easels, portfolios, lithographic presses, etching tools and electric furnaces are to be found scattered in every room in a chaos of which he himself has but a hazy idea.
Tubes of paint and turpentine, brushes and palettes lie scattered about on the floor, on packing-cases and chairs. Munch places the canvas on the easel while he glances towards his model. "Ah, yes, painting, that's quite a business," he observes as he takes a couple of steps to the side,

gazes at the model for a few moments half wrapped in thought, glances again, and then with arm outstretched draws the first strokes with a stick of charcoal. . . . Often too he does not say a word, and an oppressive silence fills the room while he continues to draw with deepening concentration. He then looks less and less often at the model, until it seems as though the canvas is absorbing his entire attention. He forgets completely that the model needs to relax a little. After twenty minutes of drawing he starts painting straight away. . . . He paints steadily, a little here, a little there with increased absorption in his work. Now and again he will take the picture from the easel, place it in another room, contemplate it awhile from a distance, replace it on the easel and set to work painting again with intensified energy. . . . All that can be heard is the soft scraping sound of the brush on the canvas, accompanied by the intermittent rattle of the loose frame beneath the force of his powerful and at times almost violent brush strokes.

I particularly recollect the case of one of his very large portraits— one of the most celebrated, now in the possession of a Swedish collector, which was painted in this fashion at a single sitting lasting only a few hours. It resulted in a splendid picture, but the unhappy model was almost in a state of collapse by the time it was completed. . . .

Munch often paints two pictures with the same subject or the same model, a large picture and a small one: he passes from one to the other and the two supplement each other. He does not paint every day, or even every week. In fact, many weeks and often months may elapse between spells of painting. He generally likes to go about for a long time considering a subject and meditating on it until one day he suddenly plunges feverishly into the work of painting it. He is eager to paint every minute, every second that he feels the inspiration working within him. There is no power in heaven or earth that could ever make him paint without this.

When he has finished at last, he sets up the picture on the wall and looks at it with narrowed eyes. "Oh well," he will comment, "that will be all right when it has stood there for a while and has had time to mature. The colors live a remarkable life of their own after they have been applied to the canvas. Some reconcile themselves to one another, others just clash, and then they go together either to perdition or to eternal life. Just wait until they have weathered a few showers of rain, a few scratches with nails, or something of the sort, and have knocked about all over the world in every kind of miserable, battered, and far from air- or water-tight packing case. Oh yes, that will turn out all right . . . when it has developed a few slight flaws it will be quite presentable."

—HODIN.

Wassily Kandinsky
(1866—1944)

He was born in Moscow and worked as a lawyer before emigrating to Munich at thirty in order to become a painter. But painting had already started for him.

❏ At the age of thirteen or fourteen, I was, at last, able to buy myself, out of my savings, a box of oil paints. And to the present day I can still feel the emotion that I experienced on first seeing the fresh paint coming out of the tube.

You just had to press lightly with your fingers—and out they came—those strange, mysterious beings we call paints.

One of the memories of my childhood connected with Aunt Elizabeth was a little tin horse I used to play with. It was a bay, with an ochre body and a tail and mane of yellow. And many years later on my arrival in Munich (where I went at the age of thirty, discarding all the long work of previous years in order to study painting), I saw during the very first days, in the streets, a bay horse that was the exact counterpart of my little tin horse. It invariably appears year after year as soon as the water-carts first make their appearance. In the winter months it mysteriously vanishes, only to reappear again next spring—it never changes, nor grows older—I think it is immortal! It has brought me a half-felt, yet clear and joyful premonition and promise. It made my little tin horse live again, and, stretching far back through the years, tied Munich and my new life forever to the memories of my childhood.
 —*In Memory of Wassily Kandinsky*, Solomon R. Guggenheim Foundation.

He was an inventor of abstraction.

❏ Using the tendency of a painted object to lose much of its form and identity to the general composition of a picture, I gradually acquired the gift of no longer noticing the given object, or, at least, of overlooking it. Much later, in Munich, I was once deeply enchanted by an unexpected sight that met my eye on returning to the studio. Twilight was drawing in. I was returning, immersed in thought, from my sketching, when, on opening the studio door, I was suddenly confronted by a picture of indescribable and incandescent loveliness. Bewildered I stopped; staring at it. The painting lacked all subject, de-

picted no identifiable object and was entirely composed of bright color-patches. Finally I approached closer and, only then, recognized it for what it really was—my own painting, standing on its side on the easel.

<div align="right">—GUGGENHEIM FOUNDATION.</div>

Pierre Bonnard
(1867–1947)

Once in a museum he persuaded his friend Vuillard to distract an attendant while he approached his own old painting, slipped from his pocket "a tiny box of paints and a brush the size of a toothpick," as the critic Annette Vaillant says, "and added to one of his consecrated canvases minute touches that set his mind at rest."

❏ In one collector's flat, he asked in the pantry for a stool so that he could add some essential half-tones to the foliage in a picture which had been hanging there for years. In the gallery of his friend Jacques Rodrigues he took down some drawings ("They aren't nailed to the wall, are they?"), had the glass taken off, and made an imperceptible correction with a rubber.

<div align="right">—ANNETTE VAILLANT, Bonnard.</div>

❏ He almost always hesitated for a long time before signing a canvas, but sometimes, unexpectedly, he would declare, "I'll readily sign that." Bonnard did not paint from life, but his pockets were full of sketches made to assist his memory. He scrawled them with "a burnt match, even a broken pen," as George Besson tells us.

<div align="right">—VAILLANT.</div>

In one habit he resembled Grandma Moses.

❏ Often he made use of a single great length of canvas which he affixed to the wall wherever he happened to be, marking on it different-sized areas for various pictures. At the end of his sojourn he would roll it up, put it in his car, unroll it again when he got home, and later cut it up.

<div align="right">—JAMES THRALL SOBY, Bonnard and His Environment.</div>

❏ The longer he lived the more he concentrated on color; stronger and stronger combinations of juxtaposed or superimposed pigment. Sometimes, having mixed one of his burning hues, vermilion, or magenta or violet blue or peacock blue, and applied it to the work in progress, he would wander around the house from canvas to canvas, finding little places where he could insert what he had left over. As he himself said, a given color is very different when you see it with other colors adjacent. André Girard tells us that when Rouault retouched his pictures to improve them he called it "Bonnard-ing."

—SOBY.

He was old when the Second World War devastated France.

❏ From time to time, kind neighbors brought him—without any thought of a return—an egg, a few extremely scarce potatoes, a little coffee, half a pound of black-market sugar. One morning they were amazed and overcome to see Bonnard's cleaning woman arrive bearing a great roll of watercolors tied up with an old bootlace. Bonnard, who always paid his debts, was minimizing his own "going rate" at a time when speculation on his work was becoming more and more active.

—VAILLANT.

He died revising.

❏ One day Jacques Rodrigues had said of a picture by Signac, "There is a lot of yellow in it."

"One can't have too much," said Bonnard. Just before he died, when he was already too weak to hold the brush himself, it was a touch of yellow that he asked his nephew Charles to add to his last painting. "On the left, at the bottom, there on the ground under the almond tree."

—VAILLANT.

Henri de Groux
(1867–1930)

Vollard knew him.

❏ He was as simple as a child. He had only to be told that so-and-so bought pictures, and he would rush off at once to one of the detainers

of his works, and announce joyously, "I've found a purchaser for my picture!"

But it might happen that other creditors besides the depositary had rights to the picture, and each of them wished to be present at the negotiations. In which case the presumptive buyer would be visited by Henri de Groux wreathed in smiles, with a painting under his arm, followed by the representatives of the frame-maker, the colorman and the stretcher-maker. . . .

If the affair failed—and it failed almost invariably—de Groux bore no grudge to anyone. At most, upon leaving the house, he would turn towards the windows of the *amateur* and, taking his bodyguard to witness, exclaim:

"That chap is a dirty dog! I should have hated to think my picture was in his house."

—AMBROISE VOLLARD, *Recollections of a Picture Dealer.*

The Belgian government bought his most famous painting, *Le Christ aux Outrages*, which showed Jesus in captivity surrounded by Romans and the mob.

❏ He had long since used up—or drunk up—the money he had received for the picture, and was bemoaning the trip he could have taken to Italy with the proceeds, when one evening, as he was dining with his wife and his young niece Cordelia, a friend came in to see him about a possible commission he had in view for the artist.

"You know, don't you," said the friend, "that I am one of the architects for the new Casino de Picardie?"

"Oh, yes. You're working for that millionaire who used to be a waiter, and is now putting up gambling-houses for silly fools at seaside resorts."

"I've been working for you too, de Groux, for I've got you a commission to do the decorations for the casino."

"What! Who? Me? De Groux work for that scoundrel, that bottle-washer, that panderer to human stupidity, when my only ambition is to decorate cathedrals?"

"Hold on! He'll give you thirty thousand francs for the job."

"Thirty thousand francs!" echoed the niece. "But, uncle dear, that's your trip to Italy, to the land of golden cathedrals. Indeed, for that amount you could even go to Greece!"

De Groux rubbed his chin thoughtfully.

"Well, after all," he conceded, "you go to the lavatory to relieve your mind as well as your bowels. I may as well go there to earn my trip. All right: it's agreed," he said, rising to his feet.

His friend gave him the address, and de Groux put on his old brown overcoat, which he had lugged all over Europe, crammed his *Tartuffe*

hat over his stage-priest's hair, and went off to see the director. On arriving at the casino, which had just been finished, he was asked his name.

"Just tell the director to come here," de Groux replied.

The commissionaire took the message to the director, who happened to be talking with a contractor.

"Who's asking for me?"

"That queer fish over there."

The man inspected the "queer fish," from his enormous shoes to his crazy hat, the sides of which were resting on its owner's shoulders.

"All right. He's only a sponger. Let him wait."

De Groux waited fifteen minutes, half-an-hour, forty minutes, grumbling the whole time.

"A retired vintner, a bottle-washer, a table-wiper, to keep *me* waiting!" he fumed.

More than three-quarters of an hour had gone by before the director finally decided to wander over to the door, and, seeing de Groux, said in an off-hand manner,

"Oh. Did you want anything?"

But our friend, exasperated by the other's tone, shook his head, raised his hand, and, throwing away his heart's desire and the thirty thousand francs, cried out in a strident voice,

"A beer, waiter!"

And away he proudly went, his shabby trousers flapping in rhythm with his hair.

—MICHEL GEORGES-MICHEL, *From Renoir to Picasso: Artists I Have Known.*

He was not continually poor, but he managed to dispose of whatever fortunes he acquired.

❏ One day, however, he received an unexpected windfall in the shape of a commission to decorate a private chapel. When he had finished it, he sauntered forth along the quays of the good town of Ghent with twenty-five thousand francs in his pocket. He wasn't interested in the waterside, only in the antique shops on the opposite pavement. Each one he came to filled him with the desire for possession. Among other objects, he was fascinated by a tapestry, and, following his usual habit, began talking aloud to himself:

"How delicate, how graceful is that young woman's body! What melancholy in her eyes: they remind me of stormy skies! What must her romance have been, that charming woman embroidered in silk, and dead so long ago? What a pleasure if one could know her story! How wonderful it would be to own such a piece. Ah, if I were only rich! But—but——!" he exclaimed, "come to think of it, I *am* rich! Because I've got——"

He entered the shop, and, with all the arrogance of an English lord, demanded,

"How much is that tapestry?"

The shopkeeper stared at the poor wretch, at his worn shoes and his eccentric hat and coat.

"Very expensive," he said in an off-hand way.

"Yes, but how much?" insisted de Groux.

"Twenty-seven thousand," said the antique-dealer, turning his back.

"That's all right," replied the artist. "I'll take it." And he pulled out the money he had just earned. "I hope you will pardon me," he went on, "but I've only twenty-five thousand francs with me. Would you be willing to trust me, and take an I.O.U. for three months from now?"

The dealer was only too willing to accept, and de Groux signed the I.O.U., which was to poison his life for years to come. He marched out of the shop humming a tune, while under his arm he carried the tapestry, which he hadn't even bothered to have wrapped up.

He sat down on a bench, unrolled his prize, admired it and called to several passers-by to share in his pleasure. Then, when he had admired it to his heart's content, he suddenly felt hungry. He searched his pockets but couldn't find a single sou.

The aroma of stew reached him from a nearby eating-house. Being a good Belgian, de Groux was never averse to a decent meal. After debating with himself for an hour in front of several restaurants he finally capitulated.

"I've had my joy of it," he told himself sadly, as he gazed at the tapestry for the last time. Then he went off to sell it to a second-hand dealer, for he did not dare to go back to the original shop. He managed to sell it for just enough for a meal and his fare back to Brussels.

His wife never heard a word of the story, but one can imagine the scene that ensued between his niece and himself.

—GEORGES-MICHEL.

Not long after the press announced that Henri de Groux had died, Georges-Michel met his ghost.

❏ For I suddenly became aware of a grotesque silhouette, whose shadow was elongated on the dry, white pavement by the light of the street lamp. It had crooked legs and a long overcoat, which flapped about like a flag, while under the dark, wide-brimmed hat two eyes glittered like steel points. Mystified and intrigued, I circled round the apparition. Presently he began to talk to me, and told me how a short while before he had been set upon by some roughs. He had taken off his hat and said to them with exquisite courtesy:

"Gentlemen, you are mistaken. I am not the one you are looking for."

They had talked to him a bit, for they didn't know what to make of this James Ensor character, who seemed like a walking, talking automaton. The joke of it was that, instead of being robbed, he had actually managed to wheedle a few sous out of them! On another occasion, de Groux had coaxed money out of a highwayman, who subsequently gave him a sound thrashing when he learned that his money had been given to the poor.

"It was the only way to get out of the predicament honorably," the old man concluded.

"But, de Groux," I said, "I thought you were dead!"

"Well—that's the official version, and, like most official versions, untrue."

"Why didn't you turn up in your shroud at your private view this afternoon?"

"To tell you the truth, I did think for a moment of doing so. But it would have been in rather poor taste, don't you think? Besides, I wanted to go to a lecture."

—GEORGES-MICHEL.

❏ It was about this time that the Bartholomé incident occurred. I have often wondered if the artist did it on purpose, for it was certainly characteristic of him.

It so happened that the sculptor Bartholomé, wishing to honor the Belgian refugee artists in Paris, decided to give a dinner for them. He decided to talk the project over with de Groux, whom he had recently met and taken a great fancy to.

"How many of them are there?" he asked de Groux. "About a dozen?"

"Oh, no," said the other. "Twenty at the very least."

"Then there won't be enough room in my house. I'll hire a private room in a restaurant. Would you like to make up a list for me?"

A week later de Groux brought Bartholomé a list containing the names of forty-eight refugee artists from Belgium.

"Oh!" exclaimed Bartholomé, on glancing at it. "The room I've engaged won't be large enough for all these people. I shall have to take the banqueting-hall at the Continental. What day shall we set?"

"You must give me at least a week's notice," replied de Groux, "because I think that when I write to them I ought to tell each one how much we think of his talent."

"That is very thoughtful of you."

De Groux spent two whole days trying to decide what color notepaper would be most suitable in each case, finally choosing mauve for the Impressionists, white for the more classical, and so on. Then he sat up at nights writing the invitations, by the light of a smoky lamp. Having composed and torn up three or more drafts of each one, the letters were finally done, and the date fixed for the dinner.

When the day arrived, de Groux put on dress clothes: that is to say, he called in various friends, people he knew in the neighborhood, several artists, his concierge, etc., and asked them to help arrange his cravat, his cuffs and trousers. Besides, he wanted them to see him in all his glory.

"It's going to be quite an affair," he told them. Then he ordered a cab.

"Now, cabman," he said to the driver "take me to the banqueting-hall at the Continental. I'm a trifle late, but I shall be all the more welcome for that reason."

On arriving at the entrance, he called out,

"Come, pages and stewards, and conduct me to the banqueting-hall!"

Solemnly, his head held high, his ringlets curled by tongs, de Groux ordered the folding-doors to be opened for him.

And there, in the banqueting-hall, were fifty-two places laid at two long tables, with chairs conspicuously empty, while white-stockinged lackeys stood waiting for the festivities to begin. At the far end of the room, with their backs to the fireplace, stood Bartholomé in full dress, his *Légion d'Honneur* ribbon across his white shirt-front, and Mme. and Mlle. Bartholomé in evening-gowns, all three gazing at the scene in consternation. When they caught sight of de Groux they rushed forward.

"Well, Monsieur de Groux, where are the guests?"

"Er—— I—— Hm——"

"Did you send out the invitations?"

De Groux's little steely eyes opened wide. He felt in his pockets, stamped his heel on the floor and struck himself on the forehead.

"Ah—that's me all over! That's just typical of me . . . !" And taking out a packet of letters he threw them down on the table.

"Well, there you are, there you are," he said. "I simply forgot to post them."

—GEORGES-MICHEL.

Käthe Kollwitz
(1867—1945)

Her son Hans almost died of diphtheria when he was ten in 1902. She remembered one night

❏ . . . an unforgettable cold chill caught and held me: it was the terrible realization that any second this young child's life may be cut off, and the child gone forever.

—*The Diary and Letters of Kathe Kollwitz,* ed. Hans Kollwitz.

Some months later she etched her *Mother with Dead Child* using Hans's brother Peter as model.

❏ I drew myself in the mirror while holding him in my arm. The pose was quite a strain, and I let out a groan. Then he said consolingly in his high little voice: "Don't worry, Mother, it will be beautiful, too."

—KOLLWITZ.

Peter was killed at eighteen in the Great War. Not until 1931 did she finish her sculpture *Mourning Parents* as a memorial for her son and all dead soldiers. Käthe and Karl Kollwitz were recognizably models for the granite figures, situated in the Roggeveldt cemetery in 1932. She spoke later of the installation:

❏ [I] looked at her, my own face, and wept and stroked her cheeks. Karl stood close behind me. I had not known it. I heard him whispering, "Yes, yes." How close we were then!

—KOLLWITZ.

Kollwitz was not popular among Nazis. At her seventieth birthday in 1937 the government banned a show of her work; yet it took place, surreptitiously enough, at the Buchholtz Bookshop and Gallery in Berlin.

❏ If someone came into the shop asking for the Kollwitz exhibit, he was told that unfortunately it had been closed—but the artwork was still upstairs in the gallery. Silently, one by one, the visitors approached the drapes, moved them aside, climbed the small stairway, and looked at the works of their great blacklisted friend, including the *Protecting Mother.*

—MINA AND ARTHUR KLEIN, *Kathe Kollwitz: Life in Art.*

She remained in Germany. In 1939 her son Hans's children repeated to their grandmother some praise of the Führer they heard in school. "Hitler is an ass!" they heard from their grandmother. This pacifist artist lost her grandson to the war in 1942 as she had lost her son in 1914.

George Luks
(1867–1933)

The American George Luks, member of the Ashcan School and friend to Everett Shinn and John Sloan, suffered from moments of confidence.

❏ He would say, "The world never had but two artists, Frans Hals and little old George Luks," with frequent remarks like "Art—my slats! Guts! Guts! Life! Life! I can paint with a shoe-string dipped in pitch and lard."

—VAN WYCK BROOKS, *John Sloan: A Painter's Life* .

He was another painter obsessed by pugilism. American painters love boxing as American poets love baseball.

❏ Luks harbored an abiding fantasy of himself as a prizefighter named "Chicago Whitey," the ferocious winner of at least 150 ring battles. He was such an accomplished actor and talker that many people believed him. A more objective view of Luks's fighting ability was provided by the observant Sloan. "He would often pick a fight in a saloon," Sloan reported, "say something nasty and get things going and then leave the place, with people who had nothing to do with the argument left to finish the fracas."

—*American Painting 1900–1970,* ed. Time-Life Editors.

Sometimes the attraction can be fatal.

❏ In 1933, when he was 66, his body was found one morning in the doorway of a building next to the Sixth Avenue elevated railway in Manhattan. The romanticized stories printed in the newspapers stated that Luks had gone to the shabby section of the city to paint the light of dawn as it filtered down through the tracks, and was set upon by derelicts. What actually happened was quite different. Luks had slipped into a speak-easy and after a few drinks had begun one of his wild routines. One of the other patrons, infuriated by the act, took the artist outside and beat him to death.

—TIME-LIFE EDITORS.

Emil Nölde
(1867–1956)

George Grosz remembered:

❏ He no longer used brushes to paint. He later told me that when inspiration seized him he had thrown away his paintbrushes, dipped his old painting rag in color and, in blissful delirium, wiped it all over the canvas.

—GEORGE GROSZ, *An Autobiography.*

❏ The new threat to naughty children was: "If you don't behave, Nolde will come and get you, and smear you all over his canvas."

—GROSZ.

Suzanne Valadon
(1867–1938)

Neglected by her alcoholic mother, before she was ten she wandered the streets of Montmartre, skipped school, and took pride in a prodigious filth. "Washing is for pigs," she said. "I am a monkey, I am a cat."

❏ When she was seven or eight years old, she said much later, she once stopped to watch Renoir working at his easel in the rue Lepic and advised him solemnly to keep on with his painting and not be discouraged; that he had a future in it.

—JOHN STORM, *The Valadon Drama: The Life of Suzanne Valadon.*

She was an acrobat with a circus and then an artist's model, with an appetite for love, and

❏ by the time she was sixteen it had given rise to a prodigious show of promiscuity which had many Montmartre tongues wagging. The

Breton waiter at Père Lathuile's restaurant, the postman Léconte, De-
gas's young friend Zandomeneghi, the sailor Guichet—they are but a
few of the remembered names of her lovers. A night or two, a week, a
month, a sudden disappearance to the forest at Fontainebleau, a rented
room above a stationer's shop in the rue Custine, a bacchanale neces-
sitating a call by the police in the studio of Louis Anquetin—such was
the substance of her amours, which for all their intensity and animal
vitality preserved an aura of playfulness and naïveté.

—STORM.

"Yet," as her biographer puts it, "even the course of promiscuity
could not long run smoothly. It was destined to be interrupted
by a romantic idyll which lasted almost six months." Puvis de
Chavannes was fifty-seven and Suzanne seventeen.

When she became pregnant in the autumn of 1883, it seems
probable that the father's identity was unclear. At first she called
her child Maurice Valadon, but later her friend and lover Mi-
guel Utrillo—who may have been the boy's father (from time to
time, Suzanne asserted that he was the father and that he could
not possibly be the father)—signed an "Act of Recognition" which
gave the child a surname.

There's a story about this recognition. Suzanne was eating with
friends, including Miguel, when one asked her directly who fa-
thered Maurice. "I've never been able to decide," Suzanne said.
"I don't know whether the little fellow is the work of Puvis de
Chavannes or Renoir." Miguel is supposed to have made the of-
fer: "I would be honored to sign my name to the work of either
of those fine artists."

Of her affair with Renoir, she later said: "A fine painter. All
brushes but no heart." It was her friend Toulouse-Lautrec (she
was so tiny that it made him feel tall to walk with her) who sent
her to show Degas her work.

❑ Degas took the portfolio from Suzanne as though it were a pack-
age from his tailor, half muttering a "Thank you" in his querulous
nasal voice. He moved toward the light by the window, hobbling like
an octogenarian and complaining that he was losing his eyesight and
was plagued with a cold. With unbearable slowness he went through
the drawings—without much interest, she thought. From time to time
he looked up from her work to Suzanne herself, and each time she was
certain he found something disagreeable in both. His heavy lip seemed
to droop, but soon the almost perpetual sneer which flickered about his
mouth dissolved. He wiped his eyes with his handkerchief, shifted his

weight, and went through the drawings again. At last, turning to face her as she sat in the straight-backed chair at the opposite side of the room, he snapped the portfolio closed. "Yes. It is true. You are indeed one of us."

—STORM.

Later when Degas saw some of her nude drawings of herself, he said, "If there were any tears left in me, I'd be happy to shed them for one of those drawings."

When she met the composer Eric Satie, he told her, "I breathe with care, a little at a time, and I dance very rarely." She was already living with Paul Mousis but no one seemed to mind when Satie made three.

❑ [He] bought Suzanne necklaces of sausages. He took her to the Luxembourg Gardens to sail toy boats. He sent an enormous funeral wreath to her son Maurice "so that you may learn the names of the flowers and make up better ones." He hired two small Negro boys to march before them beating small drums the night he took Suzanne and Mousis to Fort's Théâtre d'Art to see Pierre Quillard's *The Girl with the Chopped-off Hands.* For her birthday his gift to Suzanne was a paper sack "with all the wonderful smells of the world in it."

—STORM.

Satie performed his new compositions for her—"Real Boneless Preludes for a Dog," "Three Waltzes of Affected Disgust"—and liked her as an audience although she was unmusical.

❑ He performed in friends' studios, often with Suzanne at his feet. On such occasions he explained that it was she who radiated the love that nurtured his inventiveness despite the fact that she knew nothing about music. "She will never get a rapt expression on her face like a spaniel of a critic, and she has a tender little belch which is often inspiring."

—STORM.

As she grew older, the eccentric young girl—"I am a monkey"— grew more eccentric.

❑ At one time she took to wearing a corsage of carrots on her ragged coat, at another she would carry a nosegay of lettuce and live snails. The Butte often saw her in outsized Indian moccasins with a pair of

cats in her arms and a goat at her heels. On the night of the Armistice she appeared in the Place du Tertre clothed in nothing but fluttering flags of the Republic and a moth-eaten fur tippet. One night sightseers were flabbergasted to see her before Chez Ma Cousine milking a mare into a wine glass and drinking the milk with apparent pleasure.

—STORM.

She remained strong-minded even in the face of age.

❑ As early as 1923 she had faced the deterioration of her beauty by painting an extraordinary self-portrait, a picture no other woman would have painted of herself—flat-faced, the sensuous lips drawn to an absurd rosebud mouth obviously holding in badly fitting false teeth, the pendulous breasts of a dissolute savage. There she was—naked, completely immodest and old, and considerably more durable than the fitful humors of love.

—STORM.

When she was older her paintings became fashionable and she grew rich; she adopted bourgeois taste but not bourgeois manners.

❑ Her suits were by Paquin and Alex Maguy, and she wore tea gowns by Lucille, Lady Duff-Gordon. At a private showing at Vionnet's she sat alone with Queen Marie of Romania. Not that she cared a fig for fashion. In a few weeks she would be wearing her "creation" besmeared with paint at her easel. "One has one's caprices, and when one has money one buys them," she said airily. The Persian-lamb coat she had often dreamed of owning served as a bed for her dogs more often than it appeared on her back. The dogs lived very well indeed, dining on *faux-filets* specially prepared for them to their mistress's order at the restaurant Moulin Joyeux. Her cats had beluga caviar on Fridays.

Suzanne now cruised about Paris in a gleaming Panhard driven by a chauffeur in white livery which he was obliged to change twice a day. When the Panhard was in the repair shop she rode in a taxi. Once she took a taxi to St. Bernard, a distance of 350 miles, in order to pick strawberries out of the garden. At the château she caught from the window a view which she thought she would like to paint, and sent the taxi driver back to Paris to fetch her paints. When he returned a couple of days later, naturally the light had changed. In the meantime she had decided that she would not paint the view anyway, and had taken the train back to Paris.

—STORM.

Edouard Vuillard
(1868—1940)

Once Vuillard opened a cupboard full of studies that he had not consulted for years.

❑ . . . he looked at them anxiously. Raising his arms, he exclaimed "It's dreadful, revealing all these secrets!" It might have been thought he was about to disclose shameful thoughts, or some crime long since forgotten. I remembered the words of Degas, "A picture is an artificial work, outside nature. It calls for as much cunning as the commission of a crime." Now and then he asked me to hand him some little panel which he appeared stupefied to find was his own work.

—CLAUDE ROGER MARX, *Vuillard: His Life and Work*

Henri Matisse
(1869—1954)

Studying law in Paris as a young man, he was so uninterested in painting that he never even visited the Louvre. When he returned to Picardy, he clerked in a law office, bored with his work but submissive to family expectations. Then in his twentieth year he became ill.

❑ During his convalescence he became acquainted with a neighbor, the director of a small cloth-manufacturing firm, who passed his leisure time painting "chromos" (a kind of early and less mechanical version of painting by numbers). One bought a box containing colors and canvas along with color reproductions of paintings to be copied, usually picturesque landscapes. Matisse's neighbor, in fact, was working on a Swiss landscape, complete with chalet, pine trees, and a bubbling brook.
As Matisse was at loose ends, the neighbor suggested that he try his hand at a chromo. "You see, at the end you have something to hang

on the wall." While the idea displeased Matisse's father, who deemed such activity frivolous, his mother was sympathetic to the idea and bought him a box containing colors and two little chromos representing a water mill and the entrance to a farm. Matisse copied both and signed them with his name in reverse, as if to dissimulate his own newfound passion: *Essitam*. "A picture," he later remarked ironically, "is something that is signed, isn't it?"

—JACK FLAM, *Matisse: The Man and His Art 1869–1918* .

So his life began—and fierce combat with his bourgeois father. When he departed for Paris to become an artist, his father shouted at the departing train: "You'll starve!" We do not know that he shouted back; but sixty years later he recollected: "It was as if I had been called. Henceforth I did not lead my life. It led me."

It was not until June 1, 1904, that he had his first one-man show. The great dealer Ambroise Vollard mounted it.

❑ The previous winter the Matisses had invited Vollard to dinner in the hope of getting some kind of commitment from him, but Vollard, as was his habit, ate heavily and immediately dozed off; when he awoke, at eleven o'clock, he left at once, without looking at a single painting. Shortly afterward Vollard invited the Matisses to an evening at a cabaret on the rue Martignac. They interpreted the invitation as a sign of special interest, but there again he fell asleep right after dinner without broaching the subject of a show.

—FLAM.

And when Vollard finally came through, the show was not a success. A year later, the art critic Louis Vauxcelles, reviewing the Salon d'Automne, first used the word *fauve* as he described a conventional sculpture situated among bright paintings as "a Donatello among the wild beasts." It took two years for *fauves* to catch on and Matisse to be called king of the jungle.

Gertrude Stein introduced him to Picasso, twelve years his junior.

❑ Fernande Olivier, Picasso's mistress at the time, remarked that the two men did not have the same ideas: "North Pole and South Pole, Picasso would say, speaking of the two of them." Gertrude Stein also later remembered their mutual regard and tension at the time: "Matisse and Picasso then being introduced to each other by Gertrude Stein and her brother became friends but they were enemies. Now they are neither friends nor enemies. At that time they were both." Despite the

distance that separated them, their relationship was extremely impor-
tant to both men. Picasso constantly judged his own work in relation to
Matisse's, and Matisse regarded Picasso's work with equal interest and
esteem. Not long after he and Picasso had become acquainted, Matisse
told Picasso's friend Max Jacob that if he were not painting the way he
was, he would like to paint like Picasso.

"Well, isn't that curious," Jacob replied. "Do you know that Picasso
said the same thing about you?"

—FLAM.

The two great men danced in the same ballroom for fifty years,
never quite to the same tune. Matisse visited Picasso's studio while
Cubism was brewing. Picasso asked him to guess what a canvas
represented. When Matisse gave up, Picasso took a false mous-
tache out of his pocket and stuck it onto the canvas, revealing a
portrait. Matisse gave Cubism its name when he belittled Bra-
que's "little cubes." He denounced Picasso's *Demoiselles d'Avignon*
as a hoax. At the same time, critics continually announced that
Matisse himself was going to the dogs, as the space of his can-
vases flattened and he outlined his figures. Early in the twentieth
century, painting moved too fast for the human eye. Only a few
years after Matisse mocked Braque's "little cubes," the Cubists
themselves turned down Duchamp's *Nude Descending a Staircase*.

The painter and critic Georges-Michel remembers Matisse ask-
ing him:

❑ "Do you understand the Cubists? I must say I can't make head or
tail of them."

He told me of an incident that occurred when Diaghilev was direct-
ing a rehearsal of *Parade* by Erik Satie and Jean Cocteau, for which
Picasso had done the settings, and he asked the choreographer,

" 'When that little ballerina skips and then falls down and kicks her
legs in the air, what is that supposed to mean?"

" 'Why, it's quite simple,' said Diaghilev, shocked. 'That's the *Titanic*
disaster.'

"No," repeated Matisse, "I must say I can't make head or tail of
them——"

We were practically lost in the downpour, and, holding the umbrella
well over us, I finished the sentence for him,

"——any more than certain people can understand why you give
your figures hands three times their natural size, and asymmetrical eyes
and——"

"Oh, but that's the way I feel them," he retorted. But then, as he had

a sense of humor, instead of explaining his theories of balance or his deliberate distortion of academic forms, he went on:

"It is true that if I ever met the kind of woman I paint coming along the street, I should probably have a fit."

—MICHEL GEORGES-MICHEL, *From Renoir to Picasso: Artists I have Known.*

"It's very difficult," Matisse told Françoise Gilot many years later, "to understand and appreciate the generation that follows." He told her about calling on Renoir in the Midi when Renoir was old.

❏ He received me in very friendly fashion and so, after a few more visits, I brought him a few of my paintings, to find out what he thought of them. He looked them over with a somewhat disapproving air. Finally he said, "Well, I must speak the truth. I must say I don't like what you do, for various reasons. I should almost like to say that you're not really a good or even that you're a very bad painter. But there's one thing that prevents me from telling you that. When you put on some black, it stays right there on the canvas. All my life I have been saying that one can't any longer use black without making a hole in the canvas. It's not a color. Now, you speak the language of color. Yet you put on black and you make it stick. So even though I don't like at all what you do, and my inclination would be to tell you you're a bad painter, I suppose you are a painter, after all."

—FRANÇOISE GILOT AND CARLTON LAKE, *Life with Picasso.*

The painter Maurice Denis told André Gide of a less satisfactory encounter with another master.

❏ He tells of Henri Matisse going to show Rodin his drawings and leaving the master's studio furious because Rodin had said to him: "Fuss over it; fuss over it. When you have fussed over it two weeks more, come back and show it to me again."

—ANDRÉ GIDE, *The Journals of André Gide.*

Stories of Matisse and Picasso continue for fifty years. Françoise Gilot:

❏ Pablo became relatively agreeable. A day or two later he said, "Since we're down here, let's go see Matisse. You put on your mauve blouse and those willow-green slacks; they're two colors Matisse likes very much."

At that time Matisse was living in a house he had rented before the end of the Occupation in Vence, close to where his chapel is now. When we got there, he was in bed, since he could get up for only an hour or

two a day as a result of his operation. He looked very benevolent, al-
most like a Buddha. He was cutting out forms, with a large pair of
scissors, from very handsome papers that had been painted with gouache
according to his directions. "I call this drawing with scissors," he said.
He told us that often he worked by having paper attached to the ceiling
and drawing on it, as he lay in bed, with charcoal tied to the end of a
bamboo stick. When he had finished his cutouts, Lydia, his secretary,
attached them to the wall on a background paper on which Matisse had
drawn, with his bamboo and charcoal, marks indicating where they
should be pasted down. First she pinned the papers in place and then
changed them around until he had settled on their exact position and
the relationship they should have to one another.

That day we saw several of a series of paintings he had been working
on: among them, there were variations on two women in an interior.
One was a nude, rather naturalistic and painted in blue. It seemed not
entirely in balance. Pablo said to Matisse, "It seems to me that in a
composition like that the color can't be blue because the color that kind
of drawing suggests is pink. In a more transposed drawing, perhaps,
the local color of the nude could be blue, but here the drawing is still
that of a pink nude." Matisse thought that was quite true and said he
would change it. Then he turned to me and said, laughing, "Well, in
any case, if I made a portrait of Françoise, I would make her hair
green Pablo said, "But why would you make a portrait of her?"

"Because she has a head that interests me," Matisse said, "with her
eyebrows sticking up like circumflex accents."

"You're not fooling me," Pablo said. "If you made her hair green,
you'd make it that way to go with the Oriental carpet in the painting."

"And you'd make the body blue to go with the red-tile kitchen floor,"
Matisse answered.

Up to that time Pablo had painted only two small gray-and-white
portraits of me, but when we got back into the car, all of a sudden a
proprietary instinct took possession of him.

"Really, that's going pretty far," he said. "Do I make portraits of Ly-
dia?" I said I didn't see any connection between the two things. "In any
case," he said, "now I know how I should make your portrait."

—GILOT.

André Malraux:

❑ One day Picasso came to visit the chapel [at Vence]. He bought
some postcards from the grumpy nun. One of the visitors said: "It's
Picasso." The nun looked at him. "Well, well, M'sieu Picasso," she said,
"since you're here, I have a thing or two to tell you. All the people who

come here give their opinions, saying this and that. One day M'sieu Matisse got fed up. 'Sister,' he said, 'there's only one person who has the right to criticize me, do you understand! That's Picasso.' Except, of course, for the good Lord. You ought to tell that to all those people!" Picasso gave her his wide-eyed look: "And why doesn't the good Lord do it Himself?"

—ANDRÉ MALRAUX, *Picasso's Mask.*

Alexander Eliot visited Matisse when he was old.

❏ [He] was sitting up in bed. "Picasso sent you his love," I said. The master nodded slightly. After a minute or two he said:

"We have no need of actual contact. The last time we saw each other was at Picasso's studio in Vallauris. He offered me whatever I liked that was there. I chose the little oil painting of an owl which you see on the wall. Next day, I sent a dress to Picasso."

I laughed. Matisse continued unperturbed. "It was a rather special dress," he explained. "So heavily embroidered and frilled with feathers that it could stand erect all by itself. I thought he might enjoy painting one of his girls in that. He needed cheering up. . . .

"That dress was sheer color," Matisse went on. "Picasso's owl, you notice, is somber line. Some say that I'm really a colorist, and that Picasso is a sculptor at heart. But it is all one and the same."

—ALEXANDER ELIOT, *The Atlantic,* October 1972.

After Matisse died in 1954, a friend told Picasso that he discerned Matisse's influence on Picasso's new work. Picasso answered: "I have to paint for both of us now."

The American art critic and painter Walter Pach told him that his portrait of Mme. Matisse looked, in photographs, "as if it came easily, perhaps in two or three sittings."

❏ Matisse fairly slumped in his chair, at my words.

"I had more than a hundred sittings on it," he finally answered.

One morning after we had been talking art pretty actively for a couple of hours I looked at the time and said: "I didn't know it was so late. I have an appointment and must be off in less than ten minutes."

"I'd like to do an etching of you."

"Fine. When shall I come?"

"I'll do it right now. I have a plate all ready."

"But I've got to meet M. Hessel for lunch. I've got to leave in five minutes or so."

"All right. I'll do it in five minutes." And he took out his watch and laid it on the table. Seeing that he was in earnest, I sat down. In five minutes, he had an outline drawing on the plate and a few strokes to indicate color and shading.

"That isn't serious," he said as he showed it to me, "I got interested in what you were saying about Rembrandt, and I wanted to set down an impression of you then and there. But come on Sunday morning and we'll have time for a real one."

I came on Sunday and found the little plate he had sketched, already nicely printed. There were some unimportant spots of foul biting in it, but as Matisse said, "I did not do those. God did. What God does is well done; it is only what men do that is badly done."

For three hours he worked over one plate and then another—there may even have been a third. Each time he took turpentine and washed off the drawing so as to be under no temptation, as he said, of biting it in with the acid. The morning was a failure from the standpoint of results (it is true that there were interruptions by friends in uniform who had to be eased out); but then we looked at the little five-minute etching, and it had just the life that the more heavily worked things had lost. It is a delightful piece of character and design—the best demonstration of the difference between quantity of work and quality of work that I have encountered.

—WALTER PACH, *Queer Thing, Painting.*

Mme. Matisse—Amélie—was not always happy. Henri went off to Spain alone, to her displeasure; later, Gertrude Stein recounted a conversation about his journey as an example of the painter's egotism. "I am content," he said. "You are not content?"

"I am content that you are content."

"You are content? I am content," he said.

Especially in the early years, Matisse panicked when he painted: shook, swore, sweat, and burst into tears. Against his volatility he erected routine.

❏ At seven he would rise and make his way to a remote bathroom where, out of his fellow guests' hearing, he would practice the violin for two hours. (Matisse loved this instrument for its own sake—he never painted anything more tenderly than the sky-blue silk lining of its case—but he also had a favorite notion that if his eyesight should ever fail him, he could support his family by playing in the street.)

From nine to twelve Matisse would work at his easel, most often from

a model, and after lunch he would either take a siesta or stroll past the Aleppo pines and the parasol pines in the Jardin Albert Premier, to one of the cafés on the Place Masséna. At four he would go back to work, and in the evening when the daylight was gone, he would close the shutters and put aside his brush, to draw some aspect of whatever had occupied him during the day.

—JOHN RUSSELL, *The World of Matisse.*

The last thirteen years of his life by necessity Matisse lived largely in bed. He did not stop working.

❏ In bed, Matisse sat like a man at a desk. A table fitted over his knees and held his papers and drawing materials. He was always fully dressed and looked impressive. Indeed, he allowed no invalid disarray in his attire or around the studios. He set the household standard of neatness and organization. His white beard was clipped to a precise degree of shortness. He wore clothes that matched. If he had on a green sweater in bed and his bald head was chilly, he added a green wool cap. He drew constantly, even while talking to visitors. Drawing had become his language. He could not sit and do nothing with his strong, well-kept old hands. In this invalided man, even in his eighties, a chain of energy was still operating between the artist's hand at work and, behind thick glasses, the flickering of the myopic blue-gray, artist's eyes, set with startling color in the pink, obstinate, intelligent head. By his bed was a combination bookcase and chest of drawers he had designed. In a kind of artist's shorthand, he had painted on the drawers little pictures of what was inside, his watch, pencils and crayons, his medicine bottles, and so on. The first painter of his generation who preferred sunlight to paint in, he ordinarily worked in the biggest of his south sunny studios. He early arrived at the conviction that what he called "luminous generation" in a composition was successful if it still maintained its strength "when placed in shadow, or if when placed in the sun withstands its light." In the summer of 1950, to avoid the Midi heat, he moved temporarily into the north studio, already filled with his winter woolens, his woolen carpets, and the like, in mothballs, and started to work at once, without breaking his rhythm. He could work anywhere. He worked, slept and ate in any one of the studios, moving around like a tidy gypsy. His studios were furnished sparsely with some of the familiar objects that had crammed his paintings—the blue Persian scarf, the low onyx table, the red-and-white potpourri jar, an armchair covered in zebra skin, and the Louis XV *bergère* on which his models posed, in series, as houris. On the walls were pinned some of his drawings, mostly of girls, like pinups everywhere.

—JANET FLANNER, *Men and Monuments.*

❏ The walls of his bedroom were covered from floor to ceiling with forms cut out of colored paper. Sometimes they were fixed to canvas, sometimes they were tacked on the wall, sometimes they dangled down and trailed onto the floor. "Now that I don't often get up," he said, "I've made myself a little garden to go for walks in. Everything's there— fruit and flowers and leaves, a bird or two. . . ,." Above his head, on the ceiling, he had drawn some larger-than-life-size women's heads in charcoal: "They keep me company too," he said. "It was no trouble . . . I had someone tie the charcoal to the end of that fishing rod over there, and then I went to work."

—RUSSELL.

The "Jazz" cut-outs were so bright, word had it, that his eye doctor required Matisse to wear dark glasses when he looked at them, which he enjoyed doing: At the end of his life he referred to the images around him; "I am never alone," he said.

Ernst Barlach
(1870–1938)

He died while the Nazis were in power. Käthe Kollwitz was one friend who attended his funeral despite fear of political consequences. Over his coffin was his *Hovering Angel,* of which the Nazis later melted the bronze original. Barlach had hidden a cast, foreseeing what might happen, and his sculpture, which the Nazis thought they had destroyed, can now be seen in both East and West Germany.

John Marin
(1870–1953)

He spent his summers in Maine. His friend Ernest Haskell watched him climb far out, onto a tree's limb, over the water.

❏ Gripping the limb with his knees, his sketching board resting precariously over forked branches, Marin would paint in a fury of ambidexterity, somehow giving off the impression that it was the most natural thing in the world to paint with two hands while straddling the outthrusting limb of a tree. He painted and fished with sincerity, Haskell said, as though he *believed* in fishing and painting.
—MACKINLEY HELM, *John Marin.*

His wife Marie died after thirty years of marriage. An acquaintance remembered:

❏ His mourning for her was as private as had been their thirty years together. In my many long visits with him before his death eight years later at eighty-two, he spoke little of her, except to boast of her incomparable wood-stove baked beans, and of her equally incomparable haircuts, her quick scissors guided by an inverted bowl on his head. . . . He stopped to tell me of sitting at Marie's bedside as she lay dying, compelled to limn a final portrait of her beloved features. He showed it to no one, probably destroyed it, and never mentioned it again.
—SUE DAVIDSON LOWE, *Stieglitz: A Memoir/Biography.*

Giacomo Balla
(1871–1958)

Giacomo Balla was the most established of the painters who signed the Futurist Manifesto (1910), and when he signed it, his friends and family despaired. Balla himself recollected, in the third person:

❏ Friends . . . took him aside imploring him to return to the right course, predicting a disastrous end. Little by little acquaintances vanished, the same happened to his income, and the public labeled him MAD, BUFFOON. At home his mother begged the Madonna for help, his wife was in despair, his children perplexed! . . . [but] he regarded these obstacles as mere jests and . . . without further ado put all his *passéiste* pictures up for auction, writing on a sign between two black crosses: FOR SALE - THE WORKS OF THE LATE BALLA.
—MARIANNE MARTIN, *Futurist Art and Theory.*

It's no wonder. The manifesto at its first reading—Turin, Chiarella Theater, March 8, 1910—received not only whistles, shouts, insults, and threats, but rotten fruit and spoiled spaghetti. "Burn the museums!" the painters shouted. "Drain the canals of Venice!" "Let's kill the moonlight!"

In return, this Italian group (also Boccioni, Severini, Carrà, Russolo) suffered from the notion that they were merely transalpine Cubists. (A few years later, the Vorticists determined *not* to be known as English Futurists.) Nothing is so chauvinist as a French art critic: Georges-Michel, for instance, decided that Futurism was "somewhat outside painting as such," except for Severini, who moves inside because his "compositions are entirely French in their restraint."

Fernande Olivier remembered Boccioni and Severini especially for inventing a

❏ . . . futurist fashion which consisted of wearing socks of different colors but matching their ties. In order that they should be instantly picked out at the café de l'Ermitage, which had become fashionable in the group since Picasso had lived on the Boulevard de Clichy, they rolled up their trousers to reveal a green and a red leg sticking out of their shoes. The next day, the red one would be yellow and the green one purple, but the colors had generally to be complementary ones. I think they thought this a delightful innovation.
 —FERNANDE OLIVIER, *Picasso and His Friends.*

Lyonel Feininger
(1871—1956)

The German Cubist Lyonel Feininger was born and died in New York, where his father Karl worked as a musician. In between, he spent a lifetime in Germany, to which he emigrated at sixteen. A visitor to his Berlin studio in 1917 was shocked to discover that "Feininger is an American—a typical American." Ten years later, Alfred H. Barr, Jr., talking with Feininger at the Bauhaus, said that he was "surprised and fascinated . . . by [his] strange purity of accent and antiquated slang . . . we were talk-

ing with an American who, through some time-machine miracle, had been preserved unchanged since the 1880s."

Ten years later still, in 1937 after fifty continuous years in Germany, politics restored him to the land of his birth. As an old man in New York he remembered experiences from an American childhood that informed his life's work—most especially Feininger's ghosts:

❑ On one hot summer day, while his parents were on tour, Lyonel was "left behind with friends who had a florist shop on Third Avenue," where he was overwhelmed by the scent of tuberoses in funeral wreaths. As he sat in the open doorway he "watched the trains go by overhead, and all the white faces in the windows seemed to him to be ghosts and he began to draw ghosts." . . . "Looking across the East River to Blackwell's Island" he saw "stripe-suited prisoners walking in lock step. This made a wretched impression on me—in consequence I took to drawing ghosts for a while and this may have laid the foundation for my later works, fantastic figures and caricatures."

—ERNST SCHEYER, *Lyonel Feininger.*

Georges Rouault
(1871–1958)

He began his working life as apprentice to a maker of stained glass, studied painting at night, and rose early to draw before work. He wanted to study with Nicolas Delaunay.

❑ I had a roll in my hands, a roll of drawings. I was with a friend at the foot of the great stone staircase. Delaunay looked . . . he gave them all back to me and then he said, "It's very good, very good," and went on up the stairs. I can still see my friend, like the great buffoon he was (he spent his life joking), bursting into laughter. "You idiot!" I said, "what is there to laugh about?" . . . I ran after old Delaunay at full speed, and just as he was turning the door-handle, I yelled in his ear, "I want to paint!" The poor man was terrified; he looked at me for an instant with a dumbfounded air, and then said, "Very well, very well."

—WALDEMAR GEORGE AND GENEVIÈVE NOUAILLE-ROUAULT, *Rouault.*

He was not a technician. Vollard:

❏ I met Rouault one morning laden with files, rasps, burnishers and emery-paper.

"What's all that for?"

"For your damned plates!"

"Etchings? Aquatints?"

"I don't know what they will be called. They give me a copperplate . . . I just dig into it."

—AMBROISE VOLLARD, *Recollections of a Picture Dealer.*

His daughter wrote her memories of growing up in a chaotic if good-natured household, her father often absent.

❏ For a while we lodged in furnished rooms in Versailles—but not in the same building—in the evenings we used to take Father the meager meal served in our Institution. Mother carrying the milk-can full of soup. Jacques Maritain then lent us his Versailles flat, and two years later we finally joined up again at 20 rue La Bruyère, Paris, in a minute three-room flat. We were all at boarding-school, the girls at Asnières, where Mother was now giving lessons, and Michel at Neuilly. Father worked on *Miserere* in his room in the mornings and lunched with Vollard to paint there in the afternoons, coming home late to dinner.

It was from his mother that Rouault inherited a pronounced taste for removals. We had left rue La Bruyère for rue de Douai. In Vollard's attic there was a small bedroom and bathroom. Our removal induced my father to camp out there. But carried away by his passion for his art, bound by his commitments, he stayed there for five years, a "willing prisoner" in his own words. It was not without violent protest on our part. I cannot describe how greatly we missed him and how much he suffered.

My father often spent Sundays with us, and always the holidays. He took my sister Isabelle away from school, where she was in the second class, and she became his Antigone. It was a good choice; energetic and gentle, she tried to calm him down.

"How shall I ever manage?" he cried in despair on arranging his canvases. "Why not try to finish even only four of them," she suggested. But no! he proposed to finish a hundred and thirty-three.

—GEORGE.

She remembers Rouault complaining, as he designed for Diaghilev's Ballets Russes in 1929, that he can think only of his debts.

❏ "Atlas bearing the world on his shoulders is a child compared to me . . . it is killing me . . . The whole of my effort, past, present, and

future, is at stake with Ambroise Vollard. That is why I exhaust myself with sleepless nights, why I pray in secret, it is perhaps why I shall succumb."

It was a real wrench for Rouault to part with a picture. Once the work was signed, it was a deliverance, a euphoria. "Take it away, don't let me see it again, hide it!" and we went off for a walk. Sometimes he would accompany my mother to choose materials or dresses for us.

Sometimes he would summon one or other of us and explain what he was doing, brush in hand. It was a privilege without any merit on the part of the young listener, for, as someone once said. "You would talk about Rembrandt to a ragman."

In the street as we walked along he would deliver monologues on Corot, Chardin, Degas. At the age of six I knew that Cézanne was a misunderstood genius. He detested "intellectuals," by which he meant those who put questions and made comments. He taught us to "look at Nature"; sitting in a square, he would reveal to me the beauty of a tree, or imperiously direct my eyes, which had strayed over the Château of Combourg, back to a simple patch of grass. He never struck us, but small objects would sometimes fly across the room.

—GEORGE.

However, she and her brother "were sometimes serenely spanked—'it makes the blood circulate,' confided Father, without any anger."

Rouault's relationship with Vollard was beneficial, complex, symbiotic, maybe murderous. Eventually it was also posthumous.

❏ In 1917—Rouault was already forty-six—Vollard bought everything in the artist's studio. "All or nothing," the dealer had said. He then turned rooms on the top floor of his residence on rue Martignac, in Paris, into studios for the painter's use. For a few years, the two men had a normal relationship, Rouault pulling in silence on his chains, however, suffering from the overload of important works in progress and demanding a certain number of hours each day to retouch his earlier works. In Switzerland, in 1930, the artist was almost burned alive. "You've been through fire! Your painting will be all the more beautiful," Vollard said. As Rouault was wearing a Santa Claus suit, the cotton wadding on his costume had been set on fire by the candles on the tree and his hands were seriously burned. Touched by the accident, Vollard wrote a lovely letter to his painter, calling him a "workhorse." In the long run, the relations between the two men deteriorated. Those who knew Rouault, know of his conscientiousness, his mania for retouching his works and his hesitation to regard them as finished and worthwhile and, thus, to sign them. His output did not satisfy the dealer;

but, when Rouault finally delivered a number of works to Vollard, the situation cleared up and they arrived at a *modus vivendi*. Unfortunately, Vollard was killed in an automobile accident in 1939. Subsequently, the artist was obliged to sue Vollard's heirs in a case that caused quite a stir and brought Rouault more recognition in France and abroad than his work had. Rouault's lawyer quoted Vollard's expression "workhorse," while the other side's lawyer called Rouault a "lazy genius." The artist's spiritual rights over his work had to be defined. In 1947, the Paris Court of Appeals confirmed the Civil Court's judgment; Rouault had won the case and remained the owner of his works until he should decide, of his own free will, to part with them. The court ruled, in fact, that the unfinished canvases at Vollard's could be considered "future" works only and that, consequently, they could not be the object of a definitive transfer but, at most, constituted a tentative offer or promise. The indemnity of 100,000 francs per canvas not restored to the artist was also upheld by the Court of Appeals. In 1948, to prove that he had acted disinterestedly, the artist took several hundred canvases Vollard's heirs had returned to him and burned them in a factory furnace.

—*Homage to Georges Rousault*, ed. G. di San Lazzaro.

John Sloan
(1871—1951)

When his wife Dolly was manic it helped his slow, or passive, nature; but sometimes she was depressed, even suicidal, and he struggled to give support: he kept a diary highly flattering to Dolly, which he knew she would read, in which he praised her cooking, housekeeping, and political sympathies.

He called himself a Peeping Tom. Maybe all painters are voyeurs.

❏ The back windows of the attic studio in West Twenty-third Street afforded many a scene that appeared in his work. There was an array of roofs where tenement women hung out their wash and sometimes made love or slept on summer nights, there were backyards where stray cats took part in human dramas and there were animated windows, a dozen or a score. Some were the windows of rooming-houses with tenants that constantly changed but not before they had told Sloan a story, and there, especially when the night was warm, human nature dis-

ported itself in a fashion that delighted the eye of an etcher and painter. There was one curious two-room household with two men and two women who cooked at three in the morning and whose day began at midnight, and there was a careless couple, the woman with carrot-red hair, who lay on the bed naked playing with a kitten. The woman wiggled her toes and the kitten jumped at them, while at intervals the couple drank from a stone jug of beer. There was another couple, a fat blonde woman and a thin man who had lost one hand and whom Sloan took for a gangster, and there were two girls in nightgowns that clung close to their backs who washed their breakfast dishes at twelve o'clock noon. For Sloan their nightgowns were full of the humor of life. He painted from memory afterwards a girl who leaned out on a window-sill, and he noted another girl combing her hair whom he saw in conjunction with a cat on the leads outside. He observed a boy at a mirror making faces at himself and a young girl bathing, half-hidden by a door; and one night he watched another small drama, a half-dressed girl at a window and a man on the roof surveying her charms. This man was smoking a pipe while at another window below his wife was hanging out his newly washed linen. Sloan once saw a baby die in its mother's arms while the men of the family stood by, stupid and helpless. She held the baby in her arms after it had started to pale and stiffen, hope trying to fight off fact until fact killed hope and the men, sympathetic with her anguish, took it from her. Sloan could "hear nothing," he wrote, "but the acting was perfect."

Sometimes these stories that made pictures for Sloan went on from night to night, for three weeks in one case that he recorded in which a young man played cat and mouse with a disheveled young woman and finally agreed to patch up his quarrel with her. When he left she nursed her rage and grief with tumblers of dark beer, but the young man kept reappearing,—with his narrow face, slim nose and raw umber hair— packing suitcases and going again, after stripping the sheets from the bed, then suddenly coming back when the girl was asleep. But while the windows across the way, and the populated roofs, afforded many subjects, with girls drying their hair, old women hanging out clothes, boys playing games—pigeons at rest or flying, stealthy cats—Sloan found these on every side, at five-cent moving picture shows, at the Hippodrome, at variety shows with Harry Lauder. ("A manly sturdy little fellow," wrote Sloan, "his costumes so well conceived, over whom the house went wild when he sang 'I love a lassie.' ") He found them at Procter's, with Trixie Friganza, at "leg shows," with "girls in tights . . . a bad kind of imitation nude," and in the Bowery, at the People's Theatre, where he heard an Italian performance of *Rigoletto*. "The Bowery, that name! so romantic," wrote Sloan, "to the youth of towns in the U.S.," which seemed only a name one wintry night, "so dull and dark and

safe and slushy," while on other occasions it produced for him "a maze of living incidents . . . more than my brain could comprehend."

Whatever his reasons for writing diaries and notes, Sloan had a way with words. "I am a human sandwich," he said: "a slice of modesty, a slice of reticence, sparsely buttered with wisdom, and a thick slice of ham (actor)."

—VAN WYCK BROOKS, *John Sloan: A Painter's Life.*

Alexander Calder was one of Sloan's pupils. As a teacher he had a sharp tongue.

❏ Sloan told another, a woman painter whom he regarded as too clever by half, to draw with her left hand to overcome the poisonous facility that her right hand showed—whereupon she "wept with fury," Sloan recorded; and there was another whose left hand was as facile as his right and similarly refused to take directions from the mind. What could Sloan say to rebuke this tendency to slickness? "There is only one thing left for you to do," he said, "pull off one of your socks and try with your feet."

—BROOKS.

❏ Once a week the master criticized the work which the students had done out of school, on Sundays or in their spare time during the week, and for those who lacked imagination he would suggest themes, the barber-shop, or the Elevated, or the Automat. One could always tell his mood from the color of his necktie. If he came into class with a violet tie, the students all knew that he was depressed, and this was a warning to the initiated that they should be quiet or expect a "bawling out" in public. On the other hand, if he came in with a yellow-orange tie, they knew that somehow fortune had smiled on him, and the word went round in a whisper. "I'll bet Kraushaar has sold one of his pictures."

—BROOKS.

He taught only because he had to, to make his living.

❏ In 1933 Sloan sent the following letter to some sixty American museums: Sloan "will die some time in the next few years (he is now sixty-two). In the event of his passing, is it likely that the trustees of your museum would consider it desirable to acquire one of his pictures? . . . After a painter of repute dies, the prices of his works are at once more than doubled. John Sloan is alive and hereby offers these works at *one-half* the price asked during the last five years. . . ." The letter drew

one lone customer when the Boston Museum bought his 1910 work, *Pigeons*.

—ALEXANDER ELIOT, *Three Hundred Years of American Painting.*

Aubrey Beardsley
(1872—1898)

Beardsley saw *Tristan und Isolde* with Joseph Pennell.

❏ After the opera they went across the street to the Café de la Paix, and noticed Whistler there, who affected a very aloof air as soon as he saw them. After Beardsley went back to the Hôtel de Portugal to bed, Whistler sniffed to Pennell, "What do you make of that young thing? He has hairs on his hands, hairs on his finger ends, hairs in his ears, hairs on his toes, hairs all over him. And what shoes he wears—hairs growing out of them! Why do you take to him?"

"You don't know him," said Pennell. "Do you mind my bringing him to your place this Sunday afternoon?" Whistler was dubious about the idea, although he loved to show off the beautiful garden by his new flat in the rue du Bac. Eventually he murmured something like "Well, you come and bring him too," and the next day the two went to the rue du Bac, Beardsley in a little straw hat similar to the one he had seen Whistler wearing. The great man was in the garden with a number of his admirers, including Mallarmé, and, when most had drifted away, a wealthy English dilettante who had lingered asked the Whistlers, Pennell and Beardsley to be his guests at dinner at one of the cafés in the Champs Elysées. As they left the rue du Bac to dress for the occasion, Whistler whispered appealingly to Pennell, "Those hairs—hairs everywhere!"

—STANLEY WEINTRAUB, *Aubrey Beardsley.*

Oscar Wilde claimed that Beardsley's art "was cruel and evil, and so like dear Aubrey, who has a face like a silver hatchet, with grass-green hair." Hair seems to have been an issue. On other occasions, Wilde mocked him as inhuman, "a monstrous orchid," or insufficiently sexual. "Don't sit on the same chair as Aubrey," Wilde said. "It's not compromising."

Beardsley himself had a way with words. Once when Wilde was praising his paintings, by saying that they took him back to imperial Rome, Beardsley told him: "Don't forget the *simple* plea-

sures of life, Oscar. Nero set Christians on fire, like large tallow candles; the only light Christians have ever been known to give."

In the third volume of the *Yellow Book* there appeared two pictures by previously unknown artists:

❏ a head of Mantegna by *Philip Broughton,* and a pastel study of a Frenchwoman in a white cap, by *Albert Foschter.* Reaction was typified by the *Saturday Review,* which found Beardsley's work "as freakish as ever," while commending Broughton's "Mantegna" as a "drawing of merit," and Foschter's "Pastel" as a "clever study." Both drawings, as Max Beerbohm later put it, "had rather a success with the reviewers, one of whom advised Beardsley 'to study and profit by the sound and scholarly draughtsmanship of which Mr. Philip Broughton furnishes another example of his familiar manner.' Beardsley, who had made both the drawings and invented both signatures, was greatly amused and delighted." When enough critics had been taken in by his hoax, Beardsley admitted it.

—WEINTRAUB.

A reviewer in *St. Paul's* called him "effeminate, sexless and unclean." The magazine did not print his answer:

❏ 114 Cambridge Street, S.W.
 June 28th
Sir,
 No one more than myself welcomes frank, nay, hostile criticism, or enjoys more thoroughly a personal remark. But your art critic surely goes a little too far in last week's issue of *St. Paul's,* & I may be forgiven if I take up the pen of resentment. He says that I am "sexless and unclean."
 As to my uncleanliness I do the best for it in my morning bath, & if he has really any doubts as to my sex, he may come and see me take it.
 Yours &c. Aubrey Beardsley
 —WEINTRAUB.

Manuel Manolo
(1872–1945)

The dealer Daniel Henry Kahnweiler called Manolo "shrewd . . . with the good sense of the peasant," but his intelligence some-

times failed him. Manolo asked Picasso, as they stood in front of one of Picasso's Cubist paintings, "What would you do if your parents met you at the station in Barcelona looking like that?"

Once he stole a Gauguin portrait of his mother from Paco Durio and sold it to Vollard. On another occasion he stole Max Jacob's trousers—his only trousers—but brought them back when he couldn't find a used-clothing dealer to buy them.

Manolo was one of the great artistic swindlers of his times. Kahnweiler tells stories:

❏ One of the least of these was selling tickets to a lottery in which the prize was one of his sculptures, which did not exist and which, naturally, nobody ever won. There was another one that happened much later—after Manolo had moved to Spain—at Caldes de Monbuy. I used to send a certain sum of money every month for him and his wife to live on. One day he wrote me that he intended to make some very large sculptures, but that in order to do so, he would have to have an additional sum every month, since they would entail additional expenses. I agreed, and for months—six, eight, or more, I don't remember—I sent the additional money every month. Manolo kept me informed about what he was doing, and one day I got a letter saying, "I have just sent you a large sculpture. It is a kneeling woman, who, if she stood up, would be five feet tall." In reality, of course, she was about fifteen inches high. Of course, if she had stood up . . .

—DANIEL-HENRY KAHNWEILER, *My Galleries and Painters.*

Piet Mondrian
(1872–1944)

As early as 1915, Mondrian had decided, "Nature is a damned wretched affair." He had grown up in a Calvinist family, son of the headmaster of a Christian primary school. His mother died young. A neighbor remembered the family's afternoon constitutional.

❏ The family gathered after school hours, left the village, re-entering about an hour later on the other side. Piet headed the procession, moving not stiffly but with a loose and rhythmic stride, a walking stick under his arm. He walked in a slightly lopsided manner, had a bearded face and was outfitted in a pressed dark suit and a bowler hat. Only

once I had the courage to look into his face and then I was captured by dark eyes looking at me from far away. A few meters behind him walked the other boys and behind them came the father, tall, slim, sporting a big beard, wearing a tophat and a frock-coat. He looked straight in front of him, rather absent-mindedly. At his right walked his daughter. You never saw the two in conversation.

—L. J. F. WIJSENBEEK, in *Piet Mondrian 1872–1944.*

Nellie Van Doesburg recollected a later Mondrian.

❏ As is well known, Mondrian was a great devotee of social dancing. By the time I met him in Paris, he had already given up the waltz, and, if I remember correctly, he took lessons in such modern steps as the fox-trot, tango, etc. Whatever music was being played, however, he carried out his steps in such a personally stylized fashion that the results were frequently awkward and rarely very satisfactory to his partners. Yet, this form of social intercourse meant much to Mondrian, and, though undertaken with his usual seriousness, afforded him much pleasure, especially whenever he had found a sufficiently attractive, which is to say young and pretty, partner. His attitude toward the dance as a form of theatre was equally characterized by a love of the "modern" and the popular . . . He was completely captivated by the charms of Mae West, who at the time was quite young, but nonetheless used artificial make-up in a way that Mondrian found attractive. Indeed, his ideal wife would have been precisely this kind of youthful love goddess, whose chief virtue of character would be the patience to spend long hours in a corner of his pristine studio knitting or watching him paint— a Mae West in crinolines, so to speak.

—NELLY VAN DOESBURG, in *Piet Mondrian 1872–1944* .

Nina Kandinsky told another story: "I will never forget Piet Mondrian's visit to our apartment. It was on a glorious spring day. The chestnut trees in front of our building were in blossom and Kandinsky had placed the little tea-table in such a way that Mondrian, from where he was seated, could look out on all of their flowering splendor. Mondrian, of course, insisted on taking a different seat, so as to turn his back on nature."

Alfred and Margaret Barr visited his Paris studio.

❏ An emptiness verging on the monastic distinguishes Piet Mondrian's studio—the bare necessities of life and his working materials, all in order, are in harmony with his uninflected tones as he describes how the sight of a dock extending into the sea affected his painting in its development toward abstract art. He earnestly follows the Hay diet, a

system that compartmentalizes food so that one eats meat with vegetables, or starch with vegetables, but never the three at once. This appeals to his subdividing mind. He probably heard of it from Man Ray who, once chubby, has now become slim and youthful as a result.
—MARGARET SCOLARI BARR, *New Criterion*, Summer 1987.

Ben Nicholson remembers him in London.

❑ My chief recollection of Mondrian's stay in London was that having found him a room in Parkhill Road, Belsize Park near where Barbara Hepworth and I lived and worked in the Mall, he almost immediately transformed the usual dull, rented room into a sunlit South of France (not as the South of France is lit now but as it was then): this he did not only with the presence of his work but with orange boxes and the simplest, cheapest kitchen furniture bought in Camden Town and then painted an immaculate, glowing white. No one could make a white more white than Mondrain. The effect of entering his room on a foggy Hampstead night was indeed something. Our problem was to find enough friends who understood his work and at the same time had enough money to buy it: his smallest works were then about £25 and the larger ones £45 but even so we did not have enough to buy one. But a number of friends did buy and amongst those I remember are Leslie and Sadie Martin, Nancy Roberts, Helen Sutherland, Nicolete Gray and Winifred Nicholson (who persistently helped him both in Paris and in London and accompanied him when he left Paris for London). When war was inevitable we tried to persuade him to move out of London and Herbert Read offered to put him up in Hertfordshire but he refused to move until later he wrote to us in Cornwall that he'd "felt an urge to move." This "urge" proved to be a large unexploded bomb close to his studio, and he moved to a Hampstead hotel. Quite soon after this he left for New York. One day he brought us a present of a recent painting, a most generous gift, and as it was near tea time we asked him to have tea with us, and with our triplets then aged about four, and to their amazement he proceeded to eat his jam off the end of his knife, obviously a tremendous event in their lives. As we walked away he remarked that all small children are barbarians. I must say that during tea this particular bunch were so angelic as to be unbelievable: if only he could have seen them when they were at their barbaric best or heard their remarks on his barbaric knife. When reading notes on Mondrian I have not yet seen any mention of his *humor*— there were a number of examples of this in London but one of the more typical examples occurred when he arrived in New York and visited the enlightened collector A. E. Gallatin, who collected early Cubism, Brancusi and Mondrian. He lived in Park Avenue at a point where

there is, I understand, a single tree every two or three hundred yards—
Mondrian looked out of the window and then turned to Gallatin and
remarked, "I'd no idea that you lived in a rural district."

—*Ben Nicholson*, ed. Maurice de Sausmerez.

Harry Holtzman remembered Mondrian in New York.

❏ A few weeks after Mondrian had settled in to his new life in New
York, we were once walking across Fifty-seventh Street from a gallery
visit. "Tell me, Harry, why don't I see prostitutes on the streets here?"
In mock surprise I chided, "Why Piet!" "Don't misunderstand me," he
laughed, "it has been some time since I've had such a need, but why is
it?" In Paris prostitution was legal, and each neighborhood had its reg-
ularly assigned entrepreneurs. I explained that prostitution was illegal
here, and then told him what I knew of the way it operated. After some
discussion of culture differences, I took the opportunity to ask Piet why
he had never married. "Well," he said, "to tell you the truth, I never
could afford it." He chuckled and went on, "Once I did live with a
woman for a time, but when we differed and decided to separate, she
took all the furniture!" When he died, the Dutch press reported stories
of three women who proudly claimed to have been his very intimate
friends.

One night in New York we were returning home from a party in a
taxi, with Peggy Guggenheim sitting between us. An old friend and
admirer of Mondrian, Peggy was an uninhibited woman to say the least.
Peggy leaned her head on Piet's shoulder, snuggling close to him. Piet
put his arms around her, and after a moment he bent his head and
kissed her mouth arduously and long. "Why Mondrian!" she exclaimed
in seeming astonishment, "I thought you were so *pure!*" After we dropped
her off at her house, Mondrian was delighted: "They"—meaning the
Surrealists: Peggy was then married to Max Ernst—"*they* always call me
pure!"

—HARRY HOLTZMAN, in *The New Art, the New Life:
The Collected Writings of Mondrian.*

Carl Milles
(1875–1955)

In the summer of 1906 Carl Milles arrived at Meudon to begin
work as an assistant to Auguste Rodin.

❏ He had come out from Paris for the day, but Rodin invited him to spend the night: "I hadn't expected this; hence I had no toothbrush with me, or nightshirt. They were going to lend me a nightshirt . . . and they tried to find one of M. Rodin's, but they were all away being washed, so Madame gave me one of her shirts with lace and things; it was horribly long. I was utterly embarrassed but had to take it, and they laughed at me and thought it very funny."

After supper Rodin took him a little way from the main house to one of the cottages he had built on terraces that led down into the valley like a set of giant steps. They were mainly used to store the overflow of his own plasters and miscellaneous work by other sculptors, including "a whole store of the purest Gothic fragments" which he had bought "from an Italian molder who had this treasure hidden in his plaster shop." Milles was put up for the night in a big mahogany bed—"a huge, heavy bed so large that I could lie in any direction I wanted. There was a candle beside me. Monsieur went away and when he was gone I got up to shut the door after him in the warm summer night but there was no door . . . no door anywhere. Around my bed stood six or seven or eight statues: *l'Ombre* (the Shade) was leaning over in a very original way with his huge, fantastic forms. One arm hung down; the other had been left off. The casters had made many examples of the same figure and had placed them around the big bed: these casts were standing there, gazing down on whoever had the pleasure of sleeping there. As I lay there I felt quite lonely and hoped that the candle would burn until the sun came up. But then I heard footsteps coming nearer and nearer, and suddenly I saw an enormous Newfoundland dog standing in the door-opening and staring at me. He came up to me, sniffing and trying to find out what sort of being was lying there. All of a sudden he took a big jump into the bed, but as fast as he jumped I sprang out on the other side. This was a very big dog, and I now took my candle and tried to get him out of the bed. I held it in front of his nose— whereupon he licked it out, and I stood in the dark.

"I had to grope my way out and walk the whole way up to the house of Monsieur and ring the bell. Someone lit a candle at the head of the stairs and the head of Monsieur Rodin peered out at me from behind his big beard and asked who I was. *'C'est Milles, Monsieur.* There is a big dog in my bed.' He laughed once and came down with a new candle and followed me back to the little house and there I learned how to pet the dog, who licked my hand and we were instantly good friends. Then Monsieur Rodin turned to go: 'This dog will always sleep beside you.' And the upshot was that he always slept with me."

—FREDRIC V. GRUNFELD, *Rodin: A Biography.*

Constantin Brancusi
(1876–1957)

He was a great cook, and although he was not given to avarice, his cooking proved economically useful to him.

❑ Doucet, the collector, dressmaker and gourmet, had come to Brancusi's studio to look over his new things. Since the artist was having one of those lapses in financial returns familiar to all free lances, the occasion was very special. The scene had been prepared with the greatest care, every item placed in the most flattering light, polished as only Brancusi can polish the surface of things in the round. Doucet wandered about in a stupidly aimless way. It was perfectly plain that he showed no signs of excitement, no faint glimmering of that green-eyed desire to possess. Conversation was perhaps overdone on one side and lethargic on the other. The day seemed lost. The collector had picked up his hat and gloves, was even reaching for his stick, when an aroma slid in through the kitchen door stealthily opened by the sharpened wit of desperation. Monsieur Doucet grew straight, grinned, his nostrils widened like a war-horse's. Obviously, after this prelude he stayed for lunch and as obviously paid forty thousand francs for a work of art or for a souvenir of another work of art. Some things are priceless.
> —GUY PÈNE DUBOIS, *Artists Say the Silliest Things.*

Tchelitchew and Jane Heap took dinner at his studio.

❑ The party that takes place at Brancusi's studio is the summit of their visit; veritably, like the vision of Sacré Coeur on its mountain, which they could see on the train while still miles from Paris. Here is the genuine article—the artist's high life: the life of the great ateliers. Around the white stone rectangular table where Brancusi carves his statues, but where now he serves roast chicken, Marcel Duchamp, Tristan Tzara and Léger sit with them. The chickens have been roasted in the white kiln where the artist's works, *Bird in Space* and *Mlle. Pogany,* were fired.
> —PARKER TYLER, *The Divine Comedy of Pavel Tchelitchew.*

In his cellar he kept his cheeses, each "at its required temperature, to be eaten when ripe,

❏ . . . each carefully nurtured as a great wine. He wouldn't talk of his sculpture; Brancusi was proud of his cheese. It was only when I walked with him in the market that I began to see how his play and his work were linked. For there we found cheeses, and sausages too, formed every one with some exotic relation to their taste. They hung in formal ranks, a luxurious jungle of traditional and informative shapes, while Brancusi's studio was filled with their glorified replicas in marble and brass and wood."

—JULIEN LEVY, *Memoir of an Art Gallery.*

Sidney Janis visited his studio in 1926.

❏ His studio was so cold; I remember a girl once boasting that she had gone to bed with him, and he had kept on his long underwear! His sculpture was all set in place, each carefully wrapped in the sort of quilted material that you see the girls wearing on the streets today. When we asked to see a *Bird in Space,* he took a long pole with a hook at the end and attached it to the metal ring at the top of the cloth shield. When he gently lifted the covering from the sculpture, it was so erotic—like undressing a beautiful woman. I wanted to buy one of his pieces, but he said, "Oh, that would break up my arrangement."

—LAURA DE COPPET AND ALAN JONES, *The Art Dealers.*

Peggy Guggenheim admired him.

❏ For years I had wanted to buy a Brancusi bronze, but had not been able to afford one. Now the moment seemed to have arrived for this great acquisition. I spent months becoming more and more involved with Brancusi before this sale was actually consummated. I had known him for sixteen years, but never dreamed I was to get into such complications with him. It was very difficult to talk prices to Brancusi, and if you ever had the courage to do so, you had to expect him to ask you some monstrous sum. I was aware of this and hoped my excessive friendship with him would make things easier. But in spite of all this we ended up in a terrible row, when he asked four thousand dollars for the *Bird in Space.*

Brancusi's studio was in a *cul de sac.* It was a huge workshop filled with his enormous sculptures, and looked like a cemetery except that the sculptures were much too big to be on graves. Next to this big room was a little room where he actually worked. The walls were covered with every conceivable instrument necessary for his work. In the center was a furnace in which he heated instruments and melted bronze. In this furnace he cooked his delicious meals, burning them on purpose only to pretend that it had been an error. He ate at a counter and served lovely drinks made very carefully. Between this little room and

the big room, which was so cold it was quite unusable in winter, there was a little recess, where Brancusi played Oriental music on a phonograph he had made himself. Upstairs was his bedroom, a very modest affair. The whole place was covered in white dust from the sculptures.

Brancusi was a marvelous little man with a beard and piercing dark eyes. He was half astute peasant and half real god. He made you very happy to be with him. It was a privilege to know him; unfortunately he got too possessive, and wanted all of my time. He called me Pegitza.

Brancusi told me he liked going on long trips. He had been to India with the Maharajah of Indore in whose garden he had placed three *Birds in Space*. One was white marble, one black, and the third one bronze. He also liked to go to very elegant hotels in France and arrive dressed like a peasant, and then order the most expensive things possible. Formerly he had taken beautiful young girls traveling with him. He now wanted to take me, but I would not go. He had been back to Romania, his own country, where the government had asked him to build public monuments. He was very proud of this. Most of his life had been very austere and devoted entirely to his work. He had sacrificed everything to this, and had given up women for the most part to the point of anguish. In his old age he felt it very much and was very lonely. Brancusi used to dress up and take me out to dinner when he did not cook for me. He had a persecution complex and always thought people were spying on him. He loved me very much, but I never could get anything out of him. (I wanted him to give Giorgio Joyce a portrait in crayon which he had done of his father, James Joyce, but I could not make him do so.) Laurence [Vail, Guggenheim's ex-husband] suggested jokingly that I should marry Brancusi in order to inherit all his sculptures. I investigated the possibilities, but soon suspected that he had other ideas, and did not desire to have me as an heir. He would have preferred to sell me everything and then hide all the money in his wooden shoes.

—PEGGY GUGGENHEIM, *Out of This Century.*

Once when he sent a sculpture to the Salon d'Automne, it was denounced as indecent, but a policeman arriving to remove it disagreed: "I see nothing indecent; this looks like a snail."

Brancusi was pleased by the response of a young delivery boy who described his studio to an older workman:

❏ "In the corner was a great big stone, a figure; I don't know what it meant, but it said 'Hoo!' so you were almost scared; but I liked it." And Brancusi would repeat that "Hoo!" again and laugh in joyous triumph over this vindication of his art.

—WALTER PACH, *Queer Thing, Painting.*

William Carlos Williams visited Paris in the 1920s traveling with his wife and often with Robert McAlmon.

❏ That afternoon we went to see Brancusi in his studio on a side street nearby, a short compact peasant of a man, with his long gray hair, like a sheep dog, and well known to me because of his polished bronze *Bird in Space* and the *Mlle. Pogany,* the phallic head and neck of a woman that I had seen exhibited in New York.

There were that day the four of us, Floss, Bob, Brancusi and myself, not to mention Polaire, a white collie. The man had not been expecting us, but he put aside his work and bade us sit down wherever we could in his cluttered studio. It was a barn-like place filled with blocks of stone, formless wooden hunks and stumps for the most part, work finished and unfinished. I remember especially his *Socrates:* a big hole through the center of the block showing Socrates the talker, his mouth (and mind) wide open expounding his theses. There was the head of Isaac also. Brancusi served us cognac, poked up the fire and then began talking of Ezra Pound's recent "opera," *Villon,* which he must have heard at the performance at the Théâtre des Champs Elysées a day or two before. He pronounced it a scandal.

"Pound writing an opera?" I said. "Why, he doesn't know one note from another."

Brancusi was furious, resented it, actually resented it as a personal affront.

—WILLIAM CARLOS WILLIAMS, *Autobiography.*

Julio Gonzalez
(1876–1942)

Both his grandfather and his father had been goldsmiths in Barcelona. He grew up learning their craft and absorbed their devotion to metalwork. During the Great War he moved to Paris and labored in the Renault factory, exchanging the metier of goldsmith for the wages of ironworker. The craftsmanship transferred itself when he learned oxygen soldering, and thereby changed sculpture's history. He shaped and soldered exquisite small figures of women, sometimes skirts of single sheets of metal; and he made abstracted iron heads. He taught Picasso to work in metal, as Lipchitz told Selden Rodman.

❏ He opened Maurice Raynal's monograph on his own work and
pointed to an illustration of *Joueuse de Harpe,* a piece made in 1928
entirely out of twisted bronze rods. "Picasso saw it," he said, "along with
other macaroni-like sculptures of mine one day, and wanted to do
something like it, but he didn't have the technic. So he went to this old
friend of his from Barcelona days, Gonzales, who had a goldsmith shop
in Paris, and got him to help him. Gonzales became so interested that,
though he'd never made a sculpture before in his life, he started right
then. He was fifty-five."

—SELDEN RODMAN, *Conversations with Artists.*

Gwen John
(1876–1939)

A young sculptor named Hilda Flodin introduced Gwen John to
Rodin.

❏ The maître, who decided she had *"un corps admirable,"* began by
hiring her to pose for him and then got in the habit of sleeping with
her when the posing sessions were over and the other assistants had
gone home. Sometimes Hilda Flodin would join in their lovemaking.
. . . As long as she still posed for him regularly her life revolved en-
tirely around Rodin and their frequent lovemaking. It was quite true
that he loved English young ladies; there were times when her body
felt worn out and yet she pleaded for more. When she lost weight she
became worried about maintaining her *corps admirable:* "I am getting
quite thin. Rodin says I am too thin for his statue & that I don't eat
enough—but I rarely have time to eat.". . . And after he had modeled
Gwen's admirable body in clay she herself was dismissed from the cen-
ter of his sexual stage and banished to the wings. From then on her
role was to wait for his weekly visit with mounting desperation and
uncertainty: "What a life you give me now! What is it I have done to
you, *mon maître?* You know that my heart is profound. . . ." She moved
again, first to an attic room in the eighteenth-century Hôtel de Mont-
morency in the rue du Cherche-Midi, then to a studio space in a nar-
row backstreet full of artists, the rue de l'Ouest.

She would shut herself up in her room, painting a little and waiting
for him, often for days on end, while she grew increasingly anxious to
see him and communicate with him. The act of lovemaking was terribly
important to her, but usually he was with her only once a week; a little

more often at the beginning. She did not have enough coal to keep her room warm all day, but she made a point of keeping it well warmed during the hours she expected him.

The French have a name for this kind of relationship: she had become his *cinq-à-sept*, the lover one sees from five to seven, after work and before going home. In her case the caresses lasted barely an hour: he would make love to her, give her an orgasm, and then go instantly off. One problem was that Rodin believed in the old superstition that loss of semen meant loss of strength and creative potency. As time went on he became less and less willing to expend it on his *cinq-à-sept*.
—FREDRIC V. GRUNFELD, *Rodin: A Biography.*

He could never quite get her name straight. After a while, he gave his concièrge "instructions to keep Marie John from pestering the maître." When Rodin changed his mind, and wanted to see her in his studio, he sent her a letter and told her: "Take this letter with you to show to the concièrge if necessary."

.Her love for animals was legendary. She hated to leave Paris because of her cats.

❏ The cats had been constantly on Gwen John's mind while she had been away. There was one in particular, Valentine, old and hideous beyond belief in the opinion of Louise Roche. Valentine had no teeth and Madame Roche had been requested to feed her 250 grams of minced meat daily. "I thought of writing to tell you to give her calf's liver but I didn't because I knew you wouldn't," Gwen John told Madame Roche. *"Oh! Certainement non!"* Madame Roche commented in housewifely horror. Gwen John, who would not cook for herself, thought nothing of walking to the market to buy a cod's head for the cats which she would make into a delicate pâté.
—SUSAN CHITTY, *Gwen John 1876–1939.*

Although she suffered humiliation in love, she was not modest about her own work. Asked her opinion of a Cézanne exhibition, she spoke quietly but without hesitation: "These are very good but I prefer my own." In a letter she wrote: "I may be timid but I am never humble." Seven years after she died her brother Augustus made a prediction that seemed overly modest at the time: "Fifty years hence I shall be remembered only as the brother of Gwen John."

At the end of her life religion filled the place formerly occupied by Rodin.

❑ The spring of 1939 was cold and wet. The pain of Gwen John's illness (surely a cancer of some abdominal organ) was making it hard for her to sleep at night, and as a result she was afraid of not waking in the morning and so missing Mass. To remedy this she moved her bed to the small garden shed which she sometimes used as a studio or summer house in hot weather. The shed had no door and the icy rain on her coverlet woke her in good time, to her satisfaction.

—CHITTY.

José-Maria Sert
(1876–1945)

Salvador Dalí said that Sert looked like a potato. He was born rich and as a fashionable painter became much richer. His friend Coco Chanel described him as "an enormous gnome

❑ . . . who carried in his hump, as if it were a magician's trunk, both gold and garbage, extremely bad taste and exquisite discernment, diamonds and shit, kindness and sadism . . . good qualities and faults on a dizzying scale.

—ARTHUR GOLD AND ROBERT FIZDALE, *Misia.*

Paul Morand recounted tales that originated with Coco Chanel.

❑ Traveling in Sert's automobile with its diplomatic license—a guarantee of privilege he always managed to have—was festive. The car bulged with the pictures, statues, Capo di Monte porcelain, rare books, and crates of oranges that the affluent bohemians collected as they motored about. *"Ce dîner est à môa, Madmachelle,"* Sert would say in the Spanish accent Coco imitated so killingly. *Grand seigneur* that he was, he paid for everything and left huge tips everywhere. He insisted on ordering magnificent wines and lavish meals even though they all ate and drank sparingly. They would drive miles out of their way looking for an inn Sert remembered, and when they could not find it, he would turn a fiasco into a feast by buying a suckling pig and roasting it at the side of the road. "You must admit that Jojo makes everyone else seem dull," Misia said.

—GOLD.

He married Misia Godebski Natanson Edwards. (Her first hus-
band edited *La Revue Blanche;* her second was rich, vulgar, and
coprophiliac; Proust used portions of Misia for the Princess
Yousbeletieff and Madame Verdurin; Vuillard once declared
himself to her; all three of her husbands abandoned her.)

She took credit for Sert's success.

❏ "From the time we met, his career rose prodigiously." The walls of
the rich began to luxuriate with hundreds of Sert's elephants, camels,
and mules, dwarfs and Herculean giants, acrobats and blackamoors,
nude gods and goddesses under palm trees and parasols, popes, bish-
ops, and cardinals, mythological and biblical scenes, lanterns and bil-
lowing curtains: all the trappings of Tiepolo, Veronese, Goya, and Ve-
lasquez—but alas, without their quality. The theatricality of the work
prompted Degas, when he visited Sert's sumptuous studio, to say after
long examination, "How very Spanish—and in such a quiet street!" But
no one could outdo Forain, whose talent for disparagement almost sur-
passed his gifts as a painter. Asked how the overblown murals could be
transported, he said, "Don't worry. They're collapsible." Not surpris-
ingly, the Montmartre and Montparnasse painters looked down their
noses at Sert's work and his worldly success. "Sert paints with gold and
merde" was an often repeated quip that many were happy to take credit
for.

—GOLD.

He never concealed his wealth.

❏ It was all rich, original, and staggeringly grand: an Ali Baba's cave,
as Misia admiringly said. But all that glittered at the Serts' was not
necessarily gold. An El Greco of doubtful lineage prompted the re-
mark, "If it's not real, it's more beautiful than if it were," from Cocteau,
whose special province was the blurring and blending of the real and
the unreal. Possessed by his possessions, Sert took to storing the over-
flow in warehouses all over Europe: furniture, candelabra, paintings,
objets d'art of gold, marble, ivory, and velvet; even a rare collection of
Neapolitan nativity figures. Misia, on the other hand, tended to give
superfluous objects to friends or, with her antique dealer's instinct, sell
them to rich Americans, carelessly stuffing the profits in drawers or
behind Sert's priceless books.

—GOLD.

Everett Shinn
(1876–1953)

Although we number Shinn among the Ashcan School in the United States, he painted uptown: ". . . it's just that the uptown life with all its glitter was more good-looking. . . . Ah, the clothes then—the movement, the satins, women's skirts and men's coats and the sweep of furs and swish of wild boas, oh, Lord!"

He wanted to make illustrations to appear in the center spread of *Harper's Weekly*. When he finally met the editor, the editor remarked that he was looking for a

❏ . . . color drawing showing the Metropolitan Opera House at Broadway and Fortieth Street in a snowstorm, and asked whether he had ever treated the subject. Shinn looked out the window at a December snowfall and quickly replied that he had just such a drawing at home. He was requested to show it the following morning. He hurried out, bought a cheap box of pastels, and went to the Opera House to sketch. After working all night in his studio, Shinn emerged with the finished pastel.

—*American Painting 1900–1970*, ed. Time-Life Editors.

Maurice Vlaminck
(1876–1958)

The wild beast was an athlete.

❏ "The discovery of the world for me dates from the bicycle," wrote Vlaminck in *Tournant Dangereux*. "My first bicycle weighed fifty pounds and was bought with the money my father gave me to buy a *machine à pneumatique*. I used to spend whole days on the road, indefatigably. I could easily do 150 miles in one day on those poetic outings. . . . I

specialized in provincial racing. . . . Never, under any circumstances, did I again feel the complete sense of fulfillment that I felt after winning a simple bicycle race. That shocked my father much less than the fact that I became an artist."

—JEANINE WARNOT, *Washboat Days.*

Fernande Olivier had an eye for the way people looked:

❑ Derain, Vlaminck and Braque made an astonishing and certainly imposing trio. People would turn round to look at them in the street. All three of them were very tall, with big shoulders, and they gave an unusual impression of sheer physical power.

Vlaminck was heavier still, simpler and more direct. He was massive, with blond, almost red, hair, and a rather brutal, stubborn expression, which made one think that he knew what he wanted. His blue eyes were sometimes childlike and often astonished. He was very sure of himself and he always seemed dumbfounded if he was proved wrong at the end of an argument. He had once been a racing cyclist and he was so strong that he believed he was naturally invincible. When occasionally, owing to lack of money, he had to walk all the way back to Chatou at night, he told us that he was sometimes obliged to defend himself on the way against various forms of aggression, and that he always emerged victorious from such encounters because of his superior physical strength.

He used constantly to deny the efficacy and value of boxing, as opposed to simple brute force, until that day when Derain and Braque, both of whom boxed regularly, beat him, one after the other, and conclusively. We met him as he was leaving Derain's studio, his nose swollen like a potato and in a pretty sad state, though totally convinced.

—FERNANDE OLIVIER, *Picasso and His Friends.*

Francis Crémieux asked Vlaminck's dealer Kahnweiler about Vlaminck.

❑ KAHNWEILER: Vlaminck made himself a tie out of wood.
CRÉMIEUX: Wood?
KAHNWEILER: A wooden tie that he fastened to his collar. It was blue with yellow dots, if I remember correctly. Apollinaire describes it as "a defensive and offensive weapon."

—DANIEL-HENRY KAHNWEILER, *My Galleries and Painters.*

Kees Van Dongen
(1877–1968)

When he lived at the Bateau Lavoir, a little older than the others, he frequently sat taking the air at a window that looked out on a square; callers asked him directions under the impression that he was the concièrge.

Later, when he lived in Deauville, Georges-Michel asked him why.

❏ "How did you happen to come to Deauville?"

"Well, I wanted to stay in Paris, which I don't really know well, even after sixty years. But my dog began to sulk, and I don't like that. He wanted to go to the country. But where? We might have tried China, but things haven't been very quiet there lately. Or New York. But there you have to go to the cinema. So I preferred this charming spot on the English Channel, where the women are pretty, and you can put on a dinner-jacket to go to the Casino."

"I thought you only wore a dinner-jacket when you washed your car."

"Oh, it has to be used for something else, of course. And then, say what you like, you've got the sea here, too. And yachts. I rather like seeing those white spots moving along the horizon. They are like brushstrokes moving about, and constantly making corrections. They do the work for me, you see."

"Aren't you doing any painting?"

"Painting? Oh, yes. You have to earn a living, don't you? Rolls-Royces are expensive, even if you've only got a Citroën. I've painted in Egypt; I've painted in Montmartre; I've even painted in Deauville. After all, the sea is the same moist light everywhere, as Baudelaire said: a little more violent here, more gently whispering farther north. But wherever you go, the lines are 'written down,' and set in blue. That's the way I see it, at any rate. Another person sees it differently—luckily for us both."

"Monsieur Van Dongen," one of the women present inquired, "why did you paint a green dog in one of your canvases? There are no green dogs in Nature. . . ."

"That is true. But why have you dyed you hair mauve? Is hair mauve in Nature?"

"You're quite right, of course. But I should like to see your dog."

"My dog?"

"Didn't you just say that if you were in Deauville . . ."

"Oh, yes. But to tell you the truth, I haven't got a dog. I invented one so that I could go about with society people. . . . Fido, Fido! Down, boy, down!"

—MICHEL GEORGES-MICHEL, *From Renoir to Picasso: Artists I Have Known.*

Van Dongen accompanied Georges-Michel to Venice.

❑ We arrived at the Doges' Palace.

"And what about that?" I asked.

"Yes. I shall do that. But I want to wait till that rubbish is gone."

By the word "rubbish" Van Dongen was referring to a huge warship alongside the quay, hardly thirty feet away from the Palace, whose delicate rose color seemed crushed by the mass of metal.

"On the contrary, you should take advantage of it," I pointed out. "The contrast would be very 'Van Dongen.' "

"Well, yes. I suppose you are right," he agreed.

He stopped, half-closed his eyes, and remained thus for a minute or two. Then he said:

"There. It's all done."

(And as a matter of fact the next day he produced one of his finest canvases in grey and rose.)

"Now let's go to Florian's. I want to do some sketches of the officers there, and have a vermouth, and look at the sights of the place. This afternoon I'm going to sit in the bandstand and make some notes on St. Mark's."

I had an engagement for lunch. Later, when I returned to meet "Kiki," I was greeted by a comic spectacle. For there he was, sitting in the middle of the bandstand, just as the band arrived for the afternoon concert.

"That's a beautiful picture you're doing," the bandmaster said. "But you'll have to let us have the place."

"Just a minute," begged the painter, his brushes still in his hand.

"I'm sorry, but we have to start now."

"Very well. You can start. You won't be in my way."

"Yes, but you are in our way. If your canvas was smaller——"

"Oh, the devil! You're a nuisance. I was here first, wasn't I? What are you going to play?"

"Donizetti."

"I don't like Donizetti. Don't you think a picture of mine is as good as any opera by that musical lacemaker?"

"That's not the question."

"It most certainly is!"

"Sir, in spite of our respect for foreigners in general, and for art in particular——"

The police were sent for as well as the fire brigade, while all Florian's, Quadri's, Lavena's, the employees from Jesurum's, Griffon's, Salviati's and Asta's, not to mention the entire crowd in the Piazza and the neighboring alleys, argued the case furiously.

"The devil with them!" exclaimed the painter.

He was gently but firmly ousted.

"Don't worry about your picture," one of the firemen said to him, as he took down the painter's easel. "We helped to move Veronese."

"Never heard of him," snapped Van Dongen.

—GEORGES-MICHEL.

In Paris, Van Dongen gave parties.

❏　He led the way downstairs. As usual, he had on his overalls. As we reached the street, a big, shiny car drew up before the door. A gentleman in evening clothes got out, followed by two ladies decked out in diamonds.

"Is this Van Dongen's house?" the visitor asked.

"I think so," replied the artist.

As the party started towards the entrance, Van Dongen said to the gentleman, who evidently didn't know him:

"What about my tip, sir?"

—GEORGES-MICHEL.

Raoul Dufy
(1877–1953)

Modernist painters needed schooling—and unschooling.

❏　The years in Paris at the Ecole des Beaux-Arts certainly augmented Dufy's skill. Indeed, he achieved such virtuosity with his right hand that he deliberately switched to the still untrained left, which he came eventually to prefer.

—ALFRED WERNER, *Raoul Dufy.*

Accused of altering reality in his painting, he answered: "Nature, my dear sir, is only a hypothesis."

His work's gaiety was its triumph and its downfall. Blamed as an entertainer of the rich, he defended himself: "If Fragonard could be so gay about the life of his time, why can't I be just as gay about mine?" He was compared to a milliner, and a critic complained that looking at Dufy's pictures he heard the tinkling of champagne glasses.

Music was his greatest passion; his friend the conductor Charles Munch remembered:

❏ It was during the 1930s that I first met Raoul Dufy. At that time he regularly attended the rehearsals of the Paris Conservatory Orchestra, of which I was conductor. Unobtrusively, he would go up to the back row and take his seat beside Passerone, the famous percussion player. I can see him now, at the foot of the organ, crouching over his paper, drawing away. It was there, among us musicians, as we rehearsed our program, that he conceived his series of *Orchestras*.
 —WERNER.

Another friend was Pablo Casals, who looked at a Dufy painting and said: "I cannot name the piece that your orchestra is interpreting, but I know the key in which it is written!"

Marsden Hartley
(1877–1943)

The poet William Carlos Williams belonged to the New York of the Armory Show and Steiglitz gallery. His friend Charles Demuth later made a painting from his poem, but Williams saw "The Great Figure" (Number 5) on his way to visit Marsden Hartley.

❏ Once on a hot July day coming back exhausted from the Post Graduate Clinic, I dropped in as I sometimes did at Marsden's studio on Fifteenth Street for a talk, a little drink maybe and to see what he was doing. As I approached his number I heard a great clatter of bells and the roar of a fire engine passing the end of the street down Ninth Avenue. I turned just in time to see a golden figure 5 on a red background flash by. The impression was so sudden and forceful that I

took a piece of paper out of my pocket and wrote a short poem about
it.

I remember once, returning to New York from a visit to us in Ruth-
erford, Marsden and I were waiting on the Erie platform when an ex-
press train roared by right before our faces—crashing through making
up time in a cloud of dust and sand so that we had to put up our hands
to protect our faces.

As it passed Marsden turned and said to me, "That's what we all
want to be, isn't it, Bill?"

I said, "Yes, I suppose so."

—WILLIAM CARLOS WILLIAMS, *Autobiography.*

Jacques Lipchitz told of a party in New York.

❑ Suddenly I saw his magnificent head! Taking the woman I was
talking to aside, I asked her to ask him if he'd pose. I didn't know who
he was. She came back to me and nodded, and I looked at him. His
face was illuminated! He came over and introduced himself. It was
Marsden Hartley and I had heard that he had been to Curt Valentin,
my dealer, a month before to buy one of my drawings, but couldn't
afford it. "Give it to him, Curt," I said, "if he's a painter." So he sat for
me, and I did the head, and when we were through he said to me one
day: "Do you know we've had *twenty-seven* sittings!"

"Are you angry, Marsden?" I said.

"No," he said, "I'm happy. Now I can die!"

And a year later, Lipchitz added almost triumphantly, he did.

—SELDEN RODMAN, *Conversations with Artists.*

Augustus John
(1878–1961)

In *Chiaroscuro* Augustus John remembered the dour house of his
childhood.

❑ I felt at last that I was living in a kind of mortuary where every-
thing was dead, like the stuffed doves in their glass dome in the draw-
ing-room, and fleshless as the abominable "skeleton-clock" on the man-
telpiece: this museum of rubbish, changing only in the imperceptible
process of its decay, reflected the frozen immobility of its curator's mind.

—AUGUSTUS JOHN, *Chiaroscuro: Fragments of an Autobiography.*

Augustus John's accidental brain surgery became notorious.

❏ The story is perhaps most succinctly told on the back of a Brooke Bond Tea Card, as one of a series of fifty Famous People. Here Virginia Shankland writes that Augustus John "hit his head on a rock whilst diving, and emerged from the water a genius! He became a magnificent draughtsman; this mastery later spread to painting. John was a fiery personality with a passion for independence and personal liberty, which he expressed in his paintings, especially those of gypsies. He felt great affinity with their roving lives and often lived among them."
 —MICHAEL HOLROYD, *Augustus John: A Biography.*

The story became so notorious that John attended to it, under an elegant part-title, in his posthumously published book, *Finishing Touches*.

❏ *A Bang on the Head*

While I was a student at the Slade an event occurred to which was attributed undue importance at the time. It may now prove amusing to recall it. I had returned to Tenby for the summer holidays. I might have been about sixteen years old. One day my father and I took a walk along the beach to Giltar Point. I intended to bathe and took a towel with me. The tide was far out, but on the turn. Exploring this unaccustomed bathing place, I found a rock which offered, I thought, a good take-off. The water below appeared to be deep enough for a dive, but was by no means clear, the surface being encumbered with seaweed. Still, taking a chance, I stripped and made the plunge. Instantly I was made aware of my folly. The impact of my skull on a hidden rock was terrific. The universe seemed to explode! Yet I wasn't stunned. Perhaps the cold water saved me for I was able to get out of it, replace the flap of scalp I found hanging over one eye, tie the towel round my head, dress and rejoin my father, who was much alarmed by my plight. We made for home as fast as we could, but did not take the nearest way up the cliff, for that would have probably meant publicity which was at all costs to be avoided, but we ascended by zigzag steps further on, which permitted us to cross the Esplanade quickly and gain our house beyond more discreetly. I was feeling now decidedly weak and went to bed to await the doctor. When he arrived I was surprised and pleased to recognize, not our usual practitioner, but Dr. Lock, a much more exciting personage. I had often admired him as he drove past in his smart gig, attired for the occasion in a style as sportive as it was appropriate, or on foot taking his "old-fashioned" sheepdogs for a run. He had a strong handsome face and looked superb and perhaps a trifle haughty in his loneliness, for I never saw him in company. Could

he have been under some cloud? I wondered. Certainly there was gossip. From what I overheard, this gentleman had been involved in an affair of the heart, which actually culminated in an elopement, but not a very serious one (which made it all the worse), for the fugitives got only as far as the next village, where, on second thoughts, they decided to renounce the project and return, the lady to her teeming family, the doctor to his dogs. This reasonable Don Juan was now engaged in thrusting an apparently very blunt needle through my scalp, an uncommonly thick one, it appeared (a circumstance to which I probably owed my life.) The stitches held, there was no concussion, and in due course I was discharged cured and returned to the Slade, wearing, to conceal my wound, an out-of-date smoking-cap of black velvet with gold embroidery, produced by my father. My entry into the life room thus attired caused a sensation which my subsequent performances with a stick of charcoal only increased: and thus was born the myth of my *genius*, due, it seemed clear, solely to the bang on the head I had incurred while bathing. This, it was thought, had released hidden and unsuspected springs . . . It was all nonsense of course; I was in no way changed, unless my fitful industry with its incessant setbacks, my wool-gathering and squandering of time, my emotional ups and downs and general inconsequence can be charitably imputed to that mishap.

—AUGUSTUS JOHN, *Finishing Touches.*

John once acknowledged: "I am just a legend. I'm not a real person at all." His notoriety centered on his amorousness, the frequency with which he pursued erotic engagements with models and sitters, the numbers of children rumored to derive from his liaisons. His biographer tells a story which becomes typical.

❑ His first destination was a large mausoleum of a house set in park-lands that resembled a cemetery—altogether a monument to boredom. On arriving there, he was awestruck by the beauty of his young hostess, which seemed, after a cocktail or two, very visibly to increase. They felt shy with each other and after the drawing was done she took him upstairs to show him her home-made chapel fitted into the attic. Her husband was away shooting, she explained—he often was—and during the dull days of his absence she would seek consolation here. Within the wall, Augustus spied a recess—perhaps a confessional, or a boudoir, or both. . . . But soon he had to be on his way for the next assignment. Here, too, there was much embalmed magnificence and beauty, though the atmosphere seemed less tense with melodrama. His new hostess, unencumbered with religiosity, was as amiable as the first. There seemed to be an epidemic of "shooting" in the district, for her husband also had been carried off by it. When the drawing was done, Augustus re-

turned to London with two cheques in his pocket, but richer in more
ways than one.

—HOLROYD.

Before the Great War he was co-subject of a rhyme sometimes
called "The Virgin's Prayer."

> Ezra Pound
> And Augustus John
> Bless the bed
> That I lie on.

When he walked in London, it was said, he patted all local chil-
dren on the head, "in case it is one of mine." Speculation about
these offspring reached numbers greater than a hundred; his
biographer is skeptical.

He loved Gypsies, often traveled with them, learned Romany,
and naturally enough found the women attractive, which did not
always endear him to Gypsy men. He wrote Wyndham Lewis:

❏ This morning I find a parcel which opened—lo! the ear of a man
with a ring in it and hair sprouting around lying in a box of throat
pastilles—nothing to indicate its provenance but a scrawl in a mixture
of thieves' cant and bad Romany saying how it is the ear of a man
murdered on the highroad and inviting me to take care of my Kâri =
penis, but to beware of the dangers that lurk beneath a petticoat. So
you see even in England I cannot feel secure and in France the Police
are waiting for me, not to speak of armed civilians of my acquaintance.

—HOLROYD.

Dorelia and John never married; infinitely polygamous, John
married only Ida Nettleship. Sometimes Ida and Dorelia and John
established a *menage à trois;* sometimes the two women kept sep-
arate establishments—while John made temporary port with an-
other female companion.

❏ Dorelia made Alderney a harbor. John kept on his studio at the
Chenil Gallery and would stay there for much of the week; then, at
weekends, or in moments of sudden revulsion from town life, he ap-
peared at Alderney to pursue his work inside the converted coach-house.
It suited him in many ways, this dual existence, giving a constructive
pattern to his restlessness, a momentum supporting his work: and it
enabled Dorelia to look after him without obviously appearing to do
so. She was an anchor, discreetly out of sight.

"He behaves very well," she admitted to Charles Tennyson, "—*if I keep my eye on him.*" The eye she kept on him was at first pretty fierce. Over the early years at Alderney a pattern of existence developed between them that became roughly acceptable to both. He carried on two lives; and so, eventually, did she. In London he enjoyed affairs with models, art students, actresses, dancers—anyone new. These amatory exercises seemed almost obligatory. "The dirty little girl I meet in the lane," he declared, "has a secret for me—communicable in no language, estimable at no price, momentous beyond knowledge, though it concern but her and me."

—HOLROYD.

Dorelia complained to Richard Hughes.

❑ One afternoon, when the two of them were walking in the garden with a boy of about four believed to be John's youngest illegitimate son, Dorelia suddenly came out with: "There's one thing about John I've never got used to, not after all these years." Richard Hughes glanced apprehensively at the child, but she continued: "I don't know what to do about it. Time after time, *he's late for lunch.*"

—HOLROYD.

The second Mrs. August Strindberg pursued him as intently as he fled her.

❑ In 1910, while on the track of the fleeing Wyndham Lewis, she had called at Church Street and, expecting to quarry him there, found herself briefly in bed with John. "I then dismissed the incident from my mind," John recorded, "but it turned out to be the prelude to a long and by no means idyllic tale of misdirected energy, mad incomprehension, absurdity and even squalor."

John frequently made elaborate efforts to evade her. In vain, it appears. He came to the conclusion that she possessed second sight and the gift of obliquity. If, without telling a soul where he was going, he sought refuge in some obscure café in Paris or London, Frida would know and appear on the scene. If he boarded a train for the country, there she would be on the platform to bid him good-bye or to follow him. And it was advisable for him to watch his step in his treatment of her even when dining with her in company, for if he were discovered paying too much attention to another female member of the party she would pay a man to take up a concealed position and aim a champagne bottle at his head; and on one occasion, in Paris, when he imagined that he had been successful in eluding her by a series of swift changes of scene, he was informed through an anonymous and illiterate note that he would *again* be beaten up if his behavior towards a certain lady

did not improve—for evidently someone had been mistaken for John and had innocently suffered the attack.

—HOLROYD.

The American collector and Maecenas, John Quinn, patronized John, who paid him back with practical jokes.

❑ Descending a tortuous mountain road, Quinn had inquired the German for "slow." "Schnell," John replied. "Schnell!" Quinn shouted at their burly driver who obediently accelerated. "Schnell! Schnell!" Quinn repeatedly cried. They hurtled down the mountain at breakneck speed and arrived at their hotel "in good time for dinner" though on this occasion Quinn retired to bed at once.

—HOLROYD.

Others played jokes on him. In Ireland he stayed with Lord Dunsany.

❑ As a practical joke, Gogarty had warned Dunsany not to give John any alcohol—which made Dunsany determined to offer his guest as much as he could want. This would have suited John well, had Gogarty not confided to him that Dunsany was a fierce teetotaller and would fly into a rage if anyone in his home accepted a drink. The result was that, in an agony of politeness, John persisted in refusing everything until, according to Compton Mackenzie, "Dunsany started to explain how to play the great Irish harp . . . After they went to bed Augustus climbed over the wall of Dunsany Park and walked the fourteen miles to Dublin."

—HOLROYD.

It was as a portrait painter that he was most talented and celebrated. Portraiture—defined by John Singer Sargent as that genre of painting in which there is something always a little wrong about the mouth—raises typical problems.

❑ My portrait of the late Lord Leverhulme had a dramatic sequel or series of sequels. It had been dispatched and paid for, when I heard from my agent that the picture had been returned minus the head! The canvas was still fixed in its packing-case from which it had clearly never been removed. Much mystified, I wrote to his Lordship requiring an explanation of this remarkable proceeding, to which I proposed to give full publicity. I received in return a letter stating that on finding the picture too large to place in his safe, the owner had cut out what he considered to be the most important part, that is the head, and lodged it in that repository: as for the remainder, it had been sent back by an error on the part of his housekeeper: I was urgently requested

to keep the matter dark, and invited to dinner at Hampstead. My an-
swer to this was to inform the Press of the matter: the story was then
published, with photographs of the work, before and after treatment.
Telegrams and cables now began to pour in from artistic bodies all over
the world, including if not China and Peru, certainly Japan and the
U.S.A. Public demonstrations also took place. The students of the Lon-
don Art Schools united in organizing a procession to Hyde Park, bear-
ing aloft a gigantic replica of the celebrated soap-boiler's torso, the head
being absent: this was accompanied by eloquent expressions of indig-
nation, scorn and ridicule.

In Italy they went further. A twenty-four-hour strike was called, in-
volving everyone connected with the painting industry, including models,
color-men and frame-makers. A colossal effigy entitled "IL LE-VER-HUL-
ME" was constructed of soap and tallow, paraded through the streets of
Florence, and ceremoniously burnt in the Piazza dei Signori, after which,
the demonstrators, re-forming, proceeded to the Battisteria where a
wreath was solemnly laid on the altar of St. John. . . .

—Chiaroscuro.

Old age did not entirely destroy his spirit.

❑ Late one night at Percy Street a young girl with long fair hair came
beating on the door, shouting that she loved him and must be let in.
The Kees cowered beneath their bedclothes, the old man's snoring halted
and he eventually heaved himself downstairs. There followed a series
of substantial sounds, then silence. Next day several of the bannister
supports were missing, there was blood on the floor and, more myste-
riously, sugar. John looked sheepish. "Fraid there was rather a rumpus
last night," he muttered. Later that day he visited the girl in hospital
and came back elated. "Said she still loved me," he declared wonder-
ingly.

—HOLROYD.

The last such story comes from the year he died.

❑ In the summer of 1961, Simon John having left to marry a neigh-
bor, John's daughter Zoë came to stay at Fryern. John, then in his eighty-
fourth year, was sleeping on the ground floor. One night, carrying a
torch and still wearing his beret, he fumbled his way upstairs to Zoë's
room, and came heaving in. "Thought you might be cold," he gasped,
and ripped off her bedclothes. He was panting dreadfully, waving the
torch about. He lay down on the bed; she put her arms round him;
and he grew calmer. "Can't seem to do it now," he muttered. "I don't
know." After a little time she took him down to his own bedroom, tucked
him up, and returned to her room. It was probably his last midnight
adventure.

—HOLROYD.

Kasimir Malevich
(1878–1935)

One of the great Russian artists of Revolutionary times, Malevich grew up in the south of the Ukraine, where his father worked in a sugar factory. He remembered from childhood

❏ . . . a drive to the station with my father in March. The snow still lay on the fields, while a huge cloud shading into leaden blue at its base hung over the horizon. I remember a lake on a bright day with the sun mirrored in the wrinkles on its surface, like so many stars in continuous motion. All these strongly influenced me, but—I repeat—did no more than influence. I could do no more than carry in my visual memory those of the influences which were stamped on my mind as "good." All these images were stacked away somewhere in a suitcase by my nervous system, like negatives waiting to be developed.
—LARISSA ZHADOVA, *Malevich: Suprematism and Revolution in Russian Art.*

His words were as colorful as his most celebrated canvas was white. "I have broken the blue shade of color boundaries and come out into white. Behind me comrade pilots swim in the whiteness. I have established the semaphore of Suprematism."

When Chagall became director of the Vitebsk School of Art, 1918, he invited old friends from Moscow to teach under him, among them Malevich. Shortly thereafter, while Chagall was absent, Malevich took over the school, dismissing Chagall.

When he died in 1935, Malevich had provided himself a coffin covered with his own Suprematist designs.

Sir Alfred Munnings
(1878–1959)

Laura Knight describes an encounter before the Great War—when Munnings was already anachronistic.

❑ We went over to Norwich for the night and dined with him at the Maid's Head Hotel. We sat in the bar-parlor afterwards sipping port at a shiny mahogany table. To look at A. J. in those surroundings took you back 150 years; he fitted into the antiquity; even his clothes had a cut that belonged to the past. I unfortunately infuriated him on this occasion by taking a bath and thus adding a shilling to his account, nothing compared to the sum he had expended for the wines he had lavished on us the night before. He has never forgiven me this extravagance. "All this washing," he said. "What do you want a bath for?"
—LAURA KNIGHT, *Oil Paint and Grease Paint.*

President of the Royal Academy from 1944 to 1949, Munnings used his eminence as a platform from which to attack modern art—especially Henry Moore.

❑ Unfortunately both Munnings and Moore belonged to the Athenaeum Club in Pall Mall, where Munnings liked to hold forth to his cronies in the long drawing room. As Moore climbed the staircase one day with his friend J. M. Richards, *The Times*'s architectural correspondent, the painter and cronies came towards them. "There's that fellow Moore," Munnings said in a loud voice. "What's a bloody charlatan like him doing in this club?"
—ROGER BERTHOUD, *The Life of Henry Moore.*

The painter L. S. Lowry addressed him at the Royal Academy: "I must congratulate you on your pictures. I admire them immensely." Sir Alfred answered: "I wish I could say the same about yours but I dislike them intensely."

Sir William Orpen
(1878—1931)

Early in the century Orpen and Augustus John frequently worked together at Orpen's house.

❑ He and Orpen used to stand on either side of the fireplace drawing on the marble mantelpiece in pencil, aiming to join their composition midway and incorporating the graining and coloration of the polished surface. The results of their labors would be carefully scrubbed

away by the industrious housemaid the following morning, no doubt clicking her tongue at such dirty habits.

—BRUCE ARNOLD, *Orpen: Mirror to an Age.*

In *Finishing Touches*, Augustus John told a zoo story.

❏ It appears that as a student he was in the habit of visiting the zoo for the purpose of sketching the animals. One day, he was sketching a large anthropoid ape when he was surprised by this creature's behavior. It would approach as near as the bars of the cage permitted, and, stretching out its arm, endeavor to divert the attention of the young artist, but without malice, while at the same time uttering soft, conciliatory sounds. Orpen, touched by these overtures, and perhaps a little flattered, responded with a smile and a cordial handshake. "It seemed the only thing to do," he said. But on succeeding visits, for he had still his studies to finish, he observed with some anxiety that his model's friendly attentions not only persisted but became progressively warmer and more intimate. The hesitating touch had now become a frank caress, and there was an expression in the creature's eye which could mean only one thing—Billy Orpen was loved by a monkey! Was he offended? Not a bit! He was but a youth and still a tyro in amatory experience, although subject no doubt, like most boys and girls, to the mysterious urgencies of sex. Besides, as he confessed, he had grown, if not yet to love, certainly to esteem his simian suitor, and if the latter could hardly be classed as a beauty by European standards, no more, for that matter, could he himself. The situation was difficult, but in the end common sense, with which he was well provided, prevailed. There could be no alliance. Popular prejudices were too strong; there was the Law to think of, too, and what about his career? He consulted the keeper, who, taking the only sensible course, arranged a swap, and his disconsolate charge, in exchange for a duck-billed platypus and a young South American peccary, was removed to another establishment. I will not attempt to describe the final scene, except to report that it was heartbreaking—and violent.

—AUGUSTUS JOHN, *Finishing Touches.*

When he had an affair with a married woman, he treated the transgression, as his biographer put it, "with a characteristic lightness of touch." She was six feet tall, he five foot two.

❏ He sent drawings of the two of them being stared at in the Berkeley Hotel, going out for an evening's theatre or to parties, and in these he emphasized her grand manner, her dramatic dresses, and her high and elaborate hats which carried to absurd proportions the already quite

startling disparity in their heights. Indeed, in one drawing Orpen depicts himself standing on tiptoe to kiss her goodnight. In English society they became known as "Jack and the Beanstalk."

—ARNOLD.

Celebrated as a portrait painter, he was generous and eccentric.

❑ Orpen kept a huge china bowl in the studio filled with banknotes and cheques, and he was prodigal in his generosity, often to people who were just passing acquaintances. "Hundreds of foolish, unhappy and unlucky people had reason to thank God for him." But [the Irish painter Sean] Keating's final judgment of that span of years in which he knew Orpen, is an unequivocal and sobering one: "He was a lonely man in his heart."

—ARNOLD.

Much of his portrait work could be regarded as technical achievement or social accomplishment, perhaps even a higher sycophancy. When he painted action in the Great War, he showed a darker side. He also made himself trouble.

❑ At about this time, the winter of 1917, Orpen met Yvonne Aubicq, who was to occupy so important a part in his life. He painted two portraits of her, both of which have come down to us with the same title, *The Refugee*. Orpen, who at all times was sparing of information and explanation about his art, was particularly reticent when it came to these first paintings he did of Yvonne. They mattered greatly to him, and he planned, early in 1918, to include them in the exhibition of his work to be held at Agnew's. Only belatedly did he realize that his work as an official war artist, on major's pay, had to be confined to "war" pictures. When he submitted them to the Intelligence section at G.H.Q. to get them passed for exhibition by Major A. N. Lee, he gave the title of "The Spy" to both pictures. He developed a typical First World War story to go with the title. The girl, he explained, was a German spy called Frieda Neiter who had been arrested by the French and found guilty. As a last request she asked that she be allowed to face the firing squad in a dress of her own choosing. The gallant French agreed, and she appeared before the fusiliers draped in an army greatcoat. When the orders for her execution were given she let fall the coat, and stood naked before the soldiers. They flinched for a moment at the sight of her unparalleled beauty, but obediently squeezed the triggers of their rifles and she fell in a lifeless, crumpled heap on the ground! It was Orpen's most elaborate and notorious invention. It had a wide circulation, and was much embroidered in its detail, to some extent weakening the impact.

Lady Diana Cooper, at that time Lady Diana Manners, daughter of the eighth Duke of Rutland, was then working among the wounded at Rutland Hospital and Guy's, and wrote to Duff Cooper at the Front:

I send you another picture today, for the sake of the romance in it. She was a spy. Her prettiness you can believe. Her hair is of an acid peroxide color and her skin frail. She told her beads while Orpen painted her the day before she was shot, crying terribly. The story is told, but not believed, that she asked to be allowed to dress properly for her execution, so her maid was allowed to go to the cell taking with her an unequaled sable and chinchilla coat, and a little pair of white satin mules. She asked for no bandage, no cords round her wrists, and begged for short warning. When it came she let the furs slip from her naked body and lie like a vanquished animal round her feet. Like that they shot her. No doubt she had a little hope and faith in her beauty earning her a reprieve.

A reply came back from Duff Cooper a week later: "I can't bear the story about Orpen's spy. It quite worried me until I dismissed it from my mind, as the lady did the story of the Gospels, with the comfortable reflection that it all happened long ago and let's hope it isn't true." It was not until October 1918, when Duff Cooper met Orpen in Paris, that he learned the truth:

Orpen spent the evening with us yesterday. O you silly baby to have believed his story of the Belgian spy. The lady in question is living in Paris and is Orpen's mistress. He says she was feeling a little tired the day he painted her. He deliberately invented the story in order to advertize the picture and got into some trouble with the War Office for doing so. I am glad it isn't true. I had often thought of it since you told me.

—ARNOLD.

Paul Klee
(1879–1940)

Ernest Harms—painter become psychotherapist—remembered Klee from Blaue Reiter years.

❑ I also frequently met with Paul Klee. These meetings took place during the daily lunch and after-lunch meetings at a coffee house on Munich's Theatiner Strasse. Kandinsky, when in town, appeared punctually and dominated the group like an uncrowned king. Klee would show up irregularly and unobserved. Suddenly he was there, taking a chair by its back, and edging himself in somewhere, with his hard Swiss

"Was machst Du?" He seemed to like me because he often came, as he said, to sit beside this "young one."

One could never have a real conversation with Klee. Once in a while he would ask a question, but he gave only one word answers. When the discussion in the circle became lively, he would occasionally make a loud, snappy, ironic remark. His hard Swiss dialect, even in two or three words, broke through and usually caused a burst of laughter.

Usually, soon after he had seated himself, he brought from his pocket a handful of pencil stumps, none longer than an inch. He looked around for something to draw on: the menu, a newspaper border, or very frequently my notebook, which he took without asking. He drew constantly during whatever was going on. His fingers had to be busy. He never picked up his drawings. I kept my notebook in which there were dozens of his line sketches.

The year 1912 was fateful for the Blaue Reiter Group. Kandinsky finally broke with all "figural" art and became totally nonobjective. Klee, who up until that time had been working only in graphics, finally "discovered" color. I recall an amusing episode. I rarely had lunch at the coffee house. But once I decided to have a standard German dish, "Ei mit Spinat" (Fried egg with spinach). Before the dish was served, I was called away from my seat. And when I returned I found Klee having taken over my plate and with a pencil making a design according to his liking from the yellow, white, and green. A crowd of laughing fellows had encircled him. Of course, I had lost my taste for my lunch as it presented itself "à la Klee" to me. However, I decided to try to take this artistic concoction home. But I did not succeed in preserving it. Klee did not say a word. The whole thing was quite natural to him.

—ERNEST HARMS, *Art Journal*, Winter 1972–73.

Not many people tell anecdotes about Klee. In his diaries, he told tales on himself.

❑ Evil spirits that I had drawn (three to four years) suddenly acquired real presence. I ran to my mother for protection and complained to her that little devils had peeked in through the window (four years).

—*The Diaries of Paul Klee 1898–1918*, ed. Felix Klee.

Somewhere he said: "Were I god, I would found an order whose banner consisted of tears doing a gay dance."

❑ Klee was once observed by one of his pupils in Dessau marching absent-mindedly, but as though under a spell, in time to the music of a passing band right down the middle of the slabs of a concrete pave-

ment. As soon as his pupil spoke to him he broke off, alarmed and embarrassed, and in the course of the ensuing conversation about the suggestive power of the passing music and the rhythm of the slabs of concrete, Klee immediately set himself and his pupil the problem of expressing this rhythmic relationship in pictorial terms. The next day, Klee produced his solution: a rush of flowing lines set off against a hard rhythm of rectangular forms on the left-hand side.

—WERNER HAFTMANN, *The Mind and Work of Paul Klee.*

Jimmy Ernst, son of Max, remembered Paul Klee as a friend of the family, quick to entertain a young child.

❏ He and I had a common passion, the age-old Hänneschen Puppet Theater. If it was summertime, we went to see it in the park, and in winter, in the old section of Cologne near the river. The plot was always the same: Hänneschen fighting off ogres and villains with a cardboard stick, always coming close to annihilation but overcoming the enemy at the last second, with loud cries of support from children and Klee. This is a memory almost always evoked for me in the subject matter of Klee's marvelous works.

—JIMMY ERNST, *A Not-So-Still Life.*

Francis Picabia
(1879–1953)

Picabia was an anomaly among artists: his grandfather had built railroads in Spain and he was rich. He enjoyed being rich. When he was a child (he boasted) he replaced the old masters that hung on the walls of his father's house with copies that he made himself—selling the originals to raise money for his stamp collection.

In Dada times, Picabia nailed a stuffed monkey to a piece of wood and labeled the product "Still-Life: Portrait of Cézanne." Picabia, said Ezra Pound, "got hold of an instrument which cleared out whole racks full of rubbish." Georges-Michel tells the best stories.

❏ When he wasn't on his boat, Picabia was usually to be found at the Château de Mai, situated on a hill near Mougins. It was surrounded by water and cemeteries.

"I didn't know you had such morbid tastes," I said to him, when I noticed the gloomy situation.

"Don't worry. Those are fake cemeteries."

"What do you mean, fake?"

"Just that. I've camouflaged those fields of mine so as to force down the price of the adjoining property, which I want to buy. . . . But, speaking of morbid stories, I must tell you about the magnificent ebony coffin with bronze handles that was sent to me the day I gave my last luncheon-party here. When it came to the time for dessert, I asked my guests which of them had been responsible for the joke. And, do you know, they all turned pale, and told me that each of them had received a similar present that same morning? I didn't manage to clear up the mystery until a week later. It turned out that an undertaker friend of mine had sent us all 'samples' of his wares. And when I protested he said: 'Don't be annoyed. Business has been bad and my stock was going to be seized. So, in order to save as much of it as I could, I sent it to my friends.' "

He took me to his garage, where ten Fords were lined up in the stalls.

"So you're selling cars now, are you?" I said.

"No. But I've found Fords so practical that I don't want any other kind. I bought ten of them at the same time to be on the safe side, and so that I wouldn't be tempted to get any other make. You can have ten Fords for the price of one Hispano. Wouldn't you rather have ten Fords than just one Hispano? Of course you would. . . ."

However, when I went to pay Picabia a visit on board his boat the following year, I found him on the quay, gazing rapturously at a huge Rolls-Royce; and his first words were,

"Isn't she a beauty?"

"Is she as good as a Ford?" I asked.

"Oh, shut up," he said. "I've just bought it. I got it for running about in, errands in town and so on. But I've got something better. I'll show you. . . ."

We climbed into the Rolls and sped off to the Château de Mai. As soon as we arrived, Picabia jumped out and ran to the staircase leading to the square tower.

"Where on earth are you going?"

"Come on!" he called back.

We came out on to a terrace, and there was a superb car, with enormous exhaust-pipes and bonnet, mounted on a steel bar with a vertical pivot, like the horses on old-fashioned merry-go-rounds.

"And do you know what she can do? A hundred and twenty-five miles an hour."

"I don't understand," I said.

"About the pivot? And the terrace? Why, it's all very simple. Watch."

He sat down at the wheel, and started going round at a dizzy pace.

"You see? I love speed, but I'm afraid of danger. So I thought up this little dodge."

"But what about the pleasures of motoring? The scenery?"

"Well, I've got the hills round Grasse on one side, and the sea and the islands off Cannes on the other; there are woods close by, and the plain just beyond. Where else would I find more beautiful scenery and such peace? Where else could I do a hundred and twenty-five miles an hour without the risk of skidding, or running into a telegraph pole, or colliding with some fool coming along on the wrong side of the road? You try it. Get in and see. It's like being on a boat; if you're not used to it your head starts spinning. Perhaps we'd better have lunch first. Let's get back to the port and go aboard the boat."

At that time Picabia had no less than three yachts, named respectively *l'Horizon I*, *l'Horizon II* and *l'Horizon III*.

"So you don't approve of my cars? Whenever anything goes wrong with one of them, I buy a new one. Do you like dessert? For lunch today I've ordered nothing but various kinds of dessert, served on palettes out of old paint-tubes. After all, old man, you're visiting a painter, you know. . . ."

My charming, eccentric friend eventually died in poverty, almost completely paralyzed, and speechless. He could speak only with those flashing eyes of his—and in how tragic a language. . . .

—MICHEL GEORGES-MICHEL, *From Renoir to Picasso: Artists I Have Known.*

André Derain
(1880–1954)

Alberto Giacometti was a younger friend whom Derain entertained with stories out of his own youth, when Derain and Georges Braque had been close friends.

❏ Both were living with women whom they had not married but who hungered for matrimony and urged their lovers to wed them. Consenting at last, the two artists decided to have a double ceremony. On the appointed day, as the two couples prepared to leave Derain's studio, his bride-to-be suddenly declared that she must have a new pair of shoes, as the old ones were too shabby. Derain replied, "Oh, Alice, that's not necessary. In a crowd, nobody will notice your shoes." Alberto es-

pecially relished that story. Every time Derain told it, he laughed up-
roariously, and said, "That's perfectly true. Nobody notices shoes. They're
not important."

<div align="right">—JAMES LORD, Giacometti: A Biography.</div>

Chirico talks about Derain in his *Memoirs*. Although he praises
Derain's painting, Chirico claims that "a great part of his success
is due more to his way of behaving than to his qualities as a
painter. He is the cantankerous man *par excellence;* he never speaks,
and if someone addresses a word to him he replies with a grunt."

❏ Whenever someone goes to see him, an old maidservant replies in
imperturbable fashion, "Monsieur Derain has gone out shopping." If
some tenacious or fanatic person insists and says that he will wait until
M. Derain comes back, the maidservant adds, "Oh no, that's impossible,
for when Monsieur Derain goes out shopping he sometimes stays out
for several days."

<div align="right">—GIORGIO DE CHIRICO, Memoirs.</div>

"However," Chirico continues, "Derain's admirers are without
number. Those who fell most desperately in love were Adolphe
Basler and Paul Guillaume."

❏ Adolphe Basler was one of those dealers who in Paris are called
private dealers because they buy and sell pictures without having a gal-
lery. He was madly in love with Derain. One winter afternoon, while I
was sitting on the *terrasse* of the Café des Deux Magots, the intellectuals'
café on the Left Bank, I watched the following curious and diverting
spectacle. Derain arrived, alone, as always, and sat outside on the ter-
race. In winter the *terrasse* was heated by braziers and protected at the
sides with large glass screens. Derain sat down and ordered a *demi,* a
pint of beer, and then bought some peanuts from an Arab street-vendor
and filled his pockets with them. In his way, crunching the nuts and
sipping his beer, he remained motionless, without looking in any direc-
tion, with the expression of someone profoundly disgusted with every-
one and everything, while his elephantine eyes gazed at the doorway
of the church of St. Germain-des-Prés. Shortly afterwards, as though
by magic, as though drawn by some mysterious call, Adolphe Basler
appeared on the horizon. When he saw Derain he came closer and
began to walk up and down in front of him, looking at him lovingly
with shining eyes and making little gestures of greeting with his head
and hands. Derain, motionless and imperturbable, continued to gaze at

the church door. Since all the tables next to Derain were occupied, Basler continued walking up and down for a little time, but when a table on Derain's left became free Basler rushed towards it; but before sitting down he respectfully asked Derain's permission, as though the latter could have occupied two tables on his own. Basler, seeing that permission was not given, sat down timidly on the edge of the chair with one buttock drooping over it. Then he began another maneuver; he tried to speak to Derain: "Good afternoon, Monsieur Derain, how are you?" and the other remained silent. "Are you working hard at the moment, Monsieur Derain?" And the other was more silent than ever. Then Basler, at the height of amorous intensity, stretched out a trembling hand and with the tips of his fingers barely touched Derain's shoulder. He should never have done it! A terrifying grunt, something resembling the trumpeting of a ferocious elephant, and a no less terrifying twitch of the shoulder where Basler's hand lay, were the sole response to this timid attempt at a caress. Basler quickly withdrew his hand as though it had been burnt and then, beaten and disappointed, gave up, sadly took out of his overcoat pocket a copy of *Gringoire* or *Les Nouvelles Littéraires,* I do not remember which, and buried himself in one of those utterly boring, endless tirades with which the Parisian literary weeklies are always abundantly supplied.

—CHIRICO.

Many painters gain energy in old age but not Derain.

❏ On the contrary, old age confirmed loss of vitality, loss of talent, loss of prestige. Of all the artists he had known, and he had known them all, only two of note stayed faithful: Giacometti and Balthus. Sunday lunches at the estate in Chambourcy grew steadily more morose. Derain was not granted even the modest consolation of a dignified farewell to failure. One day he was run down by a careless motorist. The injuries at first did not seem serious. Alberto went several times to see him in the hospital at Saint-Germain-en-Laye. Then his mind seemed to go, and he lingered for some weeks in a vagueness. Asked as he was failing if there was anything he wanted, he said, "A bicycle and a piece of blue sky." Two hours later he died, the date September 8, 1954. Few people took the trouble to attend his funeral. Only a single artist of stature: Alberto Giacometti. It was a sorry end to the wild venture that had started off with such colorful exuberance half a century before.

—LORD.

Jacob Epstein
(1880–1959)

Born American, he studied in Paris.

❏ October 5, 1902, the young American attended the funeral of Emile
Zola, whose championship of the wronged Dreyfus had kindled the
admiration of Jews in the New World as well as the Old. He joined in
the huge procession going to the Cimetière Montparnasse and "wit-
nessed the clashes between the gendarmes and anti-Semites"; but he
was not near enough in the crowd to hear Anatole France pronounce
over the grave his oration which ended with the famous tribute to Zola,
"Il fut un moment de la conscience humaine." Towards the end of his
life Epstein said that he would never have gone to Zola's funeral if he
had known how badly he behaved to Cézanne.
 —RICHARD BUCKLE, *Jacob Epstein, Sculptor.*

Later he settled in England, where, as an early modernist in a
Philistine country, he had much to put up with. When his first
big sculpture was unveiled in 1908—nude figures on the new
building of the British Medical Association—the *Evening Stan-
dard and St. James's Gazette* editorialized that the five "amazing
statuary figures" comprised "a form of statuary which no careful
father would wish his daughter, or no discriminating young man
his fiancée, to see." A little later, when he carved *Night and Day*
for the London subway system, he found more trouble.

❏ Angry letters from shareholders to the board of the Underground
company almost forced its removal, and Epstein was obliged to shorten
the penis of the boy in Day by an inch and a half.
 —ROGER BERTHOUD, *The Life of Henry Moore.*

In these early years Epstein and Augustus John were still friends.
Epstein made a habit of calling on John, at the Chelsea Art School
where he taught, and leaning against a wall without speaking.
Out of a long dense patch of silence, John says, Epstein would
suddenly speak: "At least you will admit that Wagner was a
heaven-storming genius."

There was considerable abuse. In 1929 the *Children's Newspaper* offered:

❑ It was Lord Darling when on the Bench who declared that he always confused Epstein and Einstein—"I know they both misuse figures," he said.

—The Sculptor Speaks, ed. L. Haskell.

Although he was a household name, he was without funds. People confuse notoriety with prosperity. He told an interviewer:

❑ Only to-day on the bus I heard an example of this. A little girl said to her father, "Daddy, that's Epstein sitting there opposite." The man stared at me hard for some time and then shook his head. "It certainly looks like him, but Epstein wouldn't travel on a bus."

—HASKELL.

He had the usual trouble doing portraits. Lady Augusta Gregory, playwright who was William Butler Yeats's great friend, sat for him.

❑ The Lady Gregory was a commission from Sir Hugh Lane, and he intended it for the Dublin Art Gallery. The bust progressed to my own satisfaction, and it was about completed, when one morning Lady Gregory turned up with the most astonishing head of curls: she had been to the hairdresser and wished me to alter the head. I was not inclined to do this, as the bust had up to then been planned to give Lady Gregory the air of the intellectual, somewhat "school-marmish," person that she was, and her usual appearance was all of a piece and quite dignified. Also she announced that if I came to the theater that evening I would see her in evening clothes and would then see how much finer she appeared with bare shoulders. It is amazing how English women of no uncertain age fancy themselves dressed as Venus. On both points I told Lady Gregory that I could not imagine the bust any better if I altered it as she wished and in my headstrong way kept to my guns: this practically terminated the sittings.

When Sir Hugh Lane saw my bust of Lady Gregory for the first time, he threw up his hands in horror and exclaimed, "Poor Aunt Augusta. She looks as if she could eat her own children." Later I was to get accustomed to this sort of reception of a work, but at the time it nonplussed me, for I had put many days of work with long sittings, and much labor into it. Nevertheless, Sir Hugh Lane hurried the bust over to Dublin in time for Horse Show week.

—JACOB EPSTEIN, *An Autobiography.*

The apostle, even the Messiah of direct carving, Epstein met young
Henri Gaudier-Brzeska with a question. Ezra Pound described
the older sculptor,

❏ . . .who said, mustering the thunders of god and the scowlings of
Assyrian sculpture into his tone and eyebrows, "UMMHH! Do . . . you
cut . . . direct . . . in the stone?" "Most certainly!" said Gaudier, who
had never yet done anything of the sort. "That's right," said Epstein;
"I will come around to your place on Sunday." So Gaudier at once went
out, got three small stone blocks, and by working more or less night
and day had something ready by Sunday.

—BUCKLE

In Paris he carved a monument for Oscar Wilde's grave at the
Père Lachaise cemetery. Authorities affixed bronze over an an-
gel's private parts; then a goon squad of artists removed it;
thereupon the statue was covered with a tarpaulin.

Epstein made a mask of the Marchesa Casati.

❏ Epstein had met her at the luncheon of Clare Sheridan's, and asked
her to sit. "The Marchesa arrived in a taxi-cab at two o'clock and left it
waiting for her. We began the sittings and her Medusa-like head kept
me busy until nightfall. It was snowing outside, and a report came in
that the taxi-man had at length made a declaration. He did not care if
it were Epstein and if it were a countess, he would not wait any longer.
On hearing this Casati shouted: 'He is a Bolshevik! Ask him to wait a
little longer.' He was given tea and a place by the fire and shown the
bookshelf. The winter light had failed, and I had many candles brought
in. They formed a circle round my weird sitter with the fire in the grate
piled high to give more light. The tireless Marchesa, with her over-
large blood-veined eyes, sat with a basilisk stare. . . . The Medusa-like
mask was finished the next day."

—BUCKLE.

Epstein was a generous mentor to the younger carver Henry
Moore, who remembered:

❏ He jumped into a taxi with a piece of sculpture of mine which he
had just bought from me, even though I did not regard it as completely
finished, because it was his and therefore he wanted it.

—BERTHOUD.

In 1957 when Epstein was ill with a bad heart he continued
working.

❏ On August 19th, after working all day on the almost completed Bowater House group, and giving instructions to Parrott, his bronze molder, for its elaborate casting, Epstein went with Kathleen and Beth to dine at Ciccio's Restaurant on Campden Hill. It was unusual for him to walk if he could get a taxi, but this evening he suggested walking home through Kensington Gardens. Kathleen, however, would not allow this. It was a warm night, so Epstein took a chair out on the porch, saying, "Let's watch the stars come out." He began to sing Schubert songs, then fell asleep. When he woke up he said, "I don't know when I've slept so deeply. I'm going into the studio to look at my group." Kathleen begged him to go to bed, but he was firm about covering up his clay. "You've done everything for me in life, Kitty, but that's one thing you can't do"; and he went into the studio.

Epstein was fearless, but he had once said he was afraid Kathleen might not be with him when he died. In this, as in many other ways, he was lucky.

When he came out of the studio he said, "All's well. The group is finished"; and he went up to his room. Kathleen felt something was wrong, and told Beth to telephone for the doctor. She followed her husband upstairs. Epstein's eyes were open, so that he saw Kathleen when she came in to find him lying on the floor by the bed. He died a few seconds later.

—BUCKLE.

Hans Hofmann
(1880–1966)

Lee Krasner was a student of Hans Hofmann's before she married Jackson Pollock. Trying one day to compliment her work, Hofmann did not please her when he said, as Degas said to Mary Cassatt, "This is so good you would not know it was done by a woman."

Lee invited Hofmann to see Jackson's work.

❏ He spent a few minutes studying the unstretched paintings tacked on the walls, then offered a compliment for which Pollock would never forgive him. "You are very talented," Hofmann told him. "You should join my class."

Hofmann went on to question Pollock's methods. The teacher was

surprised by the bareness of the room. There were no antique casts, no tabletops set with bowls of fruit, no still-life arrangements from which the artist could abstract. Hofmann, who believed that nature was the source of inspiration of all art, wondered whether Pollock felt the same. 'Do you work from nature?" he said.

Pollock, in his most famous display of bravado, blurted, "I *am* nature."

—DEBORAH SOLOMON, *Jackson Pollack: A Biography.*

Later the Pollocks visited Hofmann on Cape Cod.

❏ They traveled to Cape Cod by train. Hofmann met them at the station in Hyannis and insisted on giving them a tour of the area before heading for Provincetown. But it didn't turn out as planned. In his enthusiasm to show them some dunes, Hofmann drove directly onto sand, and his car got stuck. When he stepped on the gas the tires sank deeper and deeper. Hofmann started cursing in German, but Pollock, for once, was unagitated. He calmly got out of the car and lifted it out of the sand. For the rest of the summer, whenever Pollock's name came up in conversation Hofmann had only praise: "Pollock? He's strong. He lifts cars."

—SOLOMON.

Franz Marc
(1880–1916)

Twenty years afterward, Vassily Kandinsky remembered Franz Marc when he first met him.

❏ We soon became acquainted with him personally and found that his outward appearance corresponded perfectly with the inner man; he was a tall, broad-shouldered man with a powerful gait, a head that was full of character and an unusual face with features that revealed a rare combination of strength, acuity, and tenderness. In Munich he seemed too tall, his gait too long. He gave the impression that the city was too small for him, that it restricted him. The countryside matched his free nature and I always took a particular delight in seeing him stroll through meadows, fields and woods with a stick in his hand and a rucksack on his back. The naturalness of his manner corresponded marvelously to those natural surroundings, and nature herself seemed

to be pleased with him. This organic bond between him and nature was reflected too in his relationship with his dog Russi, a large white sheep dog which in manner, strength of character, and mildness of disposition constituted an exact four-legged copy of his master. The Marc-Russi relationship was just one example of Marc's profound organic relationship with the entire animal world. In his pictures, however, the animals are so closely merged with the landscape that in spite of their "expressiveness," their Marc-like characteristics, they nevertheless always remain simply an organic part of the whole.

—FREDRICK S. LEVINE, *The Apocalyptic Vision.*

Just before the war, Marc bought a house in Upper Bavaria with garden, meadow, and woods. Kandinsky visited him.

❏ There Marc showed me his deer, whom he loved as if they were his own children, his entire property, coming finally to his peaceful and pleasant house. Marc was a "royal artillery gunner" and I foolishly imagined that he would spend a few months in a Bavarian castle (at beautiful Augsburg, e.g.) and that our separation would not be for long. I told him this as he accompanied me to my omnibus. "No," he replied, "we will never see each other again."

—LEVINE.

He volunteered for service in the German army. Paul Klee saw him while he returned on leave.

❏ When he had to leave again, his wife accompanied him to Munich, and they came to eat with us. I cooked risotto and he brought some raw ham. We were gay, leave-taking did not seem unbearable to him. He promised to duck assiduously whenever something dangerous came flying through the air. The fellow ought to paint again, then his quiet smile would appear, the smile that is simply part of him, simple and stupefying.

—LEVINE.

He wrote his wife: "Today I understand for the first time why suicide would be proper in this wasteland." His commanding officer told what happened on March 4, 1916:

❏ It was a radiant early-spring afternoon, as we got ourselves ready. At the foot of a hill Marc mounted his horse, a tall chestnut bay, and as long-legged as he himself. We rode together for some length along a path that the day before had been subject to some very severe fire, but on this day the fire was relatively light. In Braquis (20 kilometers

east of Verdun) we separated. Marc was supposed to reconnoiter the
woods for a path for a munitions convoy. Barely twenty minutes later
his horse-attendant, H., returned, covered with blood and slightly
wounded. His eyes filled with tears, he pointed toward the woods where,
just a few minutes earlier, his superior had been struck by a grenade
fragment and had died in his arms. Whether it was an unfortunate
accident or whether it was the French . . . will forever remain a mys-
tery. Franz Marc was dead!

—LEVINE.

Fernand Léger
(1881–1955)

When he was young and struggling, Léger painted fake Corots
for a living. On occasion he and Alexander Archipenko begged
together, singing in the streets.

In 1909 he began his *Nudes in the Forest*. He worked at it over
two years, inventing what critics inevitably called Tubism. In 1910
Kahnweiler signed him to a contract.

❏ Many years later, Léger used to tell how he had shown this con-
tract to his mother, who was an old peasant from Normandy, to prove
to her that he was capable of doing something, of making money. His
mother had absolutely refused to believe that it was real and had sub-
mitted the document to an uncle who was a notary (for there was an
uncle who was a notary), who had confirmed that it was a bona fide
contract.

—DANIEL-HENRY KAHNWEILER, *My Galleries and Painters.*

Françoise Gilot describes a complex relationship among Kahn-
weiler, Picasso, and Léger. The story begins with gossip from
Kahnweiler.

❏ Léger came to the gallery one day and asked me where I'd been.
I told him Milan. He asked me why I'd gone there. I told him I'd gone
to see the Caravaggio exhibition. "Oh," said Léger, "and what about
it?" I told him I found it very good. Léger thought awhile and then he
said, "Tell me, Kahnweiler, did Caravaggio come before or after Veláz-
quez?"

Of course Pablo was delighted with that. It even made him feel very benevolent to see Léger in such a position. "Well," he said, "Léger always claimed, 'Painting is like a glass of red table wine,' and you know as well as I do that not all painters drink *le gros rouge*. And they paint their pictures with something other than that, too, fortunately. Leonardo came nearer the truth by saying that painting is something that takes place in your mind, but he was still only halfway there. Cézanne came closer than anybody else when he said, 'Painting is something you do with your balls.' I'm inclined to think it's a question of Leonardo *plus* Cézanne. In any case, *le gros rouge* just won't do."

Madame Léger, as Russian and as unsophisticated as could be, was very eager to have her "great man"—"Missié Léger," as she called him—get together with the other great man—Picasso. Since she knew Pablo often saw Matisse and Braque and from time to time Chagall, she saw no reason why he shouldn't see Léger too. And not at the gallery, but at home. She came to *La Galloise* to call on me. She explained her point of view in her picturesque French, winding up with "I hope you understand. Is absolutely necessary two great men get together." I said nothing of this to Pablo because I knew it would only annoy him. . . .

The Légers arrived toward the end of a May morning at Pablo's atelier in the Rue du Fournas. It was a very warm day with a clear blue sky untroubled by anything other than the smoke from the wood-burning potteries. Léger looked up at the sky and said, "I certainly miss my Normandy. It's so tiresome, this constant blue sky. There's not an honest-to-God cloud up there. When you need clouds you have to send up smoke. there aren't even any cows here."

"We're a Mediterranean country," Pablo said. "We don't have any cows; only bulls."

"I can't tell you how much I miss those Norman cows," Léger said. "They're so much better than bulls. Besides, they give milk."

"Ah, yes," Pablo said, "but a bull gives blood." I could see he wasn't in the mood to show his paintings that day but the Légers gave no sign of leaving. Finally we went inside, Pablo showed them his ateliers, and brought out a few pictures for them to look at. Nadia—Madame Léger—like all Soviet stalwarts, was interested in theorizing on "the new realism," abstract versus figurative, the problem of how much of the image to bring into the painting, and so on. "Painting must return to some kind of realism," she insisted. "Is absolutely necessary. The way of the future. I have the right to say that because I was pupil of Malevich," and she turned to me as though I were a Hottentot and said, "Malevich, little white square in big white square."

Pablo and I were trying our best to keep a straight face. Pablo couldn't resist the temptation to put in, "But it's unbelievable that you should have been a pupil of Malevich. How old were you at the time?"

Madame Léger thought over the implications carefully for a mo-

ment, then, realizing that from the point of view of age perhaps she had worked herself into a corner, replied, "I was child prodigy. Pupil of Malevich twelve years old."

　　　　　　　—FRANÇOISE GILOT AND CARLTON LAKE, *Life with Picasso.*

The painter Pavel Tchelitchew looked at Léger as his master, and in later life allowed himself irony. Léger,

❏ . . . receiving them at his studio, turns out to be a bluff but kindly *hommne-du-peuple* who proceeds to show them, with an air of paternal benevolence, his latest work. Comically, when they have left, Pavlik murmurs in his "interior" voice: "Merveilleux, merveilleux, n'est-ce pas, Allousha? Un peintre comme un epicier!"—"Marvelous, marvelous, isn't it, Allousha? A painter like a grocer!"

　　　　　　　—PARKER TYLER, *The Divine Comedy of Pavel Tchelitchew.*

Wilhelm Lehmbruck
(1881—1919)

Siegfried Salzmann put it: "As a result of World War I, not only Lehmbruck, but also his concept of Germany and Europe, of an artistic synthesis in an idealized and purified society, committed suicide."

His son Manfred, who was six years old when his father killed himself, wrote a reminiscence in 1932.

❏ He cared about his children. His paternal feelings were, however, not like the lasting love and sacrifices of our mother, but were, rather, spontaneous outbursts. Once he returned home from work at about midnight, and suddenly seemed to have a longing for us children. He was highly surprised to learn that we were already asleep, but nevertheless got us straight out of bed, and took us on his knee, whilst pouring out one glass of wine after the other. . . . But there were also times when he went from exuberant high-spirits to the other extreme, and was particularly irritable. This was the case whenever he was struggling with his art. We then had to disappear from his studio, as quickly as possible. This tense mood reached its climax when my father, who was never finished with his work, eventually had to call the caster. My father was not at all disturbed by this, but carried on working, until fi-

nally the caster, after futile reproaches, began in desperation to cast the mold from the base upwards, and my father was driven higher and higher. When, finally, the tension became unbearable, and a clash inevitable, my father would suddenly grab hat and coat, and run from the studio.

—MANFRED LEHMBRUCK, in *Wilhelm Lehmbruck 1881–1919.*

Pablo Picasso
(1881–1973)

❑ At school in his birthplace of Málaga, he usually brought with him a pigeon from his father's pigeon cote, which he put on his school desk and drew pictures of during class, as a continuing protest against authority and against being taught anything at all.

—JANET FLANNER, *Men and Monuments.*

When Pablo was eleven years old, he exhibited his paintings in the doorway of a store that sold umbrellas.

His art-teacher father, with small success in his own work, moved from teaching job to job, and sometimes he

❑ . . . sold a painting of pigeons or lilacs, his specialities for bourgeois Málaga dining rooms, but as a normal thing the household was pinched for money. When the boy was thirteen, his father, as a sign of artistic resignation, handed over his paints and brushes and never painted his flowers or fowl agian. . . . In 1895, Señor Ruiz was promoted to teach at the Provincial School of Fine Arts, in Barcelona, and Pablo, because of his father's position, was exceptionally permitted to take the School's competitive entry examinations when he was only fifteen years old. The elaborate examinations were ordinarily spread over a month (they included drawing a male nude from a life-class model), but he completed them in one day and, furthermore, won first place over all the adult competitors. In Barcelona, Pablo had one of his first poor, cold studios around the corner from the Calle del Aviñó, or Avignon Street, which contained a brazen night-life establishment of considerably more warmth and color. Eleven years later, in 1907, he painted the dynamic canvas that was finally known as *Les Demoiselles d'Avignon* and that marked an epoch in European art.

—FLANNER.

When he came to Paris he was poor for many years—and rich
for many more years. In her notebooks Gertrude Stein told a
story about Picasso's portrait of her.

❏ One day a rich collector came to my house and he looked at the
portrait and he wanted to know how much I had paid for it. Nothing
I said to him, nothing he cried out, nothing I answered, naturally he
gave it to me. Some days after I told this to Picasso, he smiled, he
doesn't understand, he said, that at that time the difference between a
sale and a gift was negligible.
 —*Gertrude Stein on Picasso*, ed. Edward Burns.

Cubism, and abstraction in general, gave rise to a thousand sto-
ries. The art dealer René Gimpel heard:

❏ . . . that Picasso replied to a lady who wanted her portrait done
and asked him for an appointment for a sitting: "You need only send
me a lock of hair and your necklace."
 —RENÉ GIMPEL, *Diary of an Art Dealer*.

He and Fernande Olivier lived in the Bateau Lavoir—nicknamed
for its resemblance to the floating sheds which laundresses used
on French rivers—with a kindly concierge.

❏ She must be remembered by everybody who ever lived there and
who, though never able to pay the rent, got not one word of complaint
out of her. She used to try so hard, and always in vain, to create a little
order out of the chaos, and she never made a fuss. It was she who used
to escort possible buyers up to Picasso's when they had come too early.
 Picasso would never open up in the morning. The concierge, who
knew this and many another thing too, like, for example, the constant
need for money, used to accompany anyone who'd come early and shout
as she knocked on the door:
 "M'sieu' Picasso, M'sieu' Picasso, you can open up, it's a serious visit."
 Picasso would jump out of bed, still sound asleep, and his companion
would rush to hide in the next room.
 He would open the door.
 It was often Olivier Saincère; and he would immediately beg Picasso,
who was never in the least embarrassed by his state of undress, to put
on some trousers.
 —FERNANDE OLIVIER, *Picasso and His Friends*.

❏ Picasso was beginning to be flattered and praised and surrounded
by admirers, some of them for ulterior motives, some sincere. He soon

grew tired of them. Although he liked flattery he was by nature averse to gushing. One evening at the Lapin à Gill he had been fêted, cheered and carried in triumph by a group of Germans. He was suddenly overcome by a desire to be alone. He was on the *Butte*, in the Place du Tertre when, without warning, he took out his revolver, which he always carried on him, and fired it into the air. Within seconds the square was deserted. The Germans, vanished and dissolved into thin air, did not return in a hurry.

—OLIVIER.

❑ Time passed, and life became easier financially. The Steins bought as much as they could. The dealers visited Picasso more and more often. Picasso had a wallet with notes inside it, which he still could not bring himself to leave at home.

He kept the wallet in an inside pocket of his coat; and to make it safer he fastened the top of the pocket firmly with a huge safety-pin. Every time he had to take out a note he would undo the pin as unobtrusively as he could; but it was no mean task, though it certainly made us all laugh. His suspiciousness was sometimes amusing and sometimes extremely irritating. I remember a day when he noticed that the pin wasn't fastened quite as usual. He looked searchingly at everybody and remained convinced that somebody had been tinkering with his "safe."

—OLIVIER.

In 1909 he left the Bateau Lavoir on the rue Ravignan to live on the Boulevard de Clichy near place Pigalle.

❑ At a time when we were eager to experience new and different sensations and were prepared to spend some strange evenings in the pursuit of them, we had gathered at Princet's on one particular evening, after taking hashish. Princet, Max, Apollinaire and Picasso expanded, one by one, in ways which revealed a great deal about them.

Princet simply wept about his wife, who had just left him, though he managed to find some kind of joy and consolation in the thought, and he asked nothing more. Apollinaire, more worldly by now, shouted with delight at being in a brothel . . . where he imagined he was. Max Jacob sat in a corner, blissfully happy; he was more accustomed than the others to sensations of this sort. As for Picasso: in a state of nervous hysteria he shouted that he had discovered photography, that he wanted to kill himself, he had nothing left to learn.

—OLIVIER.

Only a little later success overtook Picasso and his friends, and success brought paranoia with it. Jean Cocteau wrote later:

❏ The Montparnasse painters barricaded themselves in their studios, for fear that Picasso might carry away some seed and bring it to bloom in his own soil. In 1916 I was present at interminable confabulations outside half-open doors when he took me to see them. We used to have to wait until they locked up their latest pictures. They were just as mistrustful of each other. . . . I remember one week when everybody was whispering and wondering who had stolen Rivera's formula for painting trees by spotting green on black.
—FRANCIS STEEGMULLER, *Cocteau: A Biography.*

Sergei Diaghilev, impresario of the Ballets Russes, commissioned Picasso to design *Pulcinella*.

❏ While working on this project, he became very much interested in a young dancer who went by the picturesque name of Kokholova.
"Be careful," Diaghilev warned him. "A Russian always intends marriage."
"You're joking," replied Picasso.
"You watch out," Bakst told him.
Soon afterwards Picasso became engaged to her. The most paradoxical part about the affair was that the young lady's mother came to Diaghilev, very upset, and said:
"A painter . . . Is painting a respectable profession?"
"At least as respectable as dancing," answered the impresario.
"But can he earn a living?"
—MICHEL GEORGES-MICHEL, *From Renoir to Picasso: Artists I Have Known.*

Georges-Michel is an indefatigable raconteur.

❏ Paul Rosenberg followed Picasso's work with feverish interest. Each time he went up to the artist's apartment he would find a new masterpiece. One morning he was shown a large still-life of grapes, apricots and peaches.
"It's admirable," he said. "I'll take it, of course."
The next day Rosenberg went to look at the finished canvas. But Picasso had taken the fruit out of the dish and used their warm colors to paint the surrounding surface, leaving only one piece of fruit as a reminder. The day after that the canvas was once more entirely re-painted.
He exhibited forty of the series, almost all of which were snapped up during the first week.
"Those canvases will have a few more brothers and sisters, I hope," Rosenberg said, enthusiastically.
"Certainly not," declared Picasso. "You mustn't expect me to repeat

myself. My past doesn't interest me. I would rather copy others than copy myself. In that way I should at least be giving them something new. I love discovering things. . . ."

There is all of Picasso in that phrase.

<div align="right">—GEORGES-MICHEL.</div>

The innovator Picasso did not have room for technological innovation.

❏ One night when Paulo was a child, he suddenly fell gravely ill. There was no telephone in the house.

It is curious how sometimes the most advanced, the most "contemporary," artists have unexpected prejudices against modern inventions and the simplest practical conveniences. How many painters of his time, I wonder, were impressed by a remark made by crusty old Degas: "Haha! Forain has had a telephone installed in his house, and when it rings he actually goes and answers it."

But Picasso had no telephone. In desperation, his wife had to go to a neighbour's and telephone for an ambulance to take the child to hospital. The next morning Dr. Grosset, the well-known surgeon, operated on little Paulo, and saved his life. And when the doctor refused to charge any fee for his services, Picasso sent him one of his finest canvases: a portrait of a young boy dressed as Pierrot. Soon afterwards he had a telephone installed in his apartment. He does not like using it: but he looks on it, in its niche, as sort of idol, to which he can always appeal in an emergency.

<div align="right">—GEORGES-MICHEL.</div>

It is Georges-Michel who is responsible for the best Picasso anecdote.

❏ One day a certain painter in Montparnasse came to see me with one of Picasso's canvases. He wanted only a modest price for it, but he insisted on my getting Picasso to verify it. I took it to the latter, who gave one look at it, and said crossly,

"It's a fake."

"But I'm sure it's a genuine Picasso," my visitor protested to me the following day. "Here's another one. Doesn't that strike you as genuine too?"

"It certainly does."

But when I showed it to Picasso, he glanced at it even more cursorily and said,

"It's a fake."

By now I began to have some doubts myself. So I took one of my

own Picassos down from the wall, and carried it to the rue de la Boétie
for the artist to pass judgment. And again he stated flatly,
"It's a fake."
That was too much, and I exclaimed,
"But I saw you do this canvas myself!"
He gave a slight shrug.
"Oh, well," he said, with a smile, "I sometimes do fake Picassos my-
self."

—GEORGES-MICHEL.

He had a sharp tongue.

❏ His humor is sardonic, frequently cruel, always deft, never clumsy
or brutal; is usually composed of oversharpened truth, penetrating and
painful when it strikes. He rarely misses. The oldest, most quoted of
his sayings was a characterization of the late Cubist painter Marcoussis,
whom Picasso accused of copying his paintings as a way of picking his
brains. "The louse that lives on my head," he called him. He described
his friend Braque as "one of those incomprehensible men easy to un-
derstand." In reference to the *démodé* paintings of his friend Derain, he
said, "He is Corot's illegitimate son." To his art merchant Paul Rosen-
berg, he announced one morning, "I have just made a fortune—I sold
my rights to paint guitars," meaning that half the modern artists of
Paris at that time were freely imitating his guitar motif. Another morn-
ing, he said to the long-suffering Rosenberg, from whom he exacted
very high prices indeed for his pictures and whom he had kept waiting
a month for a new picture, "I am so rich that I just wiped out a hundred
thousand francs," and sure enough, the new picture, which Picasso did
not like, had disappeared from the canvas. Some of his humorous ex-
ploits have had unexpectedly factual results. Years ago, when Matisse
was at the height of his fame with his haremlike series of odalisques,
Picasso, as a joke, painted an odalisque at the telephone, and for this
incongruity perfectly imitated Matisse's brush strokes, style and colors,
and his background of Orientalism—everything, including an imitation
of Matisse's signature. The joke was so authentic that the *Cahiers d'Art*,
in all ways the most serious Paris art magazine, on getting hold of a
photograph of the telephoning odalisque, solemnly published it as a
real Matisse.

—FLANNER.

There are a thousand stories that recount, not verbal wit but
mimic behavior. After a performance of *The Three-Cornered Hat*—
Massine's choreography for Diaghilev—Misia gave a party:

❑ Arthur Rubinstein played Falla's music *con amore*. Picasso borrowed Misia's eyebrow pencil and drew a crown of laurel leaves on the composer's bald head. Everybody kissed everybody else, then kissed again. It was all gloriously Spanish. Under his black dinner jacket Picasso wore a café waiter's red sash, which—with his dark, burning eyes—made him look like a bullfighter at the moment of truth. According to Paul Morand, all the women there were a little in love with Picasso, and Picasso was more than a little in love with Misia. The relation between these two lawless creatures was complicated, but they had a kind of tacit understanding. Sert, whom Picasso ironically called Don José, stubbornly insisted that Picasso did not know how to draw.

—ARTHUR GOLD AND ROBERT FIZDALE, *Misia.*

He was perhaps in love with all women, even more than they were in love with him. His amative generality created unpleasantness.

❑ The story of his divorce from poor Olga is really marvelous. She had beautiful long hair that he loved more than anything. One fine day, Olga began to talk of cutting it. Then she never stopped boring him by asking what he thought of the idea. Very coldly he took a pair of scissors and cut her hair off.

That evening he took Olga and the boy to the Opéra-Comique to hear *Pagliacci*. When they got home, he undressed Olga very affectionately and made love to her. The next morning the servant announced, "There's a gentleman waiting in the salon who wishes to speak to Madame."

"You go," she says to Picasso, "I'm not dressed." He replies, "Certainly not; it's you he wants to see."

Ten minutes later she returns from the salon, quite pale, with a paper in her hand that the gentleman has given her: it's a summons announcing a suit for divorce instigated by Picasso. He's working at his easel and singing *Pagliacci* at the top of his lungs. She packs her bags and goes with their son to live at the Hôtel Californie!

—GOLD.

When friends visited him in the atelier where he made ceramics, while Claude was a baby, "Our conversation was constantly interrupted by the noise of breaking dishes. 'Don't be disturbed, it's only the baby,' Picasso said."

The same friends told him that they had seen

❑ . . . the Stravinskys in New York only a few weeks earlier. "How is he? Is he still composing?" asked the designer of *Pulcinella*. We as-

sured him that Stravinsky had never stopped, that his music was as beautiful as ever. "And Madame Stravinsky, who is she?" Picasso asked. We were taken aback. "Why, she's Madame Stravinsky," we said, "Madame Vera Stravinsky, the same Vera he's been with for years." Picasso seemed startled by such marital constancy. *"Toujours la même Vera!"* he exclaimed. *"Tiens!"*

—GOLD.

Henry Moore and his wife Irina visited Picasso while *Guernica* was still in process.

❏ There was a big lunch with Giacometti, Max Ernst, Paul Eluard, André Breton, and Irina and me, and it was all tremendously lively and I think that even Picasso was excited by the idea of our going to his studio. But when we got there he lightened the mood of the whole thing, as he loved to do. *Guernica* was still a long way from being finished. It was like a cartoon, just laid in black and grey, and he could have coloured it as he coloured the sketches. You know the woman who comes running out of the cabin on the right with one hand held in front of her? Well, Picasso told us there was something missing there, and he went and fetched a roll of paper and stuck it in the woman's hand, as much as to say that she had been caught in the bathroom when the bombs came. That was just like him—to be so tremendously moved about Spain and yet turn it aside as a joke.

—ROGER BERTHOUD, *The Life of Henry Moore.*

In patches of personal and political turmoil, he suffered turmoil as an artist also. In a letter in 1936 he made an announcement.

❏ I announce to you that as of this evening I am giving up painting, sculpture, and engraving to consecrate myself entirely to singing. A handshake from your entirely devoted friend and admirer, Picasso.

—FLANNER.

Just before the Germans occupied Paris, Peggy Guggenheim visited his studio wanting to buy a painting,

❏ . . . but the master, wanting to show his contempt for an "American heiress," insulted her by concentrating all of his attention on some other studio visitors, "some dreadful Italian aristocrats," and then, addressing her in the servile manner of a department-store floor walker, asked, "Now, what can I do for you madame? Are you sure that you are in the right department? Lingerie is on the next floor."

—JIMMY ERNST, *A Not-So-Still Life.*

During the German occupation of Paris, Picasso kept a large photograph of his *Guernica,* which memorialized the German bombing of a loyalist Spanish town during the Spanish Civil War, on the wall of his studio. Although Picasso's politics were well known, he was largely left alone during the war—except that artistically inclined German officers were apt to try their luck with him. One of them noticed the photograph.

❏ An especially cultivated Nazi—or one, at least, who had heard of the picture—said on looking at it, "Ah, so it was you, M. Picasso, who did that," at which Picasso flashed back, "No, you did it!" He had post-cards made of his *Guernica,* and when the occasional Germans continued to call, he would thrust one in their hands, saying maliciously, "Take it, take it! Souvenir!"

—FLANNER.

The dealer Daniel-Henry Kahnweiler spoke about Picasso during the Second War.

❏ One could feel the war in Picasso's work. Not that he made monsters, as people think. He has always painted the women he loved. At the beginning of the war, throughout the war, it was Dora Maar. All the women he painted at that time resembled her. He did not want to represent her as a monster. But there is something else. Picasso told me himself, "When the Germans arrived in France, I was in Royan, and one day I did a portrait of a woman"—it was Dora Maar—"and when the Germans arrived a few days later, I saw that the head resembled a German helmet."

—DANIEL-HENRY KAHNWEILER, *My Galleries and Painters.*

Françoise Gilot described techniques employed by the master during early stages of their acquaintance. She had called on him several times, and Picasso had shown her current works; one day she happened upon his sculpture studio.

❏ "These I use in finishing my sculpture," he said. He picked up a file. "This is something I use all the time." He tossed it back and picked up another. "This one is for finer surfaces." One after another he handled a plane, pincers, nails of all kinds ("for engraving on plaster"), a hammer, and with each one he came closer to me. When he dropped the last piece back onto the table he turned abruptly and kissed me, full on the mouth. I let him. He looked at me in surprise.

"You don't mind?" he asked. I said no—should I? He seemed shocked. "That's disgusting," he said. "At least you could have pushed me away.

Otherwise I might get the idea I could do anything I wanted to." I smiled and told him to go ahead. By now he was thrown completely off the track. I knew very well he didn't know what he wanted to do— or even whether—and I had an idea that by saying, placidly, yes, I would discourage him from doing anything at all. So I said, "I'm at your disposition." He looked at me cautiously, then asked, "Are you in love with me?" I said I couldn't guarantee that, but at least I liked him and I felt very much at ease with him and I saw no reason for setting up in advance any limits to our relationship. Again he said, "That's disgusting. How do you expect me to seduce anyone under conditions like that? If you're not going to resist—well, then it's out of the question. I'll have to think it over." And he walked back out into the sculpture studio to join the others.

—FRANÇOISE GILOT AND CARLTON LAKE, *Life with Picasso.*

Showing her etchings, he laughed uncovering portrait heads of the art dealer Ambroise Vollard. "The most beautiful woman who ever lived never had her portrait painted, drawn, or engraved any oftener than Vollard—by Cézanne, Renoir, Rouault, Bonnard, Forain, almost everybody, in fact. I think that all did him through a sense of competition."

Once when Gilot praised a painting, he told her: "When I was a child, my mother said to me, 'If you become a soldier you'll be a general. If you become a monk, you'll end up as the Pope.' Instead, I became a painter and wound up as Picasso."

After the liberation, Gilot says, people came to him as if they visited the Eiffel Tower. "From that moment on, Picasso stopped being a private citizen and became public property."

A dealer whom Gilot calls "Jacques" wanted to pick up a few canvases.

❏ I think he had a sincere affection and admiration for Pablo but he wanted paintings, too. He arrived almost breathless at the Rue des Grands-Augustins. He was a very thin man and must have weighed not much more than a hundred pounds. But that day he looked almost fat. He was literally stuffed with dollars. He said to Pablo, "At last I'm going to have some paintings again. And I've got money. Look." He pulled out rolls of bills and began to pile them up on the table. Every once in a while he would snap a sheaf of them under Pablo's nose. Pablo wasn't at all impressed, but looked at him sadly and said, "It's too bad, my poor friend. You're not really rich enough for me now. I don't think you can buy any more paintings from me."

"What are you talking about?" said Jacques. "You sell to Kahnweiler.

Even to Carré. Why not to me? Look here." He found another pocket that was untapped and brought out several more rolls of bills. Finally, he pulled out his checkbook and laid it on the table. Pablo shook his head. Then he noticed Jacques's hat. "That's a nice hat," he said. "I like it."

"You should," Jacques said. 'It's from Lock, in London." He took it off, showed Pablo the label and his initials in gold-leaf on the band. Pablo tried it on. It was so small it perched on the top of his head like a peanut on an elephant's back. He took it off and returned it. "But I'll get you one in your size," Jacques offered.

"Well, all right," Pablo said. "If you want to go to London and buy me a hat—just like that one—then *perhaps,* in spite of everything, I might sell you a painting, because I'm a nice guy and I like you." Jacques left immediately, hopped on the next plane for London and was back at the atelier the following day with a duplicate of his Lock hat, with Pablo's initials in gold on the hatband. "Fine," said Pablo. He tried it on, looked at himself in the mirror, then said, "You know, this doesn't look at all good on me, this hat. You keep it." He took it off and set it onto Jacques's head. It was much too large. He pulled it down over Jacques's ears and walked away. There were no paintings for Jacques that day.

—GILOT.

Some of his aphorisms are as solid as his sculpture: ". . . when I paint smoke, I want you to be able to drive a nail into it." "You can't escape your own period. Whether you take sides for or against, you're always inside it." "While I work I leave my body outside the door, the way Moslems take off their shoes before entering the mosque." "Down with style! Does God have a style?"

Sometimes he looked back forty years and reminisced to Gilot about the heroic period of Cubism. "Just imagine. Almost every evening, either I went to Braque's studio or Braque came to mine. Each of us *had* to see what the other had done during the day. We criticized each other's work. A canvas wasn't finished unless both of us felt it was." That friendship during those early years was all-important—and of course it could not last forever: Picasso took Braque (and another party) to the railroad station as the Great War began, and "I never saw them again."

One night he took Françoise for a walk.

❏ A little farther along we reached a sloping paved square, rather pretty and a little melancholy. Ahead of us was the Hôtel Paradis and beside it, a low, flat, one-story building with two entrance doors, which

I recognized, without his telling me, as the Bateau Lavoir. Pablo nod-
ded toward it. "That's where it all started," he said quietly. We walked
across the little square to the left-hand door. To the left of it the win-
dows were shuttered. "That was where Juan Gris worked," Pablo said,
pointing to the shutters. He opened the door and we went inside. There
was a stale, damp smell. The walls were dirty-white and brown. The
floorboards were wide and ill-fitting and wobbled under our steps. "It
hasn't changed much in forty years," Pablo said with an attempt at a
laugh.

—GILOT.

They quarreled.

❏ I told him I had often thought he was the devil and now I knew
it. His eyes narrowed.
 "And you—you're an angel," he said, scornfully, "but an angel from
the hot place. Since I'm the devil, that makes you one of my subjects. I
think I'll brand you."
 He took the cigarette he was smoking and touched it to my right
cheek and held it there. He must have expected me to pull away, but I
was determined not to give him the satisfaction. After what seemed a
long time, he took it away. "No," he said, "that's not a very good idea.
After all, I may still want to look at you."

—GILOT.

When Picasso suggested that they live together, Françoise had
reasons for caution besides his habit of extinguishing cigarettes
on her face.

❏ I had little desire to go there as long as there was any tie between
him and Dora Maar. He assured me, naturally, that he would have no
major interest in his life but me. In fact, he told me, he had already
given Dora to understand that there was no longer anything between
them. He insisted they understood each other perfectly on that point.
When I seemed reluctant to believe him, he urged me to go to her
apartment with him so I could see for myself. I was even more reluc-
tant to do that. But he kept on urging.
 A few weeks after his first meeting with my grandmother, Pablo drove
up to the house with Marcel one morning to take me to an exhibition
of French tapestries that included the famous series of the Lady of the
Unicorn. As we were leaving the exhibition, we stopped at a vitrine in
the center of the hall to look at a narwhal tusk they had on display as
the nearest thing available to the unicorn variety. The hall was nearly

empty but just ahead of us, studying one of the tapestries, I saw Dora Maar. I felt a little embarrassed but Pablo seemed delighted to meet her and began questioning her about the exhibition. After they had discussed the tapestries, he said, facing her directly, "What would you say about having lunch together?" It seemed to me, when she accepted, that she was thinking that "having lunch together" meant together with him. Then Pablo said, "That's very nice. I see you're broad-minded. In that case I'll take you both to Chez Francis." I thought Dora looked surprised and disappointed, but she said nothing. We all went outside, where Marcel was waiting with the car, and drove down to the Place de l'Alma, to Chez Francis. During the short ride, Dora, I felt, was sizing up the situation and deciding that in all likelihood things had reached a phase she didn't much care for. We went inside the restaurant, were seated, and began to study the menu.

"You don't mind if I order the most expensive thing on the card, do you?" Dora asked. "I suppose I still have the right to a little luxury, for the time being."

"By all means," Pablo said. "Whatever you like." Dora ordered caviar and the rest of the lunch in keeping with it. She kept up a steady stream of very witty conversation, but Pablo didn't laugh at all. On the other hand, whenever I tried to say something reasonably clever, in order not to be totally eclipsed, he laughed so heartily, it was embarrassing. Throughout the meal, he kept saying to Dora such things as, "Isn't she marvelous? What a mind! I've really discovered somebody, haven't I?" It looked to me as though none of this was making Dora any happier.

After lunch Pablo said to Dora, "Well, you don't need me to take you home, Dora. You're a big girl now."

Dora didn't smile. "Of course not. I'm perfectly capable of getting home by myself," she said. "I imagine you need to lean on youth, though. About fifteen minutes ought to do it, I should think."

—GILOT.

When she moved in, Gilot discovered a certain disorder.

❑ In the linen room Pablo opened one of the closets. Five or six suits of his hung there, like dead leaves that had become entirely transparent, with only the tracery of their fibres remaining. Moths had eaten away everything woolen. There remained only the buckram and the threads around the lapels and pockets, wherever the tailor's needle had passed. In the skeleton breast pocket of one was a crumpled, dusty, yellowed handkerchief. Some of the doors of the wardrobe were missing.

"I thought they'd be good to paint on so I had them removed and taken upstairs to the studio," Pablo said.

We went into the kitchen. The dishes and pots and pans were all in place. I looked in the pantry and saw jams and jellies all turned to sugar.

—GILOT.

Picasso stayed up late every night. Once he started work, he was a fountain of energy, but he found it difficult getting out of bed in the morning.

❏ Then he would groan and begin his lamentations. One day typical of many then went this way: "You have no idea how unhappy I am. Nobody could be more unhappy. In the first place I'm a sick man. My God, if you only knew what sicknesses I have." Of course, he had had trouble with an ulcer off and on since 1920, but when he started to list all the diseases he was suffering from, that was only a point of departure. "I've got stomach trouble. I suppose it's a cancer. And nobody cares. Least of all Doctor Gutmann, who's supposed to be looking after my stomach. If he cared at all about me he'd be here now. He'd find a way of coming every day. But no. When I go to see him he says, 'My friend, you're not so badly off as all that,' and then what does he do? He shows me some first editions. Do I need to see his first editions? What I need is a doctor who is interested in *me*. But he's only interested in my painting. How do you think I can be well under conditions like that? My soul itches. No wonder I'm unhappy. Nobody understand me. How can you expect them to? Most people are so stupid. Who is there to talk to? I can't talk with anybody. Under those conditions life is a terrible burden. Well, there's always painting, I suppose. But my painting! It's going very badly. Every day I work worse than the day before. Is it any wonder, with all the troubles I have with my family? Here's another letter from Olga. She doesn't miss a day. Paulo is in trouble again. And tomorrow it will be worse. Somebody else will show up to make life miserable for me. When I think that it's like that day after day, going from bad to worse, do you wonder I despair about going on? Well, I do despair. I'm pretty nearly desperate. I wonder, really, why I bother to get up. Well, I won't get up. Why should I paint? Why should I continue to exist like this? A life like mine is unbearable."

Then it was my turn. "But no," I said, "you're not so sick as all that. Of course, you've got a little stomach trouble but it isn't really very serious. Besides, your doctor is very fond of you."

"Yes," Pablo shouted, "and he says I can drink whiskey. That's how fond he is of me. He ought to be ashamed. He doesn't give a damn about me."

"Not at all," I explained. "He says that because he thinks perhaps that might make you happy."

"Oh, I see," Pablo said. "Well, I won't take it, anyway. It would probably make things worse." And so I had to go on reassuring him, telling him no, he didn't really have such terrible troubles. Given a little time, things would straighten themselves out. Life would become more agreeable. All his friends loved him dearly. His painting was something absolutely marvelous and everybody was completely in accord with that opinion.

—GILOT.

When Picasso spoke about women fighting over him, Françoise told him that she declined.

❏ "Maybe you should have," he said. "I generally find that amusing. I remember one day while I was painting *Guernica* in the big studio in the Rue des Grands-Augustins, Dora Maar was with me. Marie-Thérèse dropped in and when she found Dora there, she grew angry and said to her, 'I have a child by this man. It's my place to be here with him. You can leave right now.' Dora said, 'I have as much reason as you have to be here. I haven't borne him a child but I don't see what difference that makes.' I kept on painting and they kept on arguing. Finally Marie-Thérèse turned to me and said, 'Make up your mind. Which one of us goes?' It was a hard decision to make. I liked them both, for different reasons: Marie-Thérèse because she was sweet and gentle and did whatever I wanted her to, and Dora because she was intelligent. I decided I had no interest in making a decision. I was satisfied with things as they were. I told them they'd have to fight it out themselves. So they began to wrestle. It's one of my choicest memories."

After Claude was born, Pablo began to make a Freudian slip that was quite amusing: whenever he wanted to speak of the child, *l'enfant,* he would say *l'argent,* the money. At the Rue des Grands-Augustins Claude slept in the room next to ours. We went to bed about one or two in the morning, after Pablo had finished his work. One morning about three o'clock Pablo suddenly sat up in bed and said, "The money is dead. I don't hear him breathing any more." I had no idea what he was talking about. I saw he was awake, not dreaming, so I asked him what he meant.

"You know very well what I mean. I mean the child," he said. I told him that was the most peculiar mix-up I'd ever heard.

"You don't know what you're talking about," he said. "It's the most natural thing in the world. Freud even says so. After all, the child is his mother's riches. Money is another form of riches. You just don't understand those things." I told him I could hear breathing sounds very clearly from the next room.

"That's the wind," he said. "My money is dead. You go see." I went in to look at Claude. He was sleeping peacefully. I returned to our

bedroom and reported to Pablo that the child was not dead. That happened about twice a week.

. . . During the day his anxiety continued. Often when he got home he would say, "Where's the money?" Sometimes I would say, "In the trunk" because Pablo always carried around with him an old red-leather trunk from Hermès in which he kept five or six million francs so that he'd always "have the price of a package of cigarettes," as he put it. But if I assumed he was referring to one of the children and said, "In the garden," then he would often say, "No, I mean the money in the trunk. I want to count it." There was never any real point in counting it because the trunk was always locked, Pablo had the only key and he kept it with him at all times. "You're going to count it," he'd say, "and I'll help you." He'd pull out all the money, pinned together at the bank in small sheaves of ten bills, and make little piles of it. He'd count one sheaf and it might turn out to be eleven. He'd pass it over to me and I'd count ten. So he'd try it again and this time come up with nine. This made him very suspicious, so each of us had to check again all the sheaves. He had much admired the way Chaplin had counted money in *Monsieur Verdoux* and he tried to do it fast like that. As a result, he made more and more mistakes and there were more and more recounts. Sometimes we spent as much as an hour on this ritual. Finally, when Pablo was tired of playing with the bills, he would give up and say he was satisfied, whether the books balanced or not.

—GILOT.

She was also an ambitious painter.

❏ Once as I was working at a painting that had been giving me a great deal of trouble, I heard a small, timid knock at the door.

"Yes," I called out and kept on working. I heard Claude's voice, softly, from the other side of the door.

"Mama, I love you."

I wanted to go out, but I couldn't put down my brushes, not just then. "I love you too, my darling," I said, and kept at my work.

A few minutes passed. Then I heard him again, "Mama, I like your painting."

"Thank you, darling," I said. "You're an angel."

In another minute, he spoke out again. "Mama, what you do is very nice. It's got fantasy in it but it's not fantastic."

That stayed my hand, but I said nothing. He must have felt me hesitate. He spoke up, louder now. "It's better than Papa's," he said.

I went to the door and let him in.

—GILOT.

Picasso was known for being eclectic. Françoise noticed:

❏ Most of the painters and sculptors Pablo called on were a little uneasy when Pablo was in their ateliers, perhaps because Pablo often said, "When there's anything to steal, I steal." So they all felt, I think, that if they showed him work they were doing and something caught his eye, he would take it over but do it much better and then everyone else would think that *they* had copied it from *him*.

—GILOT.

She witnessed a meeting of the great.

❏ At the end of October 1952, Chaplin came from London to Paris for the French première of his film *Limelight*. Several days later, with Aragon and a few other friends, Pablo had dinner with him, and Chaplin visited his studios in the Rue des Grands-Augustins. Chaplin didn't speak French, nor Pablo English.

"The interpreters were doing their best but the thing was dragging badly," Pablo told me. "Then I had the idea of getting Chaplin alone and seeing if maybe all by ourselves we couldn't establish some kind of communication. I took him upstairs to my painting studio and showed him the pictures I had been working on recently. When I finished, I gave him a bow and a flourish to let him know it was his turn. He understood at once. He went into the bathroom and gave me the most wonderful pantomime of a man washing and shaving, with every one of those little involuntary reflexes like blowing the soapsuds out of his nose and digging them out of his ears. When he had finished that routine, he picked up two toothbrushes and performed that marvelous dance with the rolls, from the New Year's Eve dinner sequence in *The Gold Rush*. It was just like the old days."

—GILOT.

A story is told about Claude Picasso.

❏ When he was a small child, Claude was often taken to Matisse's house by his father and left there for the day. One day in the last years of Matisse's life, when he was making the *papiers découpages,* Claude was there, and as Matisse was working he gave Claude some colored paper and scissors and glue, and Claude made his own *papier découpage.* He brought it back at the end of the day and showed it to his father. He had signed it, "Matisse." Picasso said, "Why did you sign this 'Matisse'? You name is Picasso, and that's a perfectly good name for an artist," and Claude said, "Oh, Matisse is a *serious* artist." When I asked Claude what he meant by that, he said that when he was a boy his father was very much a child to him; he would play with him, and he would dress up in his mother's slip and make masks and wear them. Matisse never did anything like that; Matisse was much more sober an individual.

—LAURA DE COPPET AND ALAN JONES, *The Art Dealers.*

Of course Picasso made an anomalous Communist.

❏ It was the death of Stalin in 1953 that brought about Picasso's most embittering and humiliating Communist experience—an attack by the French Comrades themselves, especially the working-class members, on the portrait sketch he drew as his tribute to the defunct and at that moment the hysterically mass-mourned leader. It was a hasty crayon drawing of semi-classical realism—an amazing, if unhistorical, likeness imaginatively showing Stalin's face as very youthful and very Georgian, with a surprising, unfamiliar look on it of brooding innocence, coupled with an almost quizzical look of Slavic distress; supporting the head, with its large mustaches, was an overtall, thick neck, round as a funnel of steel. Artistically, it was a masterly, minor performance and anyone would have recognized it as a young Stalin he had never known. It was printed on the front page of the March 12th issue of the weekly *Lettres Françaises,* edited by Aragon, along with Aragon's own emotional *in memoriam,* which contained (among other devotional phrases since quoted with jeers by the democratic Paris press in the recent de-Stalinization operation) his sentiments of party gratitude: "Thanks be to Stalin for those men who modeled themselves on his example, on his thinking, on Stalinist theory and practices." Two weeks later, Aragon was forced to print a recantation of his admiration for the sketch and a selection from the flood of shocked, disapproving letters the magazine had received from Communists and sympathizers elegiacally protesting the Picasso portrait. One writer declared, in his disappointment and grief, "No, this is not Stalin's face, that face which was at once so kind and strong, so expressive, so inspiring of confidence in the honesty of our dear, great Stalin. My son, aged fourteen, shares my opinion."

Another letter writer inquired, more sharply, "What is the value of a drawing that is such an obvious betrayal of what it portrays? Where is the radiance, the smile, the intelligence—in a word the humanity—elsewhere always so visible in our dear Stalin's portraits?" Since the attacks on the Picasso portrait constituted news, as well as proof of a party quarrel and scandal, they were naturally featured by the non-Communist French press. One newspaper interviewer reported Picasso, then in the Midi, as saying tartly, "When you send a funeral wreath the family customarily doesn't criticize the flowers you choose." In the April 9th issue, Aragon, who was a member of the Central Committee of the party and in troubled waters because of the Picasso picture, was also forced by party opinion to give his explanation of why he chose to publish it—and perhaps was forced by the central Committee itself to print his accompanying *mea culpa.* In this signed editorial, which he courageously titled "À Haute Voix"—"At the Top of My Voice"—he explained that he would never have published the portrait if it had occurred to him that it might offend anyone's *"grande tristesse,"* which

he and Picasso had also shared; he pointed out that in the portrait were "none of those distortions that Picasso often uses in dealing with the human face . . . proof that Picasso had tried to put his technique and the validity of his intention at the service of a real image of Stalin." Then Aragon purged himself. His error, "common to people of culture, had been to judge art on its style, rather than on its subject matter," he boldly stated. "Strange that this should have happened to me," he interspersed bitterly—he who, he said, had struggled more than any other over the years against what party doctrine, in an astonishing definition of Soviet aesthetics, had called this "deviation of the critical spirit." Aragon made his confession double-edged by including this oblique reference to his superior, intellectual *anti ouvriérisme*—his conviction that workingmen's standards automatically carried a lowering of taste—which had already been thought heretical. With what may have been a Machiavellian stroke, he inserted in his editorial a letter of militant *pro ouvriérisme,* harsher and coarser than any so far printed, expressing the writer's "stupor and anger" against "this so-called portrait, published on Aragon's responsibility"—an enraging portrait because "it was not he, our friend," the great, good Stalin, whose prestigious renown Picasso "had made a mess of, insulting our purest sentiments." The letter went on to adjure, in part, "Come now, Picasso, this portrait isn't a question of Madame X!!! Be yourself, and don't try to make fun of those who look at your paintings and drawings. You still have something to learn, such as respect for your model, and also for anybody who tries to find the interpretative meaning of your work. Don't let your pretentiousness run away with you. Your talent is not lofty enough to deal with Stalin."

—FLANNER.

André Malraux, in *Picasso's Mask,* reported on the painter's old age. His last wife Jacqueline Rocque described his fondness for an old painting, from the time of African masks before Cubism.

❏ He liked that one. It brought back more memories than the others. One day we were returning from a bullfight, where we had been given presents; he picked it up with both hands and said to me: "Famous, of course, I'm famous! Lollobrigida! what does it all mean? It was at the Bateau Lavoir that I was famous! When Uhde came from the heart of Germany to see my paintings, when young painters from every country brought me what they were doing and asked for my advice, when I never had a sou—there I was famous, I was a painter! Not a freak . . ."

—ANDRÉ MALRAUX, *Picasso's Mask.*

André Malraux remembered him saying:

❑ When we were twenty we were sure that painting meant us—sooner or later—but that we wouldn't be acknowledged until we were dead. Like Cézanne. Like Van Gogh, who had sold one canvas—only one!— for a louis d'or. Then he committed suicide. At the Bateau Lavoir, Fernande's girl friends used to tell all the very ugly models: "Why don't you go and pose for Picasso!" We thought that if we lived to be very, very old, maybe it would turn out all right. . . . But you see, we didn't have to live to be that old! When Braque said to me: "Do you realize? We each have a car, and a chauffeur!" he was as surprised as I was. . . .

 —MALRAUX.

Like everybody he thought of what his reputation would be, after his death. "What will painting do once I'm gone? Surely it will have to go over my dead body?"

 After his death, Malraux asked Jacqueline, "He had worked into the night, hadn't he?"

❑ Yes. When the doctor came in the morning, I wanted to get up. Pablo held my hand and said, "Doctor, are you a bachelor?" The doctor replied that he was. Pablito said, "You're wrong. It's good to have a wife." I threw on a dressing gown and left the room. Five minutes later I sensed that someone was behind me in the hall. I turned around, and I understood. I never even heard the doctor say, "He's dead."

 —MALRAUX.

On the morning of Picasso's funeral, his grandson Pablito, excluded from attendance, drank poison from which he later died. Picasso's former mistress and model Marie-Thérèse Walter hanged herself four years afterwards. His widow Jacqueline shot herself to death in 1986.

George Bellows
(1882–1925)

When somebody pointed out that one of George Bellows's prize-fighters could not fight if his hands and his feet were in the position Bellows gave them, he answered: "I don't know anything

about boxing"; on another occasion, "Who cares what a prize-fighter looks like? I'm just painting two men trying to kill each other."

It was the era of Isadora Duncan.

❏ Her studio was not far from East Nineteenth Street, and without any urging from Henri, a long-time devotee of Isadora's, George and Emma spent an evening there. Isadora received her guests in a recumbent position, gracefully offering her hand with a gesture that confused some of the newcomers. When Ben Ali Haggin's mother said graciously: "Please don't get up," Isadora retorted sweetly, "I have no intention of doing so." The dancer's personal beauty and charm, the loveliness of her every movement, the drama of the setting, and the compatibility of the gathering caught George up in a warm embrace. Artists, authors, all kinds of interesting people made it the kind of environment he loved best. Emma was not impressed and rarely came again, preferring to keep a relaxed sentry duty over her marital battlements, while George returned night after night to Isadora's place of enchantment.

Emma's confidence was not misplaced. One evening, when Ethel Clarke came to supper, George announced that he was going to look in on Isadora. Would the ladies come? They declined, and when he had gone Emma chuckled and said: "Do you suppose this will be the night she asks him to father her next child? She does, you know."

Isadora firmly believed in eugenic parenthood. With an unshakable self-confidence she considered her own perfection of mind, body, and spirit something that should be shared only with the most suitable of the other sex. Her three children had all had different fathers without benefit of clergy or a justice of the peace. How often her invitations were rebuffed is not known. The gruff, sensitive sculptor George Gray Barnard is said to have refused her. George Bernard Shaw used to relate that when she suggested to him that her body and his brains should combine in a perfect child he replied: "But what if it had my body and your brains?" In Europe tales of this kind were not news. In America they were salacious tidbits. The press censured her conduct, and thundering denunciations were poured on her head from dozens of pulpits. She had no objection to the publicity.

Ethel Clarke was still chatting with Emma when the front door opened and closed with a bang. George, swearing lustily, tramped heavily up the stairs past the room where they were sitting and headed for his studio and his rocking chair. As he passed, Emma called out cheerily: "Did she ask you?" It was a long time before he admitted that she had.

—CHARLES H. MORGAN, *George Bellows: Painter of America.*

Bellows's small daughter Anne made tea for herself every afternoon, setting places for three absent guests. When a visitor asked her whom she expected, she replied, "God and Rembrandt and Emma Goldman."

Georges Braque
(1882–1963)

Braque and Picasso, for one period the closest of friends, could not have been more different. Alfred Barr and his wife visited Braque in the 1930s, and Mrs. Barr noted that he "answers A.'s questions politely, but lets his technically impeccable work speak for itself. How can he have been so compatible for so many years with the dynamic Picasso . . . ?" Marie Laurencin like many found Braque the greater painter, yet when Braque is mentioned he is usually coupled with Picasso; they are opposites inextricably intertwined, in what André Malraux calls "Braque's dialogue with Picasso." Braque himself used another metaphor: ". . . it was a little like rope-work in mountain-climbing," he said later.

His earliest reputation stepped outside the borders of painting.

❑ He often sparred with an English professional whom he admired. There has long been a legend in Paris about a boxing match among the three giants of the group: the heavyweight Vlaminck; Derain, who was the tallest; and bull-necked Braque, who was the best. According to the legend, Braque successfully took both of them on, one after the other. The straight of it seems to be that it was not Vlaminck but Roché, six feet tall, who was one of the outsize fighters; he had been coached by Alfred Frueh, who was then studying art in Paris and later became a caricaturist in America. The match was fought in somebody's Montmartre studio, and neither Roché, who fought first, nor Derain, who was taller and heavier than Braque and a pretty good man with the gloves, ever got inside Braque's defense. In art circles, Braque had a big reputation as a boxer. One night, the rumor spread around the Café du Dôme, in Montparnasse, that he was fighting that evening, under another name, in one of the preliminaries at the Cirque d'Hiver;

half the artists on the café terrace hurried over to see, but it was a false
alarm. . . .

—JANET FLANNER, *Men and Monuments.*

❑ Tales about Braque's strength and prowess circulated like myths.
Roché says that the first time he ever saw him was at the 1907 Bal des
Quat'z Arts, which Braque was attending as an ex-Beaux-Arts man. He
was attired as an almost naked roman warrior, and was sitting near the
bottom of a staircase with a beautiful girl dressed rather like a statue
of Venus. At their feet was a huge decorated float that was being given
its finishing touches for the *grande entrée* by some atelier students, who
were being very discommoding to Braque and his companion. "If you
don't stop bothering us, I'll tip that idiotic chariot of yours over," Bra-
que said tranquilly.

"Just try it," one of the students jeered. "The thing weighs a ton."

Braque crawled under the middle of it, got down on all fours and
unsuccessfully tried to raise it with his back. He hurried out from un-
derneath, studied the situation a moment, then disappeared beneath
the float again and succeeded in hoisting it a fraction. A crowd had
formed, and there were shouts of "Yes, he can!" "No, he can't!" The
harder Braque worked, the more interested he became, trying modifi-
cations of his attack. Moving under one side of the float and squatting
on his hands and knees, he suddenly arched his back. The float began
to tilt dangerously on two wheels, scattering the crowd to a safe dis-
tance, and the students began yelling "You win!" "Don't tip it over,
you'll ruin it for the *grande entrée!*" "Let her down softly, softly!" This
Braque did, with such controlled strength that the float settled back
onto the dance floor without a shudder. It was a small herculean triumph,
and it became the *clou* of the ball.

—FLANNER.

With Cubism began the collaboration and competition with
Picasso, who referred to Braque as his "wife," and later as his
"ex-wife." There are many stories about their own confusion over
the provenance of certain paintings.

❑ One day after the First World War, in the Paris mansion of the
couturier Jacques Doucet, who had a fine collection of contemporary
art, somebody saw Picasso staring in puzzlement at a picture; he was
sure it was one of his own, he said, yet he could not identify it. Sud-
denly he turned it over and looked at the back; it was signed by
Braque.

—FLANNER.

Although Braque was not flamboyant, he had his quiet elegance.

❏ For years he wore the typical Frenech laborer's square-toed shoes—but made to order of beautiful leather and kept polished to a high shine. He also sported the workingman's blue cotton shirt, but it was always freshly ironed and modishly accented with a colorful scarf.
 —LAEL WERTENBAKER, *The World of Picasso.*

He was tall and stood straight and to Alice Toklas, he looked like a cowboy; following her, both Picasso and Apollinaire called him *"notre pard."* Although he was handsome, as a young man he seemed shy with women.

❏ Picasso decided that his friend needed a wife and turned match-maker. The girl in question was a cousin of Max Jacob, daughter of a cabaret owner in Montmartre. Picasso took Braque and Jacob to rent dress suits, top hats and capes, then led them in making a formal call. The evening got off to a good start, but before it was over suitor, matchmaker and assistant were roaring drunk, and the girl's father threw them out. Undaunted, Picasso introduced Braque to another girl, Marcelle Lapré, who promptly became Braque's model. After a few years—in 1912—Braque and Marcelle were married, and lived happily together until his death in 1963.

 —WERTENBAKER.

His wife was useful to him.

❏ There's an old story about Braque driving through Italy with his wife. In every town they came to, Braque would drive up in front of the museum, stop the car and say to his wife, "Marcelle, you go in and look around and then tell me what's good in there." He wouldn't go in himself for fear of spoiling his eye with "old" painting.
 —FRANÇOISE GILOT AND CARLTON LAKE, *Life with Picasso.*

Picasso was the most rivalrous human in history. Françoise Gilot tells the best Braque/Picasso story, perhaps more about Picasso than Braque—but Braque *won*.

❏ One of Pablo's oldest friends was the painter Georges Braque. A few weeks after I went to live with Pablo, he had decided it would be pleasant for me to meet Braque and see his atelier. Also, he had let me understand that he wanted to see Braque's reaction to me. When we arrived one morning at Braque's house in the Rue du Douanier, across from the Parc Montsouris, Braque was very courteous. He showed us

the paintings he had been doing recently, and after a brief visit we left. When we got outside I could see that Pablo was upset.

"Now you see the difference between Braque and Matisse," he said. "When we went to call on Matisse he was very warm-hearted and kind and called you Françoise right from the start. He even wanted to paint your portrait. I introduced you to Braque in such a way as to make him understand you weren't somebody I just happened to bring by chance, but he called you *Mademoiselle* all along. I don't know whether that was directed against you or against me but he acted as though he didn't get the point at all." Pablo began to sulk, then burst out with, "Besides, he didn't even invite us to stay for lunch."

At that period Pablo and Braque exchanged pictures from time to time. One of the fruits of those exchanges was a still life of Braque's, with a teapot, lemons, and apples, a handsome wide picture that Pablo was very fond of and used to keep prominently displayed in the atelier among the canvases of Matisse and others whose work he particularly liked. I noticed that the day we returned from our first visit to Braque, the still life disappeared.

The relationship between Pablo and Braque had been exceedingly intimate when they were young painters. The fact that their intimacy was no longer as close troubled Pablo from time to time. He felt that this situation was partly attributable to Braque's reserve but not wholly. He would try to rationalize it, get nowhere, and often wind up with the announcement, "I don't like my old friends." Once when I pressed him for an explanation he told me, "All they do is reproach you for things they don't approve of. They have no indulgence." He didn't make it any clearer than that, but it was evident that for Pablo friendship had no value unless it was being actively demonstrated.

Soon after that first visit we left for Ménerbes and the Midi but when we got back to Paris late in the fall, Pablo suddenly thought one day of that meeting with Braque.

"I'm going to give Braque one more chance," he said. "I'm going to take you back there and we're going to arrive a little before noon. If this time he doesn't invite us to stay for lunch I'll understand that he doesn't like me any more and I'll have nothing further to do with him."

So one morning that fall, just before noon, we went to Braque's house—without any advance warning, of course. One of Braque's nephews was there, a tall man of about forty who was even more re- served than Braque. The house was filled with the aromatic bouquet of roasting lamb. I could see Pablo mentally adding up the presence of the nephew plus the very appetizing kitchen odors plus his lifelong friendship with Braque to get the desired result: an invitation to lunch. But if Pablo knew his Braque by heart, Braque knew his Picasso just as well. And I am sure—since I came to know Braque much better after that—that for Braque, Pablo's black plot was sewn with white thread.

Had he made the gesture and invited us for lunch, he could well imagine Pablo having a good laugh about it later, telling everyone, "Oh, you know Braque has no mind of his own. I get there at noon, he knows I want lunch so he sits me down and serves me. I push him around and he only smiles." The only course open to a man like Braque, who had a mind of his own, was to demonstrate the fact. Especially inasmuch as Pablo was very fond of saying, when Braque's name came up, "Oh, Braque is only Madame Picasso." Somewhere along the line someone must have reported that *mot* of Pablo's to Braque.

We went up to the atelier, and Mariette, Braque's secretary, pulled out his latest things and showed them to us. There were some large sunflowers, beach scenes at Varengeville, wheatfields, and one canvas that showed a bench with just a spot of sun over it. In all these paintings, form seemed to count a good deal less for Braque than it had in his earlier work and it was clear that his main interest now was in the study of the effects of light. There was no deformation or transposition of form; the essential feeling was of a desire to find an atmosphere that could express his thought. The paintings were very handsome.

"Well," Pablo said, "I see you're returning to French painting. But you know, I never would have thought you would turn out to be the Vuillard of Cubism." Braque looked as thought he thought Pablo might have been more flattering but he continued to show us his work good-naturedly.

Near one o'clock, Pablo started to sniff very loud and said, "Oh, that smells good, that roast lamb."

Braque paid no attention. "I'd like to show you my sculpture, too," he said.

"Please do," Pablo said. "Françoise will enjoy that." Braque showed us some bas-reliefs he had done of horses' heads, one of them very large, and some small reliefs of a woman driving a chariot. I found them all very interesting, but finally we came to the end of the sculpture.

"That lamb smells to me as though it were done," Pablo said. "Overdone, in fact."

Braque said, "I think François might like to see my new lithographs." He began to show me his lithographs and a number of drawings. From time to time, Marcelle, Braque's wife, came into the atelier, smiled, then went downstairs again without having said a word. After her third trip, Pablo said, "You know, you've never shown your paintings of the Fauve period to Françoise." The Fauve paintings, as he knew, were hung in the dining room. We went downstairs, first into the large room before the dining room, where Braque showed us a few paintings, and then into the dining room. The table was laid for three: Braque, Madame Braque, and Braque's nephew, obviously. I began to admire Braque's Fauve paintings.

"That lamb smells burnt to me now," Pablo said. "It's a shame." Braque said nothing. I continued to admire the Fauve paintings, but there were only six of them and that couldn't go on forever, so at the end of a half hour Pablo said, "There's one of your recent paintings up in the atelier that I didn't really get a good look at. I'd like to go upstairs and see it again." At this point Braque's nephew said good-bye. He had to get back to work. We went upstairs and spent the next hour reviewing the new paintings we had already seen. Pablo discovered one we hadn't seen and Braque brought out several others he hadn't shown us earlier. Finally we left. It was 4:30. Pablo was bristling. But after he cooled off, it became very clear that Braque had risen considerably in his esteem. And it was only a day or two later that I noticed that the Braque still life with teapot, lemons, and apples had mysteriously reappeared and was once more in its usual place in Pablo's atelier. I was amazed at the number of times, from then on, that I heard Pablo say, "You know, I like Braque."

—GILOT.

Late in life he could no longer paint all day, but he continued his habit "of working on perhaps twenty pictures at a time, sometimes devoting the whole morning to one, and sometimes an hour each to two or three of them and perhaps five minutes to a fourth."

André Malraux saw him shortly before his death.

❏ The last time I happened to be there I had quoted to him Cézanne's remark, "If I were absolutely sure that my canvases would be destroyed, and that none of them would ever be hung in the Louvre, I would stop painting." Braque, already bowed with age, patiently considered those words, and then said in an undertone, as if he were fearful, "If *I* were certain that all my paintings would be burned, I think I'd go right on painting—yes, I'd go right on painting . . ."

—ANDRÉ MALRAUX, *Picasso's Mask.*

Eric Gill
(1882—1940)

Gill's conversion to Roman Catholicism was the great event of his life. He carved the Stations of the Cross for the cathedral at Westminster.

❏ He was working in the cathedral on one of the panels when a lady
came up, watched him intently for a few moments, and then said:
 "Young man!"
 "Yes, madam?"
 "Are these the stations of the cross?"
 "Yes, madam."
 "Are they all going to be like this one?"
 "As near as I can make them, madam."
 "Well, I don't like them."
 "I'm sorry, madam."
 "I don't think they're nice."
 "Madam, I don't think the subject is *nice*."
 —DONALD ATTWATER, *A Cell of Good Living.*

After the Great War, Gill was much in demand for war memo-
rial work. He met people he would not normally have met.

❏ At one mansion in which he was staying for the night he found
that the man-servant had carefully unpacked his bag of tools, ham-
mers, chisels, and so on, and laid them out neatly on the dressing-table
in his bedroom. I believe it was in the same house that he found him-
self at dinner with a number of other guests and was feeling very much
out of his element and rather miserable. But looking around he hap-
pened to meet the eye of an attractive and friendly-looking young par-
lormaid who was waiting at table, and he at once cheered up, contrast-
ing her favorably with his fellow-guests. When the girl came round to
proffer vegetables, he put up his hand to steady the dish, his fingers
met hers, and he could not resist giving them a squeeze. The pressure
was returned by the parlormaid.
 —ATTWATER.

Gill was a fierce critic of modern society, heir of Ruskin and
Morris, but even a Luddite finds certain technologies attractive.

❏ He never lost his boyhood enthusiasm for steam locomotives, but
that did not make him decry air travel, when during his lifetime it was
invented and developed into a normal alternative. Indeed, it was for
him a form of transport in both possible senses; I met him soon after
his first flight, and asked him how he liked it. "I can't tell you how nice
it is—it is nice enough to be a temptation."
 —ATTWATER.

His simple piety was genuine. The poet David Jones once ob-
served him when the two men were in Jerusalem.

❑ It occurred near St. Stephen's Gate which leads out from Jerusalem towards the Mount of Olives—I think it is part of the Via Dolorosa. As far as I can now recall we arranged to meet somewhere in that part of the Old City. As I went to my appointment with him I chanced to see him at the turn of a winding street where a beggar-woman sat, hoping for alms. She appeared to have either no hand or some affliction whereby her wrist looked to be no more than a swollen and livid stump. As I caught sight of him, Eric Gill was giving this woman the accustomed coin. He then leaned down and kissed the repellent and distended part, and, unconscious of my approach, moved away. He was wearing Arab dress, as was his custom during his stay in Palestine, so that he was a quite inconspicuous figure in the lanes of the Old City.

—ROBERT SPEAIGHT, *The Life of Eric Gill.*

Edward Hopper
(1882–1967)

When Edward Hopper visited New Mexico he was dazzled by the extraordinary beauty of the countryside, the likes of which he had never seen. He was also bewildered, disoriented, and unable to paint. He wandered for days looking for something; then he found an abandoned locomotive.

He lived in rudimentary comfort, and his wife

❑ . . . encouraged his thrift, shopping for most of their clothes at Woolworth's and at Sears, hooking rugs from rags she collected, cooking dinner out of cans. She too had known years of financial struggle as both an actress and a painter. Never yielding to the whims of fashion, the Hoppers always bought used cars and drove each until it would run no more. They also wore their clothes down to the threads.

—GAIL LEVIN, *Edward Hopper: The Art and the Artist.*

Andrew Wyeth

❑ . . . remembered an evening, one of the rare ones he had spent in New York, with a group of painters at Robert Beverley Hale's. Pollock and Stuart Davis had been arguing about techniques. Finally Hop-

per had tapped Davis on the shoulder and pointed from the penthouse
window to the incredible light of the setting sun on the buildings. "Can
you ignore that?"

—SELDEN RODMAN, *Conversations with Artists.*

Charles Demuth
(1883–1935)

A sickly child, Demuth became an American decadent or dandy.
Marsden Hartley remembered him from 1912, Paris and *le Res-
taurant Thomas.*

❏ I shall recall to Charles, perhaps more to give a setting for his own
entrance, several other figures later, I shall recall to him the day he
ambled up to our table, and because of a hip infirmity he had invented
a special sort of ambling walk which was so expressive of him, there
being one place left at the table at which we all sat, asking if he might
sit with us, the request being granted without further thought.

It wasn't long before Charles made us particularly aware of him by a
quaint, incisive sort of wit with an ultra sophisticated, post-eighteen-
ninety touch to it, for I always felt that Charles's special personal tone
had been formed with this period, the murmur of imagined deaths of
superior trifles clinging to his very sensitive hands, and a wistful com-
prehension of what many a too tender soul has called infectious sin,
alas how harmless and sentimental it all was.

Charles will recall as I proceed, for he always got a kick out of them,
two figures that came to life with a sort of Beardsleyesque persistence,
two figures out of Edinborough appearing up over the edge of the
curb at odd intervals, one of them ostensibly a man, disturbingly styl-
ized if you cared that way, a kind of Fleurs du Mal silhouette, with his
velvet jacket, black of course, and his white lace cuffs falling over long
white hands to which many untouchable thoughts of night seemed to
be clinging, and a cascade of immaculate silk edged with lace down the
front of the shirt, velvet coat flaring at the waist, large dark ring on
forefinger with a black cane of Empire style to complete the drawing—
evidences of much powder about the face, hours spent doubtless at
manicure, and was there not even a light touch of rouge upon the lips,
the eyes large, hollow, searching after nothing, which gives eyes the
saddest of all looks, and indeed he might have invoked another story

from that other singular being of an earlier period, Jean Lorrain to add more lustre to his Monsieur de Phocas notions.

All this *tres exagéré* of course, but life was like that then, and it all seemed to be a part of the day's run, and brings up an amusing and funny Paris, accentuated all the more acutely by the manner of the young cubists who were over-dressing in the other extreme à la Londres, with white spats on all occasions and an air of great importance whisking about them, their style of dress quite all wrong of course for no Frenchman can wear English clothes for he can never walk like an Englishman.

—*The New Caravan,* ed. Louis Kreymborg and Lewis Mumford.

Eugene O'Neill made Charles Marsden (from *Strange Interlude*) out of Marsden Hartley and Charles Demuth.

He was close friend to the poet William Carlos Williams.

❑ I met Charles Demuth over a dish of prunes at Mrs. Chain's boarding house on Locust Street and formed a lifelong friendship on the spot with dear Charles, now long since dead. . . .

Poor old Charley Demuth, this was before the days of insulin, and he was dying of diabetes. His studio then was the third floor front in one of the buildings of Washington Square South. He called me there one day to see him. He wanted me to inspect his back, which looked as though a young tiger had clawed it from top to bottom. They were deep, long digs, recently scabbed over. Charley was worried about infection.

"What in God's name happened to you?" I asked him.

"Do you think it is dangerous?" said he.

"No. But how did you get such digs?"

"A friend."

"Charming gal," said I thoughtlessly.

Demuth also was interested in writing. He had a style reminiscent of Whistler's, whom I have reason to believe he sedulously copied, and did some creditable work in it. I wonder what has become of his play.

Upon his return to this country Demuth was in bad shape. That, I think, was when I first saw his mother. She was a horse of a woman, a strange mother for such a wisp of a man: he was lame, tuberculous, with the same sort of chin as Robert Louis Stevenson and long, slender fingers. He had an evasive way of looking aslant at the ground or up at the ceiling when addressing you, followed by short, intense looks of inquiry.

His mother had taken him home to Lancaster, Pennsylvania, to care for him. Her small city backyard, not more than twenty-five by thirty feet, surrounded by a high board fence with a rectangular path around

it bordering the narrow beds, was where he did most of his flower paintings.

Dr. Allen opened a sanatorium for the dietary treatment of diabetes at Morristown that year. Demuth was one of his first patients. His intake was reduced to the caloric minimum. The result was frightening. Charley faded to mere bones, but he was able to live. They occasionally permitted him to be taken home to us for a short visit but I had to return him the same evening. He brought with him a pair of scales and weighed his food carefully. I never saw a thinner active person (this, as I say, was before the discovery of insulin), who could stand on his feet and move about.

I visited Demuth several times while he was at Dr. Allen's sanatorium and once, I think, I took Marianne Moore with me. At least she went to see him there and he was grateful to her for it. We had great talks. He always called me Carlos and once painted a "literary" picture around my name and a poem I had written to "The Great Figure" (the figure 5 on the side of a fire truck in wild transit through the New York streets). Insulin came in just in the nick of time to save Charley from dissolution, but he was careless and died later anyway while on his way home to Lancaster, either from lack of insulin or an overdose; I was never able to get the answer. During those days he once decorated the side of a barn near his home with original designs on the theme of the hex insignia common in that country. I don't know which barn it was, but the innovation was successful with the local people.

—WILLIAM CARLOS WILLIAMS, *Autobiography.*

His modesty, or his acknowledgement of limitations, was genuine. Once he said:

❏ "All of us drew our inspiration from the spring of French modernism. John Marin pulled his up in bucketfuls but he spilled much along the way. I had only a teaspoon in which to carry mine; but I never spilled a drop."

—GEORGE BIDDLE, *An American Artist's Story.*

José Orozco
(1883—1949)

❏ Orozco would frequently take a violent dislike to completed work. When a picture no longer served his development, he wanted to de-

stroy it. In Mexico, to the dismay of fellow artists and officials—including Vasconcelos—he chopped down several fresco panels, a few of which were photographed, fortunately, before they were destroyed. During the years he remained in New York, Orozco would occasionally cut to pieces or rip from its stretcher and burn some important canvas that had been favorably received by press and public. In a few instances, buying interest in the condemned paintings had already been expressed by prominent collectors. The reason the artist usually gave for eliminating a picture was: "It holds me back." If one tried to dissuade him from his announced purpose—as I invariably did—he would defend his course in still more dramatic language, insisting that the picture had become "a heavy stone around my neck," that its very existence "impedes my progress and prevents me" from taking the "next step."

—ALMA REED, *Orozco.*

He decided to come to the United States in 1917, because, he said, he "didn't find in Mexico an atmosphere favorable to artists." However, he writes,

❏ . . . in passing through Laredo, Texas, I was detained in an American Customs House and my baggage was inspected. The pictures which I carried were spread over the entire office in an "official" exhibition and carefully examined by all members of the staff. After the "examination," they were separated and some sixty were torn into bits. They told me that it was against the law to bring immoral prints into the United States.

—REED.

Living in New York, he had a notion of how to support himself:

❏ Orozco gave an amusing account of his unsuccessful attempt to function as a New York cartoonist. He told us that in the difficult winter months following his arrival, the idea of contributing occasional caricatures to American magazines and newspapers had occurred to him as a possible source of income. Hopefully, he went to the *New York Times,* taking along a collection of locally inspired drawings and a few of his more famous cartoons that had appeared in the Mexican press. The editor chuckled over Orozco's gallery of "American types." His heartiest laugh was elicited by a group of drawings that struck hard at various committees especially one labeled *Committee on Art.* The caricature was a caustic pen-and-ink impression of the bumptious individuals who frequently assume the civic responsibility of awarding cash prizes and blue ribbons at art competitions; whose momentous decisions make

or break the painter, determine his long-range financial status, often his very survival as a professional artist. The drawing showed a bevy of stout, elderly ladies with a decidedly martial air, each wearing an expensive fur coat. Their cockaded tricornes, stern visages, and domineering postures identify them as victims of the familiar Napoleonic complex. Thumping the floor with their gold-headed canes, the ladies sweep aggressively through the exhibition gallery, giving an occasional superior glance through lorgnettes to the pictures, while completely ignoring the docile, obsequious male committee members who trail attendance at a respectful distance. Despite his keen enjoyment of the caricatures, the editor handed them back to the artist, explaining why he couldn't use them. "They're *too* good, Mr. Orozco," he said, "too painfully true. You see, we'd lose circulation if we published them, because so many of our subscribers would recognize themselves. Most of them, unfortunately, serve on at least *one* committee."

—REED.

In 1932 he began painting his murals at Dartmouth College. Of course, alumni declared that this "beautiful New England college" was about to be destroyed by "brutal Mexican stuff."

❏ It was at the height of these "protests" that Orozco in an interview published in the campus paper voiced his celebrated art theory that begins: "Behind every painting there is always an idea, never a story." During this same period, I asked him what he hoped his murals at Dartmouth would accomplish. He replied: "Perhaps they may save the students from drowning in a sea of sugar. Everything there is so *sweet!*"

—REED.

Alumni were not the only problem.

❏ One of the severest winters the region had experienced in many years virtually buried New Hampshire in deep snow drifts. The painter's letters began to complain of the bitter cold, from which he really suffered. But, as usual, his humor did not fail him. Hanover, like most New England towns, went in for ancestor worship in the glorification of the Pilgrim Fathers. Private homes proudly displayed their treasured antiques. Some of the shops and hotels even bore the affected stamp of the Colonial era, using the quaint Old English "ye" instead of "the" on window name plates or swinging signs. The hotel where Orozco stayed was called Ye Buttercup Inn and when the temperature fell to forty degrees below zero, he crossed out Hanover on the hotel stationery and substituted Ye White Hell in the date line of his letters.

—REED.

Charles Sheeler
(1883–1965)

Some reviewers have found Sheeler's work cold or austere. "I favor," he once said, "a picture which arrives at its destination without the evidence of a trying journey rather than the one which shows the marks of battle. An efficient army buries its dead."

After a trip to California, he praised redwood trees: "They never change their minds."

Maurice Utrillo
(1883–1955)

Suzanne Valadon's motherhood was never easy.

❏ From earliest infancy her son Maurice had been subject to inexplicable fits of rage. Lying peacefully in his grandmother's arms, his body would suddenly stiffen and shudder violently. He would squeeze his eyes shut, bite his lips, and hold his breath until he went purple as a grape. In a panic Madeleine would rush to put him in a basin of warm water, wrap his head in a warm, moist towel, or feed him a *chabrot,* a hot mixture of soup and red wine which was believed by the peasants of the Limousin to be a remedy for many nervous disorders. . . . He would kick over pieces of furniture, rip curtains or bed linen, smash his grandmother's china figurines. Or he would threaten to jump from the window of the flat or hurl himself before the traffic in the rue Caulaincourt. Equally sudden were his outbursts of grief. He might be quietly playing with a toy or watching the drays and carriages pass in the street below when tears would stream down his cheeks and his small frame would tremble in paroxysms of misery.

—JOHN STORM, *The Valadon Drama: The Life of Suzanne Valadon.*

His whole life was seizures. They were largely alcoholic but they happened even without benefit of alcohol. The sight of a pregnant woman brought on a terrible rage.

He began drinking while still in school; Suzanne could not believe that her child was a drunk.

❑ How preposterous could schoolmasters be! A second and a third report served only to heighten her derision. But it was derision born of fear, and ultimately she could not resist the impulse to bespeak her suspicions to the boy. The results hideously confirmed what she had refused to believe. Maurice flew into a violent rage. He tore his shirt and began to howl like a dog. Panic-stricken, she tried to embrace him, only to be thrown brutally against the wall. In an effort to avoid his flailing fists she stumbled, and he tried to kick her. Cowering in a corner before his maniacal rage, pleading desperately for him to calm himself, weeping, shivering with terror, she heard herself offer him a glass of wine. It was a moment she could never again entirely wipe from her consciousness. He was calm immediately, waiting for her next move, the blue flames of his eyes boring into her—commanding. She fetched him the wine and poured a glass for him. He took it and smiled. Then with measured calm he drank it off and quietly demanded another. She poured it for him, and in doing so she arrived at the turning point of her life.

—STORM.

Utrillo found regular work difficult; he tried various jobs, and for several months worked as a bookkeeper at the Crédit Foncier, where he proved to be good at figures.

❑ But then one day at work, for no apparent reason he suddenly seized his umbrella and beat the manager of his department into unconsciousness. Thus ended his banking career.

—STORM.

He started to paint when it was urged upon him as therapy. The alcoholism never ended, nor did the painting.

❑ Hounded by ruffians, tormented by yelping urchins, abused by night revelers, he could find escape only in stupor or coma. When he fell into some merciful dark corner, young brutes stripped him of his clothes or emptied garbage buckets over him. So many were the debauches that ended for him in the police station that the gendarmes always had brushes and colors on hand and made him produce a painting before letting him go home. It no longer seemed to matter whether he was

drunk or sober when he painted. The automatic production went on. Canvas after canvas seemed "to happen" before the listless strokes of his brush. Nor did he have to look at what he was painting. Often he set up his easel to command a certain street scene and then, facing it, he would paint an altogether different one—one in his mind.

—STORM.

It is well known that he painted not from life but largely from postcards, which he bought in shops that catered to tourists. As Suzanne Valadon put it, "From picture postcards my son has made masterpieces. Others fancy they are creating masterpieces whilst they are merely turning out picture postcards."

People felt protective toward him—and flabbergasted.

❏ One of the tasks that was frequently upon his fellow-artists in Place Ravignan was to protect Utrillo from the wickedness of passers-by and street urchins, when dead drunk he made his way to rue Cortot staggering and shouting at the top of his voice. Round 1910 I saw him repeatedly in the distressing state of dissipation, sitting down in front of his easel and, at the light of a smoke-dimmed oil-lamp—sucking an extinguished cigarette-stub and mumbling unintelligible words—he would set to painting, with inexplicable assurance and speed, some of the masterpieces of this brilliant period. On his dirty stained palette he would mix into his white paint, glue, plaster or egg-shell, an odd mixture thanks to which he achieved that perplexing luminosity and freshness often encountered in his compositions. . . . He never used a model; I even witnessed Utrillo standing before some motif and painting an entirely different subject.

—*Utrillo,* ed. Irina Fortunescu.

The painter Edmond Heuze told a story in amazement and in frustration.

❏ About forty years ago I was painting a landscape in Rue Chevalier de la Barre, at the foot of the Sacré-Cœur Church. Next to me, leaning against the bannister of the staircase, stood Maurice.

—"Aren't you sketching anything?" I asked.

—"No, I prefer to watch."

And indeed, for about two or three hours while I painted, he never uttered a word. After a couple of days, calling on him in rue Cortot where he lived, I sighted in his room the landscape I had been painting a few days before; his was created out of memory. They were incomparable. As genuine and true as his was, mine, with its slight effects of light and shade was no more than a rough study with an anecdotical

lamp-post in the foreground. In brief, the truth was, he had seen the view as a grand unitary picture, whilst I had seen the picturesqueness of the subject. This had been my fundamental mistake.

—FORTUNESCU.

❏ There was, as far as Modigliani was concerned, a glow of light-hearted humor in his carousals with Maurice despite all the disgust with which the Philistines viewed them. There was, for example, the night on Montparnasse when the two of them astounded the clientele of a restaurant by suddenly whipping out their paints and brushes and executing an enormous mural of Montmartre, Utrillo doing the landscape and "Modi" the figures, while the waiters rushed about with their trays and the *patron* made feeble threats to call the police, only to be checked each time by the cheers of his customers as the scene on the wall developed.

—STORM.

Once Modigliani took him to a restaurant for dinner on credit and then to his studio.

❏ There Maurice painted a couple of Montmartre street scenes from memory in order to raise money for drinks. Modigliani took the wet canvases to Zborowski, and on the proceeds of the sale he and Maurice launched a three-day tour of the bars of the quarter. It was, as always, a wild binge. What money they did not drink up was folded into paper airplanes and sent gliding into the trees along the Boulevard Raspail.

Ultimately the two rolled back to Modigliani's studio to sleep. When Modigliani awakened, Maurice was gone, and so were Modigliani's clothes. However, Maurice soon reappeared quite drunk and laden with bottles of wine. These, he explained, he had bought after pawning his friend's clothes. Now their drinking could go on! Chaim Soutine came in at what might have been the tail end of the ensuing drinking bout, and at Modigliani's suggestion he took Maurice's clothes to the pawnbroker in order to buy more wine. When Soutine informed Zborowski of what was going on, the ex-poet managed to reclaim the pawned clothing and then succeeded in bustling Maurice off to a hotel room of his own.

—STORM.

When he had an affair with Marie Vizier, she tried to cut down his drinking and encourage him to eat. When the affair dwindled, his mother attempted to help him.

❏ Suzanne prodded Maurice to go to prostitutes. At first she gave him the money; then, aware that he was spending it on drink instead,

she took him to the *maison close* herself, made the necessary financial arrangements with the management, and waited in the street until he came out. On occasion she also brought girls home and locked Maurice in with them, in which situation he was just as likely to sit in a corner and read a book as to do anything else. If the girl grew too aggressive, or if he felt otherwise harassed, he would fly into one of his diabolic rages until she screamed for help and was set free. . . .

—STORM.

❏ During the war Suzanne had tried to arrange a marriage with a laundress named Gaby. It was of this affair that Maurice spoke wistfully to Francis Carco many years later. "You know," he mused, "it wouldn't have been bad with her, but how the bitch drank!"

—STORM.

Exceptionally fond of his grandmother and his mother (who kept a goat in her studio and fed it bad drawings), he tended to worship distant female figures like Joan of Arc. When he married, according to Georges-Michel, his wife

❏ played more the role of mother to him than nurse. She bought his cravats, and took as much care of the "Utrillo legend" as she did of his pocket-book.

"The master can't see you," she would tell intruders. "He's in his oratory, saying his prayers."

The "oratory" in question was a small room full to overflowing of Joan-of-Arcs in marble, bronze, plaster, paintings, stained glass, even in the form of picture postcards.

"I kiss all my Joan-of-Arcs several times a day," Utrillo once informed me, adding, "It's hard work, but very holy." Even as he was speaking, he suddenly remembered to kiss one of the numerous medals he wore on a little chain round his neck. . . . I never saw Utrillo in a more complete state of bliss than on the evening of the private view of an exhibition of flower-pieces by Suzanne Valadon and himself, put on by Petridès in his new gallery in the avenue Matignon. Everyone in the art world was there. Utrillo had come, accompanied by his priest— the "guardian of his conscience," as he called him—who restrained him in his drinking.

"Just one more glass, Father, so that I can explain better what a wonderful artist my mother was."

"Very well, *cher Maître*."

Scorning the champagne and the fruit juice that were being served, Utrillo slowly sipped the cheap red wine that had been specially provided for him, and then he led us to the pictures.

"Look, look," he said. "My flowers are nothing compared to my mother's."

The two artists' paintings had been hung alternately on the walls. Utrillo's lilies, poppies, corn-flowers and carnations seemed as if casually and capriciously tossed on to the canvas against their solid backgrounds; whereas Suzanne Valadon's pansies, primroses and anemones looked serious and demure in their circles of light.

"They're different; but why should one be better than the other?"

At this, Utrillo's mouth twisted in anger and his eyes blazed. He grasped each of us by the sleeve in turn, and shunted us from one canvas to the next.

"She had a better sense of design, of form, of volume!" he declared. "We should get down on our knees. . . ."

—MICHEL GEORGES-MICHEL, *From Renoir to Picasso: Artists I Have Known.*

He was celebrated, he was honored, he was infantile.

❑ At the Avenue Junot he spent countless hours playing with the toy electric railway which Suzanne had bought for him, or dropping little pieces of colored chalk from the barred window of his room onto the ground below. He might stroll about the house, his bodyguard behind him, clapping his hands and repeating aloud to himself, "I'm very happy today," or "Suzanne is going to let me have wine with my dinner tonight." The sight of a car in the driveway might send him to bed. He might be in a daze, mumbling gibberish and bumping into furniture. Or he might sit quietly for several days, the long wrinkles of his face caught up in an ironic sneer, his blue eyes weary and baffled, saying nothing.

It was thus that the official delegation of government representatives and young Lyonnais artists found Maurice at St. Bernard on the morning in 1927 when they came to decorate him with the ribbon of the Legion of Honor. He sat on a low bench under an acacia tree in the little courtyard, Suzanne beside him, her hand gently on his knee. Throughout the short presentation ceremony he gave no indication that he understood what was going on. "Suzanne's eyes were shut, and two sad little pearls of tears slithered down her drawn cheeks," reported one of the young artists. "Everyone knew it was the time of her bitter victory."

Once the little ceremony was over, Maurice seemed to brighten, and by the time luncheon was served he was quite gay. During the meal he kept stroking the ribbon. And when the toast "To the artist of the Legion of Honor" was proposed, he lifted his glass solemnly. "A word of warning, gentlemen," he said; "mine is watered." With that the glass was drained in a single draught. "What a glorious day!" he sighed after

the festivities were over. Then he added archly, "And not even a real glass of *rouge* for the artist of the Legion of Honor."

—STORM.

Max Beckman
(1884—1950)

He dressed as a bourgeois and wore a black derby hat. A young art critic remembered him in the 1930s.

❑ One afternoon we had a *Kaffeeklatsch* in my parents' garden near Paris. Suddenly he walked out on the lawn, pulled his derby a little more firmly down on his head, and did several cartwheels, whirling sideways on stiff arms and legs, without losing his hat. We all laughed and applauded. Completely deadpan, he said to me, "Can you do cartwheels? You should learn this too. Very important."

—STEPHAN LACKNER, *Max Beckman: Memories of a Friendship.*

He lived in the United States during the Second World War.

❑ There was another anxiety he could not shake off even in the free air of the United States—the fear of being suspected. Max was an inveterate walker, not only for bodily exercise but to exercise his eyes, his observation of nature and humanity. The Mississippi, that enormous, almost legendary river, had its fascination for him, and strolling there at dusk one evening about five miles from the University, where he lived, he paused to observe the ever-moving flood, the lights reflected from the Illinois shore, and the beautiful lines of the old Eads Bridge under which he stood. Deep in thought he suddenly caught sight of two policemen who were, he thought, looking his way. Panic seized him. All at once he saw himself, the refugee from Germany, speaking broken English, presumably studying in the half light a strategic structure—the most important bridge across the greatest river in America. Recollection of the police state swept his mind. No American would have thought twice about the policemen, but Max Beckmann left the scene with haste, filled with nervous anxiety.

—*Max Beckman*, ed. Peter Seltz.

In his American years, he doted on Manhattan nightclubs. After the war, in Paris, the art critic who told about cartwheels took him to a cabaret.

❏ We landed at the Bal Tabarin and drank the "noble champagne." The stage show seemed lively and exhilarating to me, but Beckmann remained somewhat critical. The girls, after years of rationed food-stuffs, were too slender for his taste: one knows, from his art, his pre-dilection for fullblown female forms. During the cancan he remarked: "It does not steam yet as it should." Apart from this the evening was highly successful.

—LACKNER.

Wyndham Lewis
(1884–1957)

There were always quarrels around Lewis. When he and the poet T. E. Hulme quarreled over a woman, Lewis muttered some-thing about killing Hulme; but it was Hulme who suspended Lewis upside down from the iron railings of Soho Square.
 Walter Sickert was less violent and just as effective.

❏ Sickert lit a cigar and, nipping round the corner of the table, pressed one upon Lewis, with the words, "I give you this cigar because I so greatly admire your writings." Lewis switched upon him as dazzling a smile as he had had time to prepare—with him, everything is weighed and premeditated—but before it was really quite ready, and he had succeeded in substituting this genial grin for his more usual expression, Sickert planted the goad by adding, "If I liked your paintings, I'd give you a bigger one!"

—*A Free House*, ed. Osbert Sitwell.

Peter Quennell tells about a luncheon party, arranged by Lady Cunard in 1917, where Lewis met the Prince of Wales.

❏ Wyndham Lewis accepted the invitation, contrary to his usual practice; but he was taciturn and pensive and self-absorbed, and, as soon as they had sat down to luncheon, produced from his pocket a small pearl-handled revolver, which he placed beside his wine-glasses.

Did he mean to assassinate the Prince? Was it his intention to commit suicide? At all events, a crisis threatened; disengaging herself from the guest of honor, [Lady Cunard] turned her attention at the first opportunity to Mr. Wyndham Lewis's "pretty little pistol," admiring its workmanship and the elegance of the design, handling it as if it had been a Fabergé Easter Egg or an enameled Georgian snuff-box, at length with an absent-minded smile dropping the weapon into the bag she carried; after which she turned to the Prince and resumed her social duties.

—JEFFREY MEYERS, *The Enemy: A Biography of Wyndham Lewis.*

Lewis and Iris Barry spent three years together and had two children "through carelessness," as a biographer puts it, "rather than desire." Both children were put out for adoption. At one point, when Iris Barry spoke of the two infants, Lewis affected not to remember: "Oh, was there more than one?" On another occasion he said to a friend, "I have no children, though some, I believe, are attributed to me."

Later when he married he kept his wife secret. Friends believed that she was somewhere in the house; one of them saw hands appear through a serving hatch. One day Geoffrey Grigson had talked with Lewis four hours when suddenly Lewis said, "Stay to dinner. I've a wife downstairs. A simple woman, but a good cook."

His portraits of Eliot and Pound are normative. When Eilot sat for the second portrait, he said that being painted by Lewis left him feeling uneasy.

❑ Wearing a look of slightly quizzical inscrutability behind which one suspects his mental muscles may be contracting for some unexpected pounce, he makes one feel that it would be undesirable, though not actually dangerous, to fall asleep in one's chair.

—MEYERS.

Writer as well as painter, by 1951 Lewis was blind and stopped painting entirely. Augustus John, hearing that Lewis was blind, telegraphed him: "to bear up and above all stick to his art-criticism. This impertinence was received, as I had expected, with complete equanimity."

❑ As a writer, I merely change from pen to dictaphone. If you ask, "And as an *artist* what about that?" I should perhaps answer, "Ah, sir,

as to the artist in England! I have often thought that it would solve a great many problems if English painters were born blind."

—MEYERS.

He was always difficult if not impossible; and he was consistent as he died.

❑ His last, cantankerous words—"Mind your own business!"—were addressed to a nurse who inquired about the state of his bowels.

—MEYERS

Amedeo Modigliani
(1884—1920)

He raised money to support his addiction. Nina Hamnett writes about arriving in Paris for the first time in 1912.

❑ I went to a little restaurant in the rue Campagne Première which was kept by an old Italian woman called "Rosalie." She looked very distinguished and had a wonderful Roman nose. She had been a great beauty and a model of Whistler's. Epstein had recommended it to me. I sat down alone and began my dinner. Suddenly the door opened and in came a man with a roll of newspaper under his arm. He wore a black hat and a corduroy suit. He had curly black hair and brown eyes and was very good looking. He came straight up to me and said, pointing to his chest, *"Je suis Modigliani, Juif, Jew,"* unrolled his newspaper, and produced some drawings. He said, *"Cinq francs."* They were very curious and interesting, long heads with pupil-less eyes. I thought them very beautiful. Some were in red and blue chalk. I gave him five francs and chose one of a head in pencil. He sat down and we tried to understand each other and I said that I knew Epstein and we got on very well, although I could not understand much of what he said.

He used to drink a great deal of wine, and absinthe when he could afford it. Picasso and the really good artists thought him very talented and bought his works, but the majority of people in the Quarter thought of him only as a perfect nuisance and told me that I was wasting my money. Whenever I had any money to spare I would buy one of his drawings. Sometimes they would come down to three francs. Every morning he would come to the Rotonde with his drawings and he gen-

erally collected five francs before twelve o'clock. He was then quite happy and able to work and drink all day.

—NINA HAMNETT, *Laughing Torso.*

Hamnett came to know him.

❑ Modigliani was living in the Rue St. Gothard and Edgar and I went to see him. He had a large studio which was very untidy and round the wall there were gouache drawings of caryatids. They were very beautiful and he said, "Choose one for yourself." The bed was unmade and had copies of *Les Liaisons Dangereuses* and *Les Chants de Maldoror* upon it. Modigliani said that this book was the one that had ruined or made his life. Attached to the end of the bed was an enormous spider-web and in the middle an enormous spider. He explained that he could not make the bed as he had grown very much attached to the spider and was afraid of disturbing it.

—HAMNETT.

Marevna tells about a Russian canteen which the painter Marie Vassilieva ran, chiefly for émigrés from revolutionary Russia, during the First World War. Artists from all over Paris met to argue about art and politics.

❑ Modi was a favored guest at Vassilieva's canteen, and of course she never charged him anything. Sometimes, when drunk, he would begin undressing under the eager eyes of the faded English and American girls who frequented the canteen. He would stand very erect and undo his girdle, which must have been four or five feet long, then let his trousers slip down to his ankles, then slowly pull his shirt up over his head and display himself quite naked, slim and white, his torso arched.

"Hi, look at me!" he would cry. "Beautiful as a new-born babe or just out of the bath. Don't I look like a god?"

And he would start reciting verses. If they were not Dante, they were from *Les Chants de Maldoror* by Lautréamont.

—MAREVNA, *Life with the Painters of La Ruche.*

Augustus John is another who speaks of Modigliani's devotion to *Les Chants de Maldoror,* where Lautréamont invented "the chance meeting upon a dissecting table of a sewing machine and an umbrella." John wrote:

❑ Epstein, Modigliani, Jack Squire and I roamed the town together. On one occasion Modi, feeling low, complained a little of his lot, with an allusion to racial prejudice. I said, "Alors, c'est malheureux d'être

Juif?" "Oui," replied Modi, "c'est malheureux," but Jacob Epstein ex-
ploded in violent dissent.

 —AUGUSTUS JOHN, *Chiaroscuro: Fragments of an Autobiography.*

At one point Modi had an affair with a faded belle of the Latin
Quarter; Gaby's official lover confronted him.

❑ Gossip brought it at last to the ears of the "lover", who, as a man
of the world and polygamous by instinct, really cared little. For form's
sake, however, he decided that his "honor", of which he made such
great stock, was involved. Through a friend he summoned Modi to
give an explanation and a rendezvous was arranged at the Café Pan-
théon on the Boul' Mich'.

Modi arrived late, but rather gay and insouciant as usual, his hat
slightly awry and his red scarf over one shoulder of his corduroys. The
rival, immaculately dressed in the latest mode and with a flower in his
buttonhole, grimly awaited him at the table indicated. When Modi, with
his charming smile—the same, no doubt, for which the lady had fallen—
presented himself, the other stood up, bowed formally, and curtly re-
quested him to be seated. Modi did so, signaling at the same time to
the waiter, from whom he ordered a bottle of wine. Evidently he was
flush at that moment. Perhaps he had just received some money from
home. The insulted one, who had been trying to work himself up into
a conventional state of indignation, led off in a circumlocutary fashion
by stating that he had good reason to believe that the name of Modi-
gliani had been linked to that of the lady under his protection. Modi,
his liquid southern eyes sparkling with malicious fun, admitted the soft
impeachment, cunningly timing his avowal to coincide with the arrival
of the sommelier. As the waiter balanced the dusty bottle in its cradle
and began to pour out the wine, he followed up his confession by an
effusive panegyric on Gaby's beauty and charm, declaring that no man,
particularly no artist, could have failed to be smitten, and that, more-
over, not only was he flattered by the association of their names but he
could assure monsieur that he also, as well as she, would one day be
equally honored by the memory of their association with a great artist,
and . . .

Each attempt of his adversary to speak was brushed aside by a ges-
ture and a speeding-up of the rhetoric, for to stop Modi when started
was an impossibility. He wound up his oration by a timely lifted glass
and a summons to drink to the most beautiful and charming woman in
Paris, which the victim could scarcely refuse to do.

The toast was drunk in silence. Then the aggrieved lover began coldly:
"That is as it may be, m'sieu, but I wish you to understand I will not
permit—"

"And, moreover, m'sieu," Modi broke in, "I assure you that I have painted not one, but several pictures of Madame in the nude—"

"I beg you to understand, m'sieu," crashed in the official lover by sheer lung power, "that in no circumstances will I permit—"

"And I, m'sieu," crescendoed Modi, "assure you that I shall be delighted to present you with a painting that one day will be worth thousands and will immortalize one whom you adore. But you are not drinking, m'sieu. I beg you! We will again, if you permit me, toast one whom I shall have the honor both to have loved and to have made immortal. Have a cigarette, cher m'sieu?"

The effect of the flattery, a touch of inherent snobbery, perhaps, at the thought of being associated with a "great artist", and Modi's way of saying so, were so convincing, combined possibly with a certain interest in a painting that might some day be of great value, that the gentleman became mollified, took the proffered cigarette, and begged his rival to do him the honor of accepting another half-bottle of the excellent Château Clos de Corvé, 1904. The end of the comedy was that both of them, immersed in mutual admiration of Venus and Bacchus, were pushed out of the Café Panthéon at half-past two in the morning, hiccoughing eternal friendship.

—CHARLES DOUGLAS, *Artist Quarter.*

His biographer Charles Douglas quotes a Mme. Gabrielle on meeting Modigliani.

❏ I was coming home one night with friends—oh, it was quite early, about one—and there was a lovely full moon. As we came into the Place Jean Baptiste Clément from the Place Ravignan, we heard a piano going full blast, playing a Spanish scherzo, and a woman's voice, wild and hoarse. We stopped to look. Outside that shed Modigliani had, to one side, there was a bit of garden, about the size of a handkerchief. Well, a woman in a kimono, nude to the waist, with her hair down, was dancing madly, and opposite to her was Modigliani, in trousers only, capering about like a lunatic and yelling like a demon. Every moment he would turn his head and scream: "You pigheaded calf! You pig, son of Madonna!" at a lighted window in that big house at the back, in the rue Norvins, where lived some kind of Treasury fellow. As we stood laughing he dropped down his trousers—Modigliani, not the Treasury chap—and started to caper around her.

—DOUGLAS.

He appeared to value so little the canvases that he traded for drink and food that the recipients, some of whom had taken them only out of kindness, put an equally low value on them.

❏ An amusing story is related of the proprietor of the studio in the
Cité Falguière. So little did he value the belongings he had seized from
his worthless lodger, that the canvases were used to cover mattresses
and sofas. When the death of Modigliani transmuted his pigment into
gold, he hurriedly began to search for them. But his good wife had
carefully scraped off as much of the "dirty paint" as she could, so a
dealer's offer of ten thousand francs for the lot fell through. The poor
fellow is said to have had such a fit of rage that he died of apoplexy.

Similar experiences happened to others. Rosalie, of the little restau-
rant in the rue Campagne Première which Modi frequented, chucked
the drawings and pictures she had accepted out of sheer kindness, in
return for meals, into a cellar, where her dear rats naturally chewed
them up. Again, in Montmartre, the owner of the carpenter's shop sold
the pictures he had seized for a hundred francs apiece, and since then
has not ceased to tear the little hair he has left at the thought of the
prices the lucky buyer obtained for them. And the woman who kept
the potato stall on the Butte, who used the drawings Modigliani ex-
changed for this nourishing commodity to wrap up her fried chips! Ah,
many were those who took, but few were those who kept!

—DOUGLAS.

There were great encounters with the great.

❏ Not far away lived Renoir. Modigliani wanted to meet him, being
naturally excited by his work and reputation. One day, after he had
come back from the village, where he had been admiring the Pernod
fils poster, he insisted on going to see the Master. "In a big arm-chair
with a small shawl over his shoulders and his face protected by netting
against the mosquitoes of Cagnes, Renoir received us in his dining-
room," says Osterlind, "where he was always carried when he had fin-
ished work, for he was infirm at that age.

"To introduce these two was rather difficult, I felt. Renoir with his
past and the other with his youth and self-confidence—particularly after
the Pernods. Sulky and ill-tempered, Modigliani listened to Renoir talk-
ing, while he had some pictures brought out for us to see.

" 'You're a painter, too, young man?' said Renoir kindly, as Modi
examined the canvases.

"No reply.

" 'Paint with joy,' advised Renoir, 'with the same joy that you would
make love to a woman.'

"No reply.

" 'I always caress the buttocks for days and days before finishing a
canvas,' added Renoir.

"I was now scared of what might happen. And with reason! Modigli-

ani rose abruptly, and, with a hand on the latch of the door, said brutally: 'I, monsieur, don't care for buttocks.' "

—DOUGLAS.

He had developed consumption when he was eighteen years old, and his habits did not help his lungs. He died in the Hôpital de la Charité where Alfred Jarry had died, and his dealer raised the prices on his pictures.

Nina Hamnett wrote:

❑ His wife, who was about to have a child, went to stay with her family, who were *sale bourgeoisie* and lived near the Panthéon. She slept in a room on the fifth floor. She was so despairing and miserable that, during the night, she jumped out of the window and was killed. Her family, who were religious, said that they could not have a suicide in the house. She was picked up by some workmen and brought to the studio in the Rue de la Grande Chaumière, in which I lived for several years afterwards. Two friends of Modigliani's sat with her body in case mice or rats were about the place; they brought some wine and spent the night there. On the day that Modigliani died his cat jumped out of the studio window and was killed.

—HAMNETT.

Robert Delaunay
(1885—1941)

For this creature of La Belle Epoque, everything was pleasure or amusement; good wine, good food . . . As René Crevel put it, ". . . the dining-room is on the left. This is Robert Delaunay's kingdom." He loved amusement parks and the Eiffel Tower. As his wife Sonia summed it up: "We lived like children. We both still had private incomes in those days, and we played at living, as children play with dolls." But if he was hedonistic he was not sybaritic.

❑ He returned frequently to the country, where he lived simply, and found renewed inspiration for the direction of his art. His apartment in Paris was filled with lush and enormous plants which he cared for attentively. A much repeated story was first told by Gilles de la Tour-

ette. He observed Delaunay, in his later years, approach one of these plants, and with tenderness and expertise, help an emerging leaf get free from its protective enclosure and move toward the light. His attachment to nature and to plant and animal life was so great that on one occasion he brought forty wild birds and their nests back to Paris with the hopes of raising them in the city.

—SHERRY BUCKBERROUGH, *Robert Delaunay.*

Gertrude Stein remembers him as competitive.

❏ He was always asking how old Picasso was when he had painted a certain picture. When he was told, he always said, oh I am not as old as that yet, I will do as much when I am that age. . . .

—BUCKBERROUGH.

Duncan Grant
(1885–1978)

Many autobiographers tell many stories. In *A Free House,* after Osbert Sitwell recounts the following anecdote, his footnote tells us that Duncan Grant denies it entirely; then Sitwell adds, "But I was walking at his side at the time it happened."

❏ Never, I am sure, could he have emulated such a feat as that I saw Duncan Grant perform some quarter of a century ago, when, while engaged in a discussion, he fell down to the bottom of a long, steep flight of stairs, holding in one hand a candlestick with a lighted candle in it, and, apparently without having noticed his tumble, and certainly without having allowed his candle to go out, continued his talk where he had left it off, as soon as he regained the landing.

—*A Free House,* ed. Osbert Sitwell.

Frances Partridge in her memoirs remembers another occasion.

❏ Much later I heard Duncan describe the trouble he had had clearing the studio of cockroaches when he first took it over—from Sickert, I believe. His chemist had provided "some form of stink-bomb that finished them all off".

"Do you know what it was?" asked Desmond MacCarthy's son Dermod, who was a doctor.

"Yes, it was called Such-and-Such," said Duncan, blinking nervously.

"Good HEAVENS! I hope there was no-one in the building?"

"Well yes, there *had* been an Italian family on the ground floor. I never saw them again. I hope it wasn't dangerous?"

"Highly, I should say."

"Oh dear . . . Now I come to think of it, I did meet some men carrying a large box downstairs later on."

—FRANCES PARTRIDGE, *Love in Bloomsbury: Memoirs.*

Everyone writing about Duncan Grant adds footnotes, in this case: "Not to be taken too seriously, but in part at least as a product of Duncan's fantastic imagination."

Mary Berenson wrote her husband at I Tatti, July 2, 1913:

❏ And now I must tell thee some more of the "Gloomsbury" doings. At Ray's party Duncan Grant, disguised as a woman, was suddenly seized with labor pains—doctors and midwives were summoned, and amid horrid groans he gave birth to a pillow. . . .

—BARBARA STRACHEY AND JAYNE SAMUELS, *Mary Berenson.*

When he was in his eighties the Queen Mother attended his show.

❏ The Queen Mother's visit to the Gallery is a success. The legendary naturalness and charm of her presence are real. She comes with two ladies-in-waiting and we have the Gallery to ourselves. Duncan pays his obeisances and accompanies the Queen. She is enthusiastic. She already possesses three "Duncans" (including the two fine paintings of St. Paul's— early and late—hanging in the show) and would like another. She and he walk slowly round the Gallery. Near a certain picture I hear her say:

"That's lovely. Perhaps that's the one I should have."

"Oh no, Ma'm," I hear him answer, "that's a very dull picture. I wouldn't advise it."

—PAUL ROCHE, *With Duncan Grant in Southern Turkey.*

Marie Laurencin
(1885—1956)

Fernande Olivier had an eye for appearances.

❏ She had the face of a goat, with eyelids drawn back and short-sighted eyes set too close to a pointed, burrowing nose, always a bit red

at the tip. She took a good deal of trouble to appear to be just as simply
naïve as she actually was. Her complexion, normally like slightly yel-
lowed ivory, could color violently on her cheeks under stress of emo-
tion or shyness. She was quite tall, and her dresses always hugged her
slim, somewhat angular figure very tightly. Her hands were long and
red, as young girls' hands often are, and dry and bony. She looked like
a rather vicious little girl, or a little girl who wants people to think she's
vicious.

—FERNANDE OLIVIER, *Picasso and His Friends.*

Apollinaire wanted to introduce Marie Laurencin into the society
of Picasso and his friends. It did not happen quickly.

❏ Marie came to see Picasso with Apollinaire one day. Rummaging
everywhere, she managed to touch and disturb every single thing. She
wanted to see everything and to look in every corner, and she did so
with an astonishing absence of embarrassment or formality. Her lor-
gnette was fixed inquisitively to her spectacles so that she could see
better.

Suddenly she stopped all this and stood still, worn-out, perhaps, by
her searchings. She sat down and seemed to be taking part in the con-
versation, which she then interrupted with a shrill, inarticulate cry . . .
There was an astonished silence . . .

"It's the cry of the Grand Lama," she informed us helpfully.

—OLIVIER.

Apollinaire wrote of her: "She is a little sun; my feminine coun-
terpart. She has a serene and infantile face of those who were
made for eternal love." Later he changed the last phrase and
modified her face "destined to cause suffering."

Louise Faure-Favier talks of a bad patch between lovers.

❏ One day in May 1914, Marie Laurencin said to me: "You know,
Louise, things aren't going at all between Guillaume and me. Yesterday
morning I took the boat at Auteuil and got off at Solferino and walked
up the stairs to the Quai du Louvre. At the top, whom do I see right
in front of me, leaning over the parapet, but Guillaume. I don't know
where he had been all night, drinking and doing heaven knows what;
he was all disheveled, his necktie was undone, his collar was dirty and
his hair uncombed. And there was I in front of him all spic and span
in my new dress and a fresh collar and my flowered hat. Guillaume
asked me point-blank, 'Where are you going?' Without batting an eye-

lash I smiled and said 'To the Louvre.' But Guillaume wasn't as drunk as he seemed. 'The Louvre is closed on Mondays,' he snapped at me.

"You can't always think of everything," Marie added, philosophically.

—FRANCIS STEEGMULLER, *Apollinaire: Poet Among the Painters.*

Long after Apollinaire's death she spoke of him.

❑ People talk of how I threw Apollinaire out, yes, I shut my door on him and have been attacked for it. He adored me, he loved only me; it's true that he suffered frightfully, but what people didn't understand is that I was twenty-five and he was sleeping with all the women, and at twenty-five you don't stand for that, even from a poet!

—RENÉ GIMPEL, *Diary of an Art Dealer.*

Portrait painters resort to all sorts of expediencies.

❑ Lady Cunard commissioned her to do her portrait, which she painted with a horse in it, but a fantastic kind of dream horse, the only sort she'll do, and naturally very far from anything seen in England in the way of horses. The lady, who was not satisfied, sent the portrait back from London to Marie Laurencin, and customs imposed a 12 percent luxury tax on it. She refused to go to their offices, Armand took care of the formalities, and she didn't have to pay anything. The matter, though settled with the customs, was not settled with Marie Laurencin. Her honor as an artist was offended, and she made Lady Cunard get down from her horse and get on a camel; she told the story and showed the picture to everyone. Lady Cunard heard of it and came in all haste to Paris. Lady Cunard, who for years had been trying to scale the last rungs of the English social ladder, Lady Cunard on a camel! What a fall! Absolute horror of seeing the canvas exhibited or reproduced in the *Burlington* or the *Tatler.* She had Armand sit down and think of something and commissioned a whole ballroom from Marie Laurencin. The artist has long since ripped up the canvas.

—GIMPEL.

When she was an old lady she spoke often of her mother, proud of her mother's strictness.

❑ One day little Marie ran to her mother, saying: *"Je m'ai brûlée"* ("I'm burned"). "No," said the mother, *"je me suis brûlée"* ("I've burned myself"). She was so badly burned that she didn't sleep all night, but the mother was more concerned with the damage to the French language than with that to the child.

—GIMPEL.

Jules Pascin
(1885–1930)

Born rich to a Spanish-Jewish family which had settled in Bulgaria, he rejected his background: "I avoided my brothers. They were grocers." He ran away from home.

❏ My brother came to bring me home. I was in bed with a prostitute. The concierge knocked to warn me. "Show him in," I said, "his behavior is irreproachable. *C'est un épicier.*"
> —GEORGE BIDDLE, *An American Artist's Story.*

"When I was young I was very snob and wore spats and gray gloves to the Academie Julien." The more artist he became, the less snob.

❏ His place was rarely swept; and so his cat, as she prowled over the drawings, could sign them for him. The bed was unmade. I don't remember furniture; perhaps a kitchen chair or two. Plenty of empty wine bottles. White wine, for he was taking one of his liver cures and on a white-wine diet.
> —BIDDLE.

He liked sordid subjects.

❏ Once he and Kisling had a curious adventure when they were trying to make sketches for paintings in the red-light district of Marseilles. At first they found it practically impossible to work there, for no sooner had they set up their easels than these were knocked over by the roughs of the Quarter and they themselves insulted and jeered at. At last someone advised them to interview Monsieur X, who was the boss of that section of the underworld. He turned out to be a tall, fierce-eyed Corsican, who had started his career in Lisbon with a "nice respectable business in girls." This had come to grief because the girls invariably ran away, and he had eventually drifted to Marseilles, where he found more scope for his abilities. In the course of conversation it appeared that he had two major interests in life, apart from business: the first was his beautiful daughter, of whom he took the most scrupulous care;

the second, art. His tastes were quite catholic. He appreciated both ancient and modern painting, but was particularly keen on making a collection of the latter. It was therefore small wonder that he sympathized with the request of the two artists. The word was sent round that in future Pascin and Kisling were not to be molested. . . .

"Jimmy the Barman," who in the nineteen-twenties became one of the most popular figures in Montparnasse, with a host of English and American friends, relates in his entertaining book, *This Must Be the Place,* how Pascin told him about the big party he was organizing to introduce Monsieur X to Montparnasse and thus to repay him for his hospitality at Marseilles. After the banquet the plan was for the artists to take their underworld guests to the Dome and the Rotonde and give them the keys of the Quarter. Nearly a hundred and fifty painters attended the dinner, and in order not to embarrass the "tough babies" from the south they all put on their oldest clothes. Unfortunately, X and his friends arrived dressed to the nines and complete in frock coats, striped trousers, boiled shirts, and spats. Both sides were equally amazed. X said he thought he must have got into the hands of a gang of Apaches.
—CHARLES DOUGLAS, *Artist Quarter.*

André Salmon says that Pascin told him: "I wanted to found a society of princes, but I had to give it up as I could never find a quorum."

He killed himself at the height of his success. Salmon spoke his epitaph: "The poor and great Pascin, the painter of voluptuousness, who in his studio on the Boulevard de Clichy, in the house of the 'Lune Rousse,' hanged himself after opening his veins . . ."

Vladimir Tatlin
(1885–1953)

When he was eighteen the young Russian ran off to sea, sailing from Odessa to Bulgaria, Turkey, Persia, and Mediterranean ports. When he returned with money saved, he could set to work painting. He continued to take jobs as a sailor, mostly during the summer, to support his painting until he was in his thirties.

He performed other odd jobs.

❏ Goncharova recalls how he once worked as a wrestler in a circus
act—but was so frail and inexpert that he put up a poor fight and lost
the hearing of his left ear as a result. In 1913 he decided to accompany
a group of his friends, Ukrainian singers and musicians, who were going
to Berlin with the "Russian Exhibition of Folk Art" which opened there
in the autumn of that year. Tatlin played the accordion in the group.
There is an amusing story about Tatlin in Berlin. Apparently he posed
as a blind musician, and somehow attracted the notice of the Kaiser—
who gave him a gold watch! This Tatlin immediately sold, and together
with the money he had made by more legitimate means at the exhibi-
tion bought himself a ticket to Paris. This was late in 1913. The great
object of the trip was to visit Picasso. Since he had seen the first Cubist
work brought back by Shchukin, Tatlin had dreamt of meeting Picasso
who was then working on his Cubist constructions. He was over-
whelmed when he visited Picasso and begged him to let him stay and
work with him—saying that he would clean his brushes, stretch his can-
vases, even sweep his floors, if only the great painter would let him
stay. But it was to no avail. Picasso had too many demands from his
own destitute friends at this time to be able to allow for an unknown
stranger, however appealing. But he remembers him often paying visits
to his studio with his accordion during that short month. At last his
money ran out and he returned to Moscow full of revolutionary ideas.
Soon after he held an exhibition of his first "constructions" in his and
Vesnin's studio in Moscow. These works are of course directly related
to Picasso's constructions but are already more radical in their abstrac-
tion.

—CAMILLA GRAY, *The Great Experiment: Russian Art 1863–1922.*

Picasso kindly gave him used tubes of paint but Tatlin in his
piety saved them instead of using them.

In 1915, just before the opening of the show that announced
Malevich and Suprematism, Tatlin objected so violently to Mal-
evich's paintings that the two artists fought. Friends parted them
and worked out a compromise whereby Tatlin and two other
artists showed in one room, Malevich and his followers in an-
other. Not wanting anyone to misunderstand, Tatlin labeled the
door of his own exhibition room "Exhibition of Professional
Painters."

He never restricted himself to the artist's studio.

❏ Tatlin's project for a flying machine, between 1929 and 1932, re-
calls both Leonardo's example and Khlebnikov's preoccupation with
birds. Tatlin the sailor had watched tireless gulls follow his ship for
days scarcely moving their wings. *Letatlin,* his glider, was a response to
that memory. The verbal punning of its name recalls the neologisms of

Khlebnikov: *letat*, to fly, plus *Tatlin* gives *Letatlin*. Furthermore in Khlebnikov's numerical theory of history, the period of 365 years, or its multiples, divides the dates of great men in comparable fields of endeavour. Tatlin was born in 1885 and Leonardo died in 1519, so that the period of time which elapsed between their lives was 366 years, perhaps close enough to Khlebnikov's "historical wave" of 365 years for the parallel to have intrigued Tatlin. . . .

By 1932 mechanized air travel did not rely upon human effort or gliding. Tatlin's glider was a machine independent of the geometrical forms of modern engines. His approach was not the engineer's disposition of materials into a predetermined form, but the exploration of material qualities and their articulation with minimal interference. His aim, as a constructor, was neither to depict bird-flight in the manner of the artist nor to build aeroplanes in the manner of the engineer. Working with a surgeon and a pilot he evolved an equivalent for the gliding mechanism of the bird.

—JOHN MILNER, *Vladimir Tatlin and the Russian Avant-Garde.*

He continued to work on his air-bicycle, as he liked to call it, and foresaw children of eight attending flying-school to learn how to use *Letatlin*.

One of his pupils described him in 1932.

❏ A huge white face and huge white hands. His pallor was not white but blue from the cold. It was hard for him to keep warm in the world about him. His sweater expressed his lack of warmth. It was of big home-made colorless woollen knitting which characterizes and depersonalizes everything old, poor and ill. Or military. Not decorative, simply a warm sweater, ever-lasting, never taken off, one and the same in autumn, winter and spring. And summer too, it seems. Over the sweater was worn one of two dark jackets—blue or black. This costume was the only one; it was unchanged. In winter a fur coat was added—not expensive, but of good red fur. In any other life V. E. Tatlin could even have looked noble.

—MILNER.

Oskar Kokoschka
(1886–1980)

Kokoschka was famous as a young playwright—with *Murder, the Hope of Women*—before he was famous as a painter.

He remembered extraordinary tales.

❏ In 1892 Kokoschka was enrolled in the local primary school. During his first years at school he sometimes played in the Galitzinberg park close to his home. There he got to know two little girls who were taken regularly to the park by their snobbish mother who was alarmed by the attentions of the boy who looked little better than a street urchin. Oskar liked the girls very much, not least because, as he discovered to his delight, one of them attracted him physically.

He tried to capture the girls' interest by showing off. One day he sought to impress them by blowing up an ants' nest with some gunpowder he had manufactured at home by following instructions received at school. The explosion was much bigger than expected; one of the girls fell in a faint from a swing and her shocked and outraged mother forbade Oskar to have anything to do with her daughters again. She told the park keeper to make sure he never entered the grounds again and "the childhood Eden of my dreams was lost behind a locked park gate."

Determined to regain his paradise, Kokoschka tried to climb into the park over the iron railings. He lost his footing and fell "on a heap of filth, a midden full of broken crocks, crawling with unimaginable, insatiable life. A stinking yellow liquid spurted up. There was a long-dead, putrefying pig, from whose swollen carcass rose a cloud of flies." Unconscious, Oskar was carried home, where he fell ill, unable to open his eyes or close his mouth: "At the root of my tongue sat a fly, which constantly turned round and round, laying its grubs in a circle." The doctor could do nothing to help. Only the prayers of a priest who came to the bedside effected a cure.

—FRANK WHITFORD, *Oskar Kokoschka: A Life.*

❏ Kokoschka had been born with second sight, like his mother and grandmother before him. Once his mother was visiting relations and when they were having their coffee she suddenly put down her cup, saying: I must go home. Something has happened to the boy. Oskar's brother, Bohuslav, had cut his leg with an axe. She took the bus, but it was an hour before she got there. He was lying in a sea of blood, and would almost certainly have bled to death.

Kokoschka painted *Knight Errant* at the beginning of 1915, and it foretold how he lay wounded on the battlefield, suspended between heaven and earth. When he gave his lecture on the *Nature of Visions* he had drawn a poster showing the position of the wounds seven years before they were inflicted. There was another drawing, made on a fan— this time the artist was on horseback, fighting the Russians before the war had begun—that he gave to the woman who loved and hated him more intensely than most, and from whom he wrung his freedom like Jacob wrestling with the angel.

—J. P. HODIN, *Oskar Kokoschka: The Artist and His Time.*

During the war, as he remembered late in his long life, he was apparently killed:

❏ Kokoschka affirms that he died in Lutek. It was indeed an experience which might well have cost him his life, for the circumstances were dangerous, and his curiosity made him wonder what it would be like to die.

He was crossing the Bug, leaning well back on his horse so that it would not know he was there, and leading other horses by the bridles. As he came to the bank a group of Cossacks appeared trailing their lances, and riding small ponies so that their feet were almost on the ground. They attacked, crying fiercely: "Stoj! Stoj!" He laid spurs to his horse and galloped like the wind. He was a good enough rider when in danger, but otherwise not at all. As a boy he had been thrown from a horse and had damaged his kneecap. But he rode well with the Cossacks after him. His horse was of bloodstock, and when urged to a gallop had a habit of turning its head, showing the white of its eye, and biting. He was hoping that the animal would not choose this moment to bite, when he was shot in the head and fell. As usual when anything dramatic happened to him, it was moonlight. He regained consciousness to see a Russian bending over him with a white mask-like face and dull eyes like stones. He drove his bayonet into Kokoschka's chest. It seemed to take hours, although he wasted no time. The Russians may at first have carried him off and then concluded that he was beyond help and decided to give him the *coup de grâce*. Kokoschka had never shot anyone, and although he had his finger on the trigger of his revolver he did not pull it. The Russian was a huge man, but Kokoschka did not shoot. He believed he was doing something important, but Kokoschka thought it senseless and debasing to shoot—it was night, if he pulled the trigger the man would collapse—Crazy!

"What tremendous courage!" I exclaimed as he described the scene. He denied it: Not at all; I was always very nervous but very inquisitive. It was terrible when the Russian bayonet pierced my tunic and the steel bit into my flesh, but my terror gave way before a strange sense of desire, as though it were a woman.

—HODIN.

He painted a portrait to pay for board and lodging.

❏ There were hysterical scenes. The portrait was begun but never finished. The lady made advances to Kokoschka which were unwelcome and increasingly difficult to resist without sparking off more scenes. He escaped from the house by climbing out of his bedroom window with the aid of bedsheets tied together.

—WHITFORD.

❑ At one time, Kokoschka explained, he used to buy old porcelain very cheaply in England and give it to his friends, because he wanted to rescue the fine pieces from the philistines. He thought it would be safer with them, as he was always traveling. If an object pleased him he would sometimes tell the dealers that their pieces were valuable and worth more, and for this he gained the reputation of being crazy. One poor and uneducated boy called Toby had learned a great deal from him. He was a barrow-boy, selling fruit in the streets. Then he bought a decrepit taxi and drove the artist all over London in it, calling him Rabbi because he was able to answer all his questions, and following Kokoschka's advice in everything. The artist loved the streets of London where there were junk shops filled with objects from all the corners of the world, from silks and carpets to furniture and *objets d'art*. Georgian silver could be found for its price as scrap, so Kokoschka told Toby: If I had money I would buy it all to save it from being melted down. Buy old silver and you will be rich!

When Kokoschka came again to London, as a refugee, Toby was a rich man and offered to present the artist, who was impoverished once more and living in an attic, with a racehorse from his stable as a thank-offering. He had bought furniture and silver from bombed-out houses and instead of sending it away to be melted or broken up, had shipped it in wagonloads to America. But when Toby wanted to send musical boxes over to the States, Kokoschka protested; they contained too much of the spirit of Europe.

 —HODIN.

In Vienna he painted furiously before an exhibition.

❑ Selection day came and, helped by a friend, Kokoschka arrived with his paintings. Three walls of the gallery were covered with pictures. The judges walked through all the rooms and came to the part where Kokoschka's work was hung. But the door was barred. Kokoschka had forgotten that there was an opening and had fixed a large mural over it. No one could get in. Quick to seize the opportunity, he began to bargain with the judges, standing inside and shouting through the door that he would not let them in till they promised to accept his work unseen. They remained outside, solemn, in frock-coats and top-hats. Klimt was president, and Kokoschka called through the door: Herr Professor Klimt, I am glad to meet you. I am told that you have praised my work. There was a scuffling outside, and Klimt's voice could be heard trying to calm them: Let him alone; a foolhardy youth like him will be torn to pieces in any case. And when Klimt said that, he spoke from experience. Then Klimt replied: I give you my word; only let us in. Kokoschka watched him as he gazed at the walls, shaking his head and saying: Mad boy. But all the same! So Kokoschka, although he was

so young, fought bravely for recognition. Klimt was the first to buy a
drawing.

<div align="right">—HODIN.</div>

For three years Kokoschka had an affair with Alma Mahler, widow
of the composer, who also had affairs with the architect Walter
Gropius, the composer Franz Schreker, and possibly with Gustav
Klimt. Later she married the novelist Franz Werfel. Kokoschka's
mother tried to break up the relationship with Mahler, as early
as 1913, threatening to shoot Alma if Alma did not let him go,
walking up and down before the Mahler house with a gun in her
purse.

Mahler aborted Kokoschka's child. His obsession with her en-
dured for the rest of his long life. In the early years after the
break-up, his obsession is clear.

❑ Kokoschka had a life-sized doll made in Alma's image. Its appear-
ance was as human as expert hands could make it and it was intended
to be as perfect a substitute as possible for the person on whom it was
based. If Alma remained beyond Kokoschka's reach, her three-dimen-
sional likeness would not be. It would be his to own for ever and it
would yield to his every whim.

The preparations for the doll's making and the manner of its man-
ufacture make it clear that what Kokoschka desired was a fetish. He
could not make it himself, not only because the necessary skills were
beyond him, but because it would not possess the required magic if he
were directly involved in its creation. He should not set eyes on the doll
until it was complete. It would enter his life in a state of perfection, as
seductive as a new mistress.

The first stage in the doll's life was a search for its creator. Ko-
koschka heard, perhaps from Käthe Richter's family, about a seam-
stress and doll-maker who lived in Stuttgart and, if some reports are to
be believed, was better qualified for the job than anyone else alive: she
had once been Alma Mahler's dressmaker. Her name was Hermine Moos,
and in September 1918 she exhibited her dolls at the Richter gallery in
Dresden. Not surprisingly she was taken aback by Kokoschka's request
that she should make a life-sized doll for him, shocked by the implica-
tions of the strange commission and soon came to regret agreeing to
undertake the task. For as soon as she did so Kokoschka immediately
began to bombard her with letters explaining in both words and pic-
tures how the doll had to look. His letters to her allow us to follow the
doll's construction closely and to understand the nature of his obses-
sion.

These letters make it clear that Kokoschka demanded the impossible.

He understood that the fetish would never move and breathe but he wanted it to look as lifelike as possible. For example, the wig "should not be made too quickly for it must be connected organically to the skin of the face and the tiny hairs around." The hair, like Alma's own, had to be "chestnut (Titian)."

—WHITFORD.

A letter of 20 August 1918 is representative of many others.

Yesterday I sent . . . a life-sized drawing of my beloved and I ask you to copy this most carefully and to transform it into reality with the application of all your patience and feeling.

Pay special attention to the dimensions of the head and neck, to the ribcage, the rump and the limbs. And take to heart the contours of body, e.g., the line of the neck to the back, the curve of the belly. I only drew in the second, bent leg so that you could see its form from the inside, otherwise the entire figure is conceived entirely in profile so that the major line from the head to the instep of the foot enables you precisely to determine the shape of the body. Please permit my sense of touch to take pleasure in those places where layers of fat or muscle suddenly give way to a sinewy covering of skin, e.g., on the shin-bone, the patella, the ends of the shoulder-blades, collar-bone and arm. You can see the . . . layering of the fat and muscles from the position of the white areas of paint which I have applied to show their natural location. The look of the head must be captured exactly and should accurately show that facial expression which I desire but never achieve. The belly and rougher muscle on the leg, back, etc., must be firm and textured! The woman should look about 35 to 40 years of age! Pay attention to the swinging of the arms and legs! The movement of the joints should correspond to the major movements in nature. *The figure must not stand!* For the first layer (inside) please use fine, curly horsehair; you must buy an old sofa or something similar; have the horsehair disinfected. Then, over that, a layer of pouches stuffed with down, cotton-wool for the seat and the breasts . . . initially in larger sewn pouches, but then in smaller and smaller layers until the form of the surface imitates nature. When the skeleton is ready perhaps you could bring it here together with the sketch so that we understand each other completely!

The skin will probably be made from the thinnest material available, either roughish silk or the very thinnest canvas and applied in very small areas. I am now trying to learn from a chemist whether it is possible chemically to treat silk so that it sticks to cottonwool without altering the structure or the appearance of the silk. . . . The point of all this for me is an experience which I must be able to embrace!

—WHITFORD.

Instructions like these were not all. Kokoschka also sent the seamstress samples of material and experimented with glues and compared various types of hair for verisimilitude. It must have required enormous powers of imagination and recall, to say nothing of the faith Kokoschka must have had in the skills of the craftswoman. He not only

needed to remember the most subtle details of Alma Mahler's naked body, he also had to describe them so clearly to the lady in Stuttgart that she was able to reproduce them from verbal descriptions and sketches alone.

By December 1918 she had progressed far enough for her to have her handiwork photographed. Although the doll remained unfinished, Kokoschka was "absolutely astounded by the uncanny vitality" the doll possessed, at least in the pictures. But he also had criticisms: "The hands and feet must be articulated more," he wrote, "take, e.g., your own hand as a model. Or think of a sophisticated Russian woman who goes riding. And the foot, e.g., like that of a dancer: Karsavina perhaps."

He left the craftswoman in little doubt about what he intended to do with the doll when it was ready. He admitted that he wanted to dress and undress it and said that he had already bought some beautiful clothes and underwear during a trip to Vienna. "Can the mouth be opened?" he asked, "And are there teeth and a tongue inside? I hope so."

If it were not for the evidence of these letters and of scores like them, the story of the making of the doll would be scarcely credible. The only explanation for this bizarre episode in Kokoschka's life is that his mind had become temporarily unbalanced.

By January 1919 he was daily expecting

the news from you that my beloved, for whom I am pining away, will soon be mine. Have you succeeded so well in your deception that I shall not be brought down to earth? . . . And does no one know about [the doll] apart from your sister? I would die of jealousy if some man were allowed to touch the artificial woman in her nakedness with his hands or glimpse her with his eyes . . . assure me that you have been able to achieve this glowing skin with the roughness of a peach, with which I have long since covered my desired love in my thoughts, and that the earthly traces of how it was made have either been eradicated thanks to the fortunate inspiration of a creative, erotic mood, or transformed into a new enrichment of the experience of happiness and voluptuousness. Color may only be applied by means of powder, . . . fruit juice, gold dust, layers of wax, and so discreetly that you can only imagine them . . . When shall I hold all this in my hands?

The doll was completed towards the end of February 1919 and it arrived in Dresden in a large packing case towards the end of March or at the beginning of April. Kokoschka's excitement may only be imagined as he removed the expensive creation and inspected it. But he was dreadfully disappointed. The many letters, the sketches, the tests and experiments, the care with which all the materials had been acquired had proved almost pointless. The doll did not look at all lifelike. The dream was shattered and the motionless dummy, its face rigid in a travesty of a human expression, seemed to mock its owner. Ko-

koschka wrote to the seamstress in Stuttgart on 6 April, "I was honestly shocked by your doll which, although I was long prepared for a certain distance from reality, contradicts what I demanded of it and hoped of you in too many ways."

Photographs of the doll exist and they make plain the reason for Kokoschka's disappointment. The face looks like a mask and the body is covered with what appears to be thick fur which ceases at the soles of the feet. It looks more like some legendary, half-human creature than a real woman.

Kokoschka nevertheless forced himself to make do with the travesty which had so miserably failed to make his fantasy flesh. He made paintings of it (the *Lady in Blue* in the Staatsgalerie Stuttgart is one of them), he made drawings of it, in most of which it appears in poses suggesting total sexual submission, and he took it for drives in a carriage, carried it into restaurants where he demanded that a place be laid for it, or took it with him to the theatre where it occupied the seat beside his.

Later, Kokoschka gave a party,

❏ . . . inviting all his friends to meet a new mistress. When they arrived, he explained that she would join them later. The supply of drink seemed endless; the music, provided by the chamber orchestra from the Dresden Opera, was appropriate to the Baroque surroundings and, since the weather was warm, the musicians played outside in the garden which was illuminated by flaming torches and where a fountain played.

According to Kokoschka, one of the guests was a celebrated Venetian courtesan who, as the evening progressed, became impatient to see the person in whose honor the party had been arranged. Finally Reserl appeared carrying the doll, presumably to the consternation of some of those present and the amusement of others. The courtesan was less surprised than curious and demanded to know whether Kokoschka slept with the doll and whether it looked like one of his former mistresses. Most of the guests were drunk by now and the doll was passed from hand to hand. Someone ceremoniously decapitated it and others doused it in red wine. Next morning the police arrived, investigating a report from the postman that there was a headless corpse in Dr. Posse's garden. The doll was eventually removed by the dustman.

—WHITFORD.

Diego Rivera
(1886–1957)

Always a man of the left, Rivera was a Communist who could not remain orthodox. People complained that he never arrived at Party meetings on time—and when he did arrive, he tried to run everything. As a good Communist, he knew that he should be expelled from the Party. An eyewitness describes an event of October 3, 1929.

❏ Diego arrived, sat down, and took out a large pistol and put it on a table. He then put a handkerchief over the pistol, and said: "I, Diego Rivera, general secretary of the Mexican Communist party, accuse the painter Diego Rivera of collaborating with the petit-bourgeois government of Mexico and of having accepted a commission to paint the stairway of the National Palace of Mexico. This contradicts the politics of the Comintern and therefore the painter Diego Rivera should be expelled from the Communist party by the general secretary of the Communist party, Diego Rivera." Diego declared himself expelled, and he stood up, removed the handkerchief, picked up the pistol, and broke it. It was made of clay.

—HAYDEN HERRERA, *Frida: A Biography of Frida Kahlo.*

He accepted the challenge, early in the Depression, to paint a mural for the ultra-capitalist Rockefeller Center. Ben Shahn, one of his assistants, remembered the artist's behavior.

❏ A newsreel crew had arrived one day when no painting was actually being done, and Rivera, when told to "Just make believe you're painting," had mumbled, "So sorry." "But Mr. Rivera, this delay is costing us seven hundred dollars an hour!" "So sorry . . ." Finally, he had agreed to pose with José Sert, the Spanish artist who was doing an innocuous "rich-man's" mural on the inside wall and who made a short speech for the radio audience on the significance of his panel. Wouldn't Mr. Rivera oblige by saying just *one* word? He would. "Merde!" . . .

—SELDEN RODMAN, *Portrait of the Artist as an American: Ben Shahn.*

❏ On another occasion when the artist really was busy, the Rockefel-
lers brought in some of their friends and he pretended not to under-
stand English. "Are you busy, Mr. Rivera?" "Yis, plis . . ." "Do you
mind if we stop awhile and look around?" "Yis, plis . . ." Jokingly,
then: "You wouldn't prefer to have us leave, would you?" "Yis, plis . . ."

—RODMAN.

Late in his composition Rivera could not resist adding the head
of Lenin, which had not formed part of the plan he submitted
to the Rockefellers. In 1933 the mural was destroyed.

 In the same year Rivera went to Detroit to paint murals at the
Detroit Institute of Arts. Edsel Ford was a member of the com-
mission that had invited him. They had a good time in Detroit.

❏ The Riveras were wooed by the wealthy supporters of culture and
entertained by the "right" people, but with less happy results. People
found Frida and her Mexican costumes bizarre, and she retaliated against
the narrow snobbism of Grosse Pointe matrons by being outrageous,
deliberately shocking the haute bourgeoisie. Invited to tea at the home
of Henry Ford's sister, she talked enthusiastically about communism;
in a Catholic household, she made sarcastic comments about the Church.
Coming home from one or another lunch or tea organized by various
commitees of society women, she would shrug her shoulders and, trying
to make up for a dull day with a lively recounting of it, would tell how
she had used four-letter words and expressions such as "Shit on you!"
while pretending not to know their meaning. "What I did to those old
biddies!" she would say, laughing with evident satisfaction. Once, when
Frida and Diego returned after spending an evening at the home of
Henry Ford, whom Frida knew to be an avowed anti-Semite, Diego
burst into the apartment chortling heartily. Pointing to Frida, he cried,
"What a girl! Do you know what she said when there was a quiet mo-
ment at the dining room table? She turned to Henry Ford, and she
said, 'Mr. Ford, are you Jewish?' "

—HERRERA.

Rivera was notoriously a philanderer, and had an affair with his
wife Frida's sister. "If I loved a woman," he said in his autobiog-
raphy, "the more I loved her the more I wanted to hurt her.
Frida was only the most obvious victim of this disgusting trait."

 Rivera was extraordinarily fat, unable to buy clothes that fit;
Frida had enormous underwear manufactured for him in bright
pink cotton. He liked Frida to baby him.

❑ One of the happier moments in the day was his bath. As a school-girl, Frida had told her friend Adelina how much she liked Rivera, how much she would love to "bathe him and clean him!" Her wish was granted, for like his earlier wives, she discovered that he needed en-couragement to take a bath. She bought various toys to float in the bathwater, and scrubbing her husband with sponges and brushes be-came a household ritual.

Like any child, when Diego did not get what he wanted he made a fuss. Antonio Rodriguez remembers an occasion when he went to see Frida, accompanied by his youngest son, "whom she treated with great affection." Diego was not there. Frida gave the child a toy, "one of those tanks that arrived in Mexico during the war, saying 'keep it hid-den, because if Diego comes and sees you playing with it, he will get angry or take it away.' My son did not pay attention to her, and he kept on playing with it. When Diego arrived, and saw my son with the toy, he made a face like a little boy almost crying, and said to Frida: 'Why do you give me things and later take them away?' Frida said, 'I'll give you another one. I'll buy another.' But Diego left the room murmur-ing, 'I don't want anything anymore.' He was almost in tears. It was as if he were really a child."

—HERRERA.

When he was an old man he told Alexander Eliot, "I do not believe in God, yet I believe in Picasso."

❑ "Crazy capitalist dupes," Diego went on, "have dared to mutilate my fresco at the Alameda Hotel. But not because they failed to under-stand it! No, they got my message very well. I put three words in that fresco: *Dios No Existe!* God does not exist. Those words alone drove my enemies mad. They went too far this time. Tomorrow you will see ten thousand Red Indian atheists come marching into Mexico City. My friends are coming from hundreds of miles around to demonstrate for me!"

—ALEXANDER ELIOT, *The Atlantic*, October 1972.

Alexander Archipenko
(1887–1964)

He was the first sculptor to carve a hole through a representa-tion of the human body. He remembers an incident from child-hood.

❏ Archipenko remembers his parents bringing home two identical vases. He said that as he looked at them, he was seized by the urge to place them close to each other. No sooner had he done this, he discovered a third, immaterial vase formed by the space between the first two.
—KATHERINE MICHAELSEN AND NEHAMA GURALNIK, *Alexander Archipenko.*

Born in Russia, he never settled down until he became an American citizen in 1928. He was rebellious before the time of rebellion.

❏ He was expelled from art school in Kiev, where he was born, because he and his friends opposed its academic conservatism; in Moscow he belonged to a small group of progressive artists who held exhibitions together; and in Paris he left the Ecole des Beaux-Arts in disgust after only two weeks. Archipenko recalls that he began making sculpture in 1904. While still at art school in Kiev, he received his first commission from a wealthy Polish landowner. After making the sculpture for his patron, Archipenko took the opportunity of staging a small exhibition in a store in the neighboring village. This being 1905, the year of the first Russian revolution, his first visitor was a police officer who demanded to know why the sign at the entrance stated that admission for workers and peasants was cheaper, and pointing to a painted sculpture titled *The Thinker,* asked what he was thinking about and why he was painted red.

—MICHAELSEN.

"If you don't like garlic," he was wont to declare, "you can't understand modern art."

Jean Arp
(1887–1966)

His mother was German and his father French. In 1915, not wanting to join either army, he went to Switzerland.

❏ There he was notified by the German consul that the Reich considered him a German subject—Strasbourg, his birthplace, belonged to Germany then—and therefore subject to deportation and conscription

into the German Army. At the preliminary examination in Zurich, he was asked to fill out a form containing about 30 questions, the first of which referred to his date of birth. Arp wrote the date—16/9/87—in the space provided, put down the same figure in answer to all the other questions, and then drew a line at the bottom of the page and added up the entries. Solemnly removing all his clothes, he handed the form to a startled official, who urged him to get dressed and go home. Arp was not bothered again.

—CALVIN TOMKINS, *The World of Marcel Duchamp.*

Original, idiosyncratic—painter, sculptor and poet—if Arp belonged to a group, it was a group as anarchic as Dada. His friend Richard Hulsenbeck remembered him.

❏ There is another characteristic of Arp which should not be forgotten—his playfulness and a certain childlike joy, his wistful understanding of embarrassing situations. Once after he had been a guest at one of the luxury hotels in St. Moritz, he told me, laughing, about something which had impressed him deeply. He had seen American women dancing without shoes. "Think of this," he said, "they get rid of their shoes and dance." "Why?" I asked. "It's very simple," he said, "because they dance better without."

—RICHARD HUELSENBECK, *Memoirs of a Dada Drummer.*

In 1938 he visited Peggy Guggenheim in England.

❏ Marcel Duchamp had helped me arrange a show of contemporary sculpture, and Arp who was one of the exhibitors came over to further it himself. Arp was very domestic about the house. He got up early and waited impatiently for me to wake up. He served me breakfast every morning and washed all the dishes. We had so much fun together and were so gay that it really was a delightful week. We went to Petersfield. Arp was enthusiastic about the English countryside and loved the little Sussex churches. He went back to Paris with a porkpie hat and a bread box under his arm. He knew only one word of English, "candlesticks." His vocabulary did not increase during his stay.

—PEGGY GUGGENHEIM, *Out of This Century.*

Friends from the time of Zurich Dada, during the Great War, Arp and Huelsenbeck met again in 1950 when Huelsenbeck returned to Europe from the United States.

❏ Arp's home was on a hill, at the end of an ascending street. The woods begin right behind it. Ancient trees, their high crowns swaying

against Arp's roof. Even if you weren't sure of where you were, you couldn't mistake the house, for suddenly, behind a normal fence, you caught sight of abstract sculptures, world eggs, universe breasts, space thighs. This was Arp, here's where the master lived. He settled here in 1926 with Sophie Taeuber, who died in 1943. In 1950, he still kept her clothes in his closets, and her paintings covered the walls.

—HUELSENBECK.

Marc Chagall
(1887–1985)

As a child in Russia he often spent school vacations with his grandfather who was a kosher butcher. On a feast day the grandfather disappeared, and the family found him sitting on the roof of their house eating carrots. Later the painter remembered his grandfather.

❑ Grandfather is in his stable with a big-bellied cow: she is standing. She looks stubborn.

Grandfather approaches and speaks to her:

"Heh, listen here, let's have those legs, I have to tie them, people need merchandise, meat y' understand?"

She collapses with a sigh.

She hears the rustling of rye and behind the hedge she sees the blue sky.

But the butcher, in black and white, knife in hand, tucks up his sleeves. One scarcely hears the prayer as, drawing taut her neck, he plunges the blade into her throat.

Pools of blood.

Impassively, the dogs, the chickens standing round await a drop of the blood, a morsel fallen by chance to the ground.

One hears only their clucking, their rustling and Grandfather's sighs amidst the jets of fat and blood.

And you, little cow, nude and crucified, in the heaven you dream. The resplendent knife has lifted you up into the skies.

Silence.

The intestines twine and the cuts of meat are separated. The skin peels off.

Rosecolored blood chunks glide. Steam mounts into the air.
What a craft to hold in one's hands!
I want to eat meat.
Thus, every day two or three cows are killed and fresh meat is made
available to the proprietor of the domain and the other inhabitants.
—SIDNEY ALEXANDER, *Marc Chagall: A Biography* .

Interviewed in 1958, Chagall told how he became a painter:

❑ In our little milieu of workers and artisans of a ghetto province,
we scarcely knew what an artistic career might be. In our house there
wasn't a single painting, not a single engraving on the walls of the rooms.
At most we had some photographs, memories of the family. At Vitebsk
up to 1906 I had never in my life seen drawings or paintings. But one
day in the communal school I caught one of my comrades as he was
copying with a pen an illustration from a magazine. This boy was my
enemy, the best student of all, but also the most wicked, the one who
persecuted me the most, and mocked most cynically at my dreamy look,
my *schlemiel* behavior, the dunce of the class. In seeing him draw I was
absolutely flabbergasted. For me this was a vision, an apocalypse in black
and white. I asked him how he went about it. "Imbecile," he replied,
"go find a book in the library, choose an image which pleases you and
copy it."

—ALEXANDER.

When he was young, he climbed on the kitchen stove to paint.

❑ His family was afraid he would soil everything with his colors. Only
perched up on the stove among the barrels and the clucking of chick-
ens, it was only there that he did not annoy anyone around him, hand-
ing the paintings down to his sisters, who spread them out on the new-
washed brick floor.

—ALEXANDER.

He married Bella Rosenfeld in 1915. While still his fiancée, Bella
posed nude for him, a most daring act.

❑ The next day when his mother came to his studio, she saw the
study: ". . . a naked woman, her breasts, her dark blot."
Marc was ashamed, his mother too.
"Remove that girl!" she exclaimed.
"—Little Mamma! I love you too much. But . . . Haven't you ever
seen yourself nude? And I just looked. I only drew her. That's all."

But I obey my mother. I remove the picture and instead of that nude,
I make another painting, a procession.

—ALEXANDER.

In 1931 the French poet Jules Supervielle brought the Spanish
poet Rafael Alberti to Chagall's house.

❏ "It was about five in the afternoon. There was still sunshine and
shadow in the garden where Chagall was painting his beautiful daugh-
ter Ida completely nude in the woods under a tree."

Alberti's eyes grew misty.

In 1931 Ida was fifteen. Undulant, full-figured, she had reddish hair,
her father's green-blue eyes, a ravishing smile.

"Oh, that girl was so beautiful it was a spectacle to see her under the
trees that way. Certainly there was nothing erotic about it, nothing im-
proper. One saw her as a model—perhaps too young—posing for her
father. And her father had no false shame about it and neither did
she. . . ."

Chagall laughed, Alberti remembers. "He was a bit pagan, you know,
a bit of a fawn, a satyr. He certainly wasn't religious in any sectarian
sense. No. He was a man truly open, free. He just laughed."

Alberti spoke about the famous photograph published in *Cahiers d'Art*
showing the adolescent girl posing nude for her father. "Oh, he did
that purposely. It created some scandal but Chagall didn't care; he just
laughed."

—ALEXANDER.

Bella died in 1944. Chagall lived with Virginia McNeil for seven
years; they had a son but never married. After Virginia ran away
with a photographer, he met Valentina Brodsky, who became his
housekeeper and then his wife. It was she who concluded Cha-
gall's 1958 interview with Edouard Roditi:

❏ It was at this moment that Madame Chagall came in to interrupt
us, to remind her husband that he had an appointment at the dentist's.
In the blink of an eye, with the rapidity of an acrobat, the great man
stretched out on the blue divan was on his feet in the middle of the
room, suddenly transformed into a sort of marvelous clown of the same
type as Harpo Marx or Charlie Chaplin. While Madame Chagall asked
him if he had enough money on him to pay for the taxi, he replied
patting his pockets: "Yes yes, but where are my teeth?" Then tapping
his jaws: "Ah! Here they are." Then he brusquely departed.

—ALEXANDER.

He liked to say, "Me, I do not understand Chagall."

Chagall and Picasso did not always get along. Chagall worked on his own pottery in Picasso's factory, but Picasso found him deficient in technique. One day in his absence Picasso finished a Chagall sketch in Chagall's manner. Françoise Gilot recollects some sarcasm as Picasso addressed Chagall.

❑ "My dear friend," he said, "I can't understand why, as a loyal, even devoted, Russian, you never set foot in your own country any more. You go everywhere else. Even to America. But now that you're back again and since you've come this far, why not go a little farther and see what your own country is like after all these years?"

Chagall had been in Russia during the revolution, and had been a commissar of fine arts in Vitebsk at the beginning of the new regime. Later, things went sour and he returned to Paris. In the light of that experience, he never had any desire either to return to his country or to see the regime flourish anywhere else.

He gave Pablo a broad smile and said, "My dear Pablo, after you. But you must go first. According to all I hear, you are greatly beloved in Russia, but not your painting. But once you get there and try it a while, perhaps I could follow along after. I don't know; we'll see how you make out."

Then suddenly Pablo got nasty and said, "With you I suppose it's a question of business. There's no money to be made there."
 —FRANÇOISE GILOT AND CARLTON LAKE, *Life with Picasso.*

Gilot records a later remark from Chagall. "What a genius, that Picasso," he said. "It's a pity he doesn't paint."

Frederick Prokosch bumped into the old painter in Venice.

❑ I was having my breakfast one day on the hotel terrace. It was a crisp, brilliant morning and everything sparkled. The mooring posts glistened like freshly painted barber poles. The *motoscafi* churned past the church of the Salute and a distant *vaporetto* was moving toward the Lido. I broke my toast into crumbs and tossed them into the water. I didn't see any fish but it didn't really matter. I kept tossing my crumbs to imaginary fish and I felt that I was participating in the life of the Grand Canal.

A man laid down his newspaper at the neighboring table. He had finished his coffee and was staring at the water. He seemed to catch sight of something strange in the water, floating idly among the ripples, which looked like molten bronze. He was a thick Jewish man with pouting lips, a bulbous nose, suspicious eyes, and an air of sweating immo-

bility. He looked like an elderly rug-seller who was trapped in a Turk-
ish bath.

He suddenly caught my eye and a grin of amusement crossed his
face. But then he looked uneasy again and turned away his head, as
though alarmed by the thought that I had guessed some guilty secret.
I said, "I own a print of your *Amants de la Tour Eiffel.* It cheers me up
whenever I look at it. It bristles with happiness. I especially like the
rooster. He looks so conceited."

"All roosters are conceited," said the painter gravely. "They have rea-
sons for being conceited. A rooster is very splendid. He exults and
crows and dominates. He is an emperor on his dung-heap."

"You like roosters more than swans? Have you never painted swans?"

"I much prefer the rooster. A rooster is an aristocrat. A swan is also
conceited but in a very bourgeois way. He tries to be an aristocrat but
he doesn't quite succeed. A swan is content merely to look at his own
reflection but the cock looks at the sun and sees his reflection in the
sun."

I said, "Picasso likes roosters but he seems to have abandoned them.
He likes bulls better than roosters. They have a bigger, blacker virility."

"He has abandoned us all. He has crawled back into a shell. It's a
very fine shell but a shell is still a shell."

His face seemed to swell with childlike reproachfulness. There were
soft, greedy lines on his sweating cheeks but they were not the wrinkles
of age or the creases of wisdom but the pure, gentle lines on the face
of a giant infant.

"But he is still a great genius, wouldn't you say, in spite of every-
thing?"

"When a talent reaches a point of such abundance you can call it
genius."

"But you say that he has abandoned us. What do you mean? How
has he abandoned us?"

"In his innermost heart Picasso has betrayed himself. Yes, Picasso has
been guilty of a very special treachery. I refer not to the communism,
for I am indifferent to all politics. I refer to the humanity, for the man
had a great humanity. But now he has crawled back into his shell and
defies humanity. There are times when it strikes me that Picasso is a
failure. There is an arrogance, like a rooster's, in flaunting all that tal-
ent. I love roosters, as I say, but art is more than being a rooster. It
must aim at something higher and yet humbler than a rooster."

I have forgotten exactly why Marc Chagall had come to Venice. It
may have been the Biennale or perhaps it was something else. As he
sat there in the sunlight, sweating among his indignations, he seemed
quite unaware of and indifferent to Venice: to the glittering canal and
the dappled white clouds and even to the sweetness and solicitude of

the Salute. He scratched his head absently and scowled at his newspaper.

He took out his wallet and studied a slip of paper. Then he tucked it back in the wallet and laid the wallet on top of the newspaper.

At that moment a gust of wind swept the paper from the table and carried it off over the Grand Canal. The wallet slid away, green and sleek, like a frog. It leered at the sun and dove nimbly into the water.

Chagall sprang to his feet and waved his arms with horror. I ripped off my jacket and jumped into the water and snatched at the wallet as it spiraled into the depths. A minute later I was clutching at one of the gilded barber poles and the hotel *ganzèr* helped me climb back on the pier.

Chagall's ruddy face broke into a big delighted grin. "What a clever man you are! How very quick! How very athletic! And you did it all so cheerfully! It was very gay and very amusing! Come, dry yourself in the sun and I shall draw a little sketch for you."

I watched hm draw a rooster on the back of the menu and over the rooster he drew a big, blazing sun, and in the middle of the sun he drew a reflection of the rooster.

I remember him still: the playful joy in his eyes, a joy which was spiced by an old Hebraic cunning and darkened momentarily by an old Hebraic sorrow. Chagall was still as remote from me as a child playing with pebbles on the shore of an ancient and undulating sea, but the joy in his eyes, tinged with sorrow and cunning, was as eternal in its way as the sun over the Salute.

—FREDRIC PROKOSCH, *Voices: A Memoir.*

Marcel Duchamp
(1887—1968)

The most famous single painting in the twentieth century comes not from Picasso or Matisse but from Marcel Duchamp: the celebrated—denounced, parodied, endlessly discussed—*Nude Descending a Staircase,* the scandalous success of the great Armory Show of 1912 in New York. (Someone suggested at the time that the Armory Show be suppressed as a menace to public morality.) The most commonly quoted descriptive phrase for the painting was "an explosion in a shingle factory." Forty-five years after the

Armory Show, X. J. Kennedy wrote a poem named for the painting.

> Toe upon toe, a snowing flesh,
> A gold of lemon, root and rind,
> She sifts in sunlight down the stairs
> With nothing on. Nor on her mind.
>
> We spy beneath the banister
> A constant thresh of thigh on thigh—
> Her lips imprint the swinging air
> That parts to let her parts go by.
>
> One-woman waterfall, she wears
> Her slow descent like a long cape
> And pausing, on the final stair
> Collects her motions into shape.

Duchamp is famous for painting and more famous for not-painting, for appearing to retire from artistic endeavor and playing chess instead. One critic called him "Picasso's conscience"—for every time Picasso painted a picture, Duchamp refrained from painting one.

There is no doubt which of his many gestures remains the most celebrated.

❏ In 1913 he produced the first of a series of objects to which he would later give the term "readymades"—manufactured items raised to the level of works of art by the mere fact of the artist's having chosen and signed them. The first was a bicycle wheel, inverted and attached by its fork to a kitchen stool, where it could be set in motion by anyone who felt like turning it. The second was a bottle-drying rack that he bought in a Paris bazaar, and inscribed with a phrase that is forever lost to art history because the object was thrown out when Duchamp went to New York in 1915, and he could never remember afterward what he had written.
 —CALVIN TOMKINS, *Off the Wall: Robert Rauschenberg and the Art World.*

❏ Duchamp once instructed himself to "limit the number of ready-mades yearly," so as to avoid turning them into an artistic activity, and he either kept them in his studio or gave them away to friends. "I never intended to sell them," he said. "The readymades were a way of getting out of the exchangeability, the monetarization of the work of art, which was just beginning about then. In art, and only in art, the original work is sold, and it acquires a sort of aura that way. But with my readymades a replica will do just as well. I never even showed them until a few

years ago, except for one exhibition at the Bourgeois Gallery in New York in 1916. I hung three of them from a coat rack in the entrance, and nobody noticed them—they thought it was just something someone had forgotten to take out. Which pleased me very much."

The real shocker, though, was the readymade that Duchamp and Joseph Stella sent in anonymously to the hanging committee of the 1917 exhibition of the Society of Independent Artists, of which Duchamp was a founding member. This was the notorious *Fountain,* a porcelain urinal turned upside down and signed, "R. Mutt." The hanging committee refused to exhibit this item, although the Society had supposedly pledged itself to show any work by any artist who paid the six-dollar fee. Duchamp argued the case soon afterward in *The Blind Man,* an ephemeral little magazine financed by Arensberg and Roché and edited by Duchamp. "Whether Mr. Mutt with his own hands made the fountain or not has no importance," he wrote. "He CHOSE it. He took an ordinary article of life, placed it so that its useful significance disappeared under the new title and point of view—created a new thought for that object." As for the moral objections, Duchamp pointed out that similar fixtures were seen every day in plumbers' show windows and added succinctly, "The only works of art America has given are her plumbing and her bridges."

—CALVIN TOMKINS, *The Bride and the Bachelors.*

Duchamp invented more than anyone else, especially overseeing the re-entry of the brain into art. Many of his works are gestures that can be duplicated.

❏ Duchamp was clearly a Dadaist when he paid for one hundred and fifteen dollars' worth of dental work in 1919 with a beautifully fabricated check drawn on "The Teeth's Loan and Trust Company, Consolidated," and his dentist, Daniel Tzanck, was equally a Dadaist when he accepted the forgery and later sold it back to Duchamp for a much larger sum. Nor could Dada's loudest sallies improve upon the quiet savagery of Duchamp's 1919 "corrected readymade," a photograph of the Mona Lisa with mustache and beard. As Duchamp explained, "The Gioconda was so universally known and admired, it was very tempting to use it for scandal. I tried to make that mustache very artistic. Also, I found that the poor girl, with a mustache and beard, became very masculine—which went very well with the homosexuality of Leonardo." The title he chose heaped a further indignity upon the world's most famous painting. Duchamp called his version L.H.O.O.Q., letters meaningless in themselves but whose sound, pronounced phonetically in French, becomes *"Elle a chaud au cul."*

—*The Bride and the Bachelors.*

He is full of puns, visual and audible.

❑ Duchamp felt the need for a change of identity. The fact that he
chose a female alter ego, "Rrose Sélavy," and even had himself photo-
graphed by Man Ray in a woman's clothes to signalize the event, puz-
zled a number of his friends and doubtless gave rise to considerable
psychoanalytic speculation. Duchamp's own explanation is characteris-
tically free of logic. "It was sort of a readymadeish action," he said. "I
first wanted to get a Jewish name, which I thought would be very good
in view of my Catholic background. But I didn't find one. Then the
idea jumped at me, why not a female name? Marvelous! Much better
than to change religion would be to change sex. 'Rose' was just the
corniest girl's name at that time in France, and Sélavy, of course, is *c'est
la vie*. The two r's in Rrose came about the next year, when Picabia did
a painting called *The Cacodylactic Eye* that he wanted all his friends to
sign. In signing I wrote the word *arroser*, and the two r's in that gave
me the idea of keeping them in the name." Rrose Sélavy soon appeared
in a readymade, as the woman of fashion on the label of a perfume
called "Belle Haleine—Eau de Voilette" ("Beautiful Breath—Veil Water"),
and a photograph of this new work served as the cover for still another
Duchamp-edited magazine, called *New York Dada*, whose one and only
issue contained, among other items, a manifesto by Tzara and a car-
toon by Rube Goldberg.

 —CALVIN TOMKINS, *The World of Marcel Duchamp*.

Some of his artistic endeavors led him directly away from art.

❑ He spent some time perfecting a system of playing roulette in which
"one neither wins nor loses," and formed a one-man company to ex-
ploit the system at Monte Carlo. His "capital" came from the sale of
stock certificates designed by Duchamp and bearing his image, in a
photo by Man Ray that showed him with his long hair soaped into a
pair of horns—the certificates, signed by Rrose Sélavy as Chairman of
the Board, are now extremely valuable.

 —*The World of Marcel Duchamp*.

The less new work he did, the more attention he received. There
was a late show in Pasadena.

❑ During the official opening of the Pasadena show, for example, he
spent one whole morning signing replicas of his work—readymades,
prints, exhibition posters, and the like. He signed and signed, smiling
all the while and looking, according to Richard Hamilton, rather pleased
with himself. When the job was finished Duchamp touched Hamilton's

arm and said softly, "You know, I like signing all those things—it *devalues* them."

—*The Bride and the Bachelors.*

Artists were impressed, but not necessarily the public at large.

❏ When Rauschenberg and Johns went down to see the Philadelphia installation, they found the Duchamp gallery momentarily deserted. Rauschenberg could not restrain a sudden impulse to steal one of the marble cubes from *Why Not Sneeze?*, an "assisted" readymade in the form of a metal birdcage partially filled with marble pieces cut to resemble lump sugar. People regularly stole the thermometer that protruded through the bars of the same piece, and it was just as regularly replaced. As Rauschenberg was reaching into the birdcage, a museum guard suddenly appeared and asked him what he thought he was doing. Rauschenberg tried to explain—he had heard that the cubes were marble, he just wanted to make sure . . .

"Don't you know," the guard said in a bored tone of voice, "that you're not supposed to touch that crap?"

—*Off the Wall.*

Juan Gris
(1887–1927)

He worked at the Bateau Lavoir, after its salad days, until about 1922. The dealer Daniel Kahnweiler remembered early impressions.

❏ Crossing the square before entering the Bateau Lavoir, I would often notice the tenant of the studio whose door opened into the corridor to the left of the entrance way of 13 rue Ravignan. In the spring and summer, he would open the two windows that looked out over the square and set himself up to work in front of one of them. He was a very young man; I thought he was handsome. He had very dark hair and an olive complexion. Even more than the Spanish type, he embodied the Creole type, that is to say, almost mulatto. His most striking features were his large, dark-brown eyes.

Picasso told me that was Juan Gris, whose signature I had seen under the illustrations in *l'Assiette au Beurre, Le Cri de Paris, Le Charivari,* and

later on, in *Le Témoin*. I learned that Gris had begun to devote himself
to painting. I got into the habit of visiting him each time I passed by.
He was incredibly vigorous in his work. The remark that Max Jacob
attributes to him must have dated from this period: "I always pet a dog
with my left hand, because if he bit me, I'd still have my right hand to
paint with."

<div align="right">—JEANINE WARNOD, *Washboat Days.*</div>

Kahnweiler and Gris became close, and Kahnweiler remembered
tempestuous moments.

❏ He had terrible rages, which did not last long. There was a certain
scene, which the two of them often told me about. Josette and Jean (we
called him Jean) loved each other very much, but there were fights.
One day Josette was in bed waiting for Jean to bring her *café au lait.*
Jean arrived with the saucer, the cup, the *café au lait,* and the *croissant*
lying prettily across the cup. He said, "Here is your *café au lait,* Jojo."
She answered, "I don't want it." "Yes, you do, my Jojo, you must have
your *café au lait.*" "No, no, I don't want it, leave me alone." "So you
don't want it? *Merde!*" roared Gris, overturning the cup and pouring
the hot coffee onto the head of Josette, who, completely inundated
with coffee and with the wet croissant on her head, first cried and then
laughed with him.

<div align="right">—DANIEL-HENRY KAHNWEILER, *My Galleries and Painters.*</div>

He remembered gaiety as well.

❏ Gris loved to dance, and since he did everything very seriously, as
we used to say, he used to buy those little booklets that were published
in those days and teach himself the new dances, which at that time were
the tango and dances of that kind.

<div align="right">—KAHNWEILER.</div>

His friends emphasize the gaiety and the charm. "Give me a
branch to perch on" he said to Jacques Lipchitz, "and I will sing
like a bird on it." Lipchitz called him "the gayest of men" but
then spoke of his "fits of terrible and sudden violence. We didn't
know how sick he was." Kahnweiler speaks of Gris's "tremendous
laugh" that "could shake a whole row of any cinema which was
showing a Charlie Chaplin. . . ."
 In 1944, Lipchitz wrote recollections for the catalog of an ex-
hibition.

❏ Gris was very shy and modest. Once at an elaborate private dinner, he did not get enough to eat and so turned to the butler timidly and whispered, "un sou de pain, s'il vous plaît" as though he were ordering bread in a cheap restaurant.

—JAMES THRALL SOBY, *Juan Gris.*

Gris said of himself that he was a "good workman." "My work may be bad 'great painting,' but at any rate it is 'great painting.' "

L. S. Lowry
(1887–1976)

Lowry lived with the burden of having been born a large clumsy boy rather than the girl his parents had wanted. His mother thought that both he and his paintings, through which he hoped to please her, were ugly. When in 1939 A.J. McNeill Reid decided to give him a one-man show at the exclusive Lefevre Gallery, it seemed that he could finally gain her approval.

❏ Publicly Lowry said: "I had some very good notices of that show and it made me feel that I had justified myself to my mother. . . . She was the only one left." But privately he admitted: "And then Reid had a show and my mother couldn't understand it." At home the show had changed nothing; and his mother's assessment of him was his assessment. Having been raised in the belief that she had an instinctive eye for beauty, he acknowledged her judgment to be true and valid. If she saw only ugliness in what he did, then ugliness there must be, despite what others said; only her conversion to his vision would bring him fulfillment.

—SHELLEY ROHDE, *A Private View of L. S. Lowry.*

After his father's death, she took to her bed to demonstrate her disappointment with her life. Lowry nursed her for seven and a half years until her death at eighty-two. "After her death he locked her room and, a full year later, painted a picture of it from memory: a sterile, empty room with an empty bed draped with a counterpane of purest white."

When he was in his eighties himself, he said of his painting:

❑ It was the only thing I had to do. I worked to get rid of the time, even now I work for something to do. If things had been natural as they were years ago I wouldn't have done the paintings. My mother's death did it. I feel it yet . . . I miss her yet. To be perfectly honest, I've not cared much about anything since she died. I've nothing left and I just don't care. Painting is a wonderful way of getting rid of the days.

—ROHDE.

He painted the industrial landscape of England's north, most especially Manchester. As a young man he had preferred to paint the countryside. Then one afternoon in 1916 he missed a train.

❑ I remember that the guard leaned out of the window and winked at me as the last coach disappeared from the platform. I was very cross about that. I went back up the steps. It would be about four o'clock and perhaps there was some peculiar condition of the atmosphere or something. But as I got to the top of the steps I saw the Acme Mill, a great square red block with the little cottages running in rows right up to it—and suddenly, I knew what I had to paint.

—ROHDE.

In 1919 he took employment as a collector of rents.

❑ It was a fortuitous change of employment; he was no longer condemned to the dreary monotony of five days a week confined to a desk—and he had landed with a firm of exceptional indulgence. "As long as his work was done, no one ever queried the hours he kept or the time he spent out of the office. No one ever remarked on the fact that it took him nearly three days to collect rents which could have been gathered in much less than two; or that he was frequently late; or that he spent much of his time drawing portrait heads on the back of office notepaper." After the impersonal bustle of General Accident, the Pall Mall Property Company was, for a man of noted shyness and little dedication to the world of commerce, a particularly pleasant place in which to work. "When you started they told you that, as long as you did not fiddle the books or pocket the rents, you had a job for life."

And that is exactly what Lowry got: a job for life. He stayed with the company until 1952, retiring at the age of sixty-five with a pension of £200 a year. He gave his colleagues no opportunity for an emotional send-off. "I'll not be in tomorrow," he announced casually after forty-two years.

—ROHDE.

When two of his paintings received an honor in the 1930s, a Manchester newspaper mentioned Lowry's rent-collection profession; he was furious. From that moment on he took pains to conceal his employment. A friend of his, who knew what Lowry had done, tried to jar the truth loose by telling a lie—and only generated Lowry's answering lie.

❑ "I've an idea, I don't know why, this may be all haywire, but I've had an idea that you were probably doing something in the estate way that took you out and around and got you into houses, and saw some of these interiors. You've always had a very accurate knowledge of streets and places."

"Well, for many years—in fact until about ten years ago—I used to rummage around all the back streets of every town I went to. Oh yes, and in Pendlebury I did a lot of that."

"But this was just mooching around?"

"Well, yes. I helped people. I had a friend, he died some years ago when he was ninety-one years of age, who I liked and I did a lot for him."

"What sort of stuff?"

"He was in the accountancy business. . . . In fact, I did feel that . . . I was going through a phase and I intended . . . really, if I could have got the industrial scene out of my mind, of joining a friend and going for the stockbroking."

—ROHDE.

Lowry never married. He seems to have invented stories of a lost love. Her name and the details changed over the years. Sometimes she was Ann and sometimes Maud. If Lowry's stories are suspect, his friendships with several young women whom he referred to as his god-daughters were an important aspect of his life. After his death Carol Ann Spiers, the last of his god-daughters and his heir, discovered a dark side of her courtly Uncle Laurie.

❑ In a state of some curiosity and a certain trepidation, which had somehow communicated itself from the executors to the heiress, Carol presented herself at the bank. Ceremoniously she was taken to the vaults where, with much embarrassment, a collection of unseen Lowry works was revealed to her.

There were drawings and paintings, some meticulously finished, some barely begun, of a young slender girl, her dark hair drawn into a single plait. She is dressed as a ballet dancer, a doll, a puppet, her costume

cut low to reveal the sensuous curve of her breasts or the dark shadow of her nipples. Some are delicate, tender, innocent; others violent and bloody; in one her head is severed from her body with a mighty sweep of an axe, in another with a sword, in yet another with a knife. In one she is prostrate beneath a guillotine, her head half-separated from her body. In some the collar of her grotesque costume is monstrously huge, like an instrument of medieval torture, so that it strangles her, twisting her head into attitudes of agony. She is always alone, the presence of a man only occasionally indicated by the hand that wields the weapon. Only in one oil is another presence suggested, a shadowy, ghostly shape who stands behind, less an observer than a puppet-master, a man who pulls the strings.

As she stared silently, almost in shock, Carol, the girl he had protected from "naughty things," felt herself flushing, silently appealing: "Oh no, not Uncle Laurie. Please, dear God, not from Uncle Laurie." Then, with an awful chill of sudden recognition, she felt herself go cold, the tiny hairs on the back of her neck bristling at the thought: "My God, it's me. They are me." She had observed, on at least two of them, her own distinctively retroussé nose, the unmistakable upward tilt that distinguished the profile of the tortured girl from the more classic features of the Coppelia-figure throttled by her theatrical yoke. She felt her blushes deepen and glanced surreptitiously at the two men to see if they had seen what she had seen; their faces were official, impenetrable.

—ROHDE.

There were other anomalies.

❏ . . . in an otherwise conventional picture he managed quite unwittingly to give a dog five legs. . . . His tailor, Albert Denis, had spotted the peculiarity of the animal when viewing the picture in the window of an art shop off St. Anne's Square; he rushed to confront the artist with his discovery, encountering on the way young Cliff Openshaw. Together the two men dragged Lowry to the shop window. "Well, I never," he remarked, surprised yet obviously pleased that the picture had gone into print without the mistake being spotted. "And to think I checked it most carefully before I let it go. All I can say is that it must have had five legs. I only paint what I see, you know."

—ROHDE.

Frequently it was the people in Lowry's paintings who were not ordinary. His friend David Carr describes an experience which convinced him that Lowry did not seek these people out, he simply saw them everywhere.

❑ On a visit to Mottram he examined the new work with fascination, suggesting a refinement of deformity here, an adjustment of maladjustment there. Then, standing back for a final assessment of a half-finished canvas, he remarked lightly that he could not seriously believe that his friend had ever seen in one place so many grotesque variations of the human form. "Right," said Lowry, grabbing his hat and propelling his friend to the car, "I'll show you." He described that trip later to an incredulous Gerald Cotton. "We started about three in the afternoon in Picadilly Gardens. Up Oldham Street we saw a man on a trestle. 'That's only one,' he said. Then a while on we saw an old gentleman being helped on to a bus, then a man with one leg, then a man with one arm and, I am ashamed to say, I was quite pleased." Between Manchester and Rochdale that day they counted 101 memorable figures. A few weeks later, on an excursion to Bury alone, Lowry failed to match that total, observing a mere ninety-three; but, as he excused himself to Carr, "I can't easily look on both sides, you must admit. On that first journey you took one side and I the other which is an advantage." The picture, he reported, was coming along well: "I have operated on one of the gentlemen in the far distance and given him a wooden leg—I think you would approve. I still laugh heartily at the hook on the arm of the gentleman; that suggestion of yours was a master stroke."

—ROHDE.

When he became a member of the Royal Academy, a reporter challenged him on the conflict between his ideals as a painter and his membership in this institution. Lowry answered that it was good for business. He liked to annoy Academicians by asking them, "How's trade?"

He surely intended to be a good businessman:

❑ A printmaker, he said, had made an arrangement with him to pay the sum of £5 per signature on a special issue of one of his pictures. When the dealer arrived a cheque was handed over which, the artist quickly noticed, worked out at only £3 a print. Without a word Lowry began to sign each one. After a while the dealer glanced over his shoulder and saw, with horror, that he had signed his name L. S. Low. "What are you doing?" the dealer demanded. "That," said Lowry, "is a small signature for a small fee. When I get the other £2, you will get the other two letters." The checque was immediately adjusted.

—ROHDE.

When he was old he suffered from popularity.

❑ He opened the door to whoever chose to call. He had learned that to accept intrusion as inevitable was less trouble than trying to evade it.

And he had yet another tale to illustrate that point: "One day a friend came in and I said: 'I'm awfully sorry, but I've got to go to London.' I wasn't really, but I wanted to be alone. And I made a dreadful mistake. I said: 'I'm going now, on the twelve o'clock train.' 'Oh,' he said, 'I'll run you to the station.' 'Oh no,' I said, 'don't bother.' 'I will bother,' he said. 'I'll run you to the station.' So I collected a bag and stuffed some very heavy books into it and dragged it into his car. We got to the station approach and he stopped the car. 'Well,' I said, 'thank you very much. It really was most kind.' 'Oh, I'll see you off,' he said. I thought, what am I going to do here? Oh, my God. So I went into the station with him and I said: 'Look here, would you go and get me a *Times* and a *Manchester Guardian?*' He did—and I darted to the booking office and bought a third-class ticket to Stockport [the first stop in the Manchester–London train]. When he came back I said: 'Well, thank you.' 'Oh,' he said, 'I'll see you off.' 'But someone might pinch your car.' I said. 'Well, what of it?' he said. 'It's well insured.' What can you do with a man like that? So I got in the carriage and he did too and I was perspiring in case he should want to come to London. But then they blew the whistle and he said: 'Well, I'd better get out now,' and he got out and I heaved a sigh of relief, my word I did, and I waved to him joyously as he went. Oh, I was thankful. I dragged that ridiculous bag down to the taxi rank and for the first time ever there wasn't a taxi there and I had to drag it down to a bus about half a mile away. That taught me. I'll never do it again. Never go into detail."

—ROHDE.

Georgia O'Keeffe
(1887–1986)

When she was young she worked as a commercial artist, and it is claimed that one of her inventions is the girl wearing a bonnet raising a broom against dirt in the name of Dutch Cleanser.

In 1916 O'Keeffe's friend Anita Pollitzer showed some O'Keeffe charcoal drawings to Alfred Stieglitz, who famously responded: "At last, a woman on paper!" They corresponded; Stieglitz showed her work, at first without her permission. In 1918, she left Texas, at least partly because she expressed unpopular sentiments against the war.

❑ When Georgia wrote him that she was ill and had left her job, he urged her to visit New York. His devoted niece, Elizabeth Stieglitz, wrote Georgia long letters on his behalf, offering her the loan of her New York studio, which Stieglitz had been using as a darkroom. By April his feelings for Georgia were so intense that he moved his personal possessions out of the bedroom he shared with his wife and began to sleep in his study. The way he put it was that Georgia had become the living spirit of 291, and fighting for her was the same as keeping its spark alive. It seemed that the more Georgia hesitated about taking a trip to the East, the more Stieglitz became obsessed by its necessity. He anxiously fretted that she might have tuberculosis, that she wasn't painting, but he was indecisive about how to "rescue" her from the alien West. Finally, in May, he hit on the idea of sending youthful Paul Strand to Texas to fetch her. Stieglitz gave Strand, who had been in Texas in 1915, the money for train tickets and then waited in great suspense.

—LAURIE LISLE, *Portrait of an Artist: A Biography of Georgia O'Keeffe.*

Paul Strand fell in love with her, but when he brought her back to New York, it was clear that her feelings directed themselves elsewhere.

❑ Stieglitz brought Georgia to the bright little studio apartment of his niece, Elizabeth, who was living elsewhere. When Georgia had arrived in New York, she was tired and ill. Stieglitz ordered her to stay in bed, and had his brother, a well-known doctor, examine her. Stieglitz himself visited every day, and even learned how to boil eggs for her. He returned to his apartment after his wife was asleep. Within a week he was writing to Arthur Dove of Georgia's "uncommon beauty, spontaneity, clearness of mind and feeling, and the marvelous intensity with which she lived every moment." A month after her arrival, they had become lovers and Stieglitz was also living in the studio at 114 East Fifty-ninth Street, a blanket modestly hung between their sleeping quarters.

—LISLE.

The fifty-four-year-old Stieglitz brought his young love to his family's summer compound at Lake George. The family was astonished at the change in the dour Stieglitz.

❑ Some found it sweet that they headed for a row on the lake every evening after dinner; others complained that it was disgusting that their holding hands on the porch led them soon to more intricate convolu-

tions and suddenly to a mad dash into the house. In my day, seven years later, an occasional exchange of winks could trigger Georgia's blouse-unbuttoning sprint up the stairs and Alfred's laughing pursuit— and the red-faced elders' rush into conversation to stifle Peggy's and my childish questions.

—SUE DAVIDSON LOWE, *Stieglitz: A Memoir/Biography.*

As she painted he photographed.

❑ Alfred's eye became insatiable, feasting on the slender but voluptuous contours of his love. The need to photograph her became exigent; the studio skylight made it possible at almost any time. Georgia's every mood and every gesture—sultry or virginal, gay or sullen, teasing or angry, drowsy or blazingly alert, quizzical or amused, clothed, nude, tousled or coiffed—propelled him to the camera. He choreographed her hands—stitching domestically, at rest, sometimes seeming to soar, sometimes lifting her breasts like twin offerings (a pose that, with almost comic predictability, he later instructed nearly all his nude subjects to assume). He sat her in a chair, propped her on pillows in the bed, stood her on the low radiator, leaned her against a table. His "portrait" of her became a love song with a new melody to record every day.

—LOWE.

A niece from Lake George remembers meeting her for the first time.

❑ Rehearsed by grandmother Lizzie, and with all the concentration of a not-quite-three-year-old, I offered my hand, performed my curtsy, and pronounced on cue, "How do you do, Aunt Georgia?"—to which her instantaneous response was a cheek-stinging slap and a blazing "Don't ever call me Aunt!"

—LOWE.

In the family kibbutz, Georgia O'Keeffe had difficulty finding privacy.

❑ One suffocatingly hot day, a tribe of four little squaws aged four to ten, dressed in fringed chintz buckskins of Lizzie's devising, dared the ultimate hazardous mission into forbidden territory: scouting Georgia's Shanty. Peering through the window, we were dumbfounded to find her naked at her easel, a tableau for which nothing in our essentially prudish upbringing had prepared us. Georgia's momentary shock turned to immediate rage. Shrieking—and still naked—she flew out,

brandishing a paintbrush, to chase us away. To her, we were prurient little horrors. To us (or at least to me) she was as magnificent and awesome as a goddess.

—LOWE.

She left a few days later to get away from all these people.

It took some time for Stieglitz's divorce to come through. There were the usual problems.

❏ When some people resented her special position as Stieglitz's paramour, she found it necessary to remind them that he had given her two shows before "he knew me personally," as she put it. After their marriage, when people addressed her as "Mrs. Stieglitz," she briskly corrected them with, "I am Georgia O'Keeffe." "I've had a hard time hanging on to my name, but I hang on to it with my teeth," she explained. "I like getting what I've got on my own."

—LISLE.

The sexuality of her paintings was always an issue.

❏ One woman who owned a big O'Keeffe flower painting was shocked to discover someone teaching a child the facts of life from it. When she hastily rehung it in her bedroom, a friend remarked, "Oh, I'm so glad you moved that vagina out of the living room."

—LISLE.

There were always other expectations.

❏ In 1954, when she greeted art critic Emily Genauer while carrying some flowers, Miss Genauer exclaimed, "How perfect to meet you with flowers in your hands." Still acutely sensitive about the subject, O'Keeffe snapped, "I hate flowers—I paint them because they're cheaper than models and they don't move!"

—LISLE.

Work was everything for her. "The days you work," she said, "are the best days." Stieglitz and O'Keeffe fell into the pattern of spending the winter months together in New York and separating for the summers—she in New Mexico and he in Vermont. As time passed they spent less time together, and O'Keeffe more time in the desert.

In the 1930s, she debated Michael Gold, Communist critic of culture for the American *New Masses*.

❏ Georgia arrived in the private dining room of the Hotel Brevoort at the prearranged time, looking as serene as usual, according to the *New York World* reporter, who covered the event in great detail. "Her face, unadorned by cosmetics, with its flash of intelligent, arched eyebrows, her severely simple silk dress, her tapered, sensitive, ivory-colored hands, merged quietly into a whole, utterly simple, utterly poised." O'Keeffe turned to the rumpled, pale young radical, who looked profoundly uncomfortable. "You look more fussed than I feel, and I had expected you to be so fearless," she remarked with a little smile. "Shall we begin?"

Gold nervously chewed his cigar, gulped some tea, tore a sandwich apart, and started to talk in a choked voice. The biggest struggle of the age was that of the working class, he ventured, and "If art is alive, it is the only possible subject." Georgia calmly took a sip of tea. "When you name the oppressed, do you include women?" she asked. Only working-class women, Gold replied, intensely, and he added, "I'm afraid it doesn't seem very important to me if the pampered bourgeoisie in her rose-colored boudoir gets equal rights or not." O'Keeffe responded that oppressed women of all classes were important because, in her case, she had been forced to look to male artists for models because social oppression had made for a paucity of female painters in history. "Before I put a brush to canvas, I question, 'Is this mine? . . . Is it influenced by some idea which I have acquired from some man?' . . . I am trying with all my skill to do a painting that is all of women, as well as all of me."

As the discussion continued, however, she denied that it was necessary to paint realistic scenes of women's struggles ("glorified cartoons," in her words), explaining that form, color, and pattern were more important than subject matter. Beauty enriches everyone's existence, she pointed out. Gold attacked her concern with abstract issues of technique, terming them "little tinkerings," the "psychological mewings of a bunch of ingrown decadents . . . prettified, artified evasions that are fit only to decorate the drawing rooms and boudoirs which hold the drunk parties and kept women of the rich." Then the young man suddenly added, while nervously extracting a cigarette from a case, and breaking the cigarette in the process, "Gosh, I hate to argue with a woman—you have to be polite." Georgia replied that she didn't think he had to be any more polite to her than to a man, and he flushed and offered an apology.

"You don't like flowers, do you, Mr. Gold?" Georgia continued. When he protested that he did, she said, "Well, I don't really see how you can approve them since you want all things to be useful. . . . You may be seeking the freedom of humanity, but you want to make art a tool— and the worst of it is that you must cheapen art to appeal to any mass, and your mass artists will inevitably become bad artists." Only a few

appreciated a Proust, a Joyce, or a Marin in any age, she added. In rebuttal, Gold mentioned the Diego Rivera murals in Mexico, which, he said, were examples of good art that also spoke to the people. They debated some more, ignoring the little cakes on the table. "You know, I think you're a nice boy all mixed up by a lot of prejudices, defenses and hatreds," Georgia said in conclusion. "We haven't talked half enough about this. I think I'll take you to see my show, and then bring you home to Stieglitz and dinner!"

—LISLE.

In the New Mexico summers, she used her car as a studio.

❏ She also spent many hours painting in her Model A Ford. She left the passenger seat back at the cottage, unbolted and swiveled the driver's seat, and propped her canvas on the back seat. Because of the auto's high windows, she had plenty of light and because of the high roof she could squeeze in a large (30″×40″) canvas. At the cottage, when she was unable to sleep in the early morning hours (perhaps because of an insistent feeling that she should be at Stieglitz's side), she used to climb up on the flat roof to watch the dawn lighten the large expanse of sky.

—LISLE.

Stieglitz died in 1946. She flew from New Mexico when she heard of his stroke.

❏ She spent the sweltering Saturday morning tracking down an unadorned pine coffin to have delivered to Frank E. Campbell's plush funeral home on Madison Avenue. There, far into the night, she worked alone, stitching the plain white linen she had found to replace the detestable pink satin lining she had torn out in the afternoon.

—LOWE.

Now she lived full time in the New Mexican landscape she painted.

As she aged she became imperious. A reporter came by asking to see Georgia O'Keeffe. She snapped: "You have."

As a museum director once put it, "Georgia is easy to get along with—as long as you do exactly what she wants." When someone asked her why she disliked signing her paintings, she answered, "Why don't you sign your faces?" She said on occasion that she would enjoy the world if there were not other human beings in it.

She collected rocks, and not only her own.

❏ One evening [Eliot] Porter discovered a small, flat, smooth black beauty without a blemish that everyone agreed was the absolutely perfect rock. Their teasing became a trifle tense when Porter realized that O'Keeffe seriously coveted it, but he said it was for his wife, Aline, who was at home.

Georgia had treasured pebbles she came upon at Lake George, on the seashore, and in mountain streams, and had displayed them in her New York apartments. In New Mexico, where a wide variety of minerals lay near the abandoned mines, she enjoyed taking visitors on all-day rocking excursions. She always discovered a new stone with delight and, long afterwards, remembered exactly how it had looked the moment she first saw it. Once she picked up a stone outside her hotel in Cambodia and carried it in her pocketbook halfway around the world.

She was uninterested in classifying rocks by their geological names, just enjoying the look of their hard, definite shapes and the feel of their polished, silken surfaces. She placed her rock treasures around her homes like precious gems—some in a glass dish in the living room, hundreds on a stone slab in the patio, and a few dramatic black ones on a mantel.

Months after Eliot had discovered the prize stone, Georgia joined the Porters for Thanksgiving in their home in Tesuque, on the outskirts of Santa Fe. They had displayed the perfect black stone on their dark-slate coffee table to see what Georgia would do. When she thought no one was looking, she slipped it into her pocket. According to one version of the story, she put it back, and the Porters later gave it to her as a gift. According to another version, she secretly took it home and, in time, they told her to keep it. At any rate, she kept the stone, displaying it on a shelf above her narrow white bed. Evidently, she was still the same person of whom Stieglitz had said long ago: "When she wants something she makes other people give it to her. They feel she is fine and has something other people have not."

—LISLE.

When she was ninety-one years old, the Metropolitan Museum in New York showed fifty-one of Stieglitz's photographs of her when she was young. Hilton Kramer called it "the most beautiful and moving photographic show in recent memory." After witnessing the many nude photographs of her young body, she said that when she looked into a mirror, she was astonished to see that her hair was white.

Kurt Schwitters
(1887–1948)

In 1922 Theo van Doesburg and Schwitters attempted to intro-
duce Dada to Holland, in a performance at the Hague Kunst-
kring. Schwitters was supposed to provide an example of Dada-
ism, as he said, "But the truth is that van Doesburg, as he appeared
on the platform in his dinner jacket, distinguished black shirt
front and white tie, and on top of that, bemonocled, powdered
all white, his severe features imprinted with an eerie solemnity
produced an effect that was quite adequately Dada. . . ."

❑ Since I didn't know a word of Dutch, we had agreed that I should
demonstrate Dadaism as soon as he took a drink of water. Van Does-
burg drank and I, sitting in the middle of the audience, to whom I was
unknown, suddenly began to bark furiously. The barking netted us a
second evening in Haarlem; as a matter of fact it was sold out, because
everyone was curious to see van Doesburg take a drink of water and
then hear me suddenly and unexpectedly bark. At van Doesburg's sug-
gestion, I neglected to bark on this occasion. This brought us our third
evening in Amsterdam.

> —*Dada Painters and Poets,* ed. Robert Motherwell.

He was a one-artist splinter group. He called his movement "Merz"
from a fragment of the name of a bank of commerce, *Commerz*.

❑ He labeled everything he painted or constructed, most of his man-
ifestoes and some of his books with the title "Merz," a term without
meaning, a fragment of a word withdrawn from circulation and be-
come a sacred symbol.

> —MOTHERWELL.

He remains most celebrated for collage. His Merz-poem exists as
a tape made by his son. His house-collage was destroyed, but Mr.
and Mrs. Alfred Barr visited the house, if not the artist, in 1935.

❑ At Kurt Schwitters's house a young man opens the door. He is the
artist's son, a photographer of animals. Schwitters himself is already in

Norway. Passing the cold, tiled kitchen where he has been eating bread and liverwurst, he shows the way to the famous *Merzbau,* installed in a back room by his father. It is like a cave; the stalactites and stalagmites of wood junk and stray rubbish picked up from the streets are joined together to fill the whole room from floor to ceiling and walls to walls. A. and M. are silenced.

—MARGARET SCOLARI BARR, *New Criterion,* Summer 1987.

Richard Huelsenbeck remembers.

❏ We spent a Christmas with him. The Christmas tree was glowing in the living room, and Frau Schwitters excused herself because she had to give one of the children a bath. It was family life with all the trimmings. Schwitters showed us his workroom, which contained a tower. This tower or tree or house had apertures, concavities, and hollows in which Schwitters said he kept souvenirs, photos, birth dates, and other respectable and less respectable data. The room was a mixture of hopeless disarray and meticulous accuracy. You could see incipient collages, wooden sculptures, pictures of stone and plaster. Books, whose pages rustled in time to our steps, were lying about. Materials of all kinds, rags, limestone, cuff links, logs of all sizes, newspaper clippings.

—RICHARD HUELSENBECK, *Memoirs of a Dada Drummer.*

William Zorach
(1887–1966)

He came from Russia to the United States when he was four and grew up in Cleveland. He returned to Europe as a young student, industrious and sober.

❏ I spent five months in Avignon sketching. I rented a room under the Palace of the Popes on the Rhone in a place called Hotel de la Marina. I was a hard-working artist. I painted all day and had a room on the top floor and went to bed early. I never heard anything that went on below. I never went into the bar except to eat. I became acquainted with a French boy who worked in a bank. He wanted to practice English; I wanted to learn French.

"My God," he said. "You live in the worst dive in Avignon."

"What do you mean?" I said. "It seems like a very nice place to me."

"I'll show you. Stay up next Saturday night."

I stayed up and we went down and sat in the bar—bottles flew, fists flew, insults and obscene language flew, knives appeared, there were knock-down and drag-out fights. The police raided the place and closed the bar temporarily. But I stayed on undisturbed.

—WILLIAM ZORACH, *Art Is My Life.*

Back in the United states, he received offers:

❏ There was another man, a Fifth Avenue dealer by the name of Kilgore, who looked me up. He said he had heard I had some paintings I had made of the south of France. He looked at them casually and said, "I'll give you fifteen dollars apiece for the lot."

I asked him why he wanted them; it seemed a bit fishy.

He said, "You know that's the country Corot painted. I have a man who can take the compositions and turn them into good Corots. Of course, if you'd like to do the job for me yourself, I will pay you well for it."

Years afterwards, when I saw Kilgore uptown at parties and a bit drunk, he would always welcome me gleefully and say, "Friends, here is the artist that threw me out of his studio and kicked me down the stairs when all I wanted was to buy his pictures."

—ZORACH.

When he was older and successful, he lived in the state of Maine and enjoyed his neighbors.

❏ Another time Lon Twombley asked me what I had done with the cat I was carving out of a boulder that I had picked out from a load of gravel he sold me. I said, "I took it down to New York and sold it to Mrs. Rockefeller for a thousand dollars."

Twombley's eyes popped out. "Highway robbery," he said.

—ZORACH.

❏ One day Cal was standing out on Blacksmith Shop Ledge with Bill Bunyon talking things over. "Now take this fellow Zorach. He's a curious one. He don't go around and do things other folks do. He goes around picking up stones and then sits around chipping away at them. Now that's a mighty funny thing for a man to do—just chipping stones."

Bill said, "You know he sells those stones he chips and sometimes he gets thousands of dollars for them."

Cal didn't say a word. He looked down at the granite under his feet. Then it came out, "Jees-us, we're standing on a gold mine."

—ZORACH.

Josef Albers
(1888–1976)

Alexander Eliot remembers the painter at Black Mountain College.

❏ "Vich of you children can draw a straight line?"

That was Josef Albers's opening gun, at Black Mountain College. A few students dared to raise their hands. "Zo!" Albers beamed. "Please do as I do." With that he faced around to the blackboard and started walking sideways, chalk in hand. *Skreeeek!* He had drawn an absolutely level line some ten feet in length.

The raised hands drifted down again, and sighs arose instead. This course would not be easy, we could see. But still we had no glimmering of the trials to come. Albers would put us to drawing letters and numbers in parallel perspective, backwards, with the pencil gripped between the toes, before very long. What for? To learn that control is freedom.

Albers's own line drawings keep involuting and popping out again as you look at them. They bring to mind impossibilities so far as the actual physical world is concerned. Flexible crystals, for instance, or cups running oval. Albers turns tables on themselves, and stirs the sea with skew pencils. His drawings are the children of a deliberately wayward pen. They appear as astonished as they are astonishing. "Vich of you," they demand, cross-eyed, without a word, "can see crooked?"

Effect-Making. That was the rather mysterious name for the seminar course which Albers gave at Black Mountain. Each student was required to produce a few provocative objects for group discussion.

It seemed simple enough, at first.

My initial contribution was a cream-colored toilet seat dressed in a stocking of white net. Dada but dull, and just a bit obscene as well, the class judged it to be. Albers said nothing; he remained aloof. The mystically inclined are often somewhat puritanical.

Next I offered an ancient broken boot from the trash dump. This I had polished and polished and polished, until it glistened like the enigmatic subject of Edgar Allan Poe's poem, "The Raven." But the group howled my surrealist bird or boot or devil out of court.

Finally one morning I came bearing what appeared to be prismatic cotton on a tray. Rather proudly, I set it down on the floor in the midst

of the circle. Complete silence greeted my offering. The secret glimmer
which I had imparted to the cotton seemed to leave everyone cold. A
fellow student nudged the cotton with his toe. Nothing happened, of
course. A second student got up, stretched, and casually stooped to flip
the cotton over. This exposed the bits of colored paper I had used. Still
bending down, the youth started to say something. I kicked his inter-
fering tail, and he tumbled flat.

"*Jawohl!*" Albers murmured. It seemed I had made an effect.
 —ALEXANDER ELIOT, *The Atlantic*, October 1972.

Giorgio de Chirico
(1888–1978)

For Chirico, everything was magic and magic was real. André
Breton told a story.

❏ One night, Breton, Louis Aragon and Chirico were seated at a café
when a flower-boy appeared so suddenly that Aragon asked Breton
whether the youth might not be a phantom. Chirico, his back to the
street, had not seen the boy, but on hearing the conversation, he pulled
a mirror from his pocket, studied the boy's image in it, and gravely
announced that this was indeed a phantom.
 —JAMES THRALL SOBY, *The Early Chirico*.

From his earliest childhood, dreams made the center of his life.

❏ In the meantime I had begun to tire of the States. During my stay
there, in July 1936 to be precise, I received the very sad news that my
dear mother had died. A few months previously my brother had writ-
ten that our mother's health was declining, and the feeling that I was
at that time so far away from her, with the vast ocean between, made
me very sad. One night I had a dream; I dreamt that I was in Greece,
in the countryside near Athens; I saw those trees and bushes which I
had seen during my childhood, and the place where I found myself in
my dream was somewhere I once went to paint a landscape with a friend
of my own age. In my dream I saw the olives and pine trees just as I
had seen them in my distant childhood, and between the trees I saw
the back of a little church painted pink, with its small apse jutting out
and a door at the side, just as I had painted them so many years before.
Suddenly my mother appeared among the olives and walked towards

the little church. I wanted to go and meet her, but I could not move; I wanted to call out to her, but my voice failed me; my heart filled with worry and anguish. I saw my mother, who seemed very old, small, bent, and weak and unsteady on her feet, just as I remembered her from the last time I had seen her in Paris. I saw my mother pass like a shadow near the apse of the little church, come up to the side door and then disappear. I woke up troubled and weeping and with the terrible thought that my mother had died just at that moment: in fact, when ten days later I read the letter from my brother in which he told me that our mother was alive no longer, I compared the date of the letter with that of my dream and, taking into account the difference in time between the United States and Europe, I realized that *this was really the case.*

—GIORGIO DE CHIRICO, *Memoirs.*

When Italy went to war in 1915, Chirico and his friend the painter Carlo Carra were excused from military duty, after brief service, "on the ground of mental instability." Rumor declared that both painters offered their work in evidence of their madness, evidence which the authorities found conclusive.

By 1926 his falling-out with the official Surrealist movement was complete. If he saw a Surrealist walking towards him, he made the sign of the cross and crossed the street.

His wife Isabella was a great help to him, as he tells us in his *Memoirs.*

❏ One day I wanted to paint a panoramic view of Genoa and the harbor seen from above, from the castle. The weather was cloudy and when we reached the castle it began to rain slightly. I settled down as best I could, with my box of colors between my legs, but I had to work fast. I crouched down in a way that made it difficult for me to stand up and move back to see my work from a distance; but Isabella came to my rescue; she sat behind me holding an umbrella and told me how I should proceed. "The shadow on the left should be darker," she told me. "That sail should be level with the last house on the left; make the gray-purple of the ground a little faded," and so on. After about three hours of uninterrupted work I was able to stand up, and as I moved aside with stiff legs I saw that this painting was more successful than any I had painted so far on the spot.

—DE CHIRICO.

The gallery-owner Julien Levy met him when he came to the United States.

❏ I helped him find lodging in New York, and suggested a list of restaurants: Barbetta's, Lindy's, Billy the Oysterman. To all these he preferred the Automat, like every other Italian painter I have known. I have never learned why, for it isn't the machinery that they like. "It has excellent food," they always say.

—JULIEN LEVY, *Memoir of an Art Gallery.*

Levy went driving in New York with Chirico and Chick Austin, curator of the Wadsworth Atheneum in Hartford, Connecticut.

❏ That night with de Chirico, Chick had his car and I wished to drive to a certain spot where there was a curious juxtaposition of electricity and moonlight. The moon was throwing shadows more ambiguous than those poignant and unnatural shadows in Chirico's own canvases, his empty arcades with the haunting shadows which seem to fall toward the light. We drove to the ghetto of New York, under the elevated trestles on Third Avenue near Grand Central Station, past those tiers of composite housing which remind one of excavated levels from past civilizations that, in other countries, are fanned out along the hillsides like cards in a conjuror's hand. In New York, the fan is pressed together into vertical packs of which only the edges show. I wondered aloud with Chick why rich Jews did not move into this quarter, so picturesque and attractive and it could be comfortable if provided with those modern utilities that the Strausses and Warburgs could so well afford. I chanced to notice the sudden, sharp contraction of Giorgio's eyes, and as we went over some rough asphalt, the trembling of his jowls, which were now melancholy and loose. I did not at that time realize how closely our conversation had approached one of what might be called Giorgio's "brushwood piles."

I remember in Kipling's story that all Georgie's dreams began in the same way: "There was the same starting-off-place—a pile of brushwood stacked somewhere near a beach . . . to the right lay the sea, sometimes at full tide, sometimes withdrawn to the very horizon; but he knew it for the same sea. By that road he would travel over a swell of rising ground covered with short, withered grass, into valleys of wonder and unreason." Kipling's Georgie could always find his way back to the lamppost which marked the end of his dream and led him into day. But our Giorgio was never sure of his return; as I was to discover with detailed proof. The sign of the entrance to his special dreams, not just his nightly dreams but that landscape which began with the brushwood pile, had become a symbol to him of terror and remorse. So far he had always come back, but only by accident and after dreams that were of more than usual length. Someday he might not return. The brushwood

pile was a sign of an unpredictable adventure and of such he was wary, if not frightened.

He was clutching Chick's arm, asking him to turn back, for he realized we had inexplicably lost our way. We were now headed uptown while we wished to continue downtown. In the middle of traffic Chick reversed direction to please de Chirico. It seemed to me that the word "Jew" had triggered his brushwood pile. I had a fantasy that Giorgio once wondered if he were a Jew and imagined what *might* his life be like in such circumstances. Thereafter, thinking himself persecuted, he might have protested that he was *not* a Jew and did not deserve persecution. But he would likely have then reproached himself to the effect that it was undignified to deny one's race in adversity and persecution, so bravely *admit* his Judaism and to resolve to suffer if necessary. But secretly he would begin to wish he had *never* been born a Jew. It would be only by the greatest good luck that, one day, he might be reminded that he had *not* been born a Jew, nor had any of his forebears.

The car was stopped by a traffic policeman near Brooklyn Bridge, and Chick was asked to dim his headlights. Chirico begged us to be submissive and polite to "the official." He recalled for us how he had once submitted to an enforced vaccination and how at first he had objected, but later he decided to be discreet, and that the officials then reacted favorably and mitigated their brutality. They allowed him to undergo the operation in a friendly house where he could be sure the instruments were clean and where other friends of his were always nearby, downstairs drinking cocktails. It was possible that the authorities might use a large, old-fashioned, and rusty syringe, and press the needle of it sharply into the corner of his eye. This time, fortunately, they chose a small and gleaming modern needle, asked him only to roll up the sleeve of his left arm and inoculated him. "It was better that way," asserted de Chirico. "It might have been so much worse," he explained, "careless and ruthless!"

—LEVY.

Frederick Prokosch in Venice read terrible reviews of a late Chirico show. He attended the show and agreed with the reviews. As he was leaving,

❏ I noticed a gray-haired man who was wandering through the hallway, eyes half-closed, reaching aimlessly into the air, like a sleepwalker.

I looked at him more closely. He opened his hangdog eyes and I detected a plea so desperate that I forced myself to say, "They are splendid! They are truly magnificent, signor!"

His lips started to tremble, his eyes grew blurred with tears. Then he pulled himself together with an air of bravado.

"Thank you kindly, my friend. I am touched. I am gratified. Certain small-minded critics have an insatiable grudge against me. Come, *caro,* we'll go to Quadri's and drink a small espresso."
—FREDRIC PROKOSCH, *Voices: A Memoir.*

Thomas Hart Benton
(1889–1975)

Benton grew up with the handicap of a respectable and successful father—lawyer, U.S. Representative—in the town of Neosho in the state of Missouri. William Jennings Bryan came to dinner at his house, but Benton was more interested in the town bums.

❏ Neosho was a whiskey town for Oklahoma in those days, and according to Tom's school friend Phil Ratliff, "There used to be a mint bed down by Big Spring Park and Tom and I would go down there and pick some mint. Then we'd take it to a saloon on Spring Street and Tom would draw a picture of the bartender who was a great big fellow with a mustache. In return for the picture the bartender would give us a mint julep with the mint we'd picked."
—POLLY BURROUGHS, *Thomas Hart Benton: A Portrait* .

Against the usual family objections, he went to art school, saying that he wanted "to be as important in art to Americans as the funny papers are." Later, in New York

❏ . . . they begged meals, borrowed money, and when he couldn't afford to buy them, Benton stole his art supplies from Macy's. One of their favorite stories during these dire times, was the day Craven expected a caller who was supposed to offer him a job. Benton had engaged a model and was busy at the easel. While cleaning up the messy flat a bit, before the caller arrived, Craven threw a fresh coat of paint on the toilet seat—unbeknownst to Benton—and then dashed out to do an errand. The model went in to use the bathroom and returned wreathed in fresh paint. Benton grabbed a cloth and was busy humming and scrubbing when the stranger walked in the door. He took one look and fled down the stairs, taking Craven's proposed job with him.
—BURROUGHS,

The 1920s was Martha's Vineyard—and many insults.

❑ One activity for the Barn House group and which the Island resi-
dents would never share was swimming in the nude. It was customary
for them to gather every sunny day for a beach picnic and swimming
where they'd be joined by other liberated intellectuals, artists, and writ-
ers in the area. With full gusto, and rough, raw language, Tom wrote
about it in his autobiography. His instinct for capturing the essence of
human behavior pervades his writing, and with his storytelling gifts, he
left nothing to the imagination. Although he wrote that there were
groups of nudes all over the Island, the Barn House guests and their
friends were the only ones at the time. He wrote of the shock value of
such behavior—"the hairy, pot-bellied, fat-assed men"—the women with
"old dried-out udders" all conspicuously prancing about, pretending to
be nonchalant. He felt it probably had nothing to do with a desire for
exposing the whole body to the sun, which could be done privately, but
rather a blind gesture toward lost youth, and a sense of superiority that
they were beyond convention.

The tradition carried on for many years, and the Bentons regularly
joined the group. Even in this relaxed, most natural setting, Tom's re-
nowned sarcasm was not always held in abeyance. On one occasion, he
was lying naked on the sand when a good friend approached with his
wife, a very pretty thirty-year-old woman who had a lovely figure. Ben-
ton looked her up and down as they were talking, and remarked, "You
know, no female is worth painting after the age of eighteen."

"He could destroy himself in one afternoon with remarks like that,"
another close friend and neighbor alleged. "It's too bad." . . .

On one well-remembered night in the mid-twenties, Mike Robinson
and Tom got drunk and headed out across the moors. Tom decided
they ought to knock over all the outhouses of their intellectual friends
and go after Lewis Mumford's first.

The latter remembered it well. "My wife and I remember quite viv-
idly the incident. Often quite trivial memories remain, while more im-
portant ones vanish. It began with one of our Chilmark neighbors
knocking breathlessly on our door and asking for 'protection' from
Benton and Robinson who were drunk, and made, so she reported,
passes at assaulting her. She wasn't one to mind the passes, but appar-
ently she didn't like the smell of liquor, or at least wanted to keep the
initiative in her own hands. Then came Benton and Mike demanding
to be admitted. With great resolution we kept them at bay, and for a
while they prowled around the house, hoping, apparently, to find some
way in. I can't imagine why we didn't burst out laughing, but somehow
the breathless refugee had made it seem very sinister, so we were all
needlessly tense. Then, frustrated, they attacked the outhouse, which
was about fifty feet away, and knocked it over. Once that was accom-
plished, Benton made a classic remark, 'I never knew what a stink phi-

losophers could make!' And then they went off, and eventually our neighbor returned home without, apparently, being raped. At least not without her consent.

"Perhaps the present generation is unfamiliar with privies, so let me add that the walls and roof form a unit that can be overturned without removing the more functional base. No problem there!"

—BURROUGHS.

It seems clear that he drank his share of alcohol.

❑ At one small dinner given by a friend, their hostess's maid, a faithful retainer and staunch Southern Baptist, was serving dinner. The conversation was on religion, and Tom was holding forth about St. Augustine. Just as the maid passed him the mashed potatoes, Tom said, "You know what happened to St. Augustine don't you?" adding with his ribald chuckle, "They chopped off his balls!" The maid pitched the platter through the air, bolted to the kitchen, and slammed the door.

—BURROUGHS.

His reputation wavered according to fashion and politics. He remained populist; he remained the rebellious son of a respectable father.

❑ Quoting from the King Korn Stamp Company's catalogue *Time* magazine noted, "In this catalogue you will find a wide selection of the finest gifts from America's leading manufacturers. For example, 5⅜ books of stamps will fetch you a Gooney-Cycle unicycle, five books a Kiddee Krome table and chair set. And for just 1,965 books you may have, from one of America's leading manufacturers indeed, 'Rice Threshers' by Thomas Hart Benton who was paid around $5,000 for the painting."

"I've always liked the idea of popularizing paintings," Benton said. "The next question is what popularized art lover is going to buy $292,250 worth of merchandise and lick 2,962,500 stamps . . . ?"

—BURROUGHS.

Paul Nash
(1889–1946)

In 1927 he painted *February*, a tree stump with a cleaver stuck into it.

❏ After Nash abandoned the practice of including human forms in his paintings, his wife, who was more familiar with the ways of the Inland Revenue than he, insisted that the trifling item for "Hire of Model" should be retained in his Tax Return, lest the authorities should begin to question his status as a professional artist. Paul agreed, but insisted in his turn that each year one picture should be solemnly elected to represent the work for which the hypothetical model had been hired. For the financial year 1927/8 the choice had fallen upon *February*.

—MARGOT EATES, *Paul Nash: The Master of the Image* .

He felt like a stranger in the world.

❏ His wife and Ruth Clark departed to Normandy for a holiday, leaving him to join them there later. Although Margaret had provided him with his tickets and given him minute instructions about the journey, a friend decided that it would be wise to escort him to London and put him on the train. Arrived at the station, the friend observed how lost and forlorn Paul was looking, and so accompanied him to Newhaven where he was struck by grave misgivings as to Paul's ability to board the boat, and did not leave him till he was safe on deck to be met by his wife on the other side.

—EATES.

Egon Schiele
(1890–1918)

He emerged from the womb carrying a pencil.

❏ Before Egon was five he had adopted the disconcerting habit of crawling out of the dining room window onto the slanting porch roof facing the tracks—some fifteen feet below—in order better to see and draw the trains. . . .

Once when Egon was about eight his father thought to win the reluctant student's cooperation by presenting him with a thick new sketchbook in which he would be allowed to draw one picture every day *after* completing his Latin. The sketchbook was given to Egon in the morning; when his father returned from work for the noonday meal the whole book had been filled. The boy had torn the pages out and arranged them throughout the house, like a little exhibition. Many of the sheets were of carefully drawn railroad cars, one to a page, and

so formed "trains" going from room to room. Adolf Schiele was so angry that he took all the drawings, stuffed them into the stove, and set fire to them.

—ALESSANDRA COMINI, *Egon Schiele's Portraits.*

He rebelled at his elementary school, and at art school he continued rebelling.

❏ One week's project was to cover a large roll of paper with a single, continuous drawing, adding to it each day. While the other students worked, Schiele simply sat at his desk staring in front of him and not drawing a line. The next day in class this conduct was repeated, and the next, until the time arrived when the assignment was due. On this day Schiele suddenly began to draw and filled the roll with an exact ground plan of the Franz Josef Railway Station, where he had often wandered about, and which he knew by heart. . . .

To copy and improvise on Klimt's themes was one thing; to meet the man in person was quite another. However, Klimt was known for his generosity towards other artists, and this, coupled with Schiele's daily irritation over the methods of the Academy, gave the young painter courage. There were two places in which the famous artist could almost surely be found. One was the old Café Tivoli where he regularly ate an early morning breakfast consisting mainly of whipped cream; the other was his Josefstadt atelier—a spacious studio with furniture designed by Josef Hoffmann and set in an overgrown garden whose "wildness" was carefully cultivated by Klimt, who loved to roam about it dressed in the sandals and exotic blue smock which he always wore when working. Schiele decided to present himself at the atelier, and it was this fabeled "wild" aspect of Klimt that he first came upon when he was shown into the garden. Somewhat taken aback in the presence of Klimt, who was twenty-eight years his senior, Schiele silently handed him a portfolio stuffed with drawings and asked simply, "Do I have talent?" As the master obligingly leafed through the seventeen-year-old boy's work, his interest turned into astonishment. After a long silence he answered sternly, "Talent? Yes! Much too much!"

—COMINI.

In a letter he wrote his mother, Schiele appeared to share Klimt's opinion.

❏ You are at the age when, I believe, one has the driving desire to want to see the world with a pure soul, unrestrained and unhindered, and to want to rejoice in the fulfilled and revealed fruits—whose wilfullness is innate and grows independent roots. This is the great sepa-

ration. Without doubt I shall be the greatest, the most beautiful, the most valuable, the purest, and the most precious fruit. . . . *I shall be the fruit which after its decay will still leave behind eternal life; therefore how great must be your joy—to have borne me?*

—COMINI.

In a letter he wrote a friend, we see the other side of the mountain.

❑ Will things go any further? I can't, I haven't been able to work for days. I don't even have any wrapping paper. . . . I have headaches, I am chained. Will no one help me? If only I could have an exhibition, then I would be out of it. But no, I can't even draw, so I must write in order to borrow money, now, in the very best years and days in which I want to work. . . . What times! Shall I become a merchant? Or a salesman? . . . Who will help me? I can't buy a single canvas; I want to paint but have no colors. . . . I am sick. . . . The artist should at least not have to worry every month about getting the money owed to him! Whoever can deal with the artist, writes at least. Why should I be silent about all this? . . . I am extremely sensitive, and all these people have absolutely no idea how they should behave towards an artist.

—COMINI.

"I am the shyest of the shy," he wrote elsewhere; and also: "I am divine!"

He designed his own clothes, one outfit a dark linen "with a double row of buttons down the front, the sleeves and trouser legs very narrow at the top and belling out at the cuffs." When he dressed so elegantly, "he refused to be seen carrying a package or even a roll of his drawings in the street because he considered it beneath his dignity."

Sequestered in the town of Neulengbach with his mistress Valerie Neuzil, known as Wally, he worked well until he was interrupted.

❑ Schiele's reputation for "pornographic' drawings, the comings and goings of his mistress, and his invitations to the village children to come and pose for him in the isolated little garden house on the outskirts of town, had aroused first the indignation and then the hostility of the provincial country folk, until at last legal steps were taken to rid Neulengbach of its undesirable inhabitant. Two constables confiscated his drawings and Schiele was arrested and locked up without bond in a basement cell of the Neulengbach district court. The charges against him were "immorality" and "seduction," but apparently the prisoner was not informed of them for over a week. The first charge alleged

that Schiele, while entertaining and drawing child models in his studio, had through the careless or willful display of erotic drawings contributed to their corruption. This was an accusation that did not come as a surprise to his friends in Vienna. Heinrich Benesch had often warned Schiele to be more judicious as to what sort of drawings he left lying around when children came to pose. Concerning the second charge, which alleged that he had seduced a young girl of the village, Schiele insisted in letters and other writings that he was innocent. Whatever the validity of the accusations against Schiele (and he had reason to believe that his own uncle Czihaczek had been instrumental in bringing them to bear), the charges were sufficient to hold him in prison for twenty-four days, first at Neulengbach during the month of April, and then, sometime after May 1, at the larger town of St. Pölten. He was released, after a court trial, on May 7. At the trial he was fined, and one of his drawings was burned by the judge in symbolic condemnation of his work. The humiliation of his arrest, imprisonment, and trial left an indelible imprint upon Schiele's personal and artistic development.

—COMINI.

He kept a diary during his twenty-four days in prison, which he concluded the day after he was released.

❏ Vienna, 8 May 1912
For 24 days I was under arrest! Twenty-four days or five hundred and seventy-six hours! An eternity!

The investigation ran its wretched course. But I have miserably borne unspeakable things. I am terribly punished without punishment.

At the hearing one of the confiscated drawings, the one that had hung in my bedroom, was solemnly burned over a candle flame by the judge in his robes! Autodafé! Savonarola! Inquisition! Middle Ages! Castration, hypocrisy! Go then to the museums and cut up the greatest works of art into little pieces. He who denies sex is a filthy person who smears in the lowest ways his own parents who have begotten him.

How anyone who has not suffered as I, will have to feel ashamed before me from now on!

—COMINI.

While he still lived with Wally, before he married Edith Harms, he courted Edith and her sister.

❏ From his studio windows Schiele had a good view of a house almost opposite his own, Hietzinger Hauptstrasse 114. This building proved of particular interest because of two of its residents, the young and attractive sisters Adele and Edith Harms. The girls used to stand at the window watching and discussing the painter at work. When Schiele

discovered their attention, he responded with outlandish pantomimes and began drawing large pictures of himself wearing nothing but his short, sleeveless painting jerkin. He would hold these brightly colored drawings out of his window to tease and shock the girls. Scribblings in his sketchbook reflect the course of his thoughts. Through the next months Schiele learned what he could about the Harms family from gossip at the local stores. Herr and Frau Harms had come to Vienna from Hanover, bringing with them a stepson, Fritz, and the two girls. The dark-haired sister, Adele, was Schiele's own age, and the blonde sister, Edith, was two and a half years younger. They had attended cooking and sewing schools and were proficient in English and French. The spectacle of this petit bourgeois family fascinated Schiele, who only a few years before had criticized the middle-class tastes of his aunt and uncle Czihaczek. He bombarded the sisters with flamboyantly written invitations to come and visit him in his atelier or to go on an outing with him. For almost a year his letters were ignored (but carefully kept) by the sisters. When he once chanced upon them in a park his elation was so great that he made a complete fool of himself, genuinely frightening the girls with an outburst of obscenities hissed in the coarsest Viennese dialect. A note of December 10, 1914, written in several colors, invites the sisters to attend a movie with him in the company of a chaperone, Wally, and also attempts to excuse his scandalous conduct in the park:

> Dear Fräulein Ed. and Ad. or Ad. and Ed. I believe that your Frau Mama will permit you to go with Walli [*sic*] and me to the movies, or to the Apollo, or wherever you want. You may rest assured that in reality I am entirely different from an "Apache." That is nothing but a momentary pose out of bravado. If you would like, therefore, to entrust yourselves to me and Walli, I would be delighted, and I await your reply as to which day would be convenient for you.

This time an answer rewarded Schiele's efforts:

> The movies are agreeable to us, and the one on Monday the 14th, at the Park-Kino, Ewers' "Launen einer Weltdame." ["Whims of a Woman of the World."] With Walli, naturally. Who will take care of getting the tickets? My mother must know nothing about this. Sincerely, Adele and Edith.

He married Edith rather suddenly.

❏ Edith had of course been aware of his relationship with Wally and had insisted that the association be ended so that their marriage might be begun in an atmosphere of "mutual trust and purity." She agreed to their seeing each other for "one last time," and a meeting was arranged at the Café Eichberger in Hietzing where Schiele was accustomed to go bowling in the evenings. When Wally arrived Schiele greeted her in silence, handed her a letter, and said, "Here. Everything is in

here." The letter was not a sentimental farewell but a remarkable formal document couched in legal terms, in which he "obligated" himself "from this date on to undertake a yearly summer vacation trip of several weeks" with Wally. She failed to appreciate the offer.

—COMINI.

He painted innumerable portraits of Edith until, in her sixth month of pregnancy, she caught influenza in the great epidemic of 1918.

❑ Schiele took his moribund wife in his arms and held her through the night, kissing her repeatedly. In a desperate gesture to arrest her ebbing spirit, he sketched her portrait as she lay on the pillow. He then placed a pencil and paper in Edith's hands and in her last moments of consciousness she wrote a tragically disjointed message of her love for him:

> 27 October 1918.
> I love, I love you unendingly and almost *more* boundlessly and . . . lessly your Edith

At eight o'clock in the morning Edith died. Schiele had already contracted the influenza from her and the next day was unable to remain on his feet. He was put to bed in the Harms house, where Adele also lay ill with the same virus. Four days later, as Edith's funeral cortege passed his window, Schiele was in his death agony. He died during the night of October 31–November 1 at one o'clock in the morning. His last words were: "The war is over . . . and I have to go. Mama!"

During the next three days Schiele's friends came to see his body on the deathbed. He had suffered severely in the last days, but Dr. Graff gave him sedation during the final hours, and his death was easy. The hand of his raised left arm pillowed his head, and the right arm lay naturally across his breast. The anguish of his self-portraits was erased; his face was calm. Schiele's last portrait was drawn with tenderness by death.

—COMINI.

Max Ernst
(1891–1976)

When Max was a boy he escaped one night from his house, wearing a white nightshirt, and walked up the railroad line to

find the place where the rails and the telegraph lines met. He
was discovered one station up the road by pilgrims returning
from a holy shrine: the young child with long blond hair in a
white nightshirt looked like an incarnation of the young Jesus.

After the Great War, Arp joined Max Ernst in Cologne in the
enterprise of German Dada. They put on a famous exhibition,
featuring *Fatagaga,* which abbreviated a French phrase meaning
"manufacture of pictures guaranteed to be so gasometric." It was
collage, you might say.

❑ It was held in a glassed-in courtyard behind a café, which could
only be reached through a public urinal. Inside, paying visitors saw
Fatagaga and other drawings on the walls; an aquarium filled with red
liquid, with a woman's head of hair floating on top and an arm pro-
truding from below the surface; a wooden sculpture to which Ernst
had chained a hatchet in case anyone wished to destroy it; and a young
girl (live) in a white communion dress who recited obscene poetry. In
no time at all someone smashed the aquarium, and the floor was awash
with red water. A complaint was lodged with the police, who came to
close down the exhibition on grounds of obscenity; on finding, how-
ever, that the item that had caused the most indignation was an etching
by Albrecht Dürer, they permitted it to stay open.
 —CALVIN TOMKINS, *The World of Marcel Duchamp.*

Jimmy Ernst was the artist's son. After Max divorced Jimmy's
mother Lou, Max visited his old family in Cologne when Jimmy
was five years old.

❑ After several days he seemed to get somewhat restless. He walked
around the apartment, looking intently at the paintings he had left be-
hind. Finally he took a large one off the wall and, carrying it, took me
along for a visit to the studio of the painter Anton Raederscheidt, just
around the corner. I was familiar with Raederscheidt's work because
his son was one of my playmates. Raederscheidt, much to my secret
delight, had been painting an endless series of full-length portraits of
his wife, showing her in the nude, exercising on parallel bars, horses,
ropes, rings and other gymnastic equipment. After some polite conver-
sation, Max began to make some very complimentary remarks about
Raederscheidt's paintings and offered to make an even exchange with
him for the one that he "just happened" to have with him. Raeder-
scheidt accepted readily.

As soon as we got back to the apartment, Max asked me to help him
unpack the cardboard box in which Lou had stored all of his art ma-
terials. Much to my chagrin, Max began to cover the exciting nude

form of Mrs. Raederscheidt with his own paint. When I asked him why he was doing that, he told me that he felt like painting and canvas was very expensive. When I said that he could have painted over his own, he merely snorted in reply. He worked for several days, on the dining table and on the floor, since there was no easel. Once, late during the night, I crept out of my bed and peeked through the living room door. Max was sitting in a high-backed chair, studying his just completed painting. The sensuous body of Mrs. Raederscheidt had become a pet-rified-forest landscape with a yellow-ringed moon floating in a gray-blue night sky.

A few days later I got into a nasty quarrel with Raederscheidt's son while we were playing in the street. When our wrestling and punching had ended I called out in frustration: *"Njae-njae, njae-njae,* my father painted right over your father's painting!" The answer was immediate: *"Njae-njae, njae-njae,* so did mine, so did mine!"

—JIMMY ERNST, *A Not-So-Still Life.*

Jimmy saw his father only from time to time.

❏ Max did his very best during those years to act the part of the caring and responsible father. I got to see again many of his old friends from the Dada days in Cologne, as well as many new ones. Attending a large party with him where Alexander Calder performed his *Circus* was a special treat and delight, only slightly marred by Max's remark that he had seen it too often, wouldn't have gone if it hadn't been for me and that, though it was all very inventive, these were, after all, merely toys. Max and Marie-Berthe had, by this time, moved into a large mod-ern apartment on the rue des Plantes with a marvelous terrace over-looking Paris. There were a few times when Max, needing privacy with a visitor, had suggested, "Jimmy, why don't you go out on the terrace for a while and play with the Giacomettis. Be careful not to break any-thing, though."

—ERNST.

Marie-Berthe was Ernst's second wife.

Julien Levy describes Ernst as Movie Star in the 1930s with Harry Crosby's widow Caresse and a cast of superstars.

❏ I turned to Marie-Berthe and told her I had brought my movie camera and hoped to make a short film of her and Max. She cooed like a dove, clapping her hands, "Max!" She begged him to stop. I feared we would be late, and we had been off to such an early start. But Max simply commented that the light was good. We drew up be-side the crumbling arched wall of some long-gone factory or priory;

perhaps it was older, a Roman aqueduct? Whatever it had been it was now most apt.

Max assumed extraordinarily photogenic aspects the moment the camera was trained on him. He composed himself perfectly in every imaginary frame, and projected an unerring image of a Max Ernst possessed. I have only seen one other individual able to be so galvanized into playing himself, and that was Dalí. Dalí always created his own self-portrait and could never be directed or interpreted by the cameraman into any direction other than his own. Seemingly unaware of the most candid camera, they both, Ernst and Dalí, fell into their pose as instantly as the shutter could snap.

Effortlessly Max acted and I improvised a scenario in accord with the limited possibilities of my camera. Marie-Berthe was less histrionic, but pretty as a pink postcard, the flowery European valentine, with her close curls like a helmet of snails. She posed; stiff, doll-like, appearing and disappearing in ruined archways, on tree trunks, behind a fence post, pursued by Max and by her animated glove and scarf, until she disappeared for the last time and there was only the glove and scarf for Max to capture.

—JULIEN LEVY, *Memoir of an Art Gallery*.

When Levy put on a Max Ernst show in California, not even a catered *vernissage* was well attended.

❏ Finally, John Barrymore, as usual outrageously drunk, did go in. Perhaps thinking it was a men's room, he did me the honor of urinating against the lower lefthand corner of a Max Ernst painting. I admired the respect he had for the signature, which was on the lower right hand.

—LEVY.

Peggy Guggenheim was Ernst's third wife. She wrote *My Life with Max Ernst*.

❏ Jimmy longed to be friends with Max but Max felt uncomfortable in his presence and did not know how to talk to him. I immediately took Jimmy to my heart and became a sort of stepmother to him. In a way I always felt like Max's mother too. It seemed to me he was a baby deposited on my doorstep and that I had to look after him. That was why I was so frantic every time he was in trouble. I always felt that when I would no longer be useful to Max he would have no further use for me. This spurred me on to doing the most difficult things for him. I not only tried to obtain everything he needed, but also everything he wanted. It was the first time in my life that I had felt maternal

toward a man. When I told Max that he was a baby deposited on my doorstep, he said, "You are a lost girl." I knew he was right and was surprised that he realized it.

Max, like all other babies, always wanted to be the center of attention. He tried to bring all conversations around to himself, no matter what they were about. He loved beautiful clothes and was jealous when I bought new dresses, because he would have loved to wear them himself instead of drab, male garments. In his paintings he portrayed himself and other men in marvelous Renaissance costumes. Once in Marseilles, when I bought myself a little sheepskin coat, Max was with me and he was so envious that I ordered him one too. No man had ever bought anything in this shop before, and the shopkeeper was rather surprised. However, the coat was made to order for Max, and when he wore it he looked like a Slavic prince. . . . I encouraged him to buy a trousseau. He looked so beautiful in American clothes, for he had a perfect figure and was extremely elegant by nature. I gave him the diamond and platinum lorgnon with the watch that had belonged to my mother, and he used it instead of glasses. It suited him perfectly, making him look English and aristocratic. . . .

When I first lived with Max I had no idea how famous he was, but little by little I realized it. People were always coming up to him and treating him with reverence and respect, like a great master. He took his adulation very well. He was perpetually being photographed for the press. He loved this, and he hated to have me included. Once, however, he had to succumb and we appeared in *Vogue* with our little dog Kachina, a Tibetan Lhasa terrier, who was all overgrown with white hair and looked like Max. Max bought an enormous chair about ten feet high. It was a Victorian theatrical prop. He sat in it as though it were his throne, and no one else ever dared use it. He was always photographed in this chair.

—PEGGY GUGGENHEIM, *Out of This Century.*

In 1942 Ernst left Peggy Guggenheim to move in with Dorothea Tanning, a young painter whom Miss Guggenheim had included in a group show of thirty-one women, who became Ernst's fourth wife. Miss Guggenheim said later that she "realized that I should only have had thirty women in the show."

Jimmy Ernst saw his father back in Paris late in his life. "I saw him, partially paralyzed, in that quiet silvery room on the rue de Lille. . . ."

❏ "Rosenberg is a friend of yours, isn't he? Whatever made me think that he didn't like me very much? . . . That nice white-haired painter . . . De Kooning . . . doesn't he live near you? What's the name of

that place near the ocean where we used to go in the summer? . . .
And Rothko . . . do you like him? . . . Do you see him? He is always
so serious . . . even when he smiles. Sad . . . is he always so sad? Do
you see a lot of the friends from what they call the School of New
York? Are you still one of them? Are they as famous as you are, over
there? Everybody in America is famous." I did not tell him that Rothko
had committed suicide five years before.

—ERNST.

Henri Gaudier-Brzeska
(1891—1915)

Nina Hamnett ran across some drawings by Gaudier; then she
discovered his sculpture.

❏ One day an elderly woman whom I knew asked me if I knew a
sculptor who could give her lessons at five shillings a time. I knew the
bookseller, Dan Rider, who lived near Charing Cross Road. He was a
fat little man who roared with laughter the whole time. He knew Frank
Harris very well. He also knew Gaudier Brzeska. I went to see him and
I said, "Is Brzeska rich?" and he said, "He is very poor"; so I said,
"There is a lady who would like lessons in sculpture." This was in 1913,
when five shillings meant more than it does now. It was not very good
payment but I wanted to meet him. Dan Rider arranged a meeting at
his book shop. I turned up and was introduced to him. I said, "Come
back to my place and we will talk about the lessons in sculpture." We
walked up Charing Cross Road. He said, "What do you do?" I said that
I painted and had exhibited at the Independents at the Albert Hall.
He said, "There were so many pictures." I said nervously I had a pic-
ture of a "Dead Soul," holding a yellow tulip. He said, "Yes, of course,
I remember it, you are the young girl who sat with my statues; my
sister and I called you 'La Fillette.' " We walked on. He gave my friend
lessons, and one day came to my room and said, "I am very poor and
I want to do a torso, will you sit for me?" I said, "I don't know, perhaps
I look awful with nothing on," and he said, "Don't worry." I went one
day to his studio in the Fulham Road and took off all my clothes. I
turned round slowly and he did drawings of me. When he had finished
he said, "Now it is your turn to work." He took off all his clothes, took
a large piece of marble and made me draw, and I had to. I did three
drawings and he said, "Now we will have some tea." From the drawings

he did two torsos. . . . We used to wander round Putney and look at stonemasons' yards, where tombstones were exhibited, in the hopes of finding odd bits of stone in reach of the railings. One day we found a nice piece of marble and that night we arranged to meet. At 10:30 we went to the yard. I watched for a policeman and he took the piece of marble and put it in his pocket. . . .

Henri had a workshop under one of the arches of Putney Bridge. I spent every Sunday afternoon with him. We bought chestnuts and roasted them and he drew me in my clothes. Henri had a bright red shirt. A friend of mine had invented a shirt, the neck was cut square, it was what is now called a jumper. Henri had a red one and wore it inside his trousers. I wore mine outside my skirt and people stared at us in the street. Henri talked about the *"sales bourgeois."* In the next arch of Putney Bridge there lived an academic sculptor who did monuments. He did not carve stone, so Henri despised him. He had a band of Italian workmen who came and did the dirty work for him, that is to say, they hacked out the stone. When the sculptor was out Henri would buy the workmen some Chianti and learn from them how to carve stone. He bought a forge cheaply and put it in his backyard. There he used to forge the tools that he sculpted with. It was a wonderful machine with large bellows and made a great noise. Henri said to me, "Don't mind what people say to you, find out what you have in yourself and do your best, that is the only hope in life." One day I sold six of Henri's drawings to a friend of mine for £1 each. He said, "Don't tell my sister you sold six, say it was only five and we will go to the 'Swiss' in Soho and have some drinks." I dined with him and his sister in their rooms in Putney. There was a row during dinner and they threw some beefsteaks at each other. After dinner she said to Henri, "You bore me, take Nina away and give her something to drink," so we went to the "Swiss." After we had some beer Henri said, "She is not my sister, she is my mistress," and I choked down some sobs.

—NINA HAMNETT, *Laughing Torso.*

Hamnett tells the origin of the best-known Gaudier carving.

❏ Henri knew Ezra Pound very well and liked him. Ezra said, "You must sculpt me," and bought him a block of marble. He said, "You must make me look like a sexual organ."

—HAMNETT.

Pound wrote a book about him.

❏ We wandered about the upper galleries hunting for new work and trying to find some good amid much bad, and a young man came after

us, like a well-made young wolf or some soft-moving, bright-eyed wild
thing. I noted him carefully because he reminded me a little of my
friend Carlos Williams.

He also took note of us, partly because we paused only before new
work, and partly because there were few people in the gallery, and
partly because I was playing the fool and he was willing to be amused
by the performance. It was a warm, lazy day, there was a little serious
criticism mixed in with our nonsense. On the ground floor we stopped
before a figure with bunchy muscles done in clay painted green. It was
one of a group of interesting things. I turned to the catalogue and
began to take liberties with the appalling assemblage of consonants:
"Brzxjk——" I began. I tried again, "Burrzisskzk——" I drew back,
breathed deeply and took another run at the hurdle, sneezed, coughed,
rumbled, got as far as "Burdidis——" when there was a dart from be-
hind the pedestal and I heard a voice speaking with the gentlest fury
in the world: "Cela s'appelle tout simplement Jaersh-ka. C'est moi qui
les ai sculptés."

He was the best fun in the world, whether he was inveighing against
the softness of modern customs, or telling tales of his life. Thus: when
he was in Munich he was part of a Rembrandt factory. He used to go
into the ghetto and draw types: the sweep, the vigor, the faces. Then a
Swiss used to take the drawings up to the pinakoteka and carefully
daub them à la Rembrandt, studying the mannerisms, all the ways of
lighting the hands, etc., etc. And then a German took them and put on
the tone of time, tea-leaves, etc., and then they were sold to a Jew. (O
my country! Wherein I have seen galleries of "old masters.") Thus they
made new Rembrandts, not doubtful copies or "originals of which the
copies are at the Hermitage."

—EZRA POUND, *Gaudier-Brzeska: A Memoir.*

Among other things they joked about Pound's hieratic head,

❏ . . . of the time when I should sell it to the "Metropolitan" for
$5000, and when we should both live at ease for a year . . . some two
or three decades hence.

—POUND.

When the war started Henri Gaudier returned to France and
after a month's training entered the trenches. He was twice pro-
moted for bravery before he was killed charging at Neuville St.
Vaast on June 15, 1915. Ford Madox Ford remembered him.

❏ I think of poor Gaudier as I last saw him, at a public dinner, stand-
ing sideways, with his fine sanguine features, his radiant and tolerant

smile, his delicate movements of the hands, answering objection after objection of stimulated, after-dinner objectors to his æsthetic ideas with such a gentleness, with such humor, with such good humor. At that date there was no thought of war; we were just all separating at the end of the London season. And within a year this poor, fine, beautiful spirit has gone out through a little hole in the high forehead.

—POUND.

Moise Kisling
(1891–1953)

Marevna describes a mortuary occasion.

❏ I have a pleasant memory of an evening at Kisling's because it was so funny. I can see myself now, climbing the staircase to his studio, hearing laughter and the hubbub of voices. One would have said that all was jollity within, but when I knocked on the door silence fell, and I entered to the accompaniment of a Jewish dirge. Before me stood a kind of catafalque, illuminated by two candelabra, each holding seven candles. In the middle lay a huge book, open. Under the white sheet, a small, motionless body lay stretched out. To the left, on a huge sofa and on the carpet at its foot were gathered the host and his guests, looking grave and continuing to sing their threnody.

Who had died? Who was the little child lying there in the studio that had witnessed so many crazy gatherings and famous orgies? I felt uncomfortable, and was about to withdraw when Kisling, in a melancholy voice, asked me to put my signature in the great book. I complied, stealing a glance at the shrouded corpse.

"Poor little girl!" Kisling said in the same tone. "The poor little thing is dead. We are assembled here to weep over her. She was beautiful, she was amusing, but her curiosity, her gluttony were too much for her. She loved, she suffered, she died. Peace be upon her soul."

At this, laughter rang out. Kisling went up to the catafalque and threw back the sheet, disclosing to my astonished eyes the corpse of a big striped cat. It was the painter's own cat, whose unwholesome curiosity had led her to eat his paints. Unable to digest them, she had begun to swell and swell, and that morning had been found dead, her mouth smeared with paint.

—MAREVNA, *Life with the Painters of La Ruche*.

The great model Kiki told Georges-Michel how she met Kisling.

❏ One day a newcomer appeared at the Rotonde. He was sun-
burned, wore his hair in a fringe, and had a disagreeable expression. I
hardly dared look at him after I heard him say to the manager, "What's
that new tart over there?"—that didn't help to endear him to me. I
didn't say anything because he frightened me a little, with his red scarf,
his hands in his pockets, and his way of staring at you. But a friend of
mine who admired him said to me, "That's Kisling. I'm going to intro-
duce you to him." After that, every time he saw me in a café he would
shout out at me and call me all sorts of names. Of course, I know that
the first words most foreigners learn in another language are always
dirty ones. But I was furiously angry, and decided not to speak to him
any more. It was a pity, because I rather liked him.

Then he promised he wouldn't insult me any more. He gave me a
contract for three months. But I'm a gloomy kind of model most of
the time. So then he would start yelling his head off to make me laugh,
or else he would make . . . well, rude noises; and we tried to out-do
each other in that. That's the only thing that really makes me laugh.
He was very nice to me after that. I would steal his soap and his tooth-
paste, and he never said a word.

—MICHEL GEORGES-MICHEL, *From Renoir to Picasso: Artists I Have Known.*

His transformation from worker to bourgeois was well docu-
mented.

❏ Kisling was wearing a cap and workman's clothes and refusing to
ride in taxis because they were symbols of the *bourgeois.* Later, he began
to make money, and sometimes he was forced to take taxis, so he drove
with the chauffeurs outside. Not so long after, we found him inside;
and presently he was driving his own car. In the end he employed a
chauffeur. The last time I saw him was in the American bar of La
Coupole, he was wearing the Legion of Honor. When I chaffed him
about this and reminded him of his first compromise when he rode
with the taxi-driver, he explained everything with the gravity always
used by a Polish Parisian when he speaks of himself. He said he was no
longer young, then decided to make the Biblical excuse, but now—the
women insisted on it.

—C. R. W. NEVINSON, *Paint and Prejudice.*

Jacques Lipchitz
(1891–1973)

When Lipchitz was very young, in 1912, Rodin admired his work. However, the young man did not admire Rodin and rejected the offer of a job as an assistant. In the same year he made another inadvertent connection when he took an apartment. He could not sleep his first night because of a continuous tapping noise which sounded like a faucet dripping.

❏ I asked the concierge: "Who makes that noise?" She showed me a bearded man and said: "That is Brancusi!" But I did not know him; I didn't even know that he was a sculptor. So I asked her what he did, and she said: "Go to the cemetery of Montparnasse, and there you will see a monument made by him." I went and looked at it, but I did not like it.

—BERT VAN BORK, *Jacques Lipchitz: The Artist at Work.*

He liked the food Gertrude Stein served at her receptions. He also enjoyed her self-regard; she asked him: "Jacques, of course you don't know too much about English literature, but besides Shakespeare and me, who do you think there is?"

❏ After the war, in 1920, I made her portrait, hoping she would buy it, but she never did. In this, I was particularly impressed by her resemblance to a fat, smooth, imperturbable Buddha, and it was this effect that I tried to get. She mentions in her autobiography that she liked to sit for me because she knew the beginnings and end of many stories and I knew the middles. She also wrote one of her "portraits" about me and someone translated it for me, but I did not understand a word of it.

—JACQUES LIPCHITZ, *My Life in Sculpture.*

He talks about the moment of Cubism.

❏ When artists are living and working as closely together as we were in those years, they are all obviously influenced in some degree by one

another; they all derive motifs from one another. I remember one day when Juan Gris told me about a bunch of grapes he had seen in a painting by Picasso. The next day these grapes appeared in a painting by Gris, this time in a bowl; and the day after, the bowl appeared in a painting by Picasso.

—LIPCHITZ.

At the opening night of Stravinsky's *Rites of Spring,* Lipchitz cheered loudly; a gentleman signified disagreement by hitting him on the head with an umbrella. Sergei Diaghilev, impresario of the Ballets Russes, was the source of a quarrel with a dear friend of Lipchitz.

❑ Juan Gris, whom I loved dearly and whom I still love, became very angry at me as a result of a ridiculous misunderstanding. He had designed a ballet for Diaghilev to be presented in the Palace of Versailles for some charity. When Diaghilev showed me the model stage as it had been set up, he asked my opinion and I made a few little suggestions. These must have been represented in a distorted form to Gris because he became furious with me, accusing me of attempting to destroy him. I, in turn, became angry and for almost a year we did not speak to each other. We were both living in the same suburb of Paris, Boulogne-sur-Seine, and we would see each other at the bus stop, but each would completely ignore the other until finally one day Gris came over to me and said, "This is really stupid, when friends like us cannot *pisser ensemble.*"

—LIPCHITZ.

Later it was the time of Surrealists.

❑ My assistant, Isadore Grossman, one day came to me in a fury, saying that the teacher had been talking about modern sculpture and a girl had asked him what he thought of the sculpture of Lipchitz. The teacher had had a lump of clay in his hands and had let it fall on the floor, where it splattered, saying that that was a Lipchitz. I only said, "That is a rather interesting idea. I think I might try to make some such sculptures." So arose the idea of the semi-automatics, in which I would just splash or squeeze a piece of warm wax in my hands, put it in a basin of water without looking at it, and then let it harden in cold water. When I took it out and examined it, the lump suggested many different images to me. Automatically a particular image would emerge several times and this I would choose to develop and clarify. Up to this point my acts were purely automatic; from here on they were com-

pletely conscious. These latter ones were far freer, even though in the last analysis they were controlled by all my experience.

—LIPCHITZ.

He came to New York in 1941. "To some of my colleagues I am still not a full-blooded American," he wrote in his 1972 autobiography. "In this context I like to emphasize the fact that when I was very ill a few years ago, I lost seventy percent of my blood. I was actually dying until they started to pour twenty-two pints of American blood into me and I was saved, so now I defy anyone to say that I am not a full-blooded American."

❏ I remember that when I first arrived in New York I was invited to the home of a very important dealer and collector. I only had the clothes I was wearing, which were dirty and disreputable, and at first I refused the invitation, explaining the reason. The collector said not to worry, to come anyway, so I went. When I arrived, my host studied me so intensely, back and front, that I became self-conscious. He then took me into a bedroom and threw open a closet door, explaining that since we were the same size I should select anything I wanted from his wardrobe. I was embarrassed, since never before in my life had I done such a thing, but my host insisted, saying that it would be fun for him; so he dressed me from top to toe and said I must keep this new outfit. Since I was then a penniless refugee newly arrived in New York, I finally and reluctantly agreed to do so, and I must admit that those new clothes became for me a symbol of hope and good fortune. For years, until they wore out, I would wear exactly that outfit whenever I had something important to do because I was convinced that the clothes would bring me luck.

—LIPCHITZ.

In 1963 he visited Israel and talked with Ben Gurion.

❏ In my first visit I had a most interesting conversation with Ben Gurion. He doesn't know much about art but he wanted to talk about it. He asked me if I liked Chagall and I replied that I liked him very much. He is a great artist, a beautiful jewel in the Jewish crown. So Ben Gurion said, "But where do you see Jews flying in the air?" I replied, "Mr. Prime Minister, you are a great expert on the Bible and the Bible is full of angels flying in the air; did you ever see any angels flying in the air?" I do not think he liked my answer.

—LIPCHITZ.

Stanley Spencer
(1891–1959)

He was twenty-one when he finished his work at the Slade by winning the Nettleship Award for his *Nativity*. As he crossed London to pick up the award, he did not resemble an award-recipient. He was small—Picasso-size, at five foot two—he was never clean, and he always dressed as disreputably as possible. "As I stepped out of the station," he remembered, "an elderly man with a beard put his bag down, whistled and called: 'I say, boy, just carry this bag for me.' I picked it up and walked by his side down Gower Street. . . ."

❑ When we got to the Slade porter's lodge he told me to put the bag down and began to fumble in his pockets. I said I was going inside myself. So we walked across the quadrangle to the door on the left which leads to the office and theatre where the award was to be made. Here he told me again to put the bag down and fished out some coins. "Oh, no," I said, "that's all right," and began going towards the theatre door. "You can't go in there," he said disapprovingly and, pointing to the office: "That's where you deliver messages." I then explained that I had come for the Nettleship prize. He apologized profusely and we walked in together to our allotted seats in the assembly.
 —MAURICE COLLIS, *Stanley Spencer: A Biography.*

He worked as an orderly in a hospital during the Great War.

❑ All was a possible subject for his art. He believed that both agreeable and disagreeable happenings were equally useful to him. Every scrap went into the pot and would turn into a delicious soup. He was sure of this, sure that he would survive his trials and return to his painting fresher than when he left it. Sometimes he experienced moments of sudden bliss in the midst of some menial task, moments so vivid as to be deliriously happy. He recalls, and has left pencil sketches of, one such moment, when he was scrubbing the floor between two baths. Right down on the ground, the baths bulging above him, he was overwhelmed with an immense undefinable joy. If it arose from an

intuitive feeling that his would be the last word on Beaufort Hospital, he was right.

—COLLIS.

He wanted indeed to marry Patricia but he wanted not to lose Hilda. He explained these matters to Hilda.

❑ "Patricia supplies what I miss in you; you supply what I miss in Patricia. I say I need and want *two wives* and this is my only way of having two." He asks Hilda, therefore, to continue as his wife outside the law. "I am fonder of you now and more ready to appreciate all that is so marvelous about you, because I have the relief of Patricia. You each make the other supportable and enjoyable." Patricia is stimulating, Hilda is restful. Patricia, he declares, is fond of Hilda. Let Hilda marry someone else, if she wants to safeguard herself materially. He would not mind, provided she regarded him also as her husband.

—COLLIS.

"I wish years ago I had found that I was polygamous," as he put it, but oddly enough neither Patricia nor Hilda saw the matter as he did. Spencer wrote Hilda again: "As you know I dislike the idea of mistresses. I have always cherished the idea of marriage, but not marriage to one person." He proposed that the three live together in a large house, with each wife in a separate suite, to be visited in turn. Again he wrote Hilda: "What I long for is when I can call both of you my wife. I want also to try all sorts of experiments with you, like, for instance, doing a nude painting of you, as I have done of Patricia, or getting you a dress."

Shortly after his marriage to Patricia he persuaded Hilda back to bed. When he told Patricia of his conquest, she was annoyed, which seemed to shock him. Instead of two wives he found himself with none. Solitude stimulated his art, and his nude paintings became especially erotic. He imagined a museum for his erotic paintings, sexual but not secular.

❑ "A church and a house combined would perfectly fit the mixture" and display its unity. Though he sees no prospect of a patron coming forward to finance such a building, he desires to have his wishes on record in case such a patron should ever appear and do for him what Mr. Behrend had done for him at Burghclere. The building would consist of a church, parish church size, and two private houses, while the grounds would be dotted with little chapels, 8 feet square, and little

rooms of the same dimensions. To bring the secular into close connec-
tion with the religious the two houses should abut on the walls of the
church. There should be doors direct from the bedrooms into the church.
"Along the church aisle would be twelve chapels for the contemplation
of married happiness, each chapel, like a cubicle, to contain pictures of
couples in the style of *The Beatitudes of Love* or those paintings them-
selves as far as they would reach. In the chancel I should want to carry
out a scheme I have drawn of angels introducing animals to their mates."
He then passes on to consider the pictures in the two houses, where
the secular side could be more stressed. The passages from them lead-
ing to the church would be hung "with different emblems of sexual
love, such as clothes, scents, brushes, smart hats and jewelry. In an
alleyway would be paintings of men and women in different stages of
undressing, opening into a room of nudes making love or lying about."

—COLLIS.

It was John Rothenstein who suggested that Spencer might paint
Biblical scenes for the chapel of Campion Hall. Father Martin
D'Arcy was head.

❏ Father D'Arcy was asked to lunch at their house in Burghclere to
meet Spencer. Walton has related to me what followed: "As the buffer
between Father D'Arcy and Spencer I was also invited to the lunch.
Spencer did not seem aware that if he wanted the commission he should
be careful to restrain his normal inclination to blurt out whatever was
passing in his mind and to talk in a way agreeable to his would-be
patron. On the contrary, he seemed determined to embarrass him and
proclaimed in a loud voice for all at table to hear: 'I've got two wives,
one divorced and one not, and feel equally married to both.' Father
D'Arcy, as a man of the world, took this fairly well, but clearly did not
like it. Embarrassment increased when Spencer followed this opening
with a monologue on the holiness of sex. The Behrends managed to
divert him from this topic and at the end of lunch Father D'Arcy in-
vited him to stay a night at Campion Hall, inspect the chapel and say
what he could do. I was asked to come also. We arrived in time for
dinner. Nothing was said during the meal, for conversation was forbid-
den. The company ate in silence, listening to a homily read by a mem-
ber of the order. Spencer was muzzled; he could only eat and drink.
After dinner we adjourned to the Senior Common Room. Port was
handed round, talk brightened up. Spencer was soon holding forth in
his usual way. Two of his *dicta* stick in my mind: 'If a picture of the
Virgin is to be any good, I must paint it from a drawing of a woman I
sleep with'; and 'In my painting I owe nothing to God and everything

to the Devil.' Father D'Arcy did not there and then withdraw his offer, but he became very guarded.

—COLLIS.

In 1942 he proposed to Hilda that they remarry, although he had not yet undertaken to divorce Patricia. Although Hilda entered a mental hospital, he continued to propose to her. He visited her constantly in her last illness until she died of cancer in 1950. After her death he continued to write her letters until he died in 1959. Meantime he served notice of desertion on Patricia and divorced her.

In later life he put on his clothes in the morning over his pajamas, dining with lords and ladies in this fashion. For his landscape painting, he kept a pram.

❑ The pram, his niece declares, had been described by reporters as an amusing eccentricity. "But it was the most practical and sensible conveyance that could be devised for a landscape painter's use." It could be lifted over stiles, carried across ploughed fields and with its hood up it protected a painting from a shower. Little has been said of Spencer's landscapes, which number over a hundred. He never regarded them as more than a means of livelihood, though among his papers he has a list of twelve which he thought not bad. He describes himself painting a landscape in the winter of 1954: "I stand in a car muff, a sack with zips up to my armpits. Into it I first put two hot-water bottles."

—COLLIS.

In any event, he loved to paint.

❑ I wish to have no status as a man. I am equally content to be a worm or rat, and am only glad that in fact I am not, because they have such a rough time without the pleasure of painting.

—COLLIS.

He was knighted late in life. He went to Buckingham Palace wearing his one suit and carrying a shopping bag full of medicines and a present for the Queen Mother—a flower picture, specially painted for the Pearly Queen. It was a disappointment when he discovered, on his arrival, that gifts were not allowed.

There was a tranquility about the eccentricities of his last years.

—COLLIS.

❏ In later years Spencer had become much attached to Michael Wes-
tropp, Vicar of Cookham, and his wife Rachel. A suggestion to hold an
exhibition of his paintings in Cookham church and vicarage was warmly
supported by Westropp. In June 1958, after collecting a total of fifty
paintings, which included such important works as the eight *Christ in
the Wilderness* pictures, *The Visitation, Odney Baptism, The Last Supper, The
Nativity* and *The Crucifixion,* to which were added many landscapes of
Cookham, he put on an exhibition which drew thousands of people
from all parts of the country. Stanley himself was one of the exhibits,
for most days he posted himself in the churchyard, made famous by
his *Resurrection* of 1927, and with canvas and brushes busied himself
with a flower painting, work which he readily interrupted to talk to
anyone who came up. He was, as it were, at home to everyone. There
had been times when the local residents, unable to make head or tail
of his private life, the outward appearance of which, as paraded before
them, had seemed shocking, had been critical of his behavior. But now
these misadventures of the past were forgotten. He had become their
famous man; he had made the name of Cookham notable throughout
the kingdom. For that reason alone the occasion was one of the hap-
piest in his life. Though what he had achieved as an artist was far short
of what he still planned to do, he felt, as he spoke to the people, many
of them friends or acquaintances from youth, that he had become iden-
tified with Cookham and its meadows, Odney, Bellrope, Widbrook and
Cockmarsh, and the Thames flowing under the bridge. Those who saw
him will never forget the simplicity of his manner. There was not a
trace of self-importance. He was in no degree impressed by the nation-
wide interest the exhibition had aroused. He still looked young though
he was sixty-seven. His hair was as thick as ever, his face unlined, though
his labors for half a century, the mysteriousness of his hidden self,
showed in his glance, and gave something august to his expression.
When he got home in the evening he was going to write to Hilda; and
nobody knew that.

—COLLIS.

Grant Wood
(1892–1942)

When *American Gothic* made his name, he was thirty-eight years
old. He had lately returned from Europe to Iowa wishing to make

art out of his own background; as models he used his sister and his dentist.

Another famous Grant Wood painting was an act of revenge. In 1928 an American Legion post commissioned a stained-glass window for a Veteran's Memorial in Cedar Rapids. When Wood installed the window, the DAR denounced it for its provenance: the glass had been manufactured in Germany, enemy of ten years before. The Legion buckled under, refusing to dedicate the window. In revenge Wood painted his *Daughters of Revolution,* which he later called, "A pretty rotten painting. Carried by its subject matter."

He died when he was fifty, overlooked in the current fashion for non-representational art. (He found it ironic that Jackson Pollock had been his student.) He told Thomas Hart Benton that if he got well he was going to change his name and start a new life with a new style of painting.

George Grosz
(1893—1959)

Although he was himself German and living in Germany at the time of the Great War, he changed his name from Georg to George out of anti-German feeling. He preferred an America he invented out of the Leatherstocking Tales, Nick Carter, and rumors of Henry Ford.

❏ When I was nine, I was so enamored with Cooper's Leatherstocking that I copied *The Last of the Mohicans* in full, in my very best handwriting. A friend had lent me the book, and unfortunately I had to return it to him. But I loved those Indian stories so much that I wanted to have them for myself, to read whenever I wished, so I had to copy them. I used to sit on the balcony that was poised like a birdcage on the corner of the ugly tenement house in which we lived in Berlin. Street, coal depot and school disappeared beneath me; I was far, far away with the Indians, with noble old Chingachgook and his son and heir Uncas. I saw brave Major Hayward, the simple-minded preacher and Mabel and Cora threatened by the painted Iroquois; I had a pow-

derhorn on my hip, a hunting knife in my belt, and a long Kentucky rifle, carefully protected against dampness, rested in my hand. That book by James Fenimore Cooper was the first piece of America that I locked in my heart.

—GEORGE GROSZ, *An Autobiography.*

His affection for his imaginary United States survived confrontation with reality. He came to New York in 1932 and painted and taught, without material success, and returned to Berlin only in 1959, twenty-six years after he had left.

He was sixty-five years old for his last party. Martin G. Buttig wrote about it, and Lothar Fischer added a final paragraph.

❑ Grosz lit his n'th cigar, a yellowish-brown, very strong, Havana, and enthusiastically offered them around. None of us had any idea how many bottles we had emptied. Eva Grosz gently suggested going home. Grosz agreed, saying they had spent enough time in one place. Out on the street, when she asked whether he would not call it a day and come home with her, he spoke of the lovely evening that had just begun and could not possibly come to such an abrupt finish. "There is something interesting that I really have to show you," he said. He was referring to a photo in the former prizefighter Franz Diener's tavern that showed Grosz with his gloves on, from the days when he was painting Schmeling's portrait. Sure enough, that posed photo was still on the tavern wall, among the framed pictures of all prominent fighters of the past. Grosz posed again and said he would henceforth patronize Diener's restaurant. The owner asked him to inscribe the autograph wall. Grosz promised to do that, and to add a drawing. He would come back very soon, some morning when there would be no interruptions. Then of course he ordered champagne, and beer from Czechoslovakia. . . .

It was shortly after midnight when we left the restaurant and strolled the short way to his house. Grosz embraced us under the starlit sky. He walked up the steps, clicked his heels, tipped his hat and started a speech with "Ladies and Gentlemen" . . . (in English), praising the day and friendship, night and stars, Berlin and mankind in general. Afterwards the door opened again a crack, and out came his straw hat with the wide black band, and waved to us. Then the key turned in the lock inside. We saw his shadow as he mounted the stairs.

—GROSZ.

Joan Miró
(1893–1983)

❑ *The Farm* was begun in Montroig in the summer of 1921 but it was finished in Paris, where Miró, feeling a need to touch the springs of modern art, had been spending his winters since 1919. Miró worked on it constantly for nine months, with such a passion for authenticity that when he left Montroig for Paris he took along two sample tufts of grass to refer to as models. When the painting was finished it hung for a while in a Montparnasse café, and was eventually bought by a virtually penniless young American writer named Ernest Hemingway, who earned the money to pay for it by loading and unloading sacks of vegetables every night at Les Halles, the Paris produce market. "No one could look at it and not know it had been painted by a great painter," Hemingway once wrote. "It has in it all that you feel about Spain when you are there and all that you feel when you are away and cannot go there."

—CALVIN TOMKINS, *The World of Marcel Duchamp.*

André Masson later recounted Hemingway's opinion of Miró as a boxer: "He takes a good stance . . . but forgets there's an opponent in front of him."

Picasso talked about Miró to Françoise Gilot.

❑ Like all Catalans, Miró is the most cautious of men. At the height of the surrealist movement, when the big demonstrations were going on, everyone was supposed to do something scandalous, to throw mud in the collective bourgeois eye. It was considered a major achievement to do something outrageous right out on the street, in sight of everyone and, as a result, be arrested and perhaps spend a day or two in jail for having committed an affront to the established order. Everybody was cudgeling his brain for some original way of setting himself up in opposition to the reign of triumphant bourgeoisie. Some of the group hit on the idea of having people go out onto the street with various kinds of subversive utterances. Robert Desnos, for example, was supposed to say, "Bonjour, Madame," to a priest down in the subway within hearing of as many people as possible. Michel Leiris, whose father or uncle or cousin was an official at the Prefecture of Police, was assigned to insult

policemen until he succeeded in provoking one into arresting him. He got drunk first, then started out on his bicycle and when he came across a policeman on duty he shouted abusive names at him. He was soon taken to a police station and there he kept it up so courageously that he was given a thorough beating and held for forty-eight hours. Since he's rather frail, when he came out after his two days he was in terrible shape, but quite a hero. Eluard went around shouting. "Down with the Army! Down with France!" in some public square. He got roughed up, too, and then dragged away to cool off in jail. Everyone carried out his assignment with exemplary zeal. Miró, too, was expected to justify his presence in the group in some manner. So what did he do? He went around declaiming politely, "Down with the Mediterranean." The Mediterranean is a pretty big, indefinite area, with so many countries along its shores that no one of them could take it very much to heart if the Mediterranean itself was being attacked, and so politely, at that. As a result nobody rose to its defense and "Down with the Mediterranean" was the only outrage that went unpunished.

—FRANÇOISE GILOT AND CARLTON LAKE, *Life with Picasso.*

For the opening of his second exhibition in Paris, in 1925, Miró dressed up.

❏ He wore an embroidered waistcoat, gray trousers, and white spats. He was profuse in paying compliments, but so afraid he might overlook somebody that he almost gave an impression of anxiety. When it was over, we persuaded him to go up to Montmartre with us, and I have a very clear recollection of Miró, looking more preoccupied than ever, dancing a tango with a woman much taller than he. Not once did he slip—not a single step or a tiny gesture was omitted. The other dancers stopped, unable to compete with such conscientiousness. And Miró, all tensed up, kept right on doing the tango as though he had just learned it out of a book.

—TOMKINS.

Alexander Calder told Selden Rodman a story about Miró. A mutual friend

❏ . . . had taken him and Miró to see an almost perfect studio in the South of France, hoping that the Spanish artist, who was at the moment without a studio of his own, might rent it. "Miró wasn't even looking at it. He had found a piece of pale blue cardboard in the bottom of an apple crate and was playing with it delightedly, mumbling, 'Isn't it wonderful!' We never could get him to look at that perfect studio. He'd found what he wanted."

—SELDEN RODMAN, *Conversations with Artists.*

Ben Nicholson
(1894–1982)

Geoffrey Grigson lived in Hampstead in the 1930s along with the rest of the English art world.

❏ I remember a game we often played next door, in Herbert Read's studio, Ben, Herbert, Henry Moore from up the road, Stephenson, myself, anyone else who was present. A roll of paper was unrolled and pinned on the table. A "course" was prepared with colored chalks: that's to say, like a long strait, geographically, the paper was filled with islands and reefs. Then one contemplated the colored islands and reefs, and shut one's eyes, and moved a pencil point firmly from one end— the starting line—as far as one could get to the other end without touching rock or coast.

 The winners, every time, with the least wavering lines were either Ben or Henry.

—*Ben Nicholson*, ed. Maurice de Sausmarez.

Adrian Stokes remembers.

❏ He has told that his mother, herself an artist, distressed by high-flown talk, would find herself wanting to scrub the kitchen table. I have always considered that his remarking of it—perhaps back in the late nineties—to be the most telling anecdote I know about Ben Nicholson.

—SAUSMAREZ.

Nicholson's third wife, Felicitas Vogler, remembers his single-mindedness.

❏ In Monemvasia, for instance, on our first trip to Greece, we were delighted by a gleaming white church with blue window arches. I photographed it quickly because of the encroaching tide of tourists, working with intense concentration. As I climbed higher up the mountainside, I saw B.N. grow smaller where he stood drawing in front of the church, until finally he was only a dot in the big square before it. When I returned more than an hour later, I found him standing on the white stone of the fountain, immobile, where I had left him.

—SAUSMAREZ.

Maurice de Sausmarez asked Henry Moore to remember.

❏ H.M. In a way my biggest contact with Ben was really through his liking of games which I liked. Quite often he would ring up and say, "Henry, what about a game of tennis?" Well, he could make rings round me, despite my having won a competition in the tennis club at Castleford. I don't know whether he ever qualified for Wimbledon but he could well have done so. Ben is a natural ball player—he was an absolute wizard at ping-pong. He actually invented a variation of the game which he demonstrated at Gamage's or somewhere, hoping to patent it. Instead of a net one had a platform about four or five inches wide and used the top of this platform to bounce the ball on to and off. It gave hazards to the game rather like those in a game of fives, one never knew quite at what angle the ball would come off the platform.

 —SAUSMAREZ.

Nicholson said that, playing ping-pong with Henry Moore, "When you hit the ball back, you have to hit his purpose back as well." Geoffrey Grigson said that "To be with Ben, in the white studio, was to be peeled down to a new skin." He quoted another artist to sum Nicholson up.

❏ A wit of the time (Jean Varda, the Greek mosaic artist) made up a story about Ben which went like this: Many people, many art critics, were drinking at a smooth bar: they were sipping or knocking back Three Star Leonardo, Poussin on the Rocks, Cocktail Gainsborough, Cocktail Chardin, Double Courbet, Turner Fizz, Van Gogh High Ball, etc; when the barman cried out "Time, Gentlemen, please!," and they all trooped out to discover themselves enclosed in a high-walled passage, open far up to a cloudless sky, in which they could turn and walk only downwards to the left. The passage conveyed them without possibility of argument or escape down the slope into a graveyard with the same high walls—no doors, no windows, again no escape—in which there was a single grave, marked by a white rectangular gravestone, itself incised with a rectangle and a circle, and bearing an inscription of four words, *Ci gît la peinture.*

 —SAUSMAREZ.

Chaim Soutine
(1894—1943)

As a boy in the Lithuanian village of Smilovitchi he was the tenth of eleven children, his father a mender of clothes. In the shtetl,

it was not done to paint pictures—and from the age of thirteen Soutine wanted to do nothing else.

❑ Two of his older brothers constantly taunted him, saying, "A Jew must not paint," and they beat him mercilessly. Their cruelty became almost a ritual. Soutine would flee his brothers and hide himself in the woods near the village until hunger forced him home. He would return to find milk and warm black bread, which he dearly loved, laid on the table. But when he crept into the kitchen he would be beaten again by his waiting brothers. Soutine also recalled being beaten for stealing a kitchen knife to trade for drawing crayons. One day, when Soutine was about sixteen, he approached a pious Jew and asked him to pose for a portrait. The next day this man's son and his friends thrashed Soutine and left him for dead. He was eventually rescued, but it was a week before he could walk again. A complaint was lodged against the aggressors by Soutine's mother, and the boy was granted as compensation the sum of twenty-five roubles.

—*Chaim Soutine 1893–1943*, ed. Ernst Gerhard Güse.

When he came to Paris, his troubles did not cease.

❑ Soutine alienated people. It was his great affliction. Even the artists at La Ruche who had helped him felt a lasting bitterness at his ingratitude. Among them was Pincus Krémègne, who had taken Soutine in when he knocked at his door on the night of his arrival in Paris. Soutine had had difficulty in finding the Passage de Dantzig and had got himself thoroughly lost in the tunnels of the *Métro*. His only luggage was a rucksack and a few pictures painted in Russia. He was hungry, and as Krémègne told me: "There was nothing left on the dish if you didn't help yourself fast enough. He'd already gulped down all of the vegetables and as he asked for another piece of bread he'd say 'It's the tapeworm.' He'd never had enough."

—GÜSE.

Madeleine Castaing and her husband found canvases for him. "He would use only seventeenth-century paintings on their original stretcher, which gave just the painting surface he required."

There are many stories, some of them repeated by everyone who writes about Soutine.

❑ Once he was intrigued by a peasant woman who brought us our fruit and asked her to sit for him—she came once, but didn't return.

I went to see her. It was lunchtime, and her husband, who was a railway signalman, was at home. I could see he was jealous and couldn't understand why we were so insistent that she should come. My request to be allowed to take her back with me met with a categorical refusal.

Our chauffeur was given the task of fetching the woman, and he stationed himself behind a hedge near her house to wait until the husband left. He returned alone, she wouldn't even listen to him, she had her laundry to do and had gone off to wash clothes . . .

"Monsieur Castaing, come with me, I must speak to her."

There in a field, beside a spring, was a long plank—set at an angle so that the clothes-beater could be used—and three women on their knees, their backs to us, leaning over the water and pounding the washing. Soutine rushed up to them: "Madame, I had no ulterior motive, you understand, it's my job, thanks to you I've started a piece of work and I must finish it." The women turned round . . . none of them was the one he was looking for. "They'll say it was a madman."

In the end I was able to persuade the husband, the woman came back, the canvas is magnificent: it's the *Reclining Woman*. . . .

In August we went south and left Soutine behind in the house with Jeanne the cook.

One Sunday, earlier than we had arranged, we returned home. The house was empty, but there was a smell, one that I have never been able to experience since without the deepest emotion, the smell of fresh paint! We searched . . . all conceivable hiding-places were explored, and in the attic under the billiard table my son Michel discovered the hidden canvas: it was a masterpiece.

The next day we were lying on the grass by the water's edge when we were surprised by the return of Soutine.

Our delight was obvious, and he realized we had seen the canvas.

That evening, in bed, we heard Soutine open the door of his room, go past our door and up the stairs to the attic.

My husband rushed out and I followed.

"Soutine, stop!" He had a knife and a bottle of petrol!

"Soutine, it's a masterpiece! It's a crime!"

"Why did you look at it, you should have waited for me."

"Yes, you're right, but we were so thrilled to know you'd been working. Let's look at it together."

And so we spent part of the night all together in a state of high excitement—it was the *Woman Entering the Water*.

—GÜSE.

He did not destroy the *Woman Entering the Water*.

André Salmon said about him:

❑ I knew Soutine well and saw little of him. His art deserved the closest attention, but I confess that there was too much about the physical presence of the man himself that revolted me. Not only the filthy state in which he stumbled through life, but above all his slobbering speech. Possibly if it had not been for this feeling of repugnance I

could have enjoyed his company. Several people have told me that Soutine had some remarkable things to say. My loss, I'm afraid. I just couldn't come to terms with the poor fellow, who incidentally gave the ear specialist quite a surprise when he finally decided to consult him about his terrible earache. In the canal of the painter's ear the doctor discovered, not an abscess, but a nest of bed-bugs. . . .

—GÜSE.

Madeleine Castaing tells the most stories.

❏ His mixture of arrogance and nervousness explains much of the difficulty of his relationships with the people who tried to help him. One of these was Indenbaum, the sculptor. I met him when he was an old man of eighty-six and he told me his memories of Soutine at La Ruche.

"One day he brought me a picture he had painted at the Academy in Vilna. It was of an old man with one eye. He wanted thirty or forty francs for it. I bought it and a little later he returned and asked for it back. I gave it to him and afterwards learned that he had sold it again. Seven times he played me the same trick, and out of sympathy I let myself be taken in. So it came about that his *Piece of Red Meat on a Green Table* only stayed in my studio for a few days.

"One afternoon in the café La Rotonde he asked me for thirty francs. At the time that was a lot of money to me.

" 'Whenever you have a few sous you disappear, and then when you've nothing left you come back.' I walked off, but he followed me on foot all the way to La Ruche, repeating like a litany: 'Give me thirty francs, give me thirty francs, give me thirty francs.'

" 'And what about all the pictures you've taken away from me?' Head in hands, Soutine could say no more than *'ouille, ouille, ouille.'* When we came to the Place de la Convention I bought two mackerel. 'Now go and do me a still life.' He went up to his studio and two hours later brought me a narrow little picture: the two fishes on a plate with a fork. I gave him thirty francs and pinned the picture to the wall with four drawing-pins. Three days later he asked me to lend it to him. One last time, I agreed.

"In Montparnasse, sometime in the course of the next few days, I met a Russian emigré called Dielewski. He was a painter but earned his living as a photographer. Equipped with an imposing camera on four legs and a black cloth, he would ask for some of his money on account, and then, click, the photo was to all appearances taken. But since he never put plates in the camera his customers never did get their portraits.

"Dielewski was hiding a little picture behind his back.

" 'Do you want it?'—'But that's my picture!' I recognized Soutine's

two mackerel. 'He just sold it to me for five francs, though I only gave him three.'

"I left Dielewski, swearing that I would never buy anything from Soutine again."

—GÜSE.

It was an American, the famous fierce Dr. Barnes of Philadelphia, who discovered the paintings of Chaim Soutine.

❏ Just a year after Chagall's return, Barnes, looking for "geniuses," was recommended by his dealer Paul Guillaume to the Galerie Zborovsky. Zborovsky showed the American works by Derain, Utrillo, Kisling, but Dr. Barnes, who had made his fortune by inventing Argyrol, a medicine for the protection of the newborn, was looking for a newborn genius whom he could invent. Finally he picked up a dusty Soutine abandoned in a corner.

"Have you others by this artist?" Enthusiastic after seeing other Soutines, he cried: "Why here is the genius I've been searching for all these years!" and purchased one hundred Soutines on the spot. The collector of course wanted to meet the artist. After a frenzied search, Soutine was finally discovered waiting for a handout on a bench in front of La Rotonde; immediately he was bundled into an auto and presented in all his redolent rags to the good doctor, who smiled benevolently, sent Chaim off for a bath, had a suit made for him by an English tailor, and finally installed him in a rented villa in the Parc Montsouris where Braque, Lurçat, Fujita, and Chana Orloff were already living. Soutine refused to pay the rent although he had already received money for it from Barnes. He was afraid of spending his unexpected fortune.

Once rich, Soutine never saw his old friends again. Marc met him once four years after he had struck the Barnes Eldorado. He found him even more intolerable than before, now that he cleaned his nails and gave himself the airs of a grand seigneur. Indolently fingering his flowered silk tie, he denied to Marc that he had ever been born in Vilna. Chana Orloff reports that Soutine told her that he had entirely forgotten Russian, he had blotted out Smilovitz, Vilna, even La Ruche. Chagall cherished, nurtured, even rainbowed his Russian Jewish past; Soutine tore it up as savagely as he had slashed his unsatisfactory canvases.

—SIDNEY ALEXANDER, *Marc Chagall: A Biography* .

❏ Soutine had a passion for painting dead beasts—that is, he was fascinated by the marvelous colors of the carcasses, in butchers' shops. One day Soutine had an idea to paint a masterpiece from the whole side of beef—the half of an ox one sees hanging in a butcher's shop.

Zborowski bought one and arranged that it should be hung in his tiny studio. Paulette was posing at the same time for her hands, for Soutine insisted that when his eyes were blinded with color, he required another model so that he should not waste time. Everything started well; but it was summer time. Flies began to accumulate. Soutine would get into a temper, chasing away the flies that obstructed his vision of color. He wanted the blood trickling against the whites of the fat and the blues and greens of the flesh. When he was tired of that, or rather, when his eyes were "blinded," as he said, he would paint the white hands of Paulette as a contrast. But nature began to have its way. After several days, decomposition set in, with the accompanying smells and more and more flies.

The neighbors protested. Soutine didn't care a hoot. He wished to finish his color scheme which was becoming increasingly interesting as the flesh putrified. The whole scheme had to be recomposed. The subject was rapidly becoming more and more marvelous! The stink was frightful, but that didn't matter to Soutine in the cause of art. Again the tiresome neighbors complained and said that the studio stank. Paulette admits as much, too. But the rottener and more verminous the carcass became, the more beautiful were the colors Soutine discovered in it. At last the neighbors took action and denounced him to the municipality as a public pest. The sanitary authorities intervened. Soutine protested. Zborowski also. Enthusiastic about the work he had already done, and quite comprehending the point of view of the artist, Zborowski offered to indemnify the furious neighbors—not quite knowing where he was going to get the money. One of the inspectors, who was apparently an amateur of painting, remarked: "I don't understand why he doesn't get another side of beef! Voyons, he can't see the colors of this one for flies!"

"But yes, yes," exclaimed Soutine, brandishing his arms and raising a cloud of flies. "La Petite—Paulette—chases them and then I can see those marvelous colors."

"Maybe," adjudged the inspector, "but it's insanitary. If you like, you can have a fresh side of beef."

"No, no," protested Soutine, "you don't understand. It's the color of this one."

"Well," said the inspector, "we'll do our best for you. Wait, I have an idea! We'll send along a veterinary surgeon and he will give several injections that will stop the disgusting but natural decay."

"No, no," screamed Soutine, "that will change all the beautiful colors!"

—CHARLES DOUGLAS, *Artist Quarter.*

❏ In Paris during the twenties he would search the poultry shops with a friend for a particular chicken, one with a "long neck and blue

skin." His friends recount how Soutine pronounced the word "blue" with savour, almost gluttony—"You know, a beautiful 'bellue.' " On one occasion, the poulterer offered him a fat chicken, out of sympathy for Soutine's apparent poverty, but Soutine insisted on buying an emaciated fowl: "I want a very lean chicken with a long neck and flaccid skin." Finally, much to the poulterer's bewilderment, he found the wretched specimen he wanted. On the street he held up the bird admiringly and said, "I'm going to hang it up by the beak with a nail. In a few days it should be perfect."

—GÜSE.

His friend the Russian exile painter Marie Vorobëva, called Marevna, looking through the books on his shelves, found that Soutine owned something called *The Man of the World,* in effect an etiquette book.

❑ Opening the book at random, I read, "You must clean your teeth in the morning and evening and after meals. This is necessary to keep your breath sweet. There is nothing more reprehensible in society than bad breath. After a meal, take a toothpick and, hiding your mouth with a napkin, clean out the particles of food from between your teeth. At table, you must *never* pick your teeth with a match, a pin or your fork." I burst out laughing.

"You know, Marevna, it was Oscar Meshchaninov who gave me this book when he no longer needed it. His father was a tailor, like mine, and wanted to make his son a tailor, just as mine did, but Oscar became an excellent sculptor. When I came to Paris in 1913, Oscar used to teach me what and what not to do, and he often told me in those early days, 'Chaim, don't pick your teeth with your fork.' "

—MAREVNA, *Life with the Painters of La Ruche.*

She also tells the story she heard from friends of the younger Soutine.

❑ One day he had the unexpected luck to pick up a young girl who was ready and willing, but he did not know how to receive her.

"Primo," his friends said, "buy a toothbrush. Next, buy a clean shirt and last, put a sheet on your bed. Like that it should go off all right."

So Soutine did as instructed. The girl came and very quickly made off again, never to return. Soutine was very disheartened.

"What went wrong?" his friends asked. "How did you set about it?"

"I bought a toothbrush, as you told me, and put it in a glass. I also bought a shirt, which cost me a great deal, and spread it out on a chair, so that she could see it properly. Then I turned the sheet on my bed

over. But obviously she was a high-class tart—she didn't want to go to bed with one sheet."

—MAREVNA.

❑ Sometimes the paints Soutine used were not of the best quality and deteriorated on the canvas after they were mixed; the thick layers of paint he liked to use cracked after drying (especially the dark blues, reds and blacks), spoiling the whole aspect of the picture. In 1928, in my presence, Soutine telephoned a client and asked him how the red dress in the portrait of his wife was faring, and received the reply that the red dress had unfortunately cracked in several places. "Well, my friend, please send me back the picture, since it's imperfect, and I'll return your cheque for twenty thousand francs. I'd be very grateful if you would do this quickly. No, no, sir, I cannot do otherwise."

The client was reluctant to return the picture and assured Soutine that the cracked paint did not look at all bad. This agitated the painter. He grew red as a beet and began to stammer and shout into the receiver, showering it with saliva. "If an artist returns your money, you are obliged to send him back his spoiled picture. You must! It is dishonest to keep it. A flaw in the paint spoils a picture and the reputation of the artist, don't you understand?"

When the conversation terminated, unsuccessfully, Soutine was trembling. "The scoundrel!" he shouted. "I suppose he's afraid that when I've repaired the picture I'll ask twice as much for it or that I won't let him have it back or that I'll tear it up! That would probably be best. I'd have to scrape off the whole dress. Colors in Paris are quite worthless, the devil take them!" His left eye began to swivel round and his face grew deathly pale, a tremor seizing his cheeks and his foaming mouth.

I went to the kitchen to get him some water and put the glass in front of him. The crisis passed, and the eye of "Frankenstein's monster" stopped swiveling.

—MAREVNA.

If a viewer expressed reservations about a picture, the picture was not always saved from the kerosene.

❑ Sometimes Soutine would lacerate a picture simply to cut out the portion of canvas he liked. In a picture of a reclining female, for example, Soutine focused upon the poignant expression of weariness in the model's face—a weariness prompted by Soutine's forcing her not to move for hours until she practically fainted. Having elicited the exact mood he had wanted, Soutine hastily painted the face and figure. Later, when he displayed the picture, he was dismayed when a viewer

did not comment on the enervated look in the model's eyes, and he promptly slashed away almost all of the canvas, save for the face of the model.

—GÜSE.

Marevna writes how, on one occasion, at the Salle Drouot, he bought one of his old pictures "and tore it into pieces before the eyes of the amazed and indignant spectators. "Absolute muck," he announced. David Sylvester tells about how Soutine systematically bought his own paintings from the time he lived in Ceret, in order to destroy them. When his patron Madeleine Castaing wanted to buy a picture, part of the price would be that they buy a couple of Cerets so that he could destroy them.

Ivan Albright
(1897–1983)

As the *Oxford Dictionary of Art* puts it, Albright's painting demonstrates "a morbid obsession with death and corruption"—or as Albright put it, "I just can't seem to paint nice things." He knew what he was doing.

❑ When I sent the painting to the Carnegie Institute I made a frame for it. It was terribly hard work. I wanted to line it with casket lining. I had to get a permit from the undertaker in Naperville to go to the casket company to buy it. At the company I bought that drab black cloth. When I asked how to put it onto a frame, the man said, "Well, what we use is library paste. They only want it for two or three weeks anyhow."

—PAUL CUMMINGS, *Artists in Their Own Words.*

He went to Hollywood to paint the title role for *The Picture of Dorian Gray* (1943), which was of course a corrupted and closeted version of the hero. Albright's identical twin Malvin, less gifted at being loathsome, painted the prelapsarian Dorian. In Hollywood, Ivan wrote poetry.

❑ I used to write a lot in Hollywood, under the piano, when I got drunk. There was Albert Lewin there. We were in Santa Monica on

producers' row. Every Saturday and Sunday they had these big cocktail parties. They never had writers there. They never had actors. You know, if they had had actors, they might try to get a job. For instance, once George Sanders went there and tried to get a job; he made an ass of himself. So it was mostly Jean Renoir, Anita Loos, people of that type. Al Lewin was a little guy, my size or smaller. And he could talk. He was professor of English at Harvard at one time. He had a good sense of amusement. He'd get up on a chair and tell story after story. Maybe there'd be about thirty people present. And Herb Staud was there. He was a musical chap; he had seventeen hits on Broadway. He'd get at the piano. Well, after, say, the nth drink I used to think: What the hell can *I* do? So I only had to take my paper and pencil and crawl under the piano and come up with a piece of poetry all in forty seconds or half a minute or a minute. Al Lewin would look at my poem and say, "Damn it! It's pretty good, anyhow."

—CUMMINGS.

Alexander Calder
(1898—1976)

The Calder family was artistic, you might say. Alexander's grandfather made the thirty-seven-foot-high statue of William Penn on top of City Hall in Philadelphia. Their parents' friends sketched nudes, which made difficulty for the younger generation. His sister explains:

❏ Social gatherings brought other teenagers to our home, and for the first time Sandy and I became aware of the general attitude toward nudity. We were surprised and embarrassed for reasons we could not understand by the sly looks and salacious remarks of two boys from Ossining. Mortified, I went weeping to Mother, who tried earnestly but unsuccessfully to explain why charcoal drawings of nudes by my parents' friends Robert Henri and Everet Shinn were ART and therefore acceptable for living room display, whereas photographs of undressed persons were not. Having been surrounded by paintings and statues of unclothed figures all our lives,Sandy and I had never given the matter much thought. Suddenly the attitudes of our new friends became all-important, and the next time they came, we took down the offending drawings and hid them behind the piano.

—MARGARET CALDER HAYES, *Three Alexander Calders* .

Like many artists he followed a crooked trail as he began.

❑ Sandy's next temporary solution to the job problem was to join a logging camp owned by Hayes and Hayes in the forest about fifty miles from Aberdeen. The loggers lived in shacks built on flatcars so they could be moved easily from a logged-off site to a fresh one. Sandy roomed with a hard-shelled old camp boss name Cranky Jack Moore, who believed that night air carried various maladies and maledictions. Convinced that fresh air was essential to health, Sandy rigged up a device that enabled him to pull open the window as soon as the rhythmic snores from the next bed proved his irascible roommate to be asleep. The alarm clock, which would alert him to close the window before Cranky Joe woke up, bothered Sandy with its loud ticking, so he put it outside the window, attaching it to his toe by a string.

—HAYES.

He was an artist but also always a maker of toys, as early as 1923, at his sister's place in Aberdeen, Washington.

❑ The garage, garden, and tennis court became the Tidelands School. Sandy undertook to install blackboards and put up swings and slides, but before turning to such mundane projects he made some toys he had thought of while playing with my boys and their friends. The toys were mostly of the runabout variety: a kangaroo that leapt when pushed at the end of a handle, a rabbit that hopped, a duck that bobbed its head. So began the line of toys that he perfected in Paris. Some he would sell to a toy manufacturer in Oshkosh. Others were the forerunners of figures in his marionette Circus. Nana Frank was censorious about his playing with toys instead of working on the school as he was being paid to. Yet fifty-three years later, busloads of school children were being ferried to the Whitney Museum and solemnly urged by their teachers to appreciate the still-enchanting products of Sandy's self-indulgent toy-making.

—HAYES.

Toys, mobiles. Whatever they were, they were often mistaken for something else. Peggy Guggenheim remembers how Bruno Alfieri identified a dismantled mobile before it was discarded by workmen at the Biennale, who thought that it was part of a packing case.

The etcher and printmaker William Hayter remembered Calder when he was about to be married.

❑ I saw him yesterday. I found him with a clothespin on his nose to which he had fastened a piece of cotton as he has a cold and couldn't

take time off for his hands to wipe his nose. He had bread and salami attached to his Bulletin Board by strings. When he wanted either he cut off a hunk. I tried to find out about Louisa, but he was noncommital. Finally I asked, "What does she do?" "She's a philosopher," he replied.

—HAYES.

Someone asked him how he knew when a piece was finished. He answered—characteristically—"When the dinner bell rings." He deflated pomposity; he turned expectations upside down.

❏ There is a story of Calder being asked officially whether he'd be willing to make a mobile for the Guggenheim Museum out of solid gold. "Sure," said Sandy, "why not? And then I'll paint it black."

—SELDEN RODMAN, *Conversations with Artists.*

René Magritte
(1898–1967)

"I dislike money," Magritte said, "both for itself and for what it can buy, since I want nothing we know about." In letters and in interviews he said many things:

❏ I have few illusions; the cause is lost in advance. As for me, I do my part, which is to drag a fairly drab existence to its conclusion.

I despise my own past and that of others. I despise resignation, patience, professional heroism, and all the obligatory sentiments. I also despise the decorative arts, folklore, advertising, radio announcers' voices, aerodynamics, the Boy Scouts, the smell of naphtha, the news, and drunks.

I like subversive humor, freckles, women's knees and long hair, the laughter of playing children, and a girl running down the street.

I hope for vibrant love, the impossible, the chimerical.

I dread knowing precisely my own limitations.

Painting *bores* me like everything else. Unfortunately, painting is one of the activities—it is bound up in the series of activities—that seems to change almost nothing in life, the same habits are always recurring.

I hope I will never stoop to pulling strings to achieve success, which I can get along without.

I am unaware of the real reason why I paint, just as I am unaware of the reason for living and dying.

I can write texts that are interesting to people who don't play a conventional game. If one wants to reach other people, one must appear to play on their terms, while at the same time avoiding in any way being for an instant conventional. In short, I take pains never to be conventional when I am painting, and insofar as possible when I am not painting, I appear to play a conventional game: to paint, for example, or to live in a house, to eat at regular mealtimes, etc. . . . Maybe because some conventions are not stupid, but then those are not the annoying ones. Still, it's a fact that despite the conventional appearance of my paintings, they look like paintings without, I believe, fulfilling the requirements defined by the treatises on aesthetics.

I visited the fair [1958 Brussels World's Fair] a bit, I had to attend some openings. I took advantage of the occasion to take a look at the U.S. pavilion, which is funnier than the U.S.S.R.'s (the latter being as unpalatable as possible). I was thus able to try a "hamburger," the Perry Mason books having made me curious as to what it was.

—HARRY TORCZYNER, *Magritte: Ideas and Images.*

In 1965 he came to New York for the opening of a Museum of Modern Art retrospective of his painting. With his wife he paid a pilgrimage to Edgar Allan Poe's house in the Bronx, and wrote in a letter that "Poe's house is the most beautiful in the U.S.A. A raven greets you from the top of a narrow wardrobe, his desk and his meager, admirable furniture . . . Georgette and I spent a long time feeling the back of a chair that had held him. . . ."

Reginald Marsh
(1898–1954)

During the years of the Depression, his paintings of Coney Island, amusement arcades in Times Square, and the Bowery transformed the shabbiness of these places. John Steuart Curry asked him why he always took the "worm's-eye view."

❏ Marsh's reply was: "You see, as a child I had rickets, and my frantic parents used to trundle me off to the beach and bury me in the

warm sand, being convinced it would cure my ailment. But imagine me, buried there, immobilized for hours on end, my only view of humanity being straight up their legs!"

　　　　　　　　—ALEXANDER ELIOT, *Three Hundred Years of American Painting.*

Henry Moore
(1898–1986)

One of his earliest commissions was *West Wind* for the London Underground.

❏　I completed the carving on a scaffolding platform where there was only about three feet to stand on, and at first I was alarmed. It was so high up. But when I got down and looked at it from the ground, I realized that the figure's navel couldn't be seen properly. This was terrible, because the umbilical area is absolutely central to me—the cord attaches you to your mother, after all. By this time the scaffolding had been dismantled, so I went up again in a cradle, winching it up myself from side to side until I reached the carving. But once there, I found I couldn't carve properly. Every time I struck a blow, the cradle shot back from the figure. So in the end I got out some charcoal and shaded the navel in . . . the cradle zigzagged all over the place on the return journey as well. Epstein watched me. After I'd come down he said: "I wouldn't have done that for all the money in the world."

　　　　　　　　—ROGER BERTHOUD, *The Life of Henry Moore.*

When rain washed the charcoal out, soot took its place.

　Moore's friend Jacob Epstein worked on another sculpture nearby.

❏　Moore took his niece Aline Reed along to see Epstein working on *Day.* Later they stood in the road looking up at *West Wind* to judge the effect it made. A stranger came and gazed with them. "What do you think of that? Who did it?" the stranger asked. "A man called Henry Moore," Henry replied. "Bloody awful, isn't it!" said the stranger. "I rather like it," said Henry pleasantly.

　　　　　　　　—BERTHOUD.

Because he dedicated his life to the pursuit of art, which required something like poverty, Moore understood that he should

not get married. After he met Irina Radetsky, as he often said,
he suddenly recalled that Rembrandt was married and Bach had
twenty children. Shortly after their wedding they rented a cot-
tage to take a holiday near his mother and sister in Colchester.
They were at Liverpool Street Station in London, waiting for the
train, when Irina tried to lift Moore's suitcase: he had packed a
block of alabaster. He carved on his holiday and sold the piece
for £65.

In Hampstead in the 1930s Moore lived in a nest of artists
including Barbara Hepworth and her husband Ben Nicholson.
The artists wandered back and forth from studio to studio. Some
witnesses have claimed that it will not suffice to know on what
day an artist invented a motif; you have to know whether it was
done in the morning or in the afternoon.

After the Second World War, a retrospective at the Museum
of Modern Art in New York, together with his prize at the Ven-
ice Biennale, elevated Moore to the pinnacle of fame.

❑ Every morning Curt Valentin would call him at 8:30 to discuss the
day's program. Part of each day before the opening was spent helping
with the installation. The rest was given over to meeting people and
looking at works of art. When it came to drinking Valentin set a stiff
pace, and Henry recalled falling asleep in a taxi one evening with his
head in Martha Graham's lap. During a session with the poet e. e. cum-
mings in Greenwich Village a smashed table landed on his foot. He
went to see Walter Lippmann, thinking this was his chance to under-
stand American politics. When he had fired off some questions the great
commentator said, "Of course I could tell you what you want to know,
but if I were you I wouldn't bother my head with it. Just get on with
your work, Mr. Moore."

 —BERTHOUD.

On his trip to New York in 1946 Moore was able to see the great
Barnes collection near Philadelphia. The acquaintanceship started
poorly.

❑ Moore had come armed with an introduction from Kenneth Clark,
only to be warned it would be fatal to use it. One day d'Harnoncourt
introduced them at MOMA. Henry confessed he was about to write to
him "since I would love to come, if I may, to see your fabulous collec-

tion." After a short silence Barnes said: "Such exaggerated flattery makes me sick."

<div align="right">—BERTHOUD.</div>

He was modest; yet he was also immodest. His friend Philip Hendy told a story.

❑ The sculptor had on one occasion described a common acquaintance as the most conceited man he knew. "Bar one," said his friend (probably Hendy himself). "Who's that?" "You, Henry. Don't tell me you have ever thought of yourself as anything but the greatest sculptor alive." There was a momentary cloud of introspection, then the sun came out brighter than ever: "Oh well," said Moore, denying nothing, "I suppose it depends on how you show it!"

<div align="right">—BERTHOUD.</div>

He was, you might say, competitive. In 1959 and 1960 I played ping-pong with him. I hit the ball quickly to his backhand; the right-handed Moore slapped the ball with the flat of his left hand, a nice defensive shot that dropped across the net. When I caught it laughing, he said, "That *counts*, doesn't it?"

Offered a knighthood he brooded about it, finally turning it down: he could not bear the notion of waking in the morning to hear his assistants address him as "Sir Henry." Later, he also refused a peerage but accepted the prestigious Order of Merit. When he turned down knighthood in the 1950s, Herbert Read praised him for the rejection, saying that such things were "not for the likes of you and me." Henry and Irina were startled a year later to read that their friend had become Sir Herbert.

All through his life, he sold drawings and sculpture to his friends at prices that they could afford, often on the installment plan. Some of them underwent the embarrassment, late in their lives, of needing to sell what they had acquired. Julian Huxley's widow Juliette sold a shelter drawing.

❑ So with great sadness I rang him up and said: "I'm sorry Henry, I had to sell your picture." "I know," he replied, "I bought it." I was glad that it went to his own collection.

<div align="right">—JULIETTE HUXLEY, *Paris Review*, Winter 1986.</div>

Ben Shahn
(1898–1969)

He remembered adventures from his Lithuanian boyhood.

❏ When he told the family ten thousand policemen had chased him down the street for yelling "Down with the Czar!" he wasn't *lying*, as they insisted, but giving the true sense of his feeling with the only round number that expressed it accurately. But Mother had been so distressed by this tendency to exaggeration in her son that she had called in her oldest brother Judel, the *kahzoner rahv*, to discipline him with these trips to the synagogue. What had made it worse was that that very day he hadn't been at home at all, but had been "busy" with the other kids in a nearby excavation for a new tannery where they had uncovered by chance a mass grave, and that just as Gittel had finished telling her brother what an impossible child he was getting to be and how she couldn't discipline him, he had burst into the room proudly leading a procession of the boys each of whom brandished a human skull on the end of a long stick.

—SELDEN RODMAN, *Portrait of the Artist as an American: Ben Shahn.*

Visiting Paris in 1927, Shahn saw Picasso and Derain sitting together at the Dôme, and he eavesdropped on the wisdom of the great men.

❏ *"Dis. T'as mangé?"*
"Non. J'ai pas mangé. Où est-ce qu'on mange par ici?"
"Je sais pas."

—RODMAN.

❏ And then one day at the opera, a few weeks before the boat was to sail, a very small incident had occurred which left an indelible impression on him. A Frenchman in the next seat had pointed out Henri Matisse sitting several rows further down across the aisle. Shahn had thought back ten years to two passages in a book about a Brooklyn boy in Paris which had made an overwhelming impression on him at the time—Ernest Poole's *The Harbor.*

There was a little Hungarian Jew [the first passage went], an ardent fol-
lower of Matisse. "Technique?" he cried. "It's nothing. To grip your soul
in your two hands and press it on your canvas—that is art, that is Matisse!"

And the second passage, a conversation between Bill, the hero, who
has taken the Hungarian's advice, and his friend, Joe, who comments
on the resulting pictures:

For God's sake, Bill, get it out of your system, quit getting reverent over
the past; you're sitting here at the feet of the masters, fellahs who were all
right in their day but are now every one of 'em out of date. And you're so
infernally busy copying their technique . . . Why can't you go to life for
your stuff? Your religion is style, technique and form. For God's sake lose
it and use your own eyes, forget you're an artist and be a reporter . . .
Believe me, Bill, the nations of this planet are ready to do things you never
dreamed of. I'm not talking of kings and government, I'm talking of the
people themselves. The place you need is the U.S.A.—and the work you
need is a job on a paper!

Shahn thought of those passages, and at that moment Matisse stood
up facing the audience way down front, and, surveying it very delib-
erately over the top of his spectacles, proceeded to pick his nose. "What
a supremely unself-conscious gesture!" thought the young American.

—RODMAN.

In 1932 he made a montage from his Sacco-Vanzetti series,
showing some villains of the famous case including Abbott Law-
rence Lowell of Harvard and Judge Thayer. He made it for a
show at the Museum of Modern Art.

❏ The artist was informed that a very wealthy patron wanted to buy
the picture and that she was willing to pay two thousand dollars for it,
provided she could have it right away—"now." Clearly, if she bought
the panel it could not be hung in the show. Shahn refused the reputed
offer. "I realized that I was being offered graft, and as I walked home
to Brooklyn that night in a daze, I kept saying over and over to myself:
'There's power in the brush! There's power in the brush!' "

—RODMAN.

During the war he worked for the Office of War Information.
As the war came to an end, the emphasis of the poster work
altered.

❏ The posters began to take on a distinctly Madison Avenue flavor.
Instead of seeing democracy highlighted and compared with the bar-
barities of Nazism, the home front was now being told that the boys in

the foxholes were fighting to get home to Mom and the corner drug-store. When one day a gas conservation poster with the slogan WALK AND BE BEAUTIFUL! was approved, the Graphics section decided the time had about come to get out. The case was first taken to Administrator Elmer Davis who agreed to back up the artists, then hesitated. In their bitterness, Shahn and the others got hold of one of the published post-ers showing soldiers with raised bayonets. Substituting Coca-Cola bot-tles for the guns, they changed the lettering to read TRY OUR FOUR DELICIOUS FREEDOMS and under that printed THE CAUSE THAT RE-FRESHES.

—RODMAN.

His carpenter friend Irving Plungian, another Lithuanian, com-missioned a painting.

❑ Plungian, whose name signifies a river in Lithuania from which, like Shahn, he emigrated many years ago, is a short, stocky fellow with a rather large head, the long sad face deeply lined, the eyes in shad-owed recesses, the expression mild but set in its ways. Some years ago he had been much taken by the realism of the picture *Handball* (1939) on which Shahn was then working and wondered if he could buy it. "How much would it set me back, Shahn?" The artist calculated the number of hours he had put into it and offered to exchange it for the same amount of time in carpentry. Plungian agreed, but the next day he had come back crestfallen. "Deal's off, Shahn. The wife says we need a new frigidaire, new car, new paint job inside and out, and the thing we need *least* is a picture." Later, when *Handball* was acquired by the Museum of Modern Art, Irving's friends started kidding him about the "fortune" in art he'd turned down, and he began to brood about it. One day, several years later, he had dropped into the studio and said: "Shahn, I want you to paint me a picture." "O.K.," the artist had re-plied, "what do you want?" It seems that the Plungian fireplace had a defective flue and what Irving wanted was a picture of neatly piled birch logs on andirons. Shahn complied with a cunningly executed piece of *trompe-l'ôeil;* but remembering Mrs. Plungian's local reputation for domestic order, he painted maliciously under one corner of the andi-rons a crumpled Chesterfield package.

—RODMAN.

Pavel Tchelitchew
(1898–1957)

His father frequently addressed him by a Russian nickname that could be translated as "Miss." He distinguished himself in the Civil War after the Russian Revolution.

❏ Pavlik is sitting in General Headquarters at Djanskoy with a Colonel and a General of the White Army. Maps are between them on a table. He is trim, a little taut, deferential; really, he is exploiting all the courtliness that military manners will allow. The heads of the two older men are bent over the table, studying something the cartographer has pointed out. Their talk ceases for a few moments. In the pause, Pavlik hears a faint, warning scamper, ever so feeble; after all, he has the ears of one attuned to hearing the music of the growing grass. His head turns as if he had heard a gun fired. Along the wall opposite, a mouse (he sees) is running in retarded little spurts. He stands up and the mouse, startled, dashes frantically past the table, diagonally, to a dark corner of the room behind them.

Pavlik's scalp shrivels and congeals. Never can he forget Aunt Sacha's terror, the way she once drew her legs up on a chair and wrapped her skirt about them in the ritual panic of ladies who hallucinate the mouse as a peculiar invader of feminine privacy. Lightly, without a thought, Pavlik jumps on the table; he is between the Colonel and the General, kneeling on the map. Too late, he realizes his awful *gaffe*. He is pale as death and becomes paler when his mind registers: "I'll have to explain to them." Hardly knowing what he says, and squatting on the table, he does explain.

"I . . . Excuse me, please . . . I just *saw* something!"

The mouse has disappeared. Neither Colonel nor General have noticed its passage. Both men have arisen.

"What did you see, Tchelitchew?"

"Something—I—I over there . . . in that corner." He points to where the mouse has disappeared.

The Colonel and General look and exchange glances with each other. They are utterly blank, of course, dumbfounded.

"Do you feel ill, Private Tchelitchew?" The Colonel is courteous. "There is nothing there. Look!"

Pavlik's hand goes to his forehead for now he is merely scared and confused. What can he say he *saw?* His hand drops across his eyes so that his superiors will not see the sudden glimmer of guile that appears there.

"You had better see the doctor," says the General severely.

The last two days Pavlik has been riding around in an open automobile in the hot sun. Smoothly, he slips into a standing position and sways slightly. "Do excuse me, sirs. I feel a bit dizzy."

Immediately the General calls an orderly and has Private Tchelitchew escorted to the doctor's office.

Tchelitchew has seen this doctor often and they have their little jokes together. Pavlik stares for a moment, now, at the friendly man who is searching his face. "Have you fainted, Pavel Fyodorovitch?" he asks. "Have you seen a ghost?"

"No," thinks Pavlik, "it will not do to try to carry it through with this medical man. It might lead to complications. I will make it simple!"

Suddenly the young cartographer relaxes with suppressed laughter. "You will never believe it—you will never believe it!" His subdued falsetto gasps out as if he were bursting with the fun of it. "I have just jumped on a table out of fright because—because—I was sitting with the General and the Colonel . . . Right on the map between them I jumped, yes, because . . . I saw a mouse, good doctor! You see . . ." Humbly, his face assumes more serious lines . . . "I am really afraid of mice—it's ridiculous but it's true"—he stamps his foot with the ecstatic absurdity of it—"it's even crazy, but it's *true!*" And with another gushing sigh, a ravishing smile garlands cheeks which actually have begun to blush.

The doctor's face, eyes wide, is a *tableau vivant* of amused surprise.

The young man now completely relaxes and his voice becomes steady and soft. "I told them I saw something—you know, an hallucination or something. Dear doctor, you must get me out of this. I can never confess the truth!"

"You—you say you jumped on the table, between them, just like that?" The doctor is terribly amused. Pavlik just drops his eyelids and slowly raises and lowers his head in majestic ascent, like a prima donna portraying an empress.

The doctor slaps Pavlik on the shoulder and gives a roar of laughter, which he abruptly checks.

"Sssh! Not a *word!* But you probably need a rest, don't you, my boy? I shall write in my report that you have a touch of sunstroke—that will account for the hallucination—and I'll suggest a furlough—you haven't had one, I believe. Two weeks. Will that do, eh?"

Pavlik starts beaming. "I'm so tired, truly, truly! Thank you. It is wonderful." He embraces the man, kissing him on both cheeks. "I must thank that mouse, too. Really, it is too funny, no? Oh, you are good! I

want to see my half-sister, Varya, who is in Sevastopol with her husband, Alyosha Zaroudny. I will go to them!"
—PARKER TYLER, *The Divine Comedy of Pavel Tchelitchew.*

Dame Edith Sitwell was fond of him, and her fondness left him nervous.

❏ For he will never believe (except for casual periods of neutralization) that hers is a true virginal passion, a Platonic affectiveness. It is "Tchelitchevian" to exaggerate, dramatize everything. But the Sacred Virgins—did they not, of old, have ambiguous duties? At the same time, his whole relationship with his new patroness depends on sexual innocence. Dame Edith will maintain, to me, that their relationship was "exactly" that between Vittoria Colonna and Michelangelo. The *exactly* holds a considerable burden yet there is not the least plausible reason to suppose their relations will follow any other pattern. Throwing into charming her all his powers of flirtation, Tchelitchew still cannot rid himself of the idea that she is dying to lay hands on him . . . One can speculate how immensely successful must be his masculine preenings, his glances, his random endearments, his coziness, especially in moments withdrawn from witnesses. She is the epitome of dignity, even majesty. Quite so! One might add: exactly so. He is just as quick to perceive what an unusual magnetic effect his mere personal presence has on this woman of high poetic gift and eyes like a male seer's. Who is to say (not themselves, certainly) it is not a love affair?

—TYLER.

He cowered. He said to a friend, "What—alone with *Sitvouka?* Non, mon cher! What do you want? I should be raped!"

There is always something a little wrong about the mouth. When he did Helena Rubinstein's portrait, she complained that the mouth was too large. He exclaimed: "If you find that the mouth is too big, then stick three little sequins, one rose and two white, at the corner of the mouth, which will make it smaller."

He became close to the stripteaser Gypsy Rose Lee when he lived in New York during the 1939 New York World's Fair.

❏ At this period, the former burlesque striptease artiste has become high fashion. Salvador Dalí has an exhibit of his own at the Fair—if Dalí can be thus defiant of good taste, he, Pavel Tchelitchew, can be just as defiant, and inevitably in better taste. What is rightly known as a "natural" comes to pass: Tchelitchew designs a number with which Miss Lee is to grace one of the Fair's entertainment functions. It will be her now luxurious routine of stripping, but done à la Tchelitchew; that is, with a chic and an ingenuity to out-Folies (demurely) the Folies-

Bergères. Pavlik makes costume designs and invents the theatrical routine: Miss Lee will furnish her inimitable personal style.

"First she take off the top. Slow. Then she keep take off down. Then she come to the pants. In the pants, pins is. The pins from the pants she takes out, and throw to the public. Whooooooo! Then comes away the pants and she is left behind with only a night shirt. She yawn sleepy. Then she go away. The public he cry out for more. She come back, this time in night shirt, and she carry a candle. Ah! Aha! candle! The candle is light. She walk on the stage and she start the night shirt to take off. Comes almost off the night shirt, but not quite. She blow the candle. Poof! It is darkness, and nobody see."

"Marrrrrrrvelous!" Miss Lee exclaims. "The candle—that is wonnnnderful!"

"Yes," agrees the artist. "Also the pins from the pants is wonderful."
 —TYLER.

Julien Levy tells about the trick played on Pavel by Edward James. James had installed red-gold lobsters (in honor of Dalí) as mouthpieces for his telephones in his house on Wimpole Street in London. His country place in Sussex contained a Surrealist garden. At his place on Capri he welcomed Tchelitchew.

❏ Edward was determined he should see the Blue Grotto, especially determined as he knew of Pavlik's intense fear of crossing water. But, as with Dalí, so with Tchelitchew, Edward was becoming that painter's great good friend and patron, so for Pavel to deny Edward his wish was tantamount to denying his bread and butter. One lovely cloudless day Tchelitchew at last consented to set sail for the hour-long voyage to the grotto on a privately chartered sailboat provided by Edward James. Also provided was a specially rehearsed cast of extras from the local opera.

On the return trip, one of the sailor-actors detected an ominous cloud in the sky. Tchelitchew could see nothing but benign blue, but the captain was consulted and he was fearful, too, from signs his instruments had given him, that they were heading into one of the deadly sudden hurricanes that occasionally devastate that coast almost without warning. A gypsy woman in the galley had the gift of second sight and straightway discovered death by drowning in the palm of Pavel's hand. Overcome with his not unexpected trepidations, Pavel allowed himself to be conducted, for greater safety, below decks, where he was soon joined by the entire cast of emotional sailor-actors and galley cooks moaning and praying in torrential stage Italian that the Holy Virgin might save their souls. This close brush with sudden drowning was one from which Tchelitchew recovered only with difficulty after several days safely in bed in his room.

 —JULIEN LEVY, *Memoir of an Art Gallery.*

Tchelitchew described his mural to Julien Levy.

❏ I remember Pavel saying, "Heaven will be children, children, children, suffer little children. But those freaks! They are many of my best friends, what a Hell! Here is Gertrude Stein and there is Alice Toklas, and Alice Astor because she bought a picture of mine, and Alice De-Lamar because she lent me her house to live in, lots of Alices and they are all going to be so *furrius*! The Bearded Lady is Bébé Bérard. He is going to be so *furrius* too. Everyone knows that he is *féerique,* and a great painter and with such a beard that he can't find his brushes when he wants to paint, but in MY Hell, my dear Julien, to find himself in my hell, when he is jealous and hating of me always, he will be so *furrius.*

"All the people in my picture are great, and such genial friends. But they are freaks because growths have grown on them by accident. That is the accident of growing. Bébé grows to have a beard and be a lady, and your Joella grows to have many children and to be heavy with maternity, breasts and breasts and breasts—just a few more babies and she will need breasts along her legs, like five cows! Nobody will understand, but these freaks will be sad and glorious. I paint them always in the most beautiful decayed colors, like pearls and butterflies and oil on water and *les Fleurs du mal.* You will be more frightened when you see my Heaven; the children who are not yet freaks, who have not grown up to have breasts and three legs and hunched backs. They are going to be so innocent that they fly without wings, and so pretty that nobody can say, 'Pavel, how can you be so disgusting and paint such frightening people?' The children are all going to be flower colors, or autumn leaves, or pink and white like candy angels, and fly. Some of them fly down behind the barn, and some of them fly into Mama's and Papa's chamber. You will see!"

—LEVY.

Yves Tanguy
(1900—1955)

Julien Levy remembered a story from the early years.

❏ Yves Tanguy spoke often of the time he saw his first de Chirico from the window of a bus. As a young sailor in the merchant marine on shore leave in Paris, he rode past a gallery which had a metaphysical

canvas by de Chirico hanging in the window. He jumped off the bus and spent the rest of the afternoon staring at the painting.

—JULIEN LEVY, *Memoir of an Art Gallery*, 1977.

Peggy Guggenheim and Tanguy decided to elope, despite the inconvenience of a Mme. Tanguy.

❏ While we sat plotting our elopement so many people saw us together that we had to move to a less known café, and even then we decided it would be safer to leave Paris at once. Tanguy had no baggage of any kind. I had only a little bag. We took a train for Rouen, where we arrived at three in the morning. It was almost impossible to get a room and we went to at least ten hotels before we found one. The next day we wandered around Rouen and took a train for Dieppe, where it was pouring rain. We had missed the last boat so we spent the night at Dieppe in a chic hotel on the port. So far no one had seen us except Nancy Cunard, who tactfully pretended she had not.

—PEGGY GUGGENHEIM, *Out of This Century*, 1980.

They came together, they parted, they traveled. Samuel Beckett entered the scene, lending Peggy his Paris apartment for her assignations with Tanguy.

❏ And then he disappeared for forty-eight hours. As neither of us had a phone I was rather worried and thought all sorts of awful things had occurred. Finally he came back and told me what had happened. There had been a row at a Surrealist party, and it had ended up with poor Brauner, the painter, losing an eye. He had had nothing to do with the row, in fact he was an innocent onlooker. Dominguez, a Surrealist painter, an awful brute, had seized a bottle and hurled it at someone else, and it had broken and rebounded in Brauner's eye, which fell out. Tanguy had taken him to the hospital, where an operation was performed to remove the pieces of glass and replace his eye. Tanguy promised Breton he would go to see Brauner every day. As Brauner was a Surrealist, Breton felt responsible for him. Tanguy and I now had to give up our project of going on our holiday to Brittany and I remained in hiding from Mrs. Tanguy in Paris. I was careful what cafés I frequented so as not to meet her.

One day, when I was having lunch with Mary Reynolds, Tanguy and Mrs. Tanguy came into our restaurant. I was very embarrassed and didn't know what to do. Mary told me to go and say *bonjour* to her. Her reception was not cordial, but it was definite. She didn't utter a word. She just picked up her knife and fork and hurled three pieces of fish at me. Tanguy took her home soon after, but the owners of the restaurant were not very pleased. It happened to be the restaurant where I

always went with Beckett. The owners were old friends of ours. They had once allowed us to go up into their private apartment to hear Giorgio Joyce sing on the radio. We had been making a futile search for a radio and at the last minute they had come to our rescue.

Now that Mrs. Tanguy knew I was in Paris, life became more difficult. Tanguy was afraid she would follow him or find us together. Of course she did not know where I lived, but she was a woman with a mystic sense and often knew things for no obvious reason. I really liked her and did not want to make her unhappy. I never meant to take her husband away from her, and he had had many other affairs. Tanguy told me that she stayed home and wept. I must say this upset me. One day when he was in the hospital with Brauner, where he told me not to come for fear of meeting his wife, I waited for him next door in a café. We were supposed to go and see a doctor for Tanguy's ulcer. Mrs. Tanguy followed him to the café and made an awful scene. He had to take her away in a taxi. This was most unfortunate, as it meant giving up the doctor. Tanguy was sick and neglected his health badly, and Mrs. Tanguy was incapable of looking after him. She was just like a child. They both drank too much and had fearful rows, but in some way were very much attached to each other. Sometimes when they had rows she disappeared for days.

Every morning Tanguy came to my house to fetch me. We spent the whole day together, then he went home to his wife. I was living in Beckett's apartment. He had gone to Brittany with his mistress in my car. I was still terribly in love with him. Tanguy once said to me, "You don't come to Paris to see me, you come to see Beckett."

We were all upset by Brauner's accident. The poor thing had to have a second operation on his eye, as the doctor had not removed all of the glass. After that we bought him a glass eye. He had enormous pride and courage and began to paint very well once he was readjusted to life. I went to see him with Tanguy and bought one of his paintings. He showed me the painting he had done of himself the year before with one eye falling out of its socket. He seemed to have prophesied this catastrophe, and after it occurred his paintings made great progress, as though he had been freed from some impending evil.

—GUGGENHEIM.

Guggenheim looked back from the vantage of later years.

❑ Tanguy really loved me, and if he had been less of a baby I would have married him though the subject was never mentioned. He always told me reproachfully that I could have had anything I wanted from him. Laurence and my children were all for the marriage, but I needed a father and not another son.

—GUGGENHEIM.

Later, with his new wife Kay, Tanguy settled in Connecticut in a grand house with grand ideas.

❏ A year or so later they went so far as to persuade a distant farmer who owned land bordering theirs at the end of their view to permit them to bulldoze their horizon line, again to match an Yves Tanguy drawing. Sitting on their terrace at twilight, having a before-dinner cocktail, one felt immersed in an Yves Tanguy landscape, otherworldly and at peace.

—LEVY.

Levy remembers repeated rages.

❏ If he got slightly drunker than this, he would go even further back and start all over again to fight with much passion that tragic French trauma, the Dreyfus case, which he took very much to heart as a boy in France. He would look for somebody who could argue the opposing, anti-Dreyfus side so that he could relive the epic debate and fight with them. His method of fighting was to suddenly grab the ears of an opponent, or a friend, or any man handy and bash his head against theirs. "Banging heads" he called it, simply. He claimed that his head was harder than anyone's. As hard as an ivory ball, he'd insist. A solution to this ominous game, or quandary, of Yves's drinking followed by obsessive skull-cracking was arrived at one day by Kay. Yves agreed to install a huge and beautiful—the finest—billiard table they could find, in their vast and immaculate drawing room. Yves was immensely cheered. The shotguns were put way out of sight, the drinking tempered to improve his game, and the billiard balls were happily banged against each other, morning, afternoon, and night, to Yves's great satisfaction, and the relief of his friends, who found visits with him safer and more peaceful when Dreyfus was forgotten and the painful head-banging ceased.

—LEVY.

Another Connecticut visitor was the art critic Alexander Eliot.

❏ "Skin!" the Surrealist painter Yves Tanguy exclaimed. Stretching his clever hands in my direction, he spread the fingers wide as if to demonstrate a pair of neat but too tight-fitting gloves. "How I yearn," he went on, "to spring out of my skin and drop the whole thing forever!" . . . Swallowing the last of his dry martini, Tanguy got up from his chair. "Let's walk in the garden, shall we? Summer came early to Connecticut this year. I keep telling myself it's lovely here."
 Strolling about Tanguy's estate, we heard a faint pathetic cheeping sound which came from the grass at our feet. Tanguy, barely breaking

stride, brought his crepe-soled boot neatly down upon a robin chick. Its little gut protruded from its pleading beak, and popped. "Too bad," the painter said as we passed on. "I have to do that all the time."

I asked him why, but Tanguy disdained to reply. The sun was warm; I shivered all the same.

—ALEXANDER ELIOT, *The Atlantic*, October 1972.

Alberto Giacometti
(1901–1966)

❑ Early in life Alberto formed an obsessive habit which seemed odd, though innocent, to the other members of his family. Every night before going to sleep, he took particular care in the arrangement of his shoes and socks on the floor beside the bed. The socks were smoothed, flattened, and laid out side by side so that each had the appearance of a foot in silhouette, while the shoes were placed in a precise position beside them. This painstaking ritual, repeated without variation each night, amused Alberto's brothers, and sometimes, to tease him, they would disturb his arrangement, provoking outbursts of rage.

For the rest of his life, Alberto continued to be obsessively concerned with the arrangement of his shoes and socks before going to bed. His passion did not extend to other articles of clothing, however; only the shoes and socks. And only before going to bed at night. Once in bed, though, the young boy did not necessarily go straight to sleep. In "Yesterday, Quicksand" he states how over a period of months at this time he was unable to fall asleep before enjoying the peculiar representations of a waking dream: "I could not go to sleep at night without having first imagined that at dusk I had passed through a dense forest and come to a gray castle which stood in the most hidden and unknown part. There I killed two men before they could defend themselves. One was about seventeen and always looked pale and frightened. The other wore a suit of armor, upon the left side of which something gleamed like gold. I raped two women, after tearing off their clothes, one of them thirty-two years old, dressed all in black, with a face like alabaster, then a young girl round whom white veils floated. The whole forest echoed with their screams and moans. I killed them also but very slowly (it was night by that time), often beside a pool of stagnant green water in front of the castle. Each time with slight variations. Then I burned the castle and went to sleep, happy."

—JAMES LORD, *Giacometti: A Biography.*

During his summers in Maloja, he expressed fondness for his cousin Bianca.

❏ They continued to go for long walks, hold hands, and squeeze together into little hiding places. She was never his mistress, but he was prepared to go to unusual lengths to demonstrate that he was her master. One evening when they were alone together in her room he took a penknife from his pocket and told her that he wanted to carve his initial in her arm. She must have been startled, and had every reason to be alarmed, but he knew how to be persuasive. Bianca agreed. Alberto opened his knife and eagerly went to work on her left upper arm. He could not have cut too deeply, for although she bore a scar for many years, it eventually disappeared. Still, he cut deeply enough to cause blood to flow, and Bianca must have felt some pain, which she endured with calm—and perhaps with pleasure. He carved a small capital *A*. He was excited and proud. "Now you are my very own little cow," he told her, pretending that the incident was a joke. Bianca was pleased because Alberto was pleased. But it was not a joke. For years to come, Bianca had time to gaze with romantic conjecture at the place where the artist's knife had entered her flesh.

 ˙ —LORD.

The same knife with which he carved his initials in Bianca's arm he used making sculpture.

 When he was thirty he made a sculpture called *No More Play*, and when he was asked why he made sculpture, he answered, "So as not to die."

 Samuel Beckett was his friend.

❏ They met most often by chance, usually at night, and went for long walks, the only destination of which was the conclusion that, having, as it were, nowhere to go, they were compelled to go there. It was a very private, almost secretive, and secret friendship. However, it did not exist in the vacuum of austere speculation. It came to be recognized by others as a confirmation of something which—even if they did not understand it—they could recognize as valuable. Many years later, when both men had become famous, a prostitute who knew them both saw them seated together on the terrace of a café. Going inside, she said to the proprietor: "It's your luck to have two of the great men of our time sitting together right now on your terrace, and I thought you ought to know it."

 —LORD.

❏ One night Alberto found himself late at the Café de Flore. Most of the other customers had left, but at an adjacent table sat a man

alone. Presently he leaned toward Alberto and said, "Pardon me but I've often seen you here, and I think we're the sort of people who understand each other. I happen to have no money on me. Would you mind paying for my drink?" That was the kind of request Alberto could never have refused. He promptly paid for the stranger's drink. A conversation ensued, and it did seem that the two men were the sort of people who understood each other. Twenty-five years later it would be worth recalling that their friendship had begun with such an optimistic assumption. The man who made it was Jean-Paul Sartre.

—LORD.

Giacometti remembered a moment of revelation.

❏ One evening Giacometti went to the movies. While seated in the theater, without forewarning, he experienced one of those miraculous instances of self-creation in which the present abolishes the past even as the future abolishes the present. It caused a radical change in the artist's view of the world and of his art. He saw this at once and later he spoke of it repeatedly.

"The true revelation," he said, "the real impetus that made me want to try to represent what I see came to me in a movie theater. I was watching a newsreel. Suddenly I no longer knew just what it was that I saw on the screen. Instead of figures moving in three-dimensional space I saw only black and white specks shifting on a flat surface. They had lost all meaning. I looked at the people beside me, and all at once *by contrast* I saw a spectacle completely unknown. It was fantastic. The unknown was the reality all around me, and no longer what was happening on the screen! When I came out onto the Boulevard Montparnasse, it was as if I'd never seen it before, a complete transformation of reality, marvelous, totally strange, and the boulevard had the beauty of the *Arabian Nights*. Everything was different, space and objects and colors and the silence, because the sense of space generates silence, bathes objects in silence.

"From that day onward I realized that my vision of the world had been photographic, as it is for almost everybody, and that a photograph or film cannot truly convey reality, and especially the third dimension, space. I realized that my vision of reality was poles apart from the supposed objectivity of a film. Everything appeared different to me, entirely new, fascinating, transformed, wondrous. So there was a curiosity to see more. Obviously I wanted to try to paint, or to make a sculpture of what I saw, but it was impossible. Still, at least, there was a possibility of trying. It was a beginning.

"I began to see heads in the void, in the space which surrounds them. When for the first time I clearly perceived how a head I was looking at could become fixed, immobilized definitively in time, I trembled with

terror as never before in my life and a cold sweat ran down my back. It was no longer a living head, but an object I was looking at like any other object, but no, differently, not like any other object, but like something simultaneously living and dead. I gave a cry of terror, as if I had just crossed a threshold, as if I was entering a world never seen before. All the living were dead, and that vision was often repeated, in the subway, in the street, in a restaurant, in front of my friends. The waiter at the Brasserie Lipp become immobile, leaning toward me, with his mouth open, without any relation to the preceding moment, to the moment following, with his mouth open, his eyes fixed in an absolute immobility. And not only people but objects at the same time underwent a transformation: tables, chairs, clothes, the street, even the trees and the landscapes."

—LORD.

He said that if he were in a burning building he would save a cat before he would save a Rembrandt.

Genet was another friend.

❏ The understanding between Genet and Giacometti was so deep that the writer's grasp of the artist's purpose had no need of an intellectual structure to support it. The friendship was so close that for a time one of their favorite amusements while sitting in cafés was for the heterosexual to select among the young male passersby those the homosexual found desirable. The choice never failed to be accurate.

—LORD.

Good fortune did not change his appearance.

❏ One day an old woman of the neighborhood came in and stood at the bar. Noticing Alberto, she said, "Who's that poor bum? I'll buy him a cup of coffee." The bartender told her that this was a well-known artist, no bum, and quite able to pay for his own coffee. The woman was unconvinced. "Hey, you poor old thing," she called, "you'd be glad to have a cup of coffee, wouldn't you?" Alberto replied that he would, yes, be very glad and thanked her warmly. She, at least, had seen him for what he was.

—LORD.

His wife did not have an easy life. Giacometti used Annette; he did not forgive himself, nor did he stop using her.

❏ He disliked hair. "Hair is a lie," he used to say. It distracted one's attention from the essential, the head, the expression, the gaze. One

day he declared that he could no longer endure seeing Annette with
hair. She would be obliged to shave her head. Dismissing the sugges-
tion as absurd, she exclaimed, "Oh, Alberto!" with a mixture of girlish
amusement and feminine annoyance. Just that reaction was needed to
pique Alberto's tenacity. He set about insisting that Annette shave her
head to please him, advancing reason after reason to show that it was
normal and imperative for her to agree, ridiculous and wrong for her
to refuse. He promised to buy the most sumptuous and expensive wigs.
He enumerated other alluring inducements. She resisted. The more
she resisted, the more he insisted. It was no fair match, and as it went
on, the weaker of the two seemed to be physically wilting away. "All
right, Alberto, all right," she said wearily at last. "If you want me to,
I'll have my head shaved." But Alberto did not hold her to her word.

—LORD.

When he was in his fifties he made another friendship.

❑ Goddesses don't come along every day. This one, however, was a
real one. Her name: Marlene Dietrich. As a deity she was doubly con-
vincing for being wholly a creature of imagination. That her firmament
was Hollywood and her temples made of tinsel mattered not at all. She
was an ageless femme fatale, a siren, a mythical devourer of men. That
image of her had been popularized for thirty years, becoming at last—
like the person herself—the object of a cult. Giacometti, an ardent mov-
iegoer, was certainly aware of it. And he understood, of course, how
movies—also—show that a woman may be simultaneously an idol, an
objet d'art, a visual creation, and a "real" person.

Marlene Dietrich was a real person. If she had made sacrifices be-
yond her means upon the altar of artifice, nobody but the public was
any the wiser. In her meretricious heaven the movie goddess was lonely,
disillusioned, world-weary. She longed for the consolations of true art.
"Cézanne," she said, "is my god above all." Watercolors by him hung
on the walls of her home. She was a conscientious visitor to galleries
and museums. One day at the Museum of Modern Art in New York
she saw the sculpture of a dog by Alberto Giacometti. She fell in love
with it. This dog is an easy sculpture to fall in love with—a bit melan-
choly in its graceful evocation of man's best friend—and the fact is that
Alberto identified it with himself, seen in his mind's eye walking alone
in the rain. Marlene's affection for *The Dog* was such that she deter-
mined to make the acquaintance of its creator.

Arriving in Paris on November 20, 1959, the star was accompanied
by forty-four pieces of luggage and met by two hundred journalists.
Imperious and lofty, she seemed, as usual, an incarnation of the glam-
our that made the weaker sex invulnerable. She had come for a much-
heralded engagement at the Théâtre de l'Etoile. The meeting with Gia-

cometti was arranged by a mutual acquaintance. It was the goddess who wooed the artist. She went to his studio and sat in the dust while he perched atop his stepladder, slathering plaster onto the tall figures or hacking it off again. One wonders how the seasoned enchantress saw those women conjured up before her eyes, or, on the other hand, how she looked to the sculptor as he gazed down at her from aloft.

They were attracted to each other. In the café at the corner of the rue Didot nobody recognized the celebrated actress. They could talk in peace, but never for long. Marlene was always in a hurry. She made appointments, then failed to keep them, sending instead huge bouquets of red roses, telegrams, and scrawled notes saying, "I'm thinking of you. Marlene." Precisely what she thought, however, remained wonderfully obscure. Her feelings were supposedly as sincere and simple as the green grass, but she never had time to come down from her pedestal and let them flourish. The brouhaha of mass adoration kept her distant and tantalizing. Alberto was fascinated. He praised her personality, her intelligence, and was shyly pleased to let his friends know he knew her. He even felt entitled to tell his mother that they had become "close friends."

The total number of meetings can't have been many, as the friendship itself lasted less than a month. Still, his admiration was genuine. He wanted to provide evidence of it. Her comings and goings were too unpredictable to allow for a portrait. So he gave her one of his sculptures, a small figure in plaster. He carried it to her hotel in the rue de Berri one rainy Sunday afternoon. It was a farewell gift, for the actress was to leave Paris in forty-eight hours. Ten days afterward, Alberto received a cable wishing him a Happy New Year, sent from Las Vegas, Nevada. He never saw Marlene Dietrich again. If she was thinking of him, she gave no further sign, sent no more roses or telegrams. Four weeks later she was back in Paris. Alberto learned of it, but he heard nothing from her. "Fortunately," he remarked.

—LORD.

After a serious illness, he reaffirmed that he did not play.

❑ "Maybe I'll be dead in a month," he said. "I have an even chance of pulling through. I'd be glad if I lived for three more years. One year, anyway. And yet if somebody told me I've got two months, that would interest me: to live for two months with the knowledge that one's going to die is surely worth twenty years of unawareness."

"And what would you do with those two months?" inquired his interlocutor.

"I'd probably do exactly what I'm doing. Between here and the inn

on the other side of the road, you see, there are three trees. Well, that's more than enough to keep me busy until the end."

—LORD.

His mother died when she was ninety-three, two years before his own death.

❑ When it was over, Alberto went to his studio. His studio had all his life been his sanctuary and hiding place. So long as his mother lived, he had never been completely alone there. He could not understand, could not condone, could not accept her loss. He called out to her, and the voice in which he called to her was her own, calling himself. "Alberto, come eat!" he cried. "Alberto, come eat! Alberto, come eat!"

—LORD.

Picasso took Françoise Gilot to call on Giacometti.

❑ "You ought to see Giacometti's atelier," Pablo said to me one evening. "We'll go call on him." As we were leaving, he asked Giacometti what would be a good time to find him in.

"If you come anytime before one in the afternoon, you'll be sure to find me," he said. "I don't get up much before then." A few days after that, on our way to lunch, we went to Giacometti's studio, in the rue Hippolyte-Maindron, a pleasant little street in the Alésia district. It is a quiet, humble quarter with small bistros and craftsmen's shops and an air of timelessness and bonhomie that has been lost in many parts of Paris. To get to Giacometti's studio we passed through a door off the street into a little yard with small wooden ateliers up and down both sides. Pablo pointed out to me Giacometti's two adjoining rooms and, on the other side of them, another atelier where Giacometti's brother Diego was working. Diego, a very gifted artisan, devoted himself entirely to his brother's work. Giacometti often worked late at night, making clay studies for sculpture. The next morning he might be inclined to destroy them if they didn't satisfy him, but Diego would get up when his brother went to bed and start molding plaster casts and doing all the other technical jobs that his brother had little interest in, to advance and preserve the work. He was the intermediary between Giacometti and the bronze-caster.

—FRANÇOISE GILOT AND CARLTON LAKE, *Life with Picasso.*

Diego Giacometti himself found moderate fame making his bronze furniture. For many years he sacrificed his own art for the art of his brother.

❏ Alberto continually urged Diego to do work of his own, and the urging seemed to grow more urgent as the opportunities for such work grew less. Diego was too busy with pressing tasks for Alberto, making armatures, plaster casts, patinating bronzes that poured in increasing numbers from the foundry. Alberto was so absorbed in making sculptures in clay or plaster that he had no time to supervise the production of bronzes, but he kept a severe eye on the outcome. The patina, in particular, had to be just right, though his view of what was right could vary unaccountably from day to day. Diego's past experience was put to unremitting use. Alberto was hard to please, and a cast that failed to reproduce the original exactly could put him into a rage. Being obsessive where his work was concerned, he saw no reason why others should be less so. Many, many sculptures had to be patinated, repatinated, then patinated again before the artist was satisfied. "Oh, he's impossible," Diego occasionally said with a sigh. "There's no denying it. Alberto is very difficult."

So there wasn't much time for Diego to do work of his own. Still, Alberto insisted, as if Diego's vocation as a creator in his own right was vital to the satisfactory performance of all tasks. It was, to be sure. But not to Diego. The proof of the importance came, unfortunately, from the older brother. Diego managed to do a little work of his own, making the occasional sculpture for a publicity display or decorative arrangement. Alberto praised his brother's work to the sky, taking visitors into his studio to admire the latest effort, repeatedly exclaiming, "Diego has talent to burn! Oh, yes, Diego has talent to burn!" The truth is that he did. But neither the proof nor the flame would come till it was too late to prove anything, though it would warm a few hearts. Meanwhile, Alberto kept on saying, "Diego has talent to burn." It was sometimes embarrassing, and the one most embarrassed must have been the one whose embarrassment it would have been tactful to spare.

—LORD.

Marino Marini
(1901–1980)

Peggy Guggenheim bought a Marini in 1949.

❏ There was also a Marino Marini, which I bought from him in Milan. I went to borrow one for the sculpture show, but ended up by buying the only thing available. It was a statue of a horse and rider, the latter

with his arms spread way out in ecstasy, and to emphasize this, Marini had added a phallus in full erection. But when he had it cast in bronze for me he had the phallus made separately, so that it could be screwed in and out at leisure. Marini placed the sculpture in my courtyard on the Grand Canal, opposite the Prefettura, and named it *The Angel of the Citadel*. Herbert Read said the statue was a challenge to the prefect. The best view of it was to be seen in profile from my sitting room window. Often, peeking through it, I watched the visitors' reaction to the statue.

When the nuns came to be blessed by the Patriarch, who on special holy days, went by my house in a motorboat, I detached the phallus of the horseman and hid it in a drawer. I also did this on certain days when I had to receive stuffy visitors, but occasionally I forgot, and when confronted with this phallus found myself in great embarrassment. The only thing to do in such cases was to ignore it. In Venice a legend spread that I had several phalluses of different sizes, like spare parts, which I used on different occasions.

—PEGGY GUGGENHEIM, *Out of This Century*.

In 1954 Marini was sculpting a bust of the art dealer Curt Valentin, beloved by Marini, Henry Moore, Oskar Kokoschka, and many other artists. While Valentin was posing and Marini's work progressed, clay dropped from one side of the armature. The superstitious Marini turned white, shaken, and announced to Valentin that there would be no more posing that day; for something terrible was going to happen. Later in the day Valentin died of an embolism.

Joseph Cornell
(1903—1972)

Julien Levy remembers how the unknown Joseph Cornell watched him package pictures to send from his gallery to the Wadsworth Atheneum in Hartford, Connecticut, for a Surrealist exhibition. Cornell lingered.

❏ "Closing time," I suggested. But he had already fumbled out of his overcoat pocket two or three cardboards on which were pasted cut-outs of steel engravings. Collages! I glanced hastily at a bundle of collages

by Max Ernst only just unpacked and stacked on the bookshelf. But these were not any of those. "Where did you find these?" Was it not a blessing I hadn't thrown the man out, thought I. "I make them," Joseph said.

—*Joseph Cornell*, ed. Kynaston McShine.

Joseph's brother Robert was spastic, severely handicapped, and Joseph built things to amuse him. John Bernard Myers remembered Joseph's creation of a landscape of toys in the living room at the Cornell house in Queens. There was a model railway system that Robert could operate from a switchboard. Laura de Coppet remembered another construction for Robert.

❑ Cornell loved his brother, and the meals he made always consisted of dishes like nuts, fruit Jello of the most incredible colors, things like that. There was never any real food, but it was always colorful. He used to squeeze violets on top of mushroom soup to make it lilac-colored. Cornell didn't eat much himself, but he adored chocolates, cakes, nuts. Above all, Greek pastries were something he could not resist. He was such an emaciated man, so thin, and he spoke with a beautiful voice.

—LAURA DE COPPET AND ALAN JONES, *The Art Dealers.*

Everyone who knew him attributed the nature of Cornell's art to his care for his brother. Julien Levy wrote:

❑ Early in this brother-sitting Joseph had hit upon a private communication system which combined play with learning. With his scissors and paste pot he illustrated everything, and it soon arrived that it could go on beyond what he had planned to say. As if, since his brother couldn't travel, a photograph of Rome would be shown to convey such a city—but then, combined with other images, it became something much less specific, a place of Joseph's, that tourists could never reach, something somewhere that finally even Joseph had no words to describe. Not "Rome" but "Ro . . . me," a city of his own, imagined, out of his love and devotion to his comprehending and delighted brother.

—JULIEN LEVY, *Memoir of an Art Gallery.*

Cornell first met Duchamp in 1934. Duchamp gave him a glue carton labeled "gimme strength." From his little house in Queens he came to the city.

❑ He let himself drift through the streets and avenues, pulled here and there by the hope that the Gotham Book Mart or a second-hand bookshop on Fourth Avenue might present him with a treasurable volume—a cache of maps, illustrations, or simply yellowed pages soaked

in the aura of a foreign language. Or a dime store might offer up an irresistible knick-knack, a thimble or an old-fashioned toy. Sometimes Cornell would be led along by the looks of a young girl. Noticing where she stopped to eat, he might stop there, too, and eat what she did. There was a certain cafeteria in Times Square where actresses could be sighted, and of course movie stars could be captured at will, simply by going to a theater.

—MCSHINE.

❏ The idea of working in boxes had occurred to Cornell years earlier when he left his house one day on his daily foray to the supermarket and passed a theatre on the opposite side of the street. He happened to look at the box office, which was separate from the theatre in the old-fashioned way, and saw a new ticket taker—blonde, blue-eyed, very young, altogether a very pretty girl. He was awestruck by this vision of a girl in a box. After a week or two of walking past this girl, he finally screwed up his courage and bought a dozen roses from a florist. When he walked up to the girl he became tongue-tied and couldn't get the words out, so he just opened the door and hurled the flowers at her. The girl screamed, and the theatre manager came running out. The police were called, and Cornell was taken off to the station house, where he spent the day.

—DE COPPET.

Jimmy Ernst was a friend.

❏ Joseph Cornell asked me about my childhood and about my father. Since neither one of us had the money for a soda, we took walks together in Central Park Zoo, which was only a few blocks away. He was obviously fascinated by the seals and the birds, particularly pigeons and starlings, who fed freely from what the animals behind the bars had left over. He would suddenly stop and look at a tree as if waiting for it to burst into leaf. We would huddle on a park bench in long silences, and I could swear that I was beginning to see the scene around me in slow motion. On the one occasion when I felt flush enough to treat both of us to tea in the zoo cafeteria, Cornell somehow transformed it into a kind of ceremony just by the way in which he raised his cup and the way he sat. I don't remember much about his house on Utopia Parkway in Queens, to which he took me a few times, except for his magic boxes in various stages of completion in his workroom. He held a small one out to me, on one of those occasions, but I could not bring myself to accept it. It seemed to be such a treasure to him. Some years after his death in 1972 I found that he had meticulously recorded this work as a gift to me.

—JIMMY ERNST, *A Not-So-Still Life.*

Barbara Hepworth
(1903–1975)

In 1931 she married Ben Nicholson, her second husband.

❏ On October 3rd Ben and I went to the cinema in Belsize Park, and
my life-long friend Margaret Gardiner had supper with us. Ben had
complained a little bit that I seemed withdrawn and concentrated over
my pregnancy. But suddenly I said "O dear," and in next to no time I
saw three small children at the foot of my bed—looking pretty deter-
mined and fairly belligerent. This was an event even my doctor did not
suspect, and we had only a basement flat, no washing in the garden,
and a kitchen-bathroom, and £20 in the bank and only one cot. . . .
 —BARBARA HEPWORTH, *A Pictorial Autobiography.*

❏ A woman artist is not deprived by cooking and having children,
nor by nursing children with measles (even in triplicate)—one is in fact
nourished by this rich life, provided one always does some work each
day; even a single half hour, so that the images grow in one's mind.
 I detest a day of no work, no music, no poetry.
 —HEPWORTH.

In 1939 she removed to St. Ives in Cornwall where she spent the
rest of her life carving wood and stone.

❏ A friend had asked for *samples* of Nigerian wood to be sent to me.
Suddenly I got a note from the docks to say that 17 tons of wood had
arrived at Tilbury Docks and would I please collect.
 Mercifully a strike occurred (mercifully for me!) and it gave me time
to try to arrange transport.
 The difficulties were immense. The smallest piece weighed ¾ of a
ton. The largest weighed 2 tons. It became a drama in St. Ives. Each
piece of wood had a giant fork driven into it, and a huge metal ring
(no doubt to enable elephants or cranes to lift each piece), but in the
cobbled streets of St. Ives we had to man-handle each piece. This was
the drama. The logs were the biggest and finest I had ever seen—most
beautiful, hard, lovely warm timber. Out of these "samples" I carved
Corinthos, Delphi, Phira, Epidauros and *Delos.* I was never happier.
 —HEPWORTH.

John Piper
(1903–)

❑ King George VI was looking through a set of newly completed drawings of Windsor Castle commissioned by the Queen from John Piper. He had volunteered to receive her visitors that morning as well as his own when a sudden bad cold obliged her to cancel engagements. Piper sat silent. Etiquette required that he should say nothing before His Majesty spoke. The King, no connoisseur, quite clearly found it extremely difficult to shape any suitable comment on these challengingly dramatic, dark visions in a modernist idiom of the Round Tower and other familiar landmarks. The silence grew tense, almost painful. The King spoke at last. . . . "You had *darned* bad weather!"

—NOEL BARBER, *Conversations with Painters.*

Mark Rothko
(1903–1970)

❑ When he used tempera, he would follow a procedure that has existed since the Renaissance, separating dozens of eggs and beating the whites into a consistency close to that of a soufflé. Those few friends who saw Rothko perform this rite were delighted by the bulky Balzacian figure with large hands, delicately transferring yolk after yolk from half-shell to half-shell.

—LEE SELDES, *The Legacy of Mark Rothko.*

In the fifties he still needed to teach to support himself. When he left "that island of Paradise which is New York City" on a teaching job, he wrote letters back complaining of his isolation. His Colorado employer—as he put in a letter—was "Boston, Harvard, and alas a poor cousin of the Fricks. To him I am Yale, Oregon, and a cousin of the rabbi of Lodz."

❏ Two of my paintings hang here for the last three weeks. The si-
lence is thick. Not a word or look from the faculty, students or the
Fricks. One of them on my first visit, I found was hung horizontally. I
phoned the hanger about his error. "Oh, it was no error," he said. "I
thought it filled the space better." I swear by the bones of Titian this is
true.

—SELDES.

He found contests demeaning. When James Johnson Sweeney of
the Guggenheim mailed him a check for a thousand dollars,
Rothko replied:

❏ If my surmisal is correct, I must return the check which is enclosed
and inform you that the picture involved [*White and Greens in Blue* (1957),
later bought by Nelson Rockefeller] cannot be available for either ex-
hibition or the contest.

I am writing this in privacy. I have no desire to embarrass anyone
should you wish to substitute anyone else's painting.

I am very sorry to take this step and do so only after searching thought.
I look forward to the time when honors can be bestowed simply for
the meaning of a man's work—without enticing paintings into the com-
petitive arena. . . .

—SELDES.

Another artist received the prize.

❏ During the fall, news that he had rejected the prize jumped out at
him from an art column. He had been betrayed, and was furious. One
Saturday afternoon as he was visiting the Whitney Museum, then on
Fifty-fourth Street, he became visibly distraught. Friends said later that
it was the sight of critic Emily Genauer across the gallery, and that
somehow in his bitterness he connected her with the news story and
the betrayal of his confidence. In any case, he angrily bolted for the
museum's front door. With blind fury, he misjudged the entrance and
put his hands through the floor-to-ceiling plate-glass window adjoining
the doorway.

Blood and bits of broken glass were spattered about the floor. But
when the museum employees rushed up to see whether Rothko was all
right, he brushed them aside, saying: "Forget about it. Just let me out
of here." He was directed to a doctor next door, who sewed up the
wounds. Rothko would not let him use anesthesia. After several quick
Scotches with his companions in a nearby bar, he went home. "Don't
forget," he told them, "I'm a moujik."

—SELDES.

Late in 1958 Rothko turned lucky.

❏ The culturally enlightened whiskey heiress Phyllis Bronfman Lambert persuaded her father to commission Rothko to paint a series of murals for the new House of Seagram Building designed by Mies van der Rohe on Park Avenue. Within his studio, then a converted YMCA gymnasium on the Bowery, Rothko built interior walls to the exact dimensions of the space designed by Philip Johnson in which the paintings would hang. Rothko was to execute murals covering some 550 square feet for $35,000, with $7,000 down and the rest to follow in equal installments over four years. The invoice sent to him from Seagram read "for decorations." It was his first major commission, but his attitude toward it was ambiguous. The huge hall, he became aware, was intended to be an expensive restaurant, "a place where the richest bastards in New York will come to feed and show off."

Rothko told [the art dealer] Fischer that he had taken the Seagram job with "strictly malicious intentions. I hope to paint something that will ruin the appetite of every son-of-a-bitch who ever eats in that room. If the restaurant would refuse to put up my murals, that would be the ultimate compliment. But they won't. People can stand anything these days." When he visited the restaurant (which had become the Four Seasons) he saw that it was as opulent as he had predicted. But spoiling the appetites of the richest bastards in New York by surrounding them with his dark visions of man's mortality no longer seemed worth the pleasure of his malicious irony; and it had become clear that the people would taint his paintings. In 1960, Rothko raised enough money to repay the commissions and withdraw the murals. . . . a decade later the Tate Gallery would establish a room devoted to them.

—SELDES.

In the 1960s, Harvard was nervous.

❏ In the early sixties, architect John Luis Cert designed an administrative and health center at Harvard, known as Holyoke Center. Cert admired Rothko's murals and asked him if he would donate some to Harvard for the building. In 1962, Bernard Reis drew up a codicil to Rothko's will deeding a gift to Harvard University, so that Rothko could deduct twenty percent of the fair market value ($200,000) of a triptych and two other large murals over four years. The paintings were to be placed under the supervision of the donor, hung in the lounge, never sold or loaned, and moved only with the permission of the donor or the Mark Rothko Foundation, a nonprofit organization still to be formed. But the Harvard Corporation, a relatively conservative group, was uncertain whether they would accept the gift. It was left to Harvard's

president, Nathan Pusey, a methodical midwesterner, to evaluate the art.

When the murals were completed and ready for delivery, Pusey, knowing little about art, and less about abstract art, made an appointment with Rothko at his studio, then on First Avenue in the Seventies. When Pusey arrived, having traveled down from Cambridge, he found himself in front of a ramshackle building in a disreputable neighborhood near the river. He rang the doorbell, but there was no response. He turned around in the entranceway and noticed a burly fellow dressed like a workman, scuffling across the street carrying a paint bucket. Rothko greeted him cheerfully and led him up a flight of stairs to the studio, where "miles of eggplant-colored paintings stood in a long line" awaiting Pusey's perusal. Rothko found two unhygienic paint-stained glasses and poured Pusey and himself a morning slug of whiskey, adding ice cubes from the cardboard container.

As Pusey and the painter sat, Rothko asked, "Well, what do you think of them?" Pusey remembers that he was at a loss but finally said that he thought they were "rather sad." From Rothko's expression Pusey understood that he had been "right on the beam."

—SELDES.

A happy ending—but finally and unhappily not an end to the story: Rothko was famously cavalier about materials—he bragged that if he ran out of paint, he sent to the five and ten—and within years his Harvard murals started to fade. Crimson turned blue. They were rolled up and stored, exhibited briefly in 1988, and put away again.

He was sixty-six when he killed himself. When they found him

❏ Rothko's body lay face up, his arms outstretched in a pool of congealed blood six by eight feet wide. His arms were slashed at the crooks inside the elbows. He was clothed in his undershirt, long johns with blue undershorts over them, and, on his feet, long black socks. More blood was spattered about, and on a nearby shelf lay a stained razor blade with Kleenex wrapped around one edge.

—SELDES.

Arshile Gorky committed suicide in 1948. In 1956 Jackson Pollock died in a car crash, and David Smith in 1965. In 1966 Frank O'Hara—poet, MOMA curator, friend of painters—died as the result of a car accident on Fire Island. Franz Kline, Bradley Walker Tomlin, and Ad Reinhardt died early and unexpectedly—though without the violence that destroyed so many of this generation of genius.

Graham Sutherland
(1903–1980)

His portrait of W. Somerset Maugham is brilliant and notorious.

❏ "The first time I saw it I was shocked," Maugham said later. "I was really stunned. Could this face really be mine? And then I began to realize that here was far more of me than I ever saw myself." He saw himself portrayed as the sardonic, aloof and quietly amused observer of human frailty, perched on the café stool with arms and legs crossed, mouth down-turned, face lined and generous bags under his eyes, against a plain background unusually thickly painted (for Graham) in shades ranging from apricot to yellow-green, with a few palm fronds suggesting a hint of the Orient at the top. Perhaps it was these which led Sir Gerald Kelly—then president of the Royal Academy, who painted Maugham eighteen times in all between 1907 and 1963, without once exciting the same interest—to remark: "To think that I have known Willie since 1902 and have only just recognized that, disguised as an old madame, he kept a brothel in Shanghai!" . . .

Once Maugham had recovered from the shock, he asked the price. Eardley Knollys had urged Graham to settle this in advance, but he had failed to grasp the nettle. He suggested £500. The following day Alan Searle came around with £300 and said that as it was in cash, it really represented £500, and anyway Mr. Maugham couldn't afford more. . . .

Up the road at Cap d'Ail, Maugham's friend Lord Beaverbrook saw the photograph at his Villa Capponcina, built near the water's edge by Captain Edward Molyneux, the fashion designer. Soon the diarists of Fleet Street were announcing that Sutherland might be going to paint the Beaver's not much less remarkable physiognomy. Suddenly Graham was news. "I am very glad that you have accepted a commission to paint Lord Beaverbrook," Maugham wrote on August 25—not wholly sincerely, since he would have preferred to remain Graham's only sitter, [Sutherland's wife] Kathleen recalled. "I think you will find him a subject very much to your taste, and I hope you are stinging him a lot of money. Don't forget the income tax will claim half of all you get."

—ROGER BERTHOUD, *Graham Sutherland: A Biography.*

When Sutherland painted Lord Beaverbrook's portrait, Beaverbrook said: "It's an outrage—but it's a masterpiece." Sutherland told Kenneth Clark about the sittings and the sitter.

❏ I found him very agreeable and amusing and entertaining. As a sitter he never keeps still, neither as regards the whole head, not the individual features on it, for, literally, one second. I had to crawl around his face to see what I was drawing a second before I made a lot of *very* indifferent drawings and one color sketch. I think I have got most of the facts, though, and they now need sorting out and co-ordinating by the aid of memory, which at the moment is still very clear about his look. But he has a thousand "faces," and it is difficult consciously to select one which seems to be the real person. Alternately he was blasting someone to hell on the telephone, or in retrospective contemplation, or allowing his face to light up with love of his granddaughter, who is the apple of his eye—or comparing the appearance of the Pope ("little rat") adversely with that of the Moderator of the Church of Scotland, or singing hymns!

 —BERTHOUD.

Maugham was plaintive: "Now that he has done me and Lord Beaverbrook, I wish he would give up portraits."

Sutherland's portrait of Winston Churchill followed. The painter remembered the first sitting, when he was deposited in Churchill's study.

❏ Suddenly I saw a nose appear around the corner of the door—just the nose alone, and it was Churchill. With that slightly sort of bent, peering look which he put on—I suppose partly to intimidate the person he was meeting—he shook hands, and showed me his hands, his mother's hands, which he had modeled: he thought his mother's hands were very much like his own.

 —BERTHOUD.

Churchill asked Sutherland, "How are you going to paint me? As a cherub or the Bulldog?" The painter said that it depended on what he was shown; later Sutherland confirmed: "consistently . . . he showed me the Bulldog."

❏ While thinking he was being very co-operative, he was a very restless sitter, smoking cigars, dictating letters and posing rather than relaxing. After lunch he tended to become "torpid," as he called it. Once he told Graham that they were really engaged in a duel: perhaps they should paint each other simultaneously. Seeing Graham drawing with

his usual pencil stub, he told him he had not got the right gear, showed him his own paints from Switzerland and promised to have some sent. He even suggested that they should go sketching in the South of France together: there was nothing he liked better, he said, and described how he would sit back to back with his detective, Sergeant (Edmund) Murray, and say, "A little more yellow ochre, please, Sergeant Murray," and Murray would squeeze a little more on to his palette.

<div align="right">—BERTHOUD.</div>

When the Bulldog became sleepy, the painter suggested, "A little more of the old lion, please, sir."

When Sutherland finished, Kenneth Clark worked on softening up the Churchills before they saw the portrait. It was the Bulldog himself who decided that it should not hang in Parliament. He became increasingly outraged. "It makes me look half-witted, which I ain't. . . ." Because he had become fond of Sutherland during the sittings, he felt hurt that the "brilliant painter with whom he had made friends while sitting for him should see him as a gross and cruel monster." Speaking in Parliament, Sir Winston raised a laugh by referring to his portrait as "a striking example of *modern* art . . ." The English newspapers made it a ten-day wonder, and Lord Hailsham expressed critical discrimination:

❏ If I had my way, I'd throw Mr. Graham Sutherland into the Thames. The portrait is a complete disgrace. . . . if I did my work the way Mr. Sutherland has done his, I would never get a brief. . . . I have wasted my money—we have all wasted our money. . . . It is bad-mannered; it is a filthy color. . . . Churchill has not got all that ink on his face—not since he left Harrow, at any rate.

<div align="right">—BERTHOUD.</div>

The portrait disappeared. Churchill died in 1965, his widow in 1977. After she died, Graham Sutherland waited for news of his portrait, finally delivered in a letter from Mary Soames who informed him that it was "no longer in existence." Her mother had ordered it destroyed in 1955 because she knew that the matter hung heavy on Sir Winston's mind.

All portraits leave stories behind.

❏ Max Egon, Prince von Fürstenberg, was a tall Bavarian landowner and founder of the music festival at Donaueschingen, where he lived

in a castle surrounded by relatives. His picture curator and cousin, Christian Altgraf zu Salm, had earlier met Graham's friend Felix Man and raised the question of Graham doing a portrait. Graham and Kathleen called in for lunch at Donaueschingen in July 1957. A fee was negotiated: the prince found Graham's suggested £4500 for a three-quarter-length portrait "for our idea rather high," he wrote on August 16. They settled for £4000. The sittings took place the following summer, when Graham and Kathleen stayed at the castle. The prince, who was sixty-three, looked rather like a retired colonel. Effortlessly he adopted exactly the same pose, with left leg crossed over right almost at a right angle, day after day. Man took some photos. Graham thought he detected a streak of the philosopher in Fürstenberg when he said one day: "You know, I'm never really happy until I'm alone in my hunting lodge," and was struck by his air of brooding and melancholy.

It was this look that he caught to good effect in the portrait, which he and Kathleen arrived to deliver on April 6, 1959, after a pleasant drive through spring blossoms. The prince and his wife Minzi saw it in privacy after lunch, then hastened to the guest apartment to express their delight. They embraced Graham and Kathleen, and all went back to look at it. Together they contemplated Graham's magnificently solid yet subtle composition. Then the prince pointed to a spluttering candle which Graham had placed near the right-hand edge of the canvas. "Does it mean that I have just one year to live?" he asked, with a smile. Graham assured him that he had just thought it would look right there.

That evening, over a high tea of frankfurters swimming in a watery soup, they were told the prince was indisposed. Graham and Kathleen retired to their rooms. It was a *Wuthering Heights* night; rain thrashed the windows. Breakfast was brought in at 7 a.m. by two maids with red-rimmed eyes, dressed in black from head to toe. The prince, they said, was dead.

—BERTHOUD.

Early in the 1970s, Sutherland sketched rock formations in Wales including an erect pinkish column that looked biomorphic indeed. Greta Garbo came calling.

❏ Speaking in his by now quite good French, Graham asked La Divine whether she would like to look at some sketch books. "O, la la," she said, when she came to the penile monolith. Graham peered over. "Oh, madame, c'est un peu phallique," he conceded apologetically, and explained that he was not guilty—the rock really looked like that and was that color too. "Mais je l'aime!" said Garbo. "C'est fantastique." From then on the phrase "un peu phallique" became something of a joke. Another was Graham's "c'est une possibilité," used, for example, when

being asked to paint some wholly uninspiring Italian industrialist. It meant that there was absolutely no chance of his ever doing it.

—BERTHOUD.

Salvador Dalí
(1904–1989)

He came to Paris in 1929, totally terrified.

❏ "He couldn't even cross the street. His only means of transport was a taxi. He fell down several times a day," Thirion recalled. He was afraid of almost everything, from traveling by boat to insects in general. He could not buy shoes because he was unable to expose his feet in public. He was the absolute victim of rigorous habit. Each day he ate the same things in the same restaurants and took the same walks. His ability to lose his keys and his wallet, and leave his change behind was already legendary. Whenever he went out, he hung on to an elaborate cane and always carried a little piece of driftwood from the beaches around Cadaqués to ward off evil spirits. The fact that he could not even take the Métro, when he first arrived in Paris, was a serious inconvenience for someone on a limited budget. Fortunately he was cured of that particular phobia by the painter Pavel Tchelitchew, who took him into the depths—Dalí laughed with sheer terror until tears came into his eyes—and then left him there alone.

> When he announced [Dalí wrote] . . . that he had to get off . . . I clutched at his coat, terrified. "You get out at the next stop," he repeated to me several times. "You'll see 'Exit' in large letters. Then you go up a few steps and you go out. Besides, all you have to do is to follow the people who get off."
> "And suppose nobody got off?"
> —MERYL SECREST, *Salvador Dali.*

There were other terrors.

❏ No matter how often he traveled in Gala's reassuring company, a train journey was a terrible ordeal. Julian Green noted, in late February 1933, "He is going to Spain and speaks with terror of the customs formalities and the thousand petty annoyances of a trip by *ferrocarril* (railroad)." Such hurdles were minor, compared with the challenge of

entering America, and presumably nothing would have come of the idea had it not been for the enthusiasm of Caresse Crosby, who swept objections aside. A section of her autobiography deals with the pathetic figure Dalí presented as he prepared for the ordeal. He was at the station hours ahead in terror of missing the train. He sat with all his canvases propped around him in the compartment, strings from each attached to his person, in case they should be stolen. He made the comment, no doubt with a straight face, that he had to sit near the engine so as to arrive sooner. His conduct on board ship was equally piteous. He spent his days in a champagne fog and went everywhere in a lifejacket. Photographs of him on deck after they docked in New York show him huddled against Gala, looking frozen, but there is an impish sparkle in his eyes that belies his panic. As was to become customary, he had spent most of the crossing stage-managing his press conference. He had persuaded the ship's baker to concoct the longest possible *baguette*—it was something like eight feet—and, when he found a mob of newspapermen waiting, he brandished it like a talisman. When the newsmen politely (he thought) forbore to mention the embarrassingly large object, he quickly shifted gear and began to declaim on a recent painting in which his wife appeared sporting a cutlet on her shoulder. The reasons for the presence of the cutlet, which had originally appeared on his own form to distract that ogre, William Tell, and had now gravitated to Gala's, would have been interesting indeed to explore. Dalí was much too smart for that. "I answered that I liked my wife, and I liked chops, and that I saw no reason why I should not paint them together."

—SECREST.

Julien Levy recollects fireworks during Dalí's 1934 visit to New York.

❏ I first approached Saks Fifth Avenue with the project of window dressings by Dalí. Saks had made a fine reputation with its novel window displays when it had first moved uptown, but now they were resting on their laurels and were not interested in in further extravaganzas. Tom Lee of Bonwit's, however, got wind of my scheme and called me. He brought Dalí down to the studios where objects, lighting, and mannequins were designed and displays executed. Dalí was enchanted by the rich prospect of realizing his inventions in this workshop. He accepted with alacrity, so enthusiastically in fact that he almost forgot to name his price, until Gala and I reminded him. What a chance to "paint" in three dimensions! The thousand-dollar fee seemed inconsequential by comparison.

Bonwit timed its window display to coincide with the opening of Dalí's

exhibition at my gallery. That morning early, on my way to work, I decided to detour by one block, from Madison to Fifth, and have a preview of the window. I arrived just two minutes late for the happening. The plate glass lay in shards, a bathtub on the sidewalk, and a small crowd was gathering. The heavy tub, a part of Dalí's display, had smashed through the plate glass window, narrowly missing passersby, and a falling piece of broken glass had just missed decapitating Dalí as it fell. Dalí was already in the hands of two policemen. Tom Lee was pale and shaken. Gala, hysterical, would have scratched him if she had not been torn between her fury and her concern in quieting Dalí.

"Get an *avocat*, Julien," Gala cried, "and telephone Edouard." I went on to the gallery and did both, telephoned Edward who gave me the name of his lawyer, Philip Wittenberg, who was to become an ubiquitous figure among us for the next several months.

Dalí's show was already hung, except for a few finishing touches which I left to Allen Porter while I went on to the police station. It was imperative somehow to bail Dalí out in time for his presence at our vernissage. At the station I sat for a couple of hours with Gala, Tom Lee, Edward, and Wittenberg until the insurance company lawyers agreed to drop criminal charges of willful destruction and came to a settlement of damages with Bonwit Teller.

The story of the fracas made headlines in the evening papers. As Dalí conceived it, the central object of interest in his display was the old-fashioned white enamel tub in which was to lie a fully clothed mannequin, wearing one of the dresses Bonwits was promoting. The window had been carefully arranged to Dalí's satisfaction the night before, but when he came back the next morning to look at it again, he found the management of Bonwit Teller's had removed the prone mannequin from the tub and stood it to one side, to better display the costume. Seeing this, Dalí plunged raging into the store, into the window scene—and somehow, in the melee and confusion, the tub was shoved through the huge plate glass window. Opinion was divided as to whether or not Dalí had planned the entire episode as a publicity stunt. It certainly proved to be a good one, but I do not believe it was calculated— although of course I was not there at the time. I'm sure Dalí had too much love for his project, the window display, to destroy it before it ever saw the light. I remember how impassioned he had been the night before when he spoke of it, saying that if a nude mannequin could provoke attention by its lack of clothes, how much more a fully dressed mannequin, *fully dressed in a bathtub*, would call attention to her costume. What an emphasis for their merchandise. "Bonwit's will embrace me," Dalí had explained, his eyes glowing with pride. It was this very pride and entanglement with his production that had provoked him into the tantrum when his idea was modified, even slightly, by some

timidity or indiscretion on the part of Bonwit's managers. "It could only have been convincing if it were precisely as I would wish," said Dalí later. Somehow, the tub had crashed through the window.

Wittenberg made it out to be an accident. "The tub had slipped." Gala reminded the court that the falling plate glass had narrowly missed decapitating Dalí. "He would not have been interested in his own death," she argued. But Dalí admitted to me he had fallen into a rage. "Rage for the absolute," he asserted.

It was, I repeat, part of his passion for precision.

And the opening of Dalí's exhibition that afternoon was almost an anticlimax, at least for me. I had seen all the pictures, knew they were good, and felt sure they would sell. With the publicity of the Bonwit window they went like hot cakes.

—JULIEN LEVY, *Memoir of an Art Gallery.*

When Dalí first received American dollars for his work, he changed them into traveler's checks.

❑ He insisted in changing $5,000 into checks of small denomination. I explained that this would be a bulky business, but that was just what he wished. He said his bundle must have bulk to be really convincing.

Dalí began signing very slowly, carefully, and elaborately. In fact he occasionally improvised little landscapes and battle scenes in combination with his signature.

"You will have to reproduce each of those signatures," a bank official tried to explain.

"I can do that too—Dalí surely can reproduce Dalí."

—LEVY.

As it happened he did *not* copy his pictures; banks cashed the checks anyway.

When Joseph Cornell showed part of a film he was making, Dalí erupted.

❑ On the screen a voiceless heroine mouths silent avowals. Suddenly the sheik enters the tent. The defenseless English girl clutches the bed-covers to her breast as she eyes the intruder with fearful fascination. She draws a deep breath and clasps her hands. The sheik's eyes flash with rapacious anticipation. A ball rolls in slow motion and splashes into a pond. The sheik, the English maiden, the sheik, galloping cam-els, the ball, the girl again, the splash. . . .

Suddenly there was a loud crash. "*Salaud!*" The silence was broken. "Lights!" I called.

"*Calme-toi*," cried Gala as she pushed her way toward Dalí.

"*Salaud, et encore salaud*," screamed Dalí as he fought his way toward Joseph Cornell.

Dalí was in a rage, a state not unusual with him but unusually impressive, somewhat between the firebreathing, lightning-flashing rampage of a demon and the spoiled yielding to frustration that is a temper tantrum. One sensed whirling blades of sharpest steel flashing about him and expected tears of uncontrolled hysteria. One couldn't be exactly frightened, but one couldn't fail to be impressed—except Joseph, who was shocked and confused. He had, apparently, no previous experience of childhood bullies or such full-sized malevolence. And he could not believe he was the one being attacked.

There was little to be said after Gala had calmed Dalí and I had comforted Cornell. "It is that my idea for a film is exactly that, and I was going to propose it to someone who would pay to have it made. It isn't that I could say Cornell stole my idea," said Dalí, "I never wrote it or told anyone, but it is as *if* he had stolen it."

Cornell protested over and over again. "Why, why—when he is such a great man and I am nobody at all?"

—LEVY.

Caresse Crosby gave him a farewell party; guests were to come dressed as their dreams.

❑ Dalí naturally took some pains with his costume. Robert Descharnes wrote that he came "disguised as a shop window." Dalí himself explained that he had dressed himself as a necrotic corpse with a bandage around his head. In the white shirt front of his tuxedo he had cut a square hole, lit from within, which acted as a shadow box for a pair of tiny breasts, decorously enclosed inside a bra. He then rolled his eyes. It was wonderful but it was only the beginning. Pierre Matisse, who was showing Miró at his New York gallery, recalled,

> Downstairs there was the carcass of a steer ready to be butchered, nice and clean, wide open, and in it sat one of the patrons of the exhibition at a table, having tea with her daughter, who was perhaps seventeen. The costumes were amazing. One woman had a crown of young tomatoes around her head. Another had cut his face, I don't know how, and had hat pins sticking to it with wax. Another lady, very well known, whose name I will not mention, wore a long gray silk dress and when she turned around there was nothing there. She was asked to go home and change. I went as Pierre Matisse.

Even Dalí was surprised at the macabre depths of the guests' imaginations: "Eyes grew on cheeks, backs, underarms, like horrible tumors. A

man in a bloody nightshirt carried a bedside table balanced on his head, from which a flock of multi-colored hummingbirds flew out."

Most shocking of all, in retrospect, was the outfit Gala wore. Exactly who designed it is not clear, but by general agreement the object she was sporting in the center of an enormous black headdress was a baby's corpse. The doll had a wound on its forehead, carefully painted by her husband, that was filled with ants and its skull was being clutched by a lobster. A pair of gloves, acting as wings on either side, completed the macabre imagery. The similarity of lobster image to grasshopper theme would suggest that some private fears were being aired in public, and the fact that Gala would appear to be dreaming of a murdered baby, in view of her rejection of her own child, would conjure up some uncomfortable thoughts about her private opinions. The press came to conclusions of a different kind. A few months before Bruno Richard Hauptmann had been tried and convicted of the kidnapping and murder of Charles and Anne Lindbergh's son, and the particularly revolting details of the event were fresh in everyone's mind. Were the Dalís capable of this kind of brutal symbolism? It suddenly seemed all too likely to those, in this case Matisse, who had heard them make such cynical comments as, "You have to boil Americans right down to their bones."

—SECREST.

His wife Gala, whom he married in 1934 after she divorced the poet Paul Eluard, paid the bills and ran the household.

❏ In saving Dalí from himself, Gala was as vigilant as Dalí's mother had been in his father's case. She needed to be because people thought there was something really bizarre about Dalí's behavior on occasion. It was said that when Dalí happened to arrive in Italy in the autumn of 1935 on the day when Mussolini invaded Abyssinia (October 3), and finding rioting in the streets, he told anyone who would listen that Il Duce had purposely held off his war until he got there. Someone saw him fly into a rage because, while watching a floor show in a Paris café, the dancers happened to come too close to his table. "They just did it to scare me," Dalí said tearfully, after he had fled. There was also the time when, having arrived at the outside door to Julien Levy's apartment, where he was expected for drinks, Dalí pushed the buzzer as a signal for Levy to let him in, which Levy promptly did, then did not appear. Levy went downstairs to investigate and was in time to see Dalí tearing off. When he had caught up with him, Levy demanded an explanation. "The door, the door!" Dalí stammered. "It *whispered* at me." . . .

There was, however, one occasion on which Gala was not there to

save Dalí at the right moment, an omission that might have had serious consequences. The incident took place during the first International Surrealist Exhibition, organized by David Gascoyne, Roland Penrose and a small group of scholars, poets and artists centering around Henry Moore, Herbert Read and the British Surrealist painters Eileen Agar and Paul Nash, which ran for almost a month at the New Burlington Galleries in London in the summer of 1936 (June 11–July 4). Dalí, although no longer in the inner circles of Surrealism, was deemed too important to be excluded and was represented by a few works (one was his famous *Aphrodisiac Dinner Jacket,* which was covered with dozens of tiny glasses of liqueur and dead flies), while reserving his choicest inventions for a one-man show being held at the Lefevre Gallery at the same time. The exhibition was a phenomenal success with the public, attracting record crowds, and helped by Dalí's unerring publicity instincts. One of his stunts was to dress up Sheila Legg, an extremely pretty member of the British Surrealist group, in a mask of red roses that covered her whole head, and send her out to feed the pigeons in Trafalgar Square. Another was to give a lecture at the Galleries, "Some Authentic Paranoiac Phantoms," wearing a diving suit, the helmet of which was decorated with the radiator cap of a Mercedes Benz. He made his entry with two white Russian wolfhounds.

As Dalí launched into his discourse, Gala left, either to watch newsreels at a nearby cinema or to get a cup of coffee. The versions differ and Dalí does not mention it, but it seems that for once she was not there to adore him as he, by chance or design, talked exclusively of his love for her. However, the old-fashioned suit, which had been efficiently bolted together by a workman who then left, was not only immobilizing—the shoes were so heavily weighted with lead that Dalí had to be helped onto the platform—but an effective sound barrier. Dalí buzzed away in French and the audience sat politely mystified. Dalí was soon more and more uncomfortable, partly because it had dawned on him that he could not be heard and also because, after spending ten minutes in his suit on a very hot day, he was perspiring profusely. He began to make elaborate gestures for the removal of his helmet, which struck everyone as a new development deserving of applause. The more he gesticulated the more they laughed and it took some time, during which Dalí thought he would faint dead away before, as David Gascoyne explained, "we realized he was in some distress. Finally Roland Penrose said, 'For heaven's sake go and get a spanner,' and I found one somehow. It took us about five minutes to get him out of there." By the time they freed him Dalí was almost prostrate but he gamely finished his lecture. He was complimented warmly on his realistic performance.

—SECREST.

With Gala's help Dalí became rich.

❑ Whenever Dalí was in town, the lobbies of the St. Regis in New
York or the Hotel Meurice on the rue de Rivoli in Paris would be full
of anonymous-looking businessmen with attaché cases and absorbed
expressions. Several hundred contracts would be proposed in any one
particular year and of these about fifty would come to fruition. They
included, in 1970, a fifteen-second commercial on French television
during which Dalí rolled his eyes roguishly and said, "I am mad, I am
completely mad . . . over Lanvin chocolates." He was paid $10,000.
The previous year he received the same amount for a spot television
appearance in which he extolled the merits of Braniff Airways al-
though, as was well known, he had never flown in a plane and declared
he never would. Such contracts would have been, until the 1960s, ne-
gotiated by Gala once her husband had agreed in principle, and there
were few propositions to which he did not agree. One of these involved
an American businessman who proposed buying the second letter of
Dalí's name so that he could open a chain of stores called Dalicatessens.
Dalí called him crazy and threw him out.

—SECREST.

Impulses of generosity were quickly corrected.

❑ Lionel Poilâne, owner of a famous Paris bakery, who collaborated
with Dalí on several sculptures made out of bread, had received no
payment for his services. Finally, Dalí presented him with one of his
paintings. When Gala heard of that, she said, "Yes, I know he gave it
to you, but give it back to me," so he did, to his eternal regret. Cocteau
told the story that, when one of his boyfriends decamped with a valu-
able Dalí, Dalí said, "Never mind, we will give you another one," and
Gala added, "Yes, we will give you another one for only the price we
would charge a dealer."
 One day the manager of the Hotel Meurice complained that Dalí's
possessions were taking up an inordinate amount of space in the hotel
strong-room and asked if he would be good enough to examine them.
Moore and Dalí descended into the vaults. Box after box was stuffed
with cash and at least half of the banknotes were no longer valid.
 Avida Dollars—the cutting anagram André Breton coined from Dalí's
name in 1942—was picked up far and wide. As the original indictment
went, "The rustle of paper money, illuminated by the light of the moon
and the setting sun, has led the squeaking patent-leather shoes along
the corridors of Palladio into that soft-lit territory of Neo-Romanticism
and the Waldorf-Astoria. There in the expensive atmosphere of 'Town
and Country' that megalomania, so long passed off as a *paranoiac intel-*

lect, can puff up and hunt its sensational publicity in the blackness of the headlines and the stupidity of the cocktail lounges."

<div align="right">—SECREST.</div>

Alone among the Spanish painters Dalí favored Franco, praising his "clarity, truth and order." In 1975 when Franco executed five Basques and pardoned six others, Dalí telegraphed congratulations; interviewed later, he said that Franco had erred only in not executing all eleven.

Later he demanded that his food be tasted by a servant before he would eat it. He withdrew from human contact, until not even old friends could reach him. It was the triumph of "paranoiac-critical" theory.

Arshile Gorky
(1904—1948)

Born in Armenia, Gorky emigrated to the United States in 1920. His younger sister Vartoosh, interviewed by her son, Karlen Mooradian, tells of the world they left behind them.

❑ KARLEN: What was your mother's illness?

VARTOOSH: Starvation, starvation. We were not able to obtain enough food. Gorky tried to put her in the hospital, but the hospital would not accept her because they said she had a husband in America. "You have your husband in America," the authorities said, "and so you have money." What money? We never received any money. . . . And Gorky never forgave them for that, for not letting Mother in the hospital.

KARLEN: What did Gorky do then?

VARTOOSH: What could he do, a 14-year-old boy? He worked, I worked to help Mother. Mother could not work. There was no food and she was starving and her stomach swelled up and she was very weak. And when the winter got worse, the ceiling of our room began to leak, and so each morning before Gorky and I went to work we would lift Mother up and put her in the window so that she would not get wet from the leaking roof. By evening we would return and Mother was the same way. Whatever Gorky and I found for lunch, we would save it. And I would save my lunch. Maybe one egg and a piece of bread and I would bring it home for Mother and Gorky.

KARLEN: Describe how your mother died.

VARTOOSH: It was March. It was March 20. I remember it well because just at that time the grass was starting to grow. 1919. We had placed Mother in the window and she was dictating a letter to Gorky. A letter to Father in America. She had no strength even to hold a pencil in her hand and so Gorky wrote down what she said. "Vosdanik," she called out to Gorky, "write that I can never leave Armenia. That I will never come to America. Say, 'this is my earth and soon, very soon we will all of us be in Van again . . .'" And she struggled to speak again. "Lord God," she cried, "return me to Vosdan, to the vank that sired me." Suddenly she stopped speaking. Gorky looked up and said, "Mother, Mother." And he rushed to her. And suddenly she starved to death in our arms. She was age 39. Her head fell on Gorky. The two of us so young. We did not know what to do. Her body was swollen as a result of starvation due to the Turkish blockade.

—KARLEN MOORADIAN, *The Many Worlds of Arshile Gorky* .

Julien Levy met Gorky in Levy's gallery.

❏ Arshile Gorky did not come to my gallery directly to show me his own work. In the winter of 1932 he came urging me to look at the work of a friend of his named John Graham, and it was Graham who generously suggested that I also look at a portfolio of Gorky's own drawings. "My portfolio is already in your back office," Gorky reluctantly confessed, and my secretary told me that "that man is always leaving his portfolio in the back office. He comes back days later and pretends he has forgotten it."

"Yes," said Gorky shamelessly, "and I always expect you will have opened it and discovered masterpieces. . . ."

—JULIEN LEVY, *Memoir of an Art Gallery.*

Levy found no masterpieces.

❏ "Your work is so very much like Picasso's," I told him. "Not imitating," I said, "but all the same too Picassoid."

"I was *with* Cézanne for a long time," said Gorky, "and now naturally I am *with* Picasso."

"Someday, when you are *with* Gorky," I promised.

—LEVY.

Gorky became Gorky only after the great wave of European artists arrived in New York in the late 1930s and '40s. Willem de Kooning describes an encounter.

❑ Pollock was a very belligerent man. I was at a party once and he
started insulting Gorky and Pollock was drunk. He was going to do
this, he was going to do that, and he said to Gorky, "You're a lousy
painter." Gorky didn't bat an eyelash. He took a long knife which he
always kept in his pocket. He used it as a pencil sharpener, used to
make piles of pencils with long lead because that's the way he drew.
Like he used to say, he used pencils in drawing "like a surgeon's tool."
Beautiful lead and then he had these enormous hands. With this part
flat, very beautiful hands. And he would have this pencil and he could
make terrific drawings, beautiful drawings, very sharp point. So it be-
came a habit for him to take that big knife out and sharpen a pencil
whenever somebody wanted to make trouble. People knew they shouldn't
fool around with him.

 —MOORADIAN.

Gorky survived and prevailed until 1946 when a fire in his Con-
necticut studio destroyed many paintings; in the same year, a
cancer operation left him with a colostomy; two years later driv-
ing with Julien Levy, he broke his neck in an automobile acci-
dent; then his wife left him.
 Milton Resnick told Mooradian an anecdote of the fire.

❑ I'll tell you one thing about that fire in which his paintings burned
to the ground in Connecticut. I don't know if you know this, but Gorky
had been working downstairs and the fire had started upstairs in the
chimney somewhere. And he seemed not to have noticed it for some
time, so it got a good hold on the building and, of course, he realized
it was in the country and he tried, but could do very little. He thought
of saving some of his paintings that he treasured very much. He always
kept a certain group of paintings aside. They were like his own little
treasury of favorites. Anyway, he thought of taking them out of the
house, saving them, and then he realized that if he took anything, he'd
have to take not what belonged to him, but what belonged to the man
from whom he rented the house. So in honor he took nothing. Just
walked out and watched the whole house burn down. So, you see, he's
a man of honor.

 —MOORADIAN.

Yenovk Der Hagopian knew that Gorky had undergone an op-
eration. But he knew no details.

❑ I heard that he had a very bad operation. And you could hear
noises in his stomach, where they had attached the sack after the colos-

tomy operation. "Pardon me, pardon me," he said when I would hear them. And I didn't know why he was so apologetic. "What kind of an aristocrat have you turned into?" I asked. "What is this 'pardon me' business?" Gorky said, "Priest's son, don't you know?" Then he explained it to me, and I cried. A few tears came into his eyes. Then he grabbed the legs of the chair I was sitting on and lifted it high up in the air with me in it. And he shook me. Had he let go, my head would have been broken. "Don't you dare cry," he shouted, "don't you dare cry." He was so mad. "All right, Manuk, forget about it," I said. "But why didn't you tell me, why didn't you write me?" And Gorky answered, "Is it a wedding to which I must send you an invitation?"

—MOORADIAN.

❑ Kay Tanguy phoned. "Have you heard from Gorky?" I told Kay of our conversation. His calls were the first news either of us had that Mougouch was away. "He sounded drunk or crazy to me," sniffed Kay. I told her he sounded to me perfectly understandable, given the circumstances. But he had told her, Kay continued, that he was calling all of his friends. "What is worse, he is apparently asking them for help, asking each something different." I remember thinking that Gorky rarely asked favors of the friends to whom he so generously gave his warmth and sympathy.

"Someone should go to him," we said together. I still couldn't drive, so Kay decided: "I'll try to reach Peter Blume or Malcolm Cowley; they live nearby."

Kay phoned me again a little later. "Peter will look in on Gorky," she said, "if not tonight, tomorrow. In the morning."

—LEVY.

❑ On the drive home Jeanne Reynal pieced together for me the details of Gorky's last night. He had phoned many friends, on one pretext or another, perhaps to hear their voices for the last time. He was drinking, progressively became more intoxicated, but must have decided to die long before beginning to drink. More than one noose was prepared, hanging from different branches and rafters, each ready in some favorite spot so that at the last Gorky could make his choice. He had chosen the rope tied about a beam in a shed where he often went to read or dream alone in bad weather. Across the raft in chalk he had written "Goodbye, my 'loveds.'"

—LEVY.

Peter Blume told Gorky's nephew:

❑ Gorky had told Schary that he wanted to be left alone because he wanted to do what he had to do by himself. He didn't want anybody

around. Meanwhile, the Tanguys had called the Cowleys to corroborate the story. So we all went over, that is Malcolm, Muriel and Ebie, my wife. We got into Malcolm's car.

MOORADIAN: Malcolm came here to pick you up?

BLUME: Yes, by this time we had checked on all these things and decided we'd better run over there. So Malcolm and I, when we got there, at first started looking all through the house for Gorky. Then we saw a rope dangling from the rafters in the barn.

MOORADIAN: Put there by Gorky.

BLUME: I don't know but there was this symbolic rope dangling around.

MOORADIAN: Did it have a noose?

BLUME: No, it was just a rope but this was a symbolic rope that was hanging from the rafters. Which gave us a turn. But then Malcolm and I started wandering off in the direction of the waterfall, of which Gorky was always so fond. Gorky had told me that he loved the waterfall. The waterfall was on this rather wild, hilly land with a number of roads built by some wealthy man who had tried to hunt for uranium. One wing of that man's house contained chemical equipment for soil testing.

MOORADIAN: What time of day did you and Malcolm arrive at Gorky's place?

BLUME: It must have been close to noon. By the time all the telephone calls had come in and Schary had come and we gathered ourselves to go over there, it was still before noon.

MOORADIAN: Then the door of Gorky's house was open.

BLUME: Yes, Gorky's door was never closed. Then Malcolm and I went up to the waterfall and the road sort of petered out and we had to stumble around in there. And we looked all over, thinking that he might possibly try to hang himself from one of the overhanging trees, because I thought that he had sort of a profound interest in the waterfall. And because it was so far removed from everything else, I thought this might be the place where he might choose to commit suicide. But he wasn't anywhere around. So we started wandering and came to a little road where the uranium prospector had placed a stone crusher for construction. Gorky had two dogs, a dachshund and a huge dog as big as a horse. And when we saw this little dog barking as we came up, we knew this was where Gorky was and that's how we found him. We found him hanging from the rafters right in this little shed right next to the stone crusher.

—MOORADIAN.

Just before he died he paid a visit to Isamu Noguchi:

❏ At MacDougal Alley. I was awakened by the ring of the bell and went through the garden to the gate outside. There was a wall and a gate. And when I opened the door, he was standing there with two rag

dolls in his hands. They were old, dirty rag dolls. And tears were streaming down his face. And Gorky said, "This is all I have. This is all I have left."

<div align="right">—MOORADIAN.</div>

Willem de Kooning
(1904–)

He is one of our more eminent illegal immigrants.

❏ It took six tries, three of them "legal" (he attempted to get hired as a deck hand by the Holland-America line, with the idea of jumping ship in the U.S., but evidently this plot was written all across his twenty-one-year-old face, and the hiring clerk adamantly refused to take him on). The next three tries were "illegal." He got a little money from his father, enough to give the sailors' union their required fee. His father wished him good luck, but told him not to come back for any more money. They said good-bye. The first try misfired when the contact did not show up. The second time, he was smuggled aboard, only to be told that there was a mistake, and the ship was bound for Buenos Aires. Feeling a touch of excitement, de Kooning said, "Let's go to Buenos Aires!" But his friend who supervised these maneuvers, Leo Cohan, dragged him off. On the third try, he made it. De Kooning was hidden in the crew's quarters, and when the ship landed at Newport News, slipped off; he then got hired by a coaler going to Boston, was able to leave her with proper landing papers, and finally went to Hoboken, where Leo Cohan had arranged for him to stay. (Some thirty years later, the statute of limitations on illegal entry having long since expired, de Kooning re-entered the U.S. from Canada on the quota. He has since completed the formalities of becoming a citizen.)

<div align="right">—THOMAS B. HESS, *Willem de Kooning*.</div>

In the 1930s he and his friends did not call themselves artists. That name was "for men with beards." Instead these men made a living designing and building. They were *waiting*—but in the meantime they were professionals.

❏ [He was a] carpenter, designer, house painter, portraitist, a man who could execute a commission with dispatch. And he has kept this

contact, physically and metaphysically, with life outside of the studio.
He designed his own house, starting with the steel framework and going
down to details of tables, benches, drawers. He works on it as he does
on a painting: tearing walls down, moving cabinets around. A number
of young artists have been hired to be his helpers. They were nick-
named "de Kooning's Peace Corps." One visitor rummaging around
came across a drawer fitted with small, neat compartments. "What is it
for?" De Kooning said, "Why, collar studs." When asked if he owned
so many studs, he admitted that a particular carpenter he employed
was good at, and enjoyed, making little wood compartments.

—HESS.

He spoke to David Sylvester about his early days in Hoboken.

❑ I was here only about three days when I got a job in Hoboken as
a house painter. I made nine dollars a day, which was quite a large
salary, and after being around four or five months doing that, I started
looking for a job doing applied art-work. I made some samples and I
was hired immediately. I didn't even ask them the salary because I
thought if I made nine dollars a day as a house painter, I would make
at least twenty dollars a day being an artist. Then at the end of two
weeks, the man gave me twenty-five dollars and I was so astonished I
asked him if that was a day's pay. He said, "No, that's for the whole
week." And I immediately quit and went back to house painting.

—HESS.

Until 1953 he tended to destroy his work and use the canvas
over again. He married Elaine in 1943.

❑ Elaine de Kooning remembers that after stopping work on one
magnificent painting, the artist reluctantly admitted that it was "pretty
good" but decided that it had to be moved "two inches to the left."
Instead of cutting down the right side and piecing out some space to
the left, he proceeded to paint over the whole image, meticulously
shifting each element—and in the process lost the whole image.

—HESS.

❑ Harold Rosenberg remembers visiting de Kooning in the early 1950s
and seeing *Woman, I* almost finished (in fact perfectly finished, if the
artist would only leave it alone); de Kooning picked up a wide loaded
brush and slapped it across the canvas.

—HESS.

He summered in North Carolina.

❏ In the summer of 1948, de Kooning taught at Black Mountain College, then headed by Josef Albers, where he renewed his friendship with composer John Cage and universal designer Buckminster Fuller. Elaine audited one of Fuller's courses and remembers that one day he showed the class two irregularly shaped solids and said they could be fitted into a perfect cube. Everybody attempted to do it, but no one could. De Kooning dropped in, and Fuller asked him to try; he looked at both sections for a few seconds, then jammed them together, and they clicked into position. Fuller said to the class that this demonstrated how "genius" can visualize forms in space. Later de Kooning explained to his wife that, knowing Fuller, he just chose the two most impossible-looking aspects—the areas that could never join—and pushed from there. But in a sense Fuller was right; joining impossibles is a de Kooning method.

—HESS.

He was a founder of The Club.

❏ De Kooning and Franz Kline participated in many of these events, and along with Phillip Pavia, Harold Rosenberg, and others gave a form and sense of intellectual excitement to the very informal gatherings of artists and artists' friends. Barnett Newman would debate issues; Ad Reinhardt would denounce his colleagues; Ibram Lassaw and Aaron Siskind would look wise; Adolph Gottlieb and Robert Motherwell put in less frequent appearances. Jackson Pollock would stay around the corner at the Cedar bar until the talking was over and then climb the stairs to join the post-symposium party.

—HESS.

When he took a gander at Michelangelo's *Last Judgment* in the Sistine Chapel, he left quickly, saying, "You know I'm no art lover."
There were famous softball games in East Hampton. In 1951, Harold Rosenberg pitched a grapefruit which had been painted by both de Koonings, together with Franz Kline, to resemble a softball.

❏ Pavia swung, and it exploded in a great ball of grapefruit juice. There was general laughter and little shouts of, "Come on, let's get on with the game."
Esteban Vicente came in from behind first base (where Ludwig Sander was stationed with a covered basket containing ammunition); he pitched the first ball over easily. Pavia swung. There was another ball of grape-fruit juice in the air. More laughter. Finally they decided that fun was fun, but now to continue play, seriously. Rosenberg came back to the mound. He smacked the softball to assure everyone of its Phenome-

nological Materiality. He pitched it over the plate. Pavia swung. It exploded into a wide, round cloud of coconut. "Look, look," shouted Pavia, as if he had always suspected that if you hit a baseball hard enough to break it, there would be coconut inside. Then, from nowhere, a crowd of kids appeared around home plate and began to pick up the fragments of coconut and eat them. They had to call the game.
—CALVIN TOMKINS, *Off the Wall: Robert Rauschenberg and the Art World.*

It was a commonplace that de Kooning and his friends from The Club and the Cedar Bar painted without an environment.

❏ The poet Frank O'Hara once met de Kooning on the street. The painter said that he had been out "buying some environment" for a picture; under his arm he had a box of drugstore cotton.
—THOMAS B. HESS, *Willem de Kooning.*

O'Hara himself, writing an article about another painter, quoted de Kooning: "I think I'm painting a picture of two women but it may turn out to be a landscape."

And sometimes he really painted a woman. Selden Rodman remembered:

❏ On my second visit to de Kooning's studio he had done a surprising clean-up job and was having trouble finding things. He had a visitor who was talking about Marilyn Monroe, and I asked him how he happened to paint that surprisingly bland but quite recognizable picture of her that was the sensation of an otherwise wholly abstract show of his a year ago.
"I don't know. I was painting a picture, and one day—there she was!"
"Subconscious desire?"
"Subconscious, hell!"
—SELDEN RODMAN, *Conversations with Artists.*

Barnett Newman
(1905–1970)

Ad Gottlieb was a friend. In 1930 nobody made a dime.

❏ In 1930, to earn a bit of money, Gottlieb and Newman both decided to look for work as high school art teachers; they took the Board

of Education examination and to their blank astonishment flunked. Gottlieb dropped the idea, but Newman went on to take and pass the exam for substitute teacher. In the spring of 1938, after seven years of intermittent teaching, he took the regular teacher's exam again and again flunked. Outraged, he took a copy of the test to his near-neighbor on Martha's Vineyard, Thomas Benton, and got him to state in writing that he would have flunked it, too. Then Newman wrote a letter to the newspapers exposing the scandal: America's most famous artist states that he couldn't pass a test given by the New York Examiners Board. It was published in the *Tribune,* made a local furor; the results of the exam were canceled. Newman, politicized and in full semicomic rebellion, organized an exhibition at the A.C.A. Gallery, titled "Can We Draw" (Max Weber was a contributor), and wrote a fiery preface attacking the official standards of academic draftsmanship. When a new test was given, Newman and his friends took it—and they were all flunked again!

—THOMAS B. HESS, *Barnett Newman.*

His pay as a substitute teacher was $7.50 a day. From 1939 to 1945, he taught at the Washington Irving Adult Center—two hour-long classes, two days—for $15 a week.

Newman was an intellectual and therefore needed to say that esthetics is to artists as ornithology is to birds.

❏ Panofsky was imprudent enough to sneer at the pretensions to education of modern American artists, citing as evidence an error in a caption to Newman's painting *Vir Heroicus Sublimis* (it was printed *Sublimus*). Newman replied by pointing out that his painting was correctly titled, was correctly mentioned in the text of the article, but was miscaptioned due to a typographical error—"*us*" for "*is.*" But, not content with this, he went on to show that Panofsky was ignorant of the fact that even the error could be correct in certain locutions, of which Newman gave a number of recondite examples, and hinted that pretensions to education were particularly ill-becoming to a professor. Panofsky replied with more citations. Newman flattened them. Finally, Panofsky surrendered. . . .

Harold Rosenberg tells the story that one day he told Newman that he didn't like a little "multiple" the artist had executed. "I'm going to go after it in my next article," Rosenberg said. "I'll write a letter," replied Newman. "Just forget the whole thing," said Rosenberg. . . .

In 1959, Meyer Schapiro invited Newman to give a graduate seminar at Columbia. Toward the end of the session, Newman remembers, Schapiro drew four rectangles on the blackboard, outlined an object in one, filled the second with dots, the third with interlocked forms and

the fourth with disassociated elements. He understood that this was a topology of modern art history: Realism, Impressionism, Cubism, Surrealism. And when Schapiro asked him where he fitted in, he went to the blackboard, erased the dots, and drew his "zip" down the edge.

When asked about this, Newman shakes his head and says: "I remember; I had to think fast; so I wiped out Impressionism!"

—HESS.

Frida Kahlo
(1907—1954)

When she was a girl, at about the time when Rivera married his mistress Lupe Mirin, Frida Kahlo announced to her schoolmates, as they ate ice cream, "My ambition is to have a child by Diego Rivera." In his autobiography, Rivera recollected an early moment.

❏ One night, as I was painting high on the scaffold and Lupe was sitting and weaving down below, there was a loud shouting and pushing against the auditorium door. All of a sudden the door flew open, and a girl who seemed to be no more than ten or twelve was propelled inside.

She was dressed like any other high school student but her manner immediately set her apart. She had unusual dignity and self-assurance, and there was a strange fire in her eyes. Her beauty was that of a child, yet her breasts were well developed.

She looked straight up at me. "Would it cause you any annoyance if I watched you at work?" she asked.

"No, young lady, I'd be charmed," I said.

She sat down and watched me silently, her eyes riveted on every move of my paint brush. After a few hours, Lupe's jealousy was aroused, and she began to insult the girl. But the girl paid no attention to her. This, of course, enraged Lupe the more. Hands on hips, Lupe walked toward the girl and confronted her belligerently. The girl merely stiffened and returned Lupe's stare without a word.

Visibly amazed, Lupe glared at her a long time, then smiled, and in a tone of grudging admiration, said to me, "Look at that girl! Small as she is, she does not fear a tall, strong woman like me. I really like her."

The girl stayed about three hours. When she left, she said only, "Good night."

<div style="text-align: right">—HAYDEN HERRERA, Frida: A Biography of Frida Kahlo.</div>

"I had no idea," he added, "that she would one day be my wife."

Between her first meeting with Rivera and their eventual union she suffered a terrible accident. Before she died twenty-six years later, she underwent thirty-two operations. She summed things up by remarking, "I suffered two grave accidents in my life. One in which a streetcar knocked me down. . . . The other accident was Diego."

A story told by Clare Boothe Luce gives a sense of Frida's style as a painter. When Luce's friend Dorothy Hale committed suicide, Luce conceived the idea of having a portrait painted by a famous artist for her friend's mother.

❏ I will always remember the shock I had when I pulled the painting out of the crate. I felt really physically *sick*. What was I going to do with this gruesome painting of the smashed corpse of my friend, and her blood dripping down all over the frame? I could not return it—across the top of the painting there was an angel waving an unfurled banner which proclaimed in Spanish that this was "The Suicide of Dorothy Hale, painted at the request of Clare Boothe Luce, for the mother of Dorothy." I would not have requested such a gory picture of my worst enemy, much less of my unfortunate friend.

<div style="text-align: right">—HERRERA.</div>

Frida's biographer, Hayden Herrera, describes the picture.

❏ Frida's memorial to Dorothy Hale turned out to be more like a *retablo* than a *recuerdo,* inasmuch as it shows the disaster taking place (as well as the protagonist's death) and there was, as Mrs. Luce points out, an angel in the sky. A gray strip along the lower edge of the portrait has a legend written in blood-red script: "In the city of New York on the 21st of the month of October, 1938, at six in the morning, Mrs. DOROTHY HALE committed suicide by throwing herself out of a very high window of the Hampshire House building. In her memory, this *retablo,* having executed it FRIDA KAHLO." At the right side of the inscription, under the words "committed suicide" and above the word "KAHLO," is a patch of red from which blood dribbles downward. And blood, painted illusionistically and in the viewer's scale, besmirches the painting's frame. It seems that . . . Frida felt compelled to extend the painting's space out into the real space of the spectator, bringing the horror of the subject home. She has enhanced his feeling of immediacy

by painting one of Dorothy Hale's shoeless, stockinged feet so that it appears to protrude into our space. The trompe l'oeil foot casts a shadow on the word "HALE" in the painting's inscription.

—HERRERA.

By 1953, suffering from a bone disease, Frida had to endure what was to her the humiliation of having her leg amputated. After initially refusing to wear an artificial leg, she soon regained her old vitality.

❏ But after three months, she did learn to walk a short distance, and slowly her spirits rose, especially after she started painting again. To hide the leg, she had boots made of luxurious red leather with Chinese gold embroidered trim adorned with little bells. With these boots, Frida said, she would "dance her joy." And she twirled in front of friends to show off her new freedom of movement. The writer Carleta Tibón recalls that "Frida was very proud of her little red boots. Once I took Emilio Pucci's sister to see Frida, who was all dressed up as a Tehuana and probably drugged. Frida said, 'These marvelous legs! And how well they work for me!' and she danced the *jarabe tapatío* with her wooden leg.

—HERRERA.

Though well known as a painter in Mexico, she had never had a one-woman show. Lola Alvarez Bravo realized that Frida was near death and planned a gala exhibition of her work at the Galeria Arte Contemporaneo. When her doctors forbade her to attend, Frida sent her huge four-poster bed so that she could lie down, and the gallery staff arranged the bed so that it would appear to be a part of the show.

❏ Minutes after the guests poured into the gallery, sirens were heard outside. People rushed to the door and were astonished to see an ambulance accompanied by a motorcycle escort and Frida Kahlo being carried from it into her exhibition on a hospital stretcher. "The photographers and reporters were so surprised," says Lola Alvarez Bravo, "that they were almost in shock. They abandoned their cameras on the floor. They were incapable of taking any pictures of the event."

Someone did, fortunately, have the presence of mind to take a photograph of this extraordinary moment in Frida's life. It shows her dressed in native costume and jewelry, lying on the stretcher. As she is carried into the gallery, she is being greeted by friends. Old, lame, white-bearded Doctor Atl, the legendary painter, revolutionary, and volcanologist, looks down at her with an expression of intense feeling. Frida's wide, staring

eyes dominate her ravaged face; undoubtedly she had had to be heavily drugged.

She was placed in her bed in the middle of the gallery. A grinning skeleton Judas affixed to the underside of her bed's mirror-lined canopy lay face down as if he were watching her. Three smaller Judas figures dangled from the canopy, and the four-poster's headboard was covered with pictures of Frida's political heroes, photographs of family, friends, and Diego. One of her paintings hung on the footboard. The bed was to remain in the exhibition even after the opening, its embroidered pillows scented with Schiaparelli's "Shocking" perfume.

Like one of those lavishly gowned saints that recline on satin sheets and are cherished in Mexican churches, Frida held court. "We asked people to keep walking," said Lola Alvarez Bravo, "to greet her and then to concentrate on the exhibition itself, because we were afraid the crowd might suffocate her. There was really a mob—not only the art world, the critics, and her friends, but quite a lot of unexpected people came that night. There was a moment when we had to take Frida's bed out to the narrow terrace in the open air, because she could hardly breathe anymore."

Carlos Pellicer acted as traffic policeman, dispersing the crowd when it gathered too closely around Frida, insisting that guests form a line in order to congratulate the artist one by one. When the "Fridos" came up to her bed, Frida said, "Stay with me a little while, *chamacos*," but they could not linger, because other well-wishers pressed them on.

Liquor flowed. The hum of talk was pierced by brays of laughter as people enjoying themselves cracked jokes and greeted friends. It was one of those parties where excitement reaches a feverish intensity. Everyone recognized it as a major event. Carlos Pellicer had tears in his eyes when he read aloud a poem he had written about Frida, who drank and sang *corridos* with her guests. She asked the writer Andrés Henestrosa to sing "La Llorona" (The Weeping Woman), and Concha Michel sang other favorites. After most of her friends had embraced her, the guests stood in a circle around the four-poster and sang:

> *Esta noche m'emborrachó*
> *Niña de mi corazón*
> *Mañana será otro día*
> *y verán que tengo razón.*

> (Tonight I will get drunk
> Child of my heart
> Tomorrow is another day
> And you will see that I am right.)

When Dr. Velasco y Polo told Diego that he thought Frida was getting tired and should be taken home, Diego was too caught up in the

festivity to pay any attention. He brushed off the doctor with a mild curse: "*Anda, hijo, te voy a dar!*" (Beat it, kid, or I'll let you have it!)

Like the sugar skulls she loved, or the grinning Judas, Frida's opening was as macabre as it was gay. "All the cripples of Mexico came to give Frida a kiss," Andrés Henestrosa remembers, and he described the various Mexican painters who attended. "María Izquierdo arrived supported by friends and family because she was an invalid. She leaned over to kiss Frida's forehead. Goitia, sick and ghostly, arrived from his hut in Xochimilco with his peasant's clothes and his long beard. Also Rodríguez Lozano, who was crazy. Doctor Atl came. He was eighty years old. He had a white beard and crutches, because one of his legs had recently been amputated. But he was not sad. He leaned over Frida's bed and laughed boisterously at some witticism that made fun of death. He and Frida joked about his foot, and he told people not to look at him with pity, for his foot would grow again and be better than before. Death, he said, only exists if you fail to give it a little life. It was a procession of monsters, like Goya, or more like the pre-Columbia world with its blood, mutilation, and sacrifice."

"Frida was very fixed up, but tired and sick," Monroy recalls. "We were deeply moved to see all her work brought together and to see that she was loved by so many people." But her former pupils felt, as did many of Frida's friends, that the opening was exhibitionistic. "It was," Raquel Tibol observed, "a little spectacular, a little bit like a Surrealist act, with Frida like the Sphinx of the Night, presenting herself in the gallery in her bed. It was all theater."

—HERRERA.

As though she were destined for drama, Frida's end was worthy of her tumultuous life.

❏ "Rivera stood with his hands in fists," Monroy recalls. "When the door to the oven opened to receive the cart with Frida in it, there was an infernal heat that forced us all to press up against the back wall of the room because we could not stand the heat. But Diego did not move."

It was at this point that something almost as grotesque as one of Goya's *Los Caprichos* took place. Adelina Zendejas remembers: "Everyone was hanging on to Frida's hands when the cart began to pull her body toward the oven's entrance. They threw themselves on top of her, and yanked at her fingers in order to take off her rings, because they wanted to have something that belonged to her."

People were crying. Cristina became hysterical and began to scream when she saw her sister's body slide toward the oven. She had to be carried outside. With good reason: at the moment when Frida entered the furnace, the intense heat made her sit up, and her blazing hair

stood out from her face in an aureole. Siqueiros said that when the flames ignited her hair, her face appeared as if smiling in the center of a large sunflower.

The fires in the old-fashioned crematorium took four hours to do their job. During the wait, the crowd kept on singing. Diego wept and dug his nails into the palms of his hands again and again, making them bleed. Finally, the oven door opened, and the red-hot cart containing Frida's ashes slid out. A blast of suffocating heat sent people once again reeling back against the walls of the room, covering their faces for protection. Only Rivera and Cardenas calmly stood their ground.

Frida's ashes retained the shape of her skeleton for a few minutes before being dispersed by currents of air. When Rivera saw this, he slowly lowered his clenched fist and reached into the right-hand pocket of his jacket to take out a small sketchbook. With his face completely absorbed in what he was doing, he drew Frida's silvery skeleton.

—HERRERA.

Balthus
(1908–)

His name was Michel Balthasar Klossowski, which he abandoned for the nickname he wore as a child. He claimed to be related to Byron. "When I was young," he said, "I always felt like a little prince."

❏ Unfortunately, he had no title, no fortune, and no fame. By dint of indefatigable diligence, he would eventually contrive to gain all three.

The title came easily. Though without legitimate claim, the artist superbly announced himself to be none other than Count Balthasar Klossowski de Rola.

—JAMES LORD, *Giacometti: A Biography.*

Alberto Giacometti was his friend and his opposite.

❏ Alberto once said, "I want to live in such a way that if I became destitute tomorrow it would change nothing for me." Balthus said, "I have a greater need for a château than a workman has for a loaf of bread."

—LORD.

Francis Bacon
(1909–)

In the early 1940s Bacon moved with his ex-nanny into the studio where Millais had painted. When he turned it into a gambling den—gambling has always been a passion—his former nanny acted as hat-check girl.

Graham Sutherland brought Kenneth Clark to Bacon's studio in 1944 or 1945.

❏ Clark came in with his tightly rolled umbrella, very much the Director of the National Gallery, gave Bacon's work a swift appraisal, and said, "Interesting, yes. What extraordinary times we live in," and walked out again. Bacon turned to Graham—who had been telling him that one could not work in a vacuum—and said, "You see, you're surrounded by cretins."

—ROGER BERTHOUD, *Graham Sutherland: A Biography.*

Patrick White's encounter with Bacon sounds happier.

❏ I got to know Francis when he designed some furniture for my Eccleston Street flat. I like to remember his beautiful pansy-shaped face, sometimes with too much lipstick on it. He opened my eyes to a thing or two. One afternoon at Battersea, crossing the river together by a temporary footbridge while the permanent structure was under repair, he became entranced by the abstract graffiti scribbled in pencil on its timbered sides. Alone, I don't expect I would have noticed the effortless convolutions of line he pointed out for me to admire. To discover something as subtle as it was simple made me feel quite elated. In those days Francis was living at the end of Ebury Street, across the Pimlico Road, within a stone's throw of the Mozart-Sackville brothel. He had an old nanny who used to go out shop-lifting whenever they were hard up, and as lover there was an alderman.

—PATRICK WHITE, *Flaws in the Glass.*

Giacometti partied with Bacon when he came to London.

❏ Alberto was fond of Bacon, and of his boyfriend George Dyer, seeing them often when in London, where he went on a number of

occasions in the last years of his life to prepare for the great exhibition
of his work at the Tate Gallery in the summer of 1965. Riding about
with them one day in a taxi, Alberto patted George on the knee and
exclaimed, "When I'm in London, I feel homosexual." Francis believed
that Alberto might have found contentment in homosexual relations.
Who knows? On the evidence of his life and work, Francis never seemed
to. He once said to Alberto, "Do you think it's possible for a homosex-
ual to be a great artist?" But he had smashing answers to his doubts.

One evening in 1962, when Isabel [Ramsthorne, the friend who
brought them together] had arranged a dinner at a London restaurant,
Francis arrived late, nervous, and drunk. He and Alberto launched into
a discussion of painting. It started well but then, as Bacon became pro-
gressively drunker, developed into one of those maundering mono-
logues about life, death, and the gravity of it all to which Francis was
prone when plastered. Alberto, who never drank to excess, listened
patiently to all this and eventually responded with a shrug of his shoul-
ders, murmuring, "Who knows?" Taken aback, Francis without a word
began to raise the edge of the table higher and higher until all the
plates, glasses, and silverware crashed to the floor.

 —JAMES LORD, *Giacometti: A Biography.*

He starts work in the morning as soon as it is light. During the
English summer he may begin at 4:30; in winter he works less
and sleeps more. Sleep is irrelevant. "It's all in how much you
want to," he says, and cites his friend Lucien Freud, who sleeps
only two or three hours a night. In the afternoon Bacon, who
has finished work by two or three, shaves, washes up, walks around
seeing friends, drinks, and gambles.

He daydreams in color. Pictures follow each other sometimes
like a series of slides—click, click, click. These images happen
especially during hangovers, which are frequent for Francis Ba-
con. The dream-pictures don't turn directly into paintings, but
paintings seem finally to derive from his dreamy slide-shows. "I
daydream for *hours*. Pictures drop in like slides. The way I see
them is not necessarily related to the way I paint them." The
nervous system, as he understands it, reveals itself in colors and
shapes—whether in quick dream Kodachromes or in the compli-
cated process of making a canvas.

"I want to make portraits and images. I don't know how. Out
of despair, I just use paint *any* way. Suddenly the things you
make coagulate and take on just the shape you intend. Totally
accurate marks, which are outside representational marks. You
want accuracy but not representation. If you *know* how to make

the figuration, it doesn't work. Anything you can make, you make by accident. In painting you have to know *what* you do, not how, when you do it.

"Paint when it is outside representation records the nervous system, makes the image irrational. Take abstract expressionism. I like what they do—but not really. It's based on esthetics. I want reality not esthetics. In my own painting I want to make a thing of sense, of reality, yet unlock the vowels of feeling on various levels."

Bacon loves to drink. One of his Crucifixion paintings was done while he was drunk for two weeks; he feels that the drinking liberated him. "At least up to a point it gets you closer to people. You loosen up. In Tangier, I knew all those people—Bill Burroughs was there and Paul Bowles—and they'd smoke grass and just stop talking to each other. They'd be all alone and not talking." Grass gives Bacon asthma.

Morris Graves
(1910–)

John Cage remembered a party in Seattle that would not end.

❏ Thus it was that about 3:00 a.m. an Irish tenor was singing loudly in our living room. Morris Graves, who had a suite down the hall, entered ours without knocking, wearing an old-fashioned nightshirt and carrying an elaborately made wooden birdcage, the bottom of which had been removed. Making straight for the tenor, Graves placed the birdcage over his head, said nothing, and left the room. The effect was that of snuffing out a candle. Shortly, Xenia and I were alone.
—JOHN CAGE, *Silence.*

Cage is a great anecdotalist.

❏ Morris Graves used to have an old Ford in Seattle. He had removed all the seats and put in a table and chairs so that the car was like a small furnished room with books, a vase with flowers and so forth. One day he drove up to a luncheonette, parked, opened the door on the street side, unrolled a red carpet across the sidewalk. Then he walked

on the carpet, went in, and ordered a hamburger. Meanwhile a crowd gathered, expecting something strange to happen. However, all Graves did was eat the hamburger, pay his bill, get back in the car, roll up the carpet, and drive off.

—JOHN CAGE, *A Year from Monday.*

Franz Kline
(1910–1962)

John Cage tells a story about Franz Kline.

❏ Franz Kline was about to have the first showing of his black and white paintings at the Egan Gallery. Realizing that his mother had never seen his paintings and that she would surely be interested in doing so, he arranged for her to come to New York for the opening. After she had been in the gallery for some time, she said, "Franz, I might have known you'd find the easy way."

—JOHN CAGE, *Silence.*

Roberto Matta
(1911–)

Julien Levy found him in Southampton.

❏ He had a black patch over one eye; the other eye was inflamed, too, and seemed infected. He was very excited about the hidden obscenity he was incorporating in his mural. He showed me a few sketches; I never saw the finished work. He was separating from Paquarito because she was subjecting him to the indignity of becoming a father. "I take it as a form of half castration," he said. "I consider fatherhood an indignity to my testicles, and that is why I am losing one of my eyes, because I have displaced from the lower balls to the eyeballs."
 "Why is your second eye also infected?" I asked.
 "Sympathetic," he answered.

—JULIEN LEVY, *Memoir of an Art Gallery.*

William Baziotes
(1912–1967)

He seriously considered becoming a boxer, and all his life was fascinated by the underworld. His manner reminded friends of Humphrey Bogart.

In 1949 he remembered an incident which "might be one example of something beautiful in the commonplace" which revealed not only beauty but "a hidden terror or morbidity."

❏ My friend and I went up to the hills at about two in the morning on a hot August night to see the shooting stars. He was eighteen and I was seventeen. Neither of us was imaginative or inclined to the search for beauty. We were simply in competition as to who could see the most shooting stars. The loser would stand treat at the end of the night for hamburgers at a local diner. And we went into this game with great seriousness.

However, as we climbed higher into the hills, we seemed to lose interest in the game, for the night was so beautiful that our chests began to burst with it. We began to philosophize and to make comments on the full moon, the shadows of the trees, and the beautiful light.

The night took complete possession of us, and we kept walking, higher and higher into the hills. Coming through some trees, we came on a plain about a hundred yards long, and looking somewhat like Stonehenge. For no apparent reason we both stopped still and observed this emptiness. Then I turned and looked and saw that my friend was as scared as I was, and that the exultation had ceased.

For a minute we stood there petrified, and then suddenly he let out a blood-curdling scream that beat my own by a fraction of a second. We turned and beat a terrific retreat down the hill, and the fear did not leave us until we were finally at the edge of the city.
　　　—BARBARA CAVALIERE, in *William Baziotes: A Retrospective Exhibition.*

The son of Greek immigrants who ran a restaurant, he grew up an American painter at the time of the European influx.

❏ It was exciting and you were compelled to paint over your head. You had to stay on a high level or drown. If your painting was criti-

cized adversely, you either imitated someone to give it importance, or you simply suffered and painted harder to make your feelings on canvas convincing.

At that time, Mondrian, Duchamp and Max Ernst were here. Later Miró came. It was wonderful to see how they conducted themselves as artists outside their studios, what their manners and attitudes were towards specific situations, how they lived, how they believed in and practiced their uniqueness, how they never spoke of ideas but only of the things they loved.

I remember Mondrian at a party, dancing the Lindy, on and on for hours and hours. Duchamp, and his kindness and interest towards young American painters. Max Ernst, describing in loving detail the snake dances of the Hopi Indians. Miró, unveiling the mural in his studio, watching for the reaction of the onlookers, walking rapidly and excitedly all over the place, upset and very nervous.

—CAVALIERE.

He watched the workings of his own unconsciousness.

❏ An ice-pick flying through the air and landing into a target is a picture that flashes across my mind when I am in a highly excited and optimistic state about my work. In these periods it happens several times a day at the most unexpected times and in the most commonplace situations: as when I am talking to someone about an unimportant thing, or when I am walking down the street, etc. It has happened to me so many times, I am consciously aware of it as a symbol of optimism.

—CAVALIERE.

He watched many things.

❏ One afternoon, a nice day, my wife and I went to the Bronx Zoo. I went to see my favorite animal—the Rhinoceros. I heard unearthly cries, the elephants were being fed. I had some peanuts, and as I gave them to the rhino, he sucked in my hand and held it. My wife got scared but I was terribly interested. He was playful and cute and toy-like, but at the same time, he chilled me. He seemed prehistoric and his eyes were cold and deadly.

—MONA HADLER, in *William Baziotes: A Retrospective Exhibition.*

As early as 1941, Baziotes investigated accident and automatism in paint. (Jackson Pollock's drip-paintings do not come until 1947.) The painter Gerome Kamrowski recollects.

❏ Baziotes . . . did bring Pollock over to the place I was working at Sullivan Street at that time [1941]. Baziotes was enthusiastically talking

about the new freedoms and techniques of painting and noticing the quart cans of lacquer asked if he could use some to show Pollock how the paint could be spun around. He asked for something to work on and a canvas that I had been pouring paint on and was not going well was handy. Bill then began to throw and drip the white paint on the canvas. He handed the palatte [*sic*] knife to Jackson and Jackson with his intense concentration, was flipping the paint with abandon. . . . Baziotes had obviously made his point, Jackson was puzzling the thing out and was more or less relaxed about it so we just stopped.

—HADLER.

Jackson Pollock
(1912–1956)

There was always the Cedar Bar.

❑ In the Cedar Street Tavern one night, Pollock and de Kooning got into an argument that became heated. De Kooning suddenly hit the much bigger Pollock in the face. Pollock looked surprised and a little dazed. "Aren't you going to do anything?" a bystander asked him. Pollock said, "What? Me hit an artist?"
—CALVIN TOMKINS, *Off the Wall: Robert Rauschenberg and the Art World.*

Writing a reminiscence of Larry Rivers, the poet Frank O'Hara dropped a detail.

❑ When Larry introduced me to de Kooning I nearly got sick, as I almost did when I met Auden; if Jackson Pollock tore the door off the men's room in the Cedar it was something he just did and was interesting, not an annoyance.
—FRANK O'HARA, *Standing Still and Walking in New York,* 1975.

Peggy Guggenheim commissioned Pollock "to paint a mural twenty-three feet wide and six feet high. Marcel Duchamp said he should put it on a canvas, otherwise it would have to be abandoned when I left the apartment."

❑ Pollock obtained a big canvas and tore down a wall in his apartment in order to make room to hang it up. He sat in front of it, com-

pletely uninspired for days, getting more and more depressed. He then sent his wife Lee Krasner away to the country, hoping to feel more free, and that when alone he might get a fresh idea. Lee came back and found him still sitting brooding, no progress made and nothing even attempted. Then suddenly one day, after weeks of hesitation, he began wildly splashing on paint and finished the whole thing in three hours.

The mural was more abstract than Pollock's previous work. It consisted of a continuous band of abstract figures in a rhythmic dance painted in blue and white and yellow, and over this black paint was splashed in drip fashion. Max Ernst had once invented, or set up, a very primitive machine to cover his canvases with drip paint. It had shocked me terribly at the time, but now I accepted this manner of painting unhesitatingly.

We had great trouble in installing this enormous mural, which was bigger than the wall it was destined for. Pollock tried to do it himself, but not succeeding, he became quite hysterical and went up to my flat and began drinking from all the bottles I had purposely hidden, knowing his great weakness.

—PEGGY GUGGENHEIM, *Out of This Century.*

In 1941 he met Lee Krasner. May Tabak remembered how

❏ . . . a guy in overalls would come in at Lee's and never say a word. I didn't know whether he was half-witted or deaf; he'd sit silently for maybe half an hour, then get up and leave. She never said hello or anything to him, so I didn't know who he was any more than why she didn't introduce him. Then I decided he was the local handyman and probably was making stretchers for her—maybe didn't speak English. It was Jackson.

—JEFFREY POTTER, *To a Violent Grave: An Oral Biography of Jackson Pollock.*

Jimmy Ernst told of a scene in 1943 when Peggy Guggenheim showed young artists and asked critics and other artists—including Piet Mondrian, who lived in New York then—to look at the work.

❏ Painters were asked to bring in three or four works for final selection by the jury members. Mondrian came in very early and looked at the paintings while Peggy and I rushed around arranging things. But then he came to the Pollocks—I can't remember what they were, but it was before the drip period—good paintings, interesting paintings. *Stenographic Figure* (c. 1942) was one.

Peggy stopped next to him and looked at the Pollock he was looking

at. "Awful," she said. "Dreadful, isn't it?" and walked away. After a while she came back and he was still there. She said, "It's so disorganized. There's no discipline and the color is muddy in places." Then she walked away again, but Mondrian went on looking. When she came back, she said, "You're still standing here? I think it's an awful work."

Mondrian, still looking, said, "I'm not so sure . . . I'm trying to understand what's happening here. I believe it's the most interesting work I've seen in America yet."

"You of all people, you? The way you paint, *you* like this work?"

"Well, merely because my work seems serene doesn't mean I can't admire other work."

Now, this is not against Peggy, but when Barr came in, she pulled him over to the Pollock and said, "Look what an exciting new thing we have here!"

—POTTER.

❑ He not only telephoned me [Peggy Guggenheim] at the gallery every few minutes to come home at once and help place the painting, but he got so drunk that he undressed and walked quite naked into a party that Jean Connolly, who was living with me, was giving in the sitting room. Then he peed in the fireplace.

—B. H. FRIEDMAN, *Jackson Pollock: Energy Made Visible*

There are other sagas of micturation. A friend remembers him spraying a snowbank: "I can piss on the whole world."

Lee Krasner Pollock talks about the way he worked.

❑ He always slept very late. Drinking or not, he never got up in the morning. He could sleep twelve, fourteen hours, around the clock. We'd always talk about his insane guilt about sleeping late. Morning was my best time for work, so I would be in my studio when I heard him stirring around. I would go back, and while he had his breakfast I had my lunch. His breakfast would not set him up and make him bolt from the table like most people. He would sit over that damn cup of coffee for two hours. By that time it was afternoon. He'd get off and work until it was dark. There were no lights in his studio. When the days were short he could only work for a few hours, but what he managed to do in those few hours was incredible. We had an agreement that neither of us would go into the other's studio without being asked. Occasionally, it was something like once a week, he would say, "I have something to show you." I would always be astonished by the amount of work that he had accomplished. In discussing the paintings, he would ask, "Does it work?" Or in looking at mine, he would comment, "It works" or "It doesn't work."

One thing I will say about Pollock; the one time I saw temperament in him was when he baked an apple pie. Or when he tried to take a photograph. He never showed any artistic temperament. He loved to bake. I did the cooking but he did the baking when he felt like it. He was very fastidious about his baking—marvelous bread and pies. He also made a great spaghetti sauce.

He loved machinery, so he got a lawn mower. We made an agreement about the garden when he said, "I'll dig it and set it out if you'll water and weed." He took great pride in the house. One of the reasons for our move to Springs was that Jackson wanted to do sculpture. You know, it was his original interest in high school and art school. He often said, "One of these days I'll get back to sculpture." There was a large junk pile of iron in the backyard he expected to use.

He would get into grooves of listening to his jazz records—not just for days—day and night, day and night for three days running until you thought you would climb the roof! The house would *shake*. Jazz? He thought it was the only other really creative thing happening in this country. He had a passion for music. He had trouble carrying a tune, and although he loved to dance he was an awkward dancer. He told me that when he was a boy he bought himself a violin expecting to play it immediately. When he couldn't get the sound he wanted out of it, he smashed it in a rage.

—FRIEDMAN.

When he lived in Springs, New York, he baked pies for the Springs Fair.

Hans Namuth made a film about him.

❏ The day before I was to come to his studio (summer 1950) he had promised that he would start a new painting for me and perhaps finish it while I was still there. When I arrived, however, he shrugged his shoulders and told me it was too late, the painting was done; we could not take any pictures.

I was disappointed; I also was aware of his reluctance to have anyone present while he was at work. Hesitantly, I suggested going into the studio.

An enormous painting, covered almost the entire surface of the floor. Dripping wet paint, white, black, maroon; the painting was finished.

There was complete silence. (He never communicated much, verbally). I looked aimlessly through the ground-glass of my Rollei. He examined the painting. Suddenly (he must have decided then that there was more work to be done) he took hold of a paint can and a brush

and began to re-do the entire painting, his movements, slow at first, gradually becoming faster and almost dancelike. . . .

He had forgotten that I—and Lee, his wife—were present.

—FRIEDMAN.

He had stopped drinking but when the film was finished

❏ Pollock went right for the bourbon and poured stiff drinks for Namuth and himself. Namuth knew immediately what was happening: that after being on the wagon for two years, Jackson was going off. What he didn't know was that Dr. Heller had recently died and that Jackson would never again find anyone who could help him with his alcoholism. "Don't be a fool," Hans said, but by dinnertime Jackson was drunk. Namuth describes the evening in a way which agrees substantially with a description by Lee Pollock. ". . . we were having ten or twelve people for dinner. Jackson and Hans Namuth were at one end of the table. I don't know what the argument was about, but I heard loud voices and suddenly Jackson overturned the whole table with twelve roast beef dinners. It was a mess. I said, 'Coffee will be served in the living room.' Everyone filed out and Jackson went off without any trouble. Jeffrey Potter and I cleaned up."

—FRIEDMAN.

Betty Parsons had been Pollock's dealer.

❏ He was always sad. He made you feel sad; even when he was happy, he made you feel like crying. There was a depression about him; there was something desperate. When he wasn't drinking, he was shy; he could hardly speak. And when he was drinking, he wanted to fight. He cursed a lot, used every four-letter word in the book. You felt he wanted to hit you; I would run away.

His whole rhythm was either sensitive or very wild. You never quite knew whether he was going to kiss your hand or throw something at you. The first time I went out to see him at Springs, Barney [Newman, whom the Pollocks then met for the first time] brought me; we were planning Jack's first show. After dinner we all sat on the floor, drawing with some Japanese pens. He broke three pens in a row. His first drawings were sensitive, then he went wild. He became hostile, you know. Next morning he was absolutely fine.

I had met him around New York since 1945. One day in '47 he telephoned me and said he wanted a show in my gallery. I gave him a show the next season. In all the time he was with me he was never drunk either during the show or during the hanging. At Sidney Janis's

[Pollock's next dealer] it was different; once they waited for him until four in the morning to hang a show. . . .

He thought he was the greatest painter ever, but at the same time he wondered. Painting was what he *had* to do. But he had a lot of the negative in him. He was apt to say, "It didn't work—it'll never work." When he got in those terrible negative states he would drink.

His most passionate interest after painting was baseball. He adored baseball and talked about it often. He also loved poetry and meeting poets. He often talked about Joyce. He loved architecture and talked a lot about that too. He adored animals; he had two dogs and a crow—he had tamed the old crow. He had that kind of overall feeling about nature—about the cosmic—the power of it all—how scary it is.

—FRIEDMAN.

Lee describes a process.

❏ Jackson used rolls of cotton duck, just as he had intermittently since the early forties. All of the major black-and-white paintings were on unprimed duck. He would order remnants, bolts of canvas anywhere from five to nine feet high, having maybe fifty or a hundred yards left on them—commercial duck, used for ships and upholstery—from John Boyle down on Duane Street. He'd roll a stretch of this out on the studio floor, maybe twenty feet, so the weight of the canvas would hold it down—it didn't have to be tacked. Then typically he'd size it with a coat or two of Rivit glue to preserve the canvas and give it a harder surface. Or sometimes, with the black-and-white paintings, he would size them after they were completed, to seal them. The Rivit came from Behlen and Brother on Christopher Street. Like Boyle, it's not an art-supplier. The paint Jackson used for the black-and-whites was commercial too—mostly black industrial enamel, Duco or Davoe & Reynolds. There was some brown in a couple of the paintings. But this "palette" was typically a can or two of the black—thinned to the consistency he wanted—standing on the floor beside the rolled-out canvas. Then, using sticks, and hardened or worn-out brushes (which were, in effect, like sticks) and basting syringes, he'd begin. His control was amazing. Using a stick was difficult enough, but the basting syringe was like a giant fountain pen. With it he had to control the flow of paint, as well as his gesture. He used to buy those syringes by the dozen at the hardware store. . . . With the larger black-and-whites he'd either finish one and cut it off the roll of canvas, or cut it off in advance and then work on it. But with the smaller ones he'd often do several on a large strip of canvas and then cut that strip from the roll to study it on the wall and make more working space. Sometimes he'd ask, "Should I cut it here? Should this be the bottom?" He'd have long sessions of cutting and editing, some of which I was in on, but the final decisions

were always his. Working around the canvas—in "the arena" as he called it—there was really no absolute top or bottom. And leaving space between paintings, there was no absolute "frame" the way there is working on a pre-stretched canvas. Those were difficult sessions. His signing the canvases was even worse. I'd think everything was settled—tops, bottoms—and then he'd have last-minute thoughts and doubts. He hated signing. There's something so final about a signature. . . .

—FRIEDMAN.

He told Lee, "Painting is no problem; the problem is what to do when you're not painting." In the last years of his life he could not work. He lit the stove in his studio every morning. "I light the stove so that the studio will be warm in case this is the day I can start to paint again." He stared at empty canvases. Depression and rage took him over. He threw his easel down the stairs as Hans Hofmann climbed them to pay a call, burst into tears, and cried, "I hate my easel. I hate art." Pollock wept often. He tried to watch *Waiting for Godot* but he could not stand it. At mention of the play he wept.

Robert Creeley remembered a night.

❏ . . . I'd been in the Cedar Bar talking with Franz Kline, and another friend of Kline's and Fielding Dawson probably was there. We were sitting over at a corner booth, and they were talking and drinking in a kind of relaxed manner. But I, again, you know, very characteristic of me, I was all keyed up with the conversation and I'd start to run to get the beer, or whatever we were drinking, and it wasn't coming fast enough. I'd go up to the bar, have a quick drink, and return to the table and pick up the drink that by then had come, and I was getting awfully lushed, and excited, and listening, and I was up at the bar getting another drink, when the door swings open and in comes this very, you know, very *solid* man, this very particular man, again with this intensity. He comes up to the bar, and almost immediately he made some gesture that bugged me. Something like putting his glass on the bar close to mine, that kind of business where he was pushing me just by *being there*. So I was trying to re-assert my place. The next thing we knew we were swinging at each other. And I remember this guy John, one of the owners, just put his hand on the bar and vaulted, literally, right over the bar, right between us, and he said, like "Okay, you guys," and he started pushing at both of us, whereupon, without even thinking, we both zeroed in on him, and he said, like, "Come on now, cut it out." Then he said, "Do you two guys know each other?" And so then he introduced us, and—God! It was Jackson Pollock! So I was showing

him pictures of my children and he was saying, "I'm their godfather."
Instantly affable, you know. We were instantly very friendly. And he
was very good to me. . . .

—FRIEDMAN.

Fielding Dawson tells about late days at the Cedar.

❏ I was sitting at the bar having a beer, and I heard John, the bar-
tender, murmur,
"Oh. No."
In the small square window of the red front door, I saw a part of
Jackson's face; one brightly anxious eye was peering in. John walked
down the duckboards towards the end of the bar near the door, and
stopped, put his left fist on his hip, and extended his right index finger
at the small window. He shook his head. The eye looked hurt. John
was tightlipped. I was laughing.
The eye disappeared.
John muttered out of the corner of his mouth and he is a man who
can mutter out of the corner of his mouth,
"He'll be back."
We watched the square window.
Jackson's eye popped in.
"NO!" John yelled. "YOU'RE 86 JACKSON!"
The eye was sad and puzzled. Me 86?
The eye got angry. Jackson's face slid across the window; then his
whole face was framed by it; mask of an angry smile.
"NO!" John shouted, shaking his head. "Beat it!"
Jackson's eyes became bright, and he smiled affectionately. John shook
his head.
"Whaddya gonna do? I can't say no to the son of a bitch."
He sighed. "All right!" he cried, and pointed to the window, wagging
his finger, "But you've got to be GOOD!"
The door opened and Jackson loped in and they faced each other
over the corner of the bar. Jackson had a happy friendly smile. John
jabbed a finger in his face.
"Remember—one trick and you're finished." John leaned forward.
"Do you get that? No cussin', no messin' with the girls—"
Jackson said, darkly,
"Scotch."
With the drink in his hand Jackson left John angrily wiping the bar;
and as I was the only one at the bar that Jackson vaguely recognized,
he made his way toward me, looking intently at me. You never knew.
When he got to the empty stool beside me he put his hand on it and a
little stooping gave me his flickering friendly Rumpelstiltskin smile,

"Okay if I sit here?"

I stammered sure Jackson sure, and in my apprehension rather compulsively arranged the pack of matches exactly in the center on top of a new pack of cigarettes. Jackson watched me, and glanced down at my neat arrangement, and then at me, then at the cigarettes; then at me. He gravely shook his head. Wrong. He crushed my smokes and matches in his left hand.

He gazed back where people sat at tables, eating supper. Many of them were watching him. It was the right beginning for another eight-cylinder Monday night. They had come from the Bronx, from Queens, from New Jersey and from the upper East Side to eat at the Cedar and wait until Jackson finished his fifty minutes with his analyst, and came down to the bar to play. Jackson walked by each table glaring down at them. They trembled. Pity the poor fellow that brought his date in for supper, for Jackson was happy to see her. He immediately sat beside the fellow, glared nastily at him and then gave his full crude nonsensical attention to the girl while the fellow said—something—timidly—"Say, now just a minute—" Jackson turned to him, and looking at the poor guy with a naughty smile, swept the cream pitcher, salt, pepper, parmesan cheese, silverware, bread, butter, napkins, placemats, and drinks on the floor, while waiters screamed, John shouted, Jackson leaned toward the guy with an expression as if to say, how do you like that?

We all got a little of it. But Franz was the real one who gave it back, and then some. One time Franz and Nancy were sitting at the bar, talking, and unaware Jackson was behind them, staring at Franz. Jackson grabbed Franz by the hair and threw him backwards off the barstool onto the floor. Franz got up, straightened himself, glanced at Jackson, and said,

"Okay Jackson, cut it out."

Jackson had backed away, slightly stooped, head thrust forward, eyes bright. He was so happy he glittered. After Franz had sat down Jackson did it again.

"Jackson!" Nancy cried.

But when Franz got up the third time, he wheeled, grabbed Jackson, slammed him up against the wall and let Jackson have it in the gut with a hard left-right combination. Jackson was much taller, and so surprised, and happy—he laughed in his pain and bent over, as Franz told me, whispered, "Not so hard."

—FRIEDMAN.

❏ The art historian Sidney Geist recalls arriving at the Cedar one night to find Pollock and de Kooning sitting outside on the curb, passing a bottle between them. "Jackson, you're the greatest painter in America," de Kooning was mumbling drunkenly, slapping him on the

back. "No, Bill," Pollock blabbered, "you're the greatest painter in America."

—DEBORAH SOLOMON, *Jackson Pollock: A Biography* .

On August 11, 1956, just after ten o'clock at night, Pollock lost control of his Oldsmobile convertible, which ran into trees, rolled over, and landed upside down. He was thrown from the car and his head smashed against a tree.

Friends remembered him miserable at the end.

❏ The day before Jackson died, he came to the Farm with some tools in the back of his car that Jeffrey had lent him. He was going to take them out, but Jeffrey said not to bother and went off in his truck. We remarked later on what a lonely thing Jackson then said. "Good. That'll give me an excuse to come again." Jackson was sober, I remember, and I went into the house, where I was cooking something. He stayed quite a while and played with our six-year-old son, Job, and I watched out the window as they threw a ball. He left finally, was so obviously miserable. He said to me that sometimes he felt as if his skin was off.

—POTTER.

Philip Guston
(1913–1980)

He lived in Los Angeles during the Depression, working in factories—and occasionally in Hollywood.

❏ Guston was able to penetrate the mysterious world of the movie lots, a world that appealed to his visual imagination, and one that paid better than factory work. He remembers earning a grand fifteen dollars a day plus overtime at 20th Century-Fox, where he also caught a fleeting glimpse of Charlie Chaplin leaning against a luxurious automobile. "I did extra work on and off for about two years," he recalls. "I stormed the Bastille, participated in the fall of Babylon, and, in *She* by Ryder Haggard, I played the role of the high priest." His most auspicious stunt, however, was during the filming of *Trilby*, in which John Barrymore starred as Svengali, where, wearing a beret and a goatee, Guston painted a nude for three whole weeks in an atelier scene.

—DORE ASHTON, *Yes but . . . A Critical Study of Philip Guston*.

Later in prosperity he became *happy*. "When I finish the most horribly depressing painting, I can barely contain myself. I lie down on the floor and rollick with laughter."

Ad Reinhardt
(1913—1967)

He called himself "The Conscience of the Art World" or "The Great Demurrer in This Time of Great Enthusiasms." Constantly, he criticized other painters for vanity and commercialism. "It is not right for artists to think that painting is like prostitution, that 'first you do it for love, then you do it for others, and finally you do it for money.' " "Does one not have to remove oneself from the business world in order to create 'fine' art or to exist as a 'fine artist'? Why does everybody think priests, artists, teachers should be better than businessmen? Because they aren't businessmen . . . Art is not the spiritual side of business. . . . The artist as businessman is uglier than the businessman as artist."

Barnett Newman sued him for a hundred thousand dollars when Reinhardt published "The Artist in Search of an Academy: Who Are the Artists?" in which he spoke of "the latest up-to-date popular image of the early fifties, the artist professor and traveling design salesman, the Art-Digest-Philosopher-Poet and Bauhaus exerciser, the avant-garde-huckster-handicrafts-man and educational shop-keeper . . ." and named Newman among others. Nothing came of the lawsuit but Newman and Reinhardt never spoke again.

When Reinhardt agreed to a retrospective at the Jewish Museum, Thomas B. Hess in *Art News*, noting a certain inconsistency, awarded Reinhardt the "Run-With-the-Hare, Hunt-With-the-Hounds speed record (plus 30 pieces of silver) . . . for agreeing after all those protestations to have a show in the Jewish Museum." Reinhardt answered him, "Yes, TBH, this year I decide to sell out. My paintings are now available at the very highest prices. All museums are invited to show large exhibitions

of my work . . . Thank you, one and all, for all your kindnesses.
P.S.: You forgot to give your TBH a prize for the best line of
art criticism of the year in his article on de Kooning's paintings
in which he writes that the women in them seem 'calmer, pret-
tier, blonder, and more friendly this year.' "

Richard Lippold
(1915–)

John Cage tells a shaggy anecdote.

❏ Richard Lippold called up and said, "Would you come to dinner
and bring the *I-Ching*?" I said I would. It turned out he'd written a
letter to the Metropolitan proposing that he be commissioned for a
certain figure to do *The Sun*. This letter withheld nothing about the
excellence of his art, and so he hesitated to send it, not wishing to seem
presumptuous. Using the coin oracle, we consulted the *I-Ching*. It men-
tioned a letter. Advice to send it was given. Success was promised, but
the need for patience was mentioned. A few weeks later, Richard Lip-
pold called to say that his proposal had been answered but without
commitment, and that that should make clear to me as it did to him
what to think of the *I-Ching*. A year passed. The Metropolitan Museum
finally commissioned *The Sun*. Richard Lippold still does not see eye to
eye with me on the subject of chance operations.
 —JOHN CAGE, *Silence.*

Robert Motherwell
(1915–)

He studied esthetics at Stanford and Harvard and did not start
painting seriously until he was twenty-six. He and Helen Fran-
kenthaler were married from 1958 to 1971.
 Emile de Antonio interviewed him.

❏ It's what's left over after revising and revising and revising. There was always meant to be a figure in it. There has been such interest in my Elegies to the Spanish Republic and collages and some of the abstract pictures that it tends to be forgotten that I was involved in a very abstract, but nevertheless really figurative painting. I was very puzzled by this figure, and it was then to be in an exhibition, and I was given the form to fill out with a place for the title, and I thought, "What shall I call it?" And because I was puzzled by the picture, I couldn't think of a title. (I usually title pictures after the fact.) In my difficulty in finding a title for the picture, in my despair of finding the title . . . because I think titles are important; I like titles that lead into the picture and in that sense try to make them either very accurate or, if I can't, make them not misleading. In this particular picture, which puzzled me, I wanted an accurate title, could not find one, and then I remembered the Surrealist device, which I'd never used before, of taking a book— and it had to be a favorite book, so I took Joyce—and opening it at random. Without looking at it, I put my finger on a page, and where my finger rested, it said, "The homely Protestant," and I thought, "Of course. The picture is *The Homely Protestant*," which is to say, it is myself.

—EMILE DE ANTONIO AND MITCH TUCHMAN, *Painters Painting.*

Sydney Nolan
(1917–)

He told an interviewer about his beginnings.

❏ While working at night school, I had chummed up with a very good painter called Howard Matthews, a man with a rather Bohemian outlook on life; you know, Paris and all that stuff. He taught me a great deal and when I was twenty-one I decided to quit my factory job. We got what money we could—I had about £20, I think; the outcome of seven years' hard labor! He had about the same amount, maybe a bit more. And we spent half of it on pickled raw tripe—all because Howard's sister was a food faddist who insisted that tripe would sustain life. She pickled scores and scores of bottles of it for us. The rest of the money we spent on barrels of Madeira wine. We borrowed an old house in the bush, fifty miles outside Melbourne, got a friend to drive us there in a car, with our tripe in the back. He dumped us there on a frosty winter's morning. It was a weekend shack, with a big veranda at

the back, glassed in, and Howard painted at one end while I painted at the other. We painted in that shack for about four months—until we had eaten all the tripe and drunk all the Madeira wine. Each morning we got up and had a glass of Madeira wine—in order to face the tripe. And we waited—and painted—and painted. Those four months taught me to respect painting—perhaps the most important thing one could be taught at that age.

—NOEL BARBER, *Conversations with Painters.*

Visiting Australia, Kenneth Clark looked into a show of contemporary landscape painting, which he found unimpressive.

❑ As I was leaving the exhibition I noticed, hung high up above the entrance stairs, a work of remarkable originality and painter-like qualities. I asked who it was by. "Oh, nobody." "But you must have his name in your catalogue." "Let's see; here it is, Nolan, Sidney Nolan. Never heard of him." I said I would like to see some more of his work. "Well, he's not on the telephone." "But you must have his address." More angry scuffling finally produced an address in a suburb of Sydney. I took a taxi there that afternoon, and found the painter dressed in khaki shorts, at work on a series of large paintings of imaginary birds. He seemed to me an entirely original artist, and incidentally a fascinating human being. I bought the landscape in the exhibition, not that it was necessarily the best, but in order to annoy the exhibition secretary, and was confident that I stumbled on a genius.

—KENNETH CLARK, *The Other Half.*

Andrew Wyeth
(1917–)

His illustrator father, N. C. Wyeth, gave him advice.

❑ I remember his saying, "If you paint a man leaning over, your *own* back must ache." He taught me to feel the cheekbones and eye sockets. (I combed Christina's hair many times, and felt the drops of sweat on her neck and brow.) You can't look out of the corners of your eyes and paint a good portrait.

—SELDEN RODMAN, *Conversations with Artists.*

The Olson farm in Maine—Christina was an Olson—became a locus for Wyeth's work.

❏ I finally used the upstairs room almost as a permanent studio. *Christina Olson* came about like this: one day I came in and saw her on the back door step in the late afternoon. She had finished all her work in the kitchen, and there she was sitting quietly, with a far-off look to the sea. At the time, I thought she looked like a wounded seagull with her bony arms, slightly long hair back over her shoulder, and strange shadows of her cast on the side of the weathered door, which had this white porcelain knob on it. And that was the beginning of the painting. She didn't mind being disturbed at all, actually she enjoyed it.

We had a great communion. We could go for hours without saying anything; and then sometimes we would do a great deal of talking. That's New England. Sometimes I would even wash her face. She would cook over a wood stove and sometimes she would get dirt all over her face and I'd say I'd better wash your face and she'd say all right. Sometimes I would comb her hair. Touching that head was a terrific experience for me and in a sense, I really was in awe of it. Christina had remarkable eyes, penetrating eyes. I became really fond of her as a friend. She had read a great deal. Her letters to me in the wintertime were fabulous, telling me of moose and foxes that she would see crossing the open fields on moonlight nights. . . .

We had a gathering in the afternoon at Betsy's house. We had a few drinks and then I left the party, went out into the barn, picked up a piece of paper, and made that first notation in pencil. The next day I did the second drawing which is squared off for transfer to a panel. Then I drew it a little in my mind and imagination. I got a panel 48 × 32, squared it off, because I like the position I had gotten in that first drawing. I squared it off and lined it up. There it was before me and I knew it was right. The next day I put the panel in the back of the Jeep, drove it to Olsons, took it upstairs onto the easel, sat there, and looked at it. It wasn't until the following week that I could really begin anything. I wanted to think about it, and at the same time I needed to get something tangible down, so I'd know that was what I wanted. You have to get something down, so you can relax a little and think. But you simply have got to get something tangible. You know, it isn't tiring to actually work on a painting, but it is terribly tiring when you have nothing on the panel but just one stroke and you are filling in between the lines of what's not there. Those are the times that are the most exhausting to me. That's when I lose weight like mad, because I am seeing something that doesn't yet exist. Once I get going and get rolling, I can work for long hours with no fatigue.

I worked on that picture from eight o'clock until five-thirty every day

for weeks. I had that room upstairs, and I'd move the tempera panel around to different rooms to look at it while I was working. I was worried that she knew what I was doing. I knew I was getting pretty close to putting Christina in the position I wanted, the arms and everything, you know, where it showed the tragedy as well as the joyfulness of her life. There were two sides to her. But then one day, suddenly, I noticed that my chair had been moved and I could see by the dust on the floor that something had dragged itself along across the steps. The floor was polished slightly. She knew what I was doing, all right, and never said anything.

—*Two Worlds of Andrew Wyeth*, ed. Thomas Hoving

Christina died in 1969.

❑ I went up there the day of her funeral. It was snowing. I happened to look into this kitchen. It had snowed hard during the night, and the snow had sifted in the cracks and chinks of the door so that there was a thin line of snow right across the floor right up over her chair and down. It was icy white, almost like a finger pointing. Damnedest thing. God, the way the snow had sifted, very much how grain will sift through the finest sliver or opening. It was like lightning coming across the chair. I was wandering around and I looked into this dark room from the window and at the same time I could hear them using a jackhammer to dig the grave down there because the ground was so frozen, and I was shocked by that line of snow.

—HOVING.

In 1986 came word of the Helga paintings.

❑ The now-it-can-be-told news that for some 15 years Wyeth had been painting, obsessively, in secret, a woman wrapped in mystery, a model known as Helga, has been greeted by the nation's press as a revelation: "Andrew Wyeth's Stunning Secret," announced the cover of *Time*. *Newsweek* gave its cover to his "Secret Obsession." Advance September copies of both Schaire's *Art & Antiques* and Thomas Hoving's *Connoisseur* contain color reproductions of Wyeth's Helga portraits. Every paper in the country gave the story ink.

The tale as recounted had irresistible ingredients—a blue-eyed naked beauty, no identity disclosed, a suggestion of illicit sex (she took her clothes off, didn't she?), a long-concealed treasure suddenly acquired for a seven-figure sum and juiciest of all, a wife misled for 15 years until her husband, fearing death, reveals the stunning truth.

When at last Betsy Wyeth saw his Helga portraits—the vast majority are studies, and will go on view next summer at the National Gallery of Art—she described their content touchingly with the one word "love."

There is one flaw in the story of Wyeth's Helga "secret."

Much of it is not true.

That Wyeth had been painting a sexy blond model with high Germanic cheekbones and a fine, curvaceous body was no secret to Betsy Wyeth. Nor was it a secret to the world at large:

In May 1979, a full-page color photograph of *Loden Coat* (1976), a watercolor of Helga in the snow, now in the Arthur Magill collection, was published by John Canaday in *The ARTgallery* magazine.

In 1980, a poster reproducing *Knapsack* (1980), a watercolor portrait of Helga on a rock, accompanied a Wyeth show at the Claude Bernard gallery in Paris.

Late in 1980, while visiting that gallery in search of a Daumier, Dr. Armand Hammer saw *Daydream* (1980), a full-frontal nude of Helga done in tempera on wood panel. The price was $350,000. "That's her all right," says Hammer. He bought the picture on the spot. He first exhibited it in America, in March 1981, at the Corcoran Gallery of Art.

Daydream has since been placed on view in China (in Peking), in Russia (in Moscow, Leningrad and Novosibirsk), in West Palm Beach, Palm Springs, Cincinnati and four times in Los Angeles. In January 1985, during Ronald Reagan's second inaugural, the painting was displayed in an "inaugural celebration" at the National Gallery of Art.

"According to the artist, *Daydream* was painted in the bedroom of the house where he grew up in Port Clyde, Maine," the catalog reported. Maybe Betsy Wyeth did not recognize her husband's room, or the nude blond in his bed.

Lovers (1981), another frontal Helga nude, has been owned by Betsy Wyeth since 1982. It was a present from her husband. *Lovers* is one of numerous Helga portraits (*Cape Coat Refuge* is another) displayed in recent years at the Brandywine River Museum near the Wyeth home in Chadds Ford, Pennsylvania.

The September 1985 issue of *Art & Antiques*—the same issue in which Wyeth confided that "not even my wife" had been shown his Helga portraits—illustrated yet another Helga portrait, *Pagebody* (1980).

Betsy Wyeth has told *Time* she did not know that Wyeth "had been doing a (Helga) series" until he told her so last summer.

—PAUL RICHARD, *The Washington Post,* August 20, 1986.

Elaine de Kooning
(1920—1989)

Elaine's portraits are not considered improvements on nature. Her friend Wolf Kahn tells how the "late Alice Neel, noted for

horribly unflattering versions of her sitters, once asked Elaine to pose for a portrait. Elaine answered that she would accept the challenge, with easels at twenty paces."

Roy Lichtenstein
(1923–)

The origins of a style have never been clearer. One of his children asserted that their father could not draw as cartoonists did. It was a challenge he could not resist: his mature work started with a Mickey Mouse.

Philip Pearlstein
(1924–)

Paul Cummings asked him why he chose to paint rocks.

❏ Everything about the abstract expressionist era had to do with nervousness, tenseness, frenetic . . . One day I picked up a rock. It looked very splintered. It looked neurotic to me. So I combed the beach looking for neurotic rocks. The summer after that we were up in Maine, on Deer Isle. There were big boulders—neurotic rocks with fractures.
—PAUL CUMMINGS, *Artists in Their Own Words.*

Robert Rauschenberg
(1925–)

While he was in the Navy in California, at the end of the Second World War, he visited the Huntington Library for its gardens. He did not know that there was an art gallery attached.

❏ "It sounds really corny," he says, "but my moment of realization that there was such a thing as being an artist happened right there." Three paintings did it: *Pinkie* (Thomas Lawrence's portrait of Miss Sarah Moulton-Barett); Gainsborough's *The Blue Boy;* and Joshua Reynolds's portrait of *Sarah Siddons as the Tragic Muse.* . . . As he described the experience years later to *Time*'s Robert Hughes, what struck him was "that someone had thought those things out and made them. Behind each of them was a man whose profession it was to make them. That just never occurred to me before." Even today, he says, he can't remember seeing a brown painting as interesting as Reynolds's *Sarah Siddons.*

— CALVIN TOMKINS, *Off the Wall: Robert Rauschenberg and the Art World.*

Two years later he was at Black Mountain College.

❏ The 1948 summer had been a particularly brilliant one. John Cage and Merce Cunningham, who had visited the campus for the first time that spring, were invited back for the summer session, Cunningham to offer a workshop in modern dance and Cage to teach a course in "The Structure of Music and Choreography," an assignment that he somehow managed to convert into a summer-long series of concerts and lectures devoted to the music of Erik Satie. Willem de Kooning and his wife Elaine, also a painter, were there at Cage's suggestion, and so was the sculptor Richard Lippold. [The painter Joseph] Albers himself had invited Buckminster Fuller, who captivated everyone with his "comprehensivist" thinking and his experimental geodesic dome, made of venetian blind slats and bolts, which failed to stand up when assembled; Fuller had said in advance that it probably wouldn't (the materials weren't right), and blithely referred to the experiment as "the supine dome." The summer had ended in a blaze of vanguard glory with the production of Satie's pre-World War I play, *Le Piège de Méduse,* translated for the occasion by Black Mountain's literature and writing teacher, Mary Caroline Richards, directed by a talented student named Arthur Penn, and starring Elaine de Kooning as Medusa, Cunningham as a "mechanical monkey," and Bucky Fuller as the Baron Medusa. While all this was taking place, the college itself was going through another of its administrative crises, which resolved itself in August by Albers's agreeing to become the new rector.

Nothing, that year, appears to have displeased Albers so much as having to teach Rauschenberg. "I represented everything he hated most," Rauschenberg himself once said. "Coming that way in mid-semester, and his knowing I'd been in Paris, I think he assumed I was going to be some kind of show-off. I was willing to submerge any desires I had into his discipline, but he never believed that. I don't think he ever realized it was his discipline I came for. I was Albers's dunce, the out-

standing example of what he was *not* talking about. He'd pick up some-
thing of mine and say, 'This is the most stupid thing I have ever seen,
I dun't even vant to know who did it.' If I hadn't had such great respect
for him I could never have put up with the treatment."

—TOMKINS.

"He was a beautiful teacher," Rauschenberg noted, "and an im-
possible person."

In Paris he met the American painter Sue Weil whom he later
married.

❏ "We were scared of the *concièrge*," Rauschenberg has recalled, "and
whenever one of us spilled a drop of paint on the grimy old Oriental
rug we'd go around and carefully put a drop of the same color in sev-
eral other places, to equalize it. After a while the room began to seem
brighter and brighter."

—CALVIN TOMKINS, *The Bride and the Bachelors.*

From his early show at the Betty Parsons Gallery, only one work
survives in its original condition.

❏ Rauschenberg met John Cage for the first time in the spring of
1951, at the Betty Parsons Gallery. Cage made a point of looking at the
work of young artists, and he had come in especially to see the Raus-
chenbergs, which he liked so much that he asked to have one; the price
was unimportant, he said, because he couldn't pay anything. He went
away with a pink-and-tan collage that would have been the second sur-
vivor from the Parsons show if Rauschenberg had not come to Cage's
New York studio some time afterward and, finding no one at home,
whiled away his time by painting over the picture in the black enamel
he was using then.

They saw each other often in New York that fall, and even collabo-
rated on a twenty-two-foot-long Rauschenberg "print" created by au-
tomation; guided by Rauschenberg, Cage drove his Model A Ford
through an inked section of downtown pavement and then across a
series of twenty sheets of paper pasted together.

—*Off the Wall.*

On a brief trip to Europe, Rauschenberg showed in Florence.

❏ One of the more eminent Florentine art historians wrote a long
review of it, covering half a page in a local newspaper. The critic de-
scribed how, on his way to the exhibition, he had passed by the Uffizi
with its treasures, had seen once again the Duomo and the Campanile

and the great monuments of the city, had contemplated its noble and inspiring history as the cradle of the highest art, and then, at last, he had come to what he called the "psychological mess" at the Galleria d'Arte Contemporanea. His conclusion, after a good deal of scathing prose, was that the works of Robert Rauschenberg should be thrown into the Arno.

Rauschenberg had the review translated. His first thought about its conclusion, he claims, was "What a wonderful idea!" He was leaving Europe in a few days, and he had packing problems. Putting aside five or six of the objects to carry back with him on the plane, he bundled up the rest and, early on the Sunday morning before his Monday departure, he went walking along the Arno until he came to a fairly secluded spot where the water looked sufficiently deep—he didn't want somebody fishing the objects out later; it was important to him that they "really disappear." Nobody saw him throw them in, and not one of them has ever been seen since. Rauschenberg insists that he was not making a Dadaist gesture, but he did say that he thought it might make the eminent art critic feel uneasy if he knew about it, so before leaving the next day he wrote him a note saying, in effect, "I took your advice."

—Off the Wall.

John Cage was chance's apostle and Rauschenberg's friend.

❏ In hardware stores on Canal Street he found that he could buy, at a discount, cans of paint whose labels had come off, so that there was no way of knowing what color he was going to use until he got a can home and pried off the lid.

—The Bride and the Bachelors.

In the mid-fifties, he made the famous, or at least notorious, *Bed.*

❏ He simply woke up one May morning with the desire to paint but nothing to paint on and no money to buy canvas. His eye fell on the quilt at the foot of his bed. The quilt had come up from Black Mountain with him, and he had slept under it for several winters. The weather was getting warm, though, and next winter seemed a long way off. He made a stretcher for the quilt, just as though it were canvas, and started to paint. Something was wrong, though; the quilt pattern was too self-assertive. Rauschenberg added his pillow. "That solved everything—the quilt stopped insisting on itself, and the pillow gave me a nice white area to paint on." The finished work not only has caused a great many people intense discomfort (more than one viewer has said that it looks like a bed in which an ax murder has been committed), but has figured prominently in an international cultural *crise.* In 1958, at the first Fes-

tival of Two Worlds in Spoleto, Italy, *Bed* was part of an exhibition of work by twelve young American artists. The whole exhibition so outraged the Italian authorities at the Festival that they refused to hang it. Eventually, however, after much transatlantic wrangling and an anticensorship appeal to the International Association of Art Critics, the American contributions *were* hung—with the sole exception of *Bed,* which was sequestered in a back room.

Rauschenberg is perplexed by such reactions. "I think of *Bed* as one of the friendliest pictures I've ever painted. My fear has always been that someone would want to crawl into it."

—The Bride and the Bachelors.

Bed was not the only famous fabrication of this era.

❑ Strolling along Seventh Avenue one day, Rauschenberg paused to look in the window of a store that sold office furniture. Gazing morosely back at him was one of the strangest creatures he had ever seen— a large stuffed Angora goat with curving backswept horns and a thick, curly fleece that hung almost to the floor. He immediately went inside and asked the price. The store owner was somewhat reluctant to sell the trophy, which he had bought sight unseen at a railroad auction (it had been in a crate with some other unclaimed merchandise), but Rauschenberg talked him into letting it go for thirty-five dollars—fifteen down and twenty on account. When he got the goat home he saw that the long, ropelike fleece was thick with dirt and that the animal's muzzle had been badly bashed in. He set to work with rug shampoo and scrubbed away at the fleece until it was several dozen shades lighter. Then he turned his attention to the damaged muzzle. After hours of painstaking plastic surgery it still looked discolored and uneven on one side. Rauschenberg decided to conceal this defect with paint, which he applied in a thick impasto to the goat's cheeks. "So many people ask me why I put all that awful paint on his face," Rauschenberg said once. "It's what seems to bother people the most. But, you see, I know exactly why I did it!"

The next problem was how to use such an extraordinary object in a picture. "I'd never used anything as large as that, and for a long time I couldn't make it fit—couldn't make it look as though it belonged there." He worked on the goat, off and on, for three years, and its present version was preceded by two others. "In the first version I had it resting on a high shelf in the painting—flat against it, with light bulbs set underneath. That was no good, because there was only one side of him showing, and I felt it was a terrible shame not to be able to see all of him. Next I tried mounting him with his rear end to the canvas, but that was awful—it looked as though he was *pulling* it." It was at this

point that he had the inspiration of placing an automobile tire around the goat's middle.

—The Bride and the Bachelors.

Jasper Johns and Rauschenberg supported themselves by doing window displays for Bonwit Teller and Tiffany from 1955 until they became popular and prosperous.

❏ What they did, for the most part, was to make astonishingly realistic, meticulously executed "natural" settings for the jewelry to be displayed in Tiffany's windows: a miniature highway, complete with white line and telephone poles, over which a diamond bracelet was negligently draped; a sinister, murky-looking swamp, with tree trunks rising from slimy water and a few emeralds glittering like snakes' eyes in the mud; a wintry forest on the morning after an ice storm, with snow on the ground and real diamonds looking as though they had just fallen in showers from the icy branches.

—The Bride and the Bachelors.

A famous early work was a subtraction.

❏ "Nobody believes it yet, but the whole idea just came from my wanting to know whether a drawing could be made out of erasing," Rauschenberg rather plaintively explains. "I went to Bill and told him I'd been working for several weeks trying to do that, to use the eraser as a drawing tool. I'd been trying with my own drawings, and it didn't work, because that was only fifty percent of what I wanted to get. I had to start with something that was a hundred percent art, which mine might not be; but his work was definitely art, he was the clearest figure around so far as quality and appreciation were concerned. I couldn't use the drawings I'd stolen from him, because the process required his cooperation. Bill was uncomfortable with it at first. We talked about it for quite a while—I'd gone to his studio on Tenth Street. He said he understood the idea but he didn't like it much. But finally he agreed to cooperate. He had several portfolios of his drawings, and he went to the first one and looked through it, and said, 'No, I'd miss one of these too much.' He took up another, but that one had drawings that were unfinished, that he wanted to work on some more. He went to the third portfolio, and said he was going to give me something really hard, and he did. It was a drawing done partly with a hard line, and also with grease pencil, and ink, and heavy crayon. It took me a month, and about forty erasers, to do it. But in the end it really worked. I *liked* the result. I felt it was a legitimate work of art, created by the technique of erasing. So the problem was solved, and I didn't have to do it again."

The result is a white sheet of paper bearing the faint, ghostly shadow
of its former markings, and Rauschenberg still owns it. He keeps it in
a gold-leaf frame bought specially for that purpose, with a label that
he hand-lettered himself. It reads:

<div align="center">

ERASED DE KOONING DRAWING
ROBERT RAUSCHENBERG
1953

</div>

—Off the Wall.

In the early sixties he sent a telegram to Iris Clert, a Parisian art
dealer: "This telegram is a work of art if I say it is."

Fluxus. Happenings, Neo-dada: all theater.

❏ Rauschenberg's contributions to the First New York Theater Rally
were certainly less boring than some of the others. One was a revival
of *Pelican,* with Carolyn Brown, himself, and Alex Hay (taking Per Olof
Ultvelt's place). The other was a new work called *Spring Training.* It
opened with Christopher Rauschenberg, the artist's thirteen-year-old
son, coming out on the darkened stage with a laundry hamper contain-
ing thirty large desert turtles (rented from Trefflich's animal store on
Fulton Street) which he proceeded to turn loose. Each turtle had a
flashlight strapped to its back, and each performed in an exemplary
fashion, moving at dignified speed and sending shafts of light in all
directions until Christopher came out and collected them again. Raus-
chenberg then made his entrance wearing a sport shirt over jockey shorts,
and did a sort of slow sidle across the stage, wiggling his toes and fin-
gers. Steve Paxton followed with ungainly looking movements, and
Paxton and Rauschenberg took turns carrying each other about like
large timbers. Three young women dressed as brides served Saltines to
the audience, then danced together. Deborah Hay came out in a black
leotard and a shoulder harness that supported a screen, on which
Rauschenberg projected Kodachrome slides of canned goods, the Em-
pire State Building, and other images. She then slid into an old-fash-
ioned tap dance. Paxton danced with a tin can strapped to one knee.
Chris Rauschenberg sat down next to a microphone and tore up pages
from a telephone book. The finale was Rauschenberg, solo, on stilts,
wearing a white dinner jacket, with a bucket of dry ice slung from his
waist; as he poured water from a pitcher into the bucket, clouds of
steam rose to envelop him—an ending that he subsequently decided
had been "too dramatic."

Later that night, carrying the turtles back to 809 Broadway in a taxi,
Rauschenberg said he had realized while performing it that his piece
was too long. He would shorten it somewhat for the second perfor-

mance, from forty-five to thirty minutes. "But the turtles turned out to be real troupers, didn't they?" he said happily. "They were saving it all for the performance. They don't have very much, so they saved it." One of the rented turtles did not go back to Trefflich's. A fearless and lethal-looking reptile named Rocky, it remained to share the Broadway loft with Laika, the part-Samoyed puppy that Rauschenberg had bought to replace his ill-tempered kinkajous. He had Laika for seventeen years; Rocky is living yet.

—Off the Wall.

Jean Tinguely
(1925–)

He considers that his best work was his first, constructed in woods outside Basel.

❏ At intervals along a fast-running stream, he placed some thirty small water wheels he had made, each fitted with a camshaft that, when activated by the turning wheel, struck with its own particular rhythm on a tin can, a bottle, or some other noise-making object. The sound of this percussive orchestra was amplified by the natural dome of the trees overhead, and when the wheels were all going at once, the effect, Tinguely recalls, was weird and beautiful—a pastoral symphony played out on the detritus of Basel's back streets.

—CALVIN TOMKINS, *The Bride and the Bachelors.*

The Futurists worshiped the machine and represented it. Dadaists from Picabia to Rube Goldberg loved and mocked machines. The machine lay behind the work of Russian Contructivists and others.

❏ It was not entirely an anarchistic sense of humor that impelled Tinguely to remove the doors from their hinges in the spare rooms of his apartment and to hang them from the ceilings, where, attached to motors, they could be made to revolve at high speed. He suspended some of his paintings and sculptures in the same fashion and revolved them until they flew to pieces, while he and Eva and their friends took cover behind screens to watch. "It was just like Cape Canaveral," Tinguely says with satisfaction.

—TOMKINS.

He came to the United States for the first time in January of
1960. On the trip over he had his most famous idea.

❑ During the trip he began drawing up rough sketches for a work
that would express some of his complex ideas about New York, a city
he had never seen. New York, to Tinguely, had always seemed the
place where modern man was in closest contact with his machines. "The
skyscraper itself is a kind of machine," he has said. "The American
house is a machine. I saw in my mind's eye all those skyscrapers, those
monster buildings, all that magnificent accumulation of human power
and vitality, all that uneasiness, as though everyone were living on the
edge of a precipice, and I thought how nice it would be to make a little
machine there that would be conceived, like Chinese fireworks, in total
anarchy and freedom." The machine that Tinguely envisioned was to
be called *Homage to New York,* and its sole *raison d'être* would be to de-
stroy itself in one act of glorious mechanical freedom. The simplicity,
appropriateness, and grandeur of this vision so impressed Tinguely that
he decided at once that the only proper locale for the event was the
outdoor sculpture garden of the Museum of Modern Art, and as soon
as he landed he set about achieving this almost impossible objective.
The fact that he spoke practically no English and that he had few friends
and, at best, a tiny reputation in New York seemed small obstacles to
him, and he immediately began lining up supporters for his plan. Dore
Ashton, an art critic for the *New York Times* who had seen his work in
Europe, came down to the pier to meet him, and he showed her the
drawings for his machine. "It has to be in the Museum of Modern Art,"
she remembers his saying. "It has to end up in the garbage cans of the
museum." Miss Ashton, who had considerable opportunity to observe
Tinguely in action during the next few weeks, was somewhat awed by
his talent for getting what he wanted. "He often adopts the manner of
a simple peasant when you ask him serious questions," she reports, "but
he is certainly not at all simple. He is a very complicated person. If he
feels you understand him, you're in; if you don't, he uses you."
 One of the people who proved most helpful to Tinguely was Dr.
Richard Huelsenbeck, in whose apartment he stayed for the three months
he was in New York. Huelsenbeck, the Dadaist turned psychiatrist, had
met Tinguely in Paris, admired his work, and enthusiastically pro-
claimed him a "Meta-Dadaist," who had "fulfilled certain ideas of ours,
notably the idea of motion." Dr. Huelsenbeck provided Tinguely's en-
trée to a group of young innovators in New York that included the
painters Robert Rauschenberg and Jasper Johns and the sculptors John
Chamberlain and Richard Stankiewicz, and helped him renew his ac-
quaintance with Marcel Duchamp. Duchamp and Tinguely had met
before, in Paris, and were full of admiration for each other. "I feel with

him a closeness and a rapport that I have felt with few other artists," Duchamp has said. "He has this great thing, a sense of humor—something I have been preaching for artists all my life. Painters usually think they are the last word in divinity; they become like *grands prêtres*. I believe in humor as a thing of great dignity, and so does Tinguely."

The neo-Dada group told Tinguely that the best he could hope for was to place his self-destroying machine in some rental assembly hall in Manhattan, or perhaps in an empty lot. Tinguely, however, would not abandon his dream. George Staempfli had called a staff member of the Museum of Modern Art and mentioned Tinguely's scheme and three days later got word that it would not be possible. Undaunted, Tinguely got Dore Ashton to broach the matter to Peter Selz, the museum's young and energetic Curator of Painting and Sculpture Exhibitions. Selz was interested. He had been fascinated by Tinguely's big meta-matic at the Paris Biennale the year before, and he was receptive to the playful and humorous aspects of Tinguely's work ("Art hasn't been fun for a long time," he said.) Selz spoke to the museum's director, René d'Harnoncourt, and this led to a meeting between d'Harnoncourt and Tinguely. D'Harnoncourt asked some searching questions about the machine and received what Tinguely refers to as "spiritual explanations." This was followed by a much longer session between Tinguely and Richard Koch, the museum's Director of Administration. As Tinguely remembers it, "Koch asked me fifty questions, of which I could answer one or two." Would there be dynamite? Tinguely wasn't sure. Fire? Tinguely didn't know. How long would it last? Tinguely had no idea. Not surprisingly, Koch wouldn't commit himself. Selz, however, kept exerting pressure from his end, and Tinguely's admirers and allies in the neo-Dada group, some of whom had had their own work shown by the museum, mounted a modest crusade on his behalf.

Tinguely's show of meta-matics and rotating reliefs opened in January at the Staempfli Gallery, to astonished but generally friendly reviews. Feature stories on Tinguely appeared in several national magazines. Shortly afterward the museum reversed its earlier decision, and Tinguely's success was absolute. D'Harnoncourt agreed to let Tinguely set off his doomsday machine in the sculpture garden on the night of March 17, three weeks off, and offered him the use of the temporary Buckminster Fuller geodesic dome, at the far end of the garden, as a workshop; he assured Tinguely that no one would interfere in any way with the great work—a pledge that was faithfully observed.

Tinguely plunged immediately into a wide-ranging search for material. He bought dozens of used motors and a powerful electric fan in secondhand electrical shops on Canal Street. In an army-surplus store he found a big orange meterological balloon and some smoke signals. His friends collected enough money for him to buy a quantity of steel tubing, his only major item of expense, and the museum provided him

with his indispensable tool, an acetylene torch. All this, however, was
only a beginning. Tinguely likes to surround himself with a great mass
of material, from which he draws his ideas, and at that moment he felt
overpoweringly in need of bicycle wheels—items that no junk dealer in
New York City seemed to have in stock. This problem was solved by
Billy Klüver, a young Swedish research scientist whom Tinguely had
known in Paris and who was currently working at the Bell Laboratories
in New Jersey. Klüver took time off from his work with electron beams
and microwave tubes to become Tinguely's assistant, and the first thing
he did was to find a bicycle dealer near his home, in Plainfield, New
Jersey, who had recently dredged up thirty-five old bicycle wheels from
a corner of his lot. "I put them in the back of my car and drove in to
the museum about ten o'clock that night," Klüver said later. "When
Jean saw them he was like a child; he had expected maybe five or six.
His ideas took shape from them. That's how he works. He creates with
what comes to hand, and the material shapes the creation. 'I want more
wheels,' he said."

The next day Klüver and his wife raided a dump in Summit and
loaded up their car with twenty-five more bicycle and baby-carriage
wheels, a child's bassinet, and the drum from a derelict washing ma-
chine. They passed these over the garden wall to Tinguely, who carried
them into the Fuller dome and immediately set to work. Two days later
he had finished welding together the first section of his creation. This
part centered on a large meta-matic painting machine and included the
bassinet and the washing-machine drum as percussion elements. A hor-
izontal roll of paper was to be fed down a sheet-metal trough, where it
would be attacked by two large brushes held by an elaborately con-
structed painting arm. When the paper reached the bottom of the meta-
matic it would be blown out toward the audience by the electric fan.

Material was running short again. This time Klüver took Tinguely to
a big Newark dump. "I had said that his great machine should be one
continuous process—out of the chaos of the dump and back again,"
Klüver has recalled. "Jean liked that, and when he came out and saw
the dump he fell in love with the place. He wanted to live there. He
had the idea that if he could just find the right girl they could live right
in the dump, like the bums there did, in a little shack, and he could
spend his time building large, involved constructions, and that eventu-
ally the bums would become his friends and help him, although the
word 'art' was never to be mentioned and his constructions would never
be anything but part of the dump." The local inhabitants of the dump
did help Tinguely and Klüver find the materials they wanted, including
a cable drum, a rusty oilcan, a bedraggled American flag, and a great
many more baby-carriage wheels, of which there seemed to be unlim-
ited quantities. The next day Klüver located a dealer who was willing
to sell him a workable radio and an antique upright piano for ten dol-

lars. Then Tinguely got the museum to sell him, for two dollars, an ancient Addressograph machine that made an incredible amount of noise.

For the next two weeks Tinguely worked from twelve to sixteen hours a day in the dome, which was damp and ice-cold. The second section of the machine took shape around the piano. Tinguely fashioned ten armatures out of old bicycle parts and mounted them in such a way that they struck the piano keys in sequence, with considerable force. A small meta-matic was attached to the piano, where it would produce a continuous painting that would immediately roll itself up again—*l'art éphémère*. Two pairs of spindles operating at right angles to each other (one vertical, one horizontal) were designed to unroll two written texts and roll *them* up again. The radio, sawed in half but still able to function, was nailed to the piano. The Addressograph machine, with the addition of armatures and a bell, became a percussion instrument. Dozens of wheels were fitted in place to drive the various moving parts. Above the whole structure rose a twenty-foot steel tube supporting the meteorological balloon.

The idea of the machine's destruction had by now begun to seem of only secondary importance to Tinguely. Originally he had planned to incorporate into the structure a number of saws that would attack the metal supports and cause an ear-splitting din. But an associate of Klüver's at Bell Laboratories hit on the idea of sawing through the metal tubing in crucial places beforehand, and holding it together with joints of soft metal that would melt when an electrical charge was sent through concealed wire resistors inside them. Tinguely enthusiastically embraced this new plan. The joints were never really perfected, according to Klüver, but Tinguely no longer cared. "He wasn't interested in perfecting something so that it would be sure to work," Klüver has said. "He preferred to spend the time adding new things, new gadgets."

A good many of Tinguely's friends dropped in to lend a hand at odd times, and nearly every one of them caught a heavy cold after a few hours in the unheated dome. Tinguely, whose somatic reactions are peculiar—he is often prostrated just before a surge of prodigious labors, as though, a friend says, he needed "a kind of pain before he can create"—insists that he was never sick a moment while working on *Homage*. Almost everyone else remembers that he had a high fever for several days. In any case, toward the end, he was working almost around the clock, scarcely bothering to eat or sleep. He made two more small constructions, self-propelled, and designed to break off from the main machine as it perished. The first had a giant motor and a two-foot klaxon mounted on four baby-carriage wheels. The second, also on wheels, consisted of the cable drum and the oilcan, from which sprouted a wire with a corner of the American flag attached to it. This was tested in the museum lobby the night before the performance. While Tin-

guely and Klüver stood in rapt attention, the little cart rolled back and forth across the polished floor with an uncertain, jerky motion, its arm tapping a march rhythm on the oilcan and its bit of flag waving bravely. This oddly appealing mechanism was supposed to roll away from the dying parent machine and drown itself in the reflecting pool of the garden, where Maillol's monumental nude female figure *The River* would preside over its demise.

Because the show was scheduled for early evening Tinguely decided at the last moment to paint the entire construction white, in order to make it more clearly visible. He also confided to Peter Selz that he wanted *Homage* to be very beautiful, so that people watching it would feel dismayed when it began to destroy itself. ("I had no idea how beautiful it was going to be," Selz said later. "You had a real feeling of tragedy that that great white machine couldn't be preserved somehow.") Tinguely worried for fear painting it white might make it *too* beautiful, but he reassured himself that this danger would be averted when the meteorological balloon burst from its overdose of compressed air and descended limply over it. Museum employees and officials pitched in to help with the painting. The excitement of the event had spread to everyone connected with the museum, including Alfred H. Barr, Jr., the Director of Museum Collections, who wrote, in a De Mille–like museum broadside, about Tinguely's "apocalyptic far-out breakthrough, which, it is said, clinks and clanks, tingles and tangles, whirs and buzzes, grinds and creaks, whistles and pops itself into a katabolic Götterdämmerung of junk and scrap. Oh, great brotherhood of Jules Verne, Paul Klee, Sandy Calder, Leonardo da Vinci, Rube Goldberg, Marcel Duhamp, Piranesi, Man Ray, Picabia, Filippo Morghen, are you with it?"

Doomsday, a Thursday, dawned gray and wet. The temperature, which had been below freezing for the three weeks that Tinguely had been at work on the machine, rose slightly, and a light snow that had been falling since the previous night turned into a cold rain, which kept up intermittently all day. Over on Fifth Avenue the Saint Patrick's Day parade bravely drummed and blared its way uptown. Hordes of high-school children in green cardboard hats passed the Fifty-fourth Street wall and stopped to look into the garden, where workmen were struggling to move Tinguely's creation from the dome to the central court. The workmen kept slipping and sliding in the wet slush, and there were accidents. The Addressograph machine was damaged. Tinguely became tense. In his black boots, open storm jacket, and two-day-old beard, he looked like a Cuban revolutionary, and for the first time his spirits seemed a trifle subdued.

Robert Rauschenberg showed up at about noon, bringing a device he had made called a "money thrower." Tinguely had suggested to several New York artists that they contribute to the master machine, in a sort of Bauhaus effort, and Rauschenberg, whose "combine paintings" were

in some ways even farther out than Tinguely's creations, had promised to add a mascot. This took the form of two heavy springs held in tension by a thin cord, with silver dollars inserted between the coils; when the cord was disintegrated by flash powder, the springs would fly up and scatter the silver dollars. Rauschenberg waited patiently for several hours to have his money thrower connected. "I felt privileged to be able to hand him a screwdriver," Rauschenberg has said. "There were so many different aspects of life involved in the big piece. It was as real, as interesting, as complicated, as vulnerable, and as gay as life itself."

After a great deal of searching Klüver had managed to fill a request of Tinguely's for several bottles full of powerful chemical stinks. He arrived, carrying them gingerly, and set them down near the partly assembled machine. Klüver also brought several containers of titanium tetrachloride for making smoke, since several previous methods had proved unsatisfactory. He asked Tinguely if it was all right to put the containers in the bassinet. Tinguely said it was. Time was running so short that decisions were being made on the spur of the moment.

Georgine Oeri, a New York art critic and teacher who had grown up in Tinguely's home town of Basel, came by to wish him luck. She found him in a state of momentary despair. He told her he had been trying to explain to the workmen that they must find a way to paint the snow black, so it would not detract from his white machine. The workmen had grown very fond of Tinguely (the day after the performance he gave a party for all of them in the boiler room of the museum), but at this point they were convinced that he had lost his mind. Oddly, although they spoke no French and Tinguely very little English, he and they never had the slightest trouble understanding one another.

Tinguely found that the klaxon on the small carriage did not work. Robert Breer went off in search of another. The museum people suddenly became concerned about the garden's marble flagstones, and everything stopped while the workmen set wooden blocks under the machine. Toward five o'clock a sizable crowd began to gather in the garden, despite the rain. Invitations had gone out to two hundred people, including Governor and Mrs. Rockefeller, specifying that "the spectacle will begin at 6:30 and will take approximately 30 minutes," but many came early, and many others who had not been invited came too. The cafeteria facing the garden was full of spectators, and an NBC camera crew was setting up lights and cameras to film the event. Outside the museum's main entrance, on Fifty-third Street, a German sculptor named Mathias Goeritz was handing out copies of an anti-Tinguely manifesto: "STOP the aesthetic, so-called 'profound' jokes! STOP boring us with another sample of egocentric folk art. . . . We need faith! We need love! We need GOD!"

Tinguely gave up trying to have the snow painted black. Breer re-

out a vital connection. Black smoke poured from the machine. With a limping, eccentric motion, the small suicide carriage broke away from the main machine, its flag waving. Then it stopped. Tinguely helped it along tenderly toward the pool, but its motor was too weak, and it never got there. The Addressograph machine started up, thrashing and clattering. It had been too badly damaged in transit, though, and it fell over after a minute or so, stone dead. Brilliant yellow smoke flashes now began going off all over the machine.

Some twenty minutes after the start of the destruction the resistors in the sawed-through supports began to melt the joints. The mechanism sagged but did not collapse entirely, because some crossbars at the bottom stubbornly refused to give way. The other small carriage suddenly shot out from under the piano, its klaxon shrieking, and smoke and flames pouring from its rear end. It headed straight for the audience, caromed off a photographer's bag, and rammed into a ladder on which a correspondent for *Paris-Match* was standing; he courageously descended, turned it around, and sent it scuttling into the NBC sound equipment. Tinguely suddenly began to worry for fear the fire extinguisher in the piano would explode from the heat, and he wanted firemen to put out the blaze. Klüver found a fireman in attendance, who seemed to be enjoying the show. He listened to Klüver's pleading and then, with apparent reluctance, signaled to two museum guards, who ran out with small extinguishers and applied them to the piano fire. The audience booed the men angrily, assuming that they were spoiling the show. A *Times* photographer who went inside the museum a few minutes later overheard the fireman talking to headquarters on the telephone. "There are these machines, see," he was saying, "and one of them is on fire, but they tell me it's a work of art, see, and then this guy tells me *himself* to put it out, see, and the crowd yells 'No! No!' "

One of the guards ran into the museum and returned trundling a big extinguisher, with which he doused the piano and the surrounding machinery. He was furiously booed. The audience had seen everything go wrong, and now, it seemed, it was to be denied the machine's climactic act of self-destruction. More boos, interspersed with a few cheers, attended the final anticlimax as the fireman and the two guards attacked the sagging machine with axes, knocking down the piano, the big meta-matic, and the mast that held the balloon. At the end, though, there was a rousing cheer for the dying monster. The crowd descended on the debris for souvenirs and managed to add to the general discomfort by breaking every one of the stink bottles. But if the audience felt frustrated, the museum authorities were in a state approaching shock; some of them were so angry about the fire that they refused to attend a reception held at George Staempfli's following the event. As Philip Johnson, a trustee, said later, "It was not a good joke."

Not everyone agreed with Johnson. The newspaper reviews were

mixed, most of them treating it as a crazy stunt that failed to come off. There were so few downright hostile reactions that the *Nation* was moved to comment sourly, "This is what social protest has fallen to in our day—a garden party." The only critic (aside from Dore Ashton, in a later article) to write about *Homage* at any length was the *Times*'s John Canaday. Although he called the show a "fiasco," he saw the machine as "an object of bizarre attraction, if not of classical beauty," and "a legitimate work of art as social expression, even if it pooped a bit." Returning to the subject in a Sunday column, he said that the machine was at least honest in its destructiveness, and that Tinguely himself "deserved a nod of recognition for an elaborate witticism on a subject of deadly seriousness, man's loss of faith."

That sort of interpretation was fine with Tinguely, and so were all the others. To him, the machine was anything that anyone said it was—social protest, joke, abomination, satire—but, in addition, it was a machine that had rejected itself in order to become humor and poetry. It was the opposite of the skyscrapers, the opposite of the Pyramids, the opposite of the fixed, petrified work of art, and thus the best solution he had yet found to the problem of making something that would be as free, as ephemeral, and as vulnerable as life itself. It had evolved, after all, "in total anarchy and freedom," and he had been as surprised as any other spectator by this evolution. All the unforeseen accidents and failures delighted Tinguely. The fact that only three notes of the piano worked moved him deeply. As he said afterward, "It was beautiful, I thought, and absolutely unplanned that one part of the piano should continue to play for almost fifteen minutes while the rest was being consumed by fire—those three notes still playing in the midst of the fire, calmly, sadly, monotonously, just those three. Many people told me afterward that for them it was a terrible thing. One woman told me later that she had wept, she found it so sad. It *was* sad, in many respects. It was also funny. I laughed a great deal while it was happening. I was the best spectator. I had never seen anything like that."

Whatever else it achieved, *Homage to New York* had a profoundly liberating effect on Jean Tinguely. The technical knowledge gained in building the machine and the excitement of working for (and with) a large audience had, in a sense, opened up to him a whole new career as a *régisseur*—a stage director for spectacles in which the crowd was as important to the total effect as the absurd antics of his liberated machines. In his post-*Homage* mood of exhilaration, ideas for new projects poured out of him. He would create a machine to destroy museums. He would make two huge machines, one black and one white, and set them to destroying each other. He would make a meta-matic vehicle that would go along a highway (Klüver suggested the Los Angeles Freeway) painting a continuous abstract picture, and another machine

turned with a klaxon that he had bought for a dollar from a scrap dealer on Tenth Avenue, and Tinguely substituted it for the defective one. He also checked the arm of the big meta-matic and adjusted the roller. At one point Klüver picked up a metal ring from the slush and asked Tinguely what it was for. Tinguely said he didn't know. He was calmer now, working steadily but without haste or tension, and seemingly unaware of the gathering crowd. At six o'clock Klüver finally got a power line out to the machine, and they began connecting the circuits. Breer accidently turned on a fire extinguisher that was concealed inside the piano but managed to turn it off before anyone noticed. At six-thirty they were still working on the machine. The crowd now filled the garden, standing patiently in slush that was nearly ankle-deep, under a fitful rain. Apartment dwellers on Fifty-fourth Street, across from the garden, were waiting at their windows. Some of the spectators were growing restless. David Sylvester, a British art critic, made a conspicuous departure, saying, "I don't like tuxedo Dada." Two noted Abstract Expressionist painters followed him, muttering angrily. Kenneth Tynan, the theater critic, was asked by a reporter to make a statement. "I'd say it was the end of civilization as we know it," Tynan replied.

The big orange meteorological balloon was inflated and raised to the top of its mast. It looked like the moon rising, and the crowd hushed expectantly. Half an hour more went by while Tinguely and Klüver dashed back and forth between the dome and the machine. At seven-twenty, nearly an hour after the event had been scheduled to begin, Klüver discovered that they had neglected to saw through one leg of the machine. He sawed it quickly. The creation phase was now completed. The machine stood twenty-three feet long and twenty-seven feet high, its white, dripping structure cleanly outlined against the dark evergreens behind it, its eighty bicycle wheels poised for action. The destruction could now begin.

"At seven-thirty I was finished," Klüver wrote in his subsequent log of the event. " '*On va?*' '*On va,*' said Jean. He looked as calm as if he were about to take a bus. Not once did we go over and check everything. The end of the construction and the beginning of the destruction were indistinguishable." Klüver put in the plug, the machine gave a convulsive shudder, rattled, and immediately broke down. The belt driving the piano mechanism had slipped off its wheel as soon as the motor started up. Klüver tried frantically to fix it, his fingers numb with cold. "*Laisse-moi faire,* Billy!" Tinguely called out. A blown fuse was replaced. The piano started to play again, but other belts had jumped off and only three notes were working.

The big meta-matic clanked into operation. Instead of rolling down past the paint brushes, though, the paper rolled itself up the wrong way and flapped derisively atop the machine; Tinguely had accidentally reversed the belt when he was attaching it to the painting arm. When

he saw what had happened he grabbed Klüver's arm and pointed, doubling up with laughter. From that moment on it was clear that the machine would proceed about its destruction in its own way, but the audience, unaware that Tinguely's machines hardly ever worked as they were supposed to, gave a collective groan.

What happened next was pure, vintage Tinguely. Thick, yellow, strong-smelling smoke billowed from the baby's bassinet, where Klüver had put the titanium tetrachloride, and was caught by the blast from the powerful fan that had been supposed to blow the meta-matic painting toward the audience. Having waited an hour and a half to see the show, the spectators now found themselves enveloped in a choking cloud that completely obscured their view of the machine. They could hear it, though. Most of the percussion elements were working splendidly, and the din was tremendous.

When the smoke finally cleared, the machine could be seen shaking and quivering in all its members. Smoke and flames began to emerge from inside the piano, which continued to sound its melancholy three-note dirge; a can of gasoline had been set to overturn onto a burning candle there. The radio turned itself on, but nobody could hear it. Rauschenberg's money thrower went off with a brilliant flash. An arm began to beat in sepulchral rhythm on the washing-machine drum. At this point the bottles of strong-smelling liquids were supposed to slide down from their rack and break, but the strings holding them failed to snap. The meteorological balloon refused to burst—there was not enough compressed air in the bottle.

The second meta-matic worked perfectly, producing a long black painting that immediately wound itself up again. The two texts unrolled, but the horizontal one began to sag instead of winding itself up. "Do you remember that little ring you picked up and asked about?" Tinguely shouted to Klüver. "It was to hold the paper roll up!" The vertical text had finished unrolling, and its loose end hung teasingly over the burning piano. Tinguely was beside himself with wonder and delight. Each element of his machine was having its chance to be, as he said later, "a poem in itself." A photographer took his picture standing in front of the machine, arms outspread, smiling, with the words "Ying Is Yang" on the horizontal text just above his head.

The piano was really blazing now. "There is something very odd about seeing a piano burn," George Staempfli has since said. "All your ideas about music are somehow involved." For the museum authorities, a good deal more than ideas about music was involved. They had not anticipated a fire and were understandably sensitive on that subject in view of the museum's second-foor fire the year before, which had destroyed almost two hundred thousand dollars' worth of paintings. The concealed fire extinguisher was supposed to go off at the eighteenth minute, but the flames had spread through the whole piano and burned

that would come along behind washing it off. He would take three windows in a department store and install three machines to destroy products sold inside the store; in the first window there would be a machine slashing dresses, in the second window a machine rending straw hats, and in the third window a machine smashing teacups. Across all three windows there would be a sign reading, "Come In and Buy Before Jean Tinguely Destroys Everything!"

—TOMKINS.

Calvin Tompkins credits Tinguely with beginning the 1960s. In *Edie,* Walter Hopps says that he "set the tone of hysteria. He had an icebox that had been stolen from an alley outside Marcel Duchamp's secret studio, and when you opened it, a very noisy siren went off and red lights flashed."

Ed Kienholz
(1927–)

Two Los Angeles gallery owners bought a particularly beautiful Stickley desk in Pasadena and set it into their gallery "where it shown like a beacon."

❏ I remember Kienholz coming in one day and admiring it. He then said, "You know, Irving, I don't really have respect for your opinion." I asked, my opinion about everything? He replied, "No, about art, and I'll tell you why if you really want to know. It's because you like everything I do. Every time I show you something you say it's remarkable, and since I know everything I do isn't, I feel I can't get a straight response from you." I said if that's what you really want, and you feel it would be useful to you, that's how we will proceed. Ed was relieved, and said he felt much better.

Some weeks passed, and Ed surfaced in the gallery one day with a sculpture that looked rather like a cigar box, painted black, and with a long extenion cord coming out of one side. He set it on the Stickley desk, and I peered at it while he said nothing. I then said, "Ed, it's silly. It just doesn't mean anything at all. It's rather stupid." Of course, I was thinking back to our conversation. Ed explained that it wasn't fully operational, and proceeded to unroll the cord and plug it into the wall. The box began to shake slowly and hum. I watched it, and said, "Ed,

it's trash. It has no meaning to me whatsoever." He said, "Fine, Irving, you're being as honest and straight as you can be, and that's exactly what I wanted in terms of our relationship." He then rolled up the cord, picked up the little box, and walked out with it under his arm. He was gone by the time I noticed the three-quarter-inch hole in the Stickley desk. The box was actually a drill which had gone right through the top.

—LAURA DE COPPET AND ALAN JONES, *The Art Dealers.*

John Chamberlain
(1928–)

Someone asked John Chamberlain why he used discarded automobile parts for his sculpture. When Michelangelo looked out his window—he told them—Michelangelo saw marble; John Chamberlain's backyard was full of junked cars.

Sol LeWitt
(1928–)

According to Françoise Gilot, Picasso liked to say: "If I telegraph one of my canvases to New York, any housepainter should be able to do it properly." What an artist daydreams in one generation, artists of a subsequent generation will make real. Sol LeWitt can telegraph his work anywhere.

On May 5, 1987, Christie's auctioned the idea of a work of art: "Ten thousand lines ten inches (25cm.) long, covering the wall evenly . . ." The title is concept and instruction.

"Ten thousand lines" was first executed in 1971 in a gallery in New York City; in 1976 a business bought the rights and redrew it for its collection of conceptual art. When the company made a move, it sold its collection at auction.

LeWitt's concept sold for $24,000.

Earlier, when conceptual artists were an embattled minority, they exhanged ideas on postcards. Carl Andre wrote Sol LeWitt: "I hate to measure but I love to rule." LeWitt pinned the post-card over his drafting table.

Jasper Johns
(1930–)

Born in Augusta, Georgia, he brought a pleasing demeanor with him when he came north.

❏ At an opening at the Museum of Modern Art, a woman charmed by his elegance of manner said to him, "Jasper, you must be from the southern aristocracy."
 "No," he replied. "I'm just trash."
 —CALVIN TOMKINS, *Off the Wall: Robert Rauschenberg and the Art World*.

In New York Rachel Rosenthal lived with Johns and Rauschen-berg.

❏ "I used to work all night at my sculpture, with my cats, and cry because I couldn't have Jasper," Rachel remembers. "At the same time I was very attracted to Bob. He was so seductive and yet so shrewd; he knew just how to play on your weak points. We had this weird relation-ship. I was crazy about Jap, and so was Bob, but Bob and I used to gang up on him and tease him. Jasper had such a quality of *jeune fille* in those days, he was so shy, and his looks were so amazing; he had skin like moonstone, almost transparent, and silky platinum hair, and huge blue eyes with very long lashes. Bob was emotional where Jap was cool. There was a lot of murkiness, and games being played, and crossed signals. Actually I guess it was sort of god-awful."

 —TOMKINS.

As noted earlier, Rauschenberg and Johns supported themselves by making shop windows for Tiffany's and Bonwit's. They made

❏ Old Master still lifes in three dimensions, with painted plaster fruit. Another window for Tiffany's was all potatoes (simulated), dirt (real), and diamonds (also real).

 —TOMKINS.

Rauschenberg and Johns were so close that, as Rauschenberg remembers, they "literally traded ideas. He would say, 'I've got a terrific idea for you,' and then I'd have to find one for him."

❏ "I was very envious of his encaustic, I must admit, but too respectful ever to touch it. Except once, he let me. He was painting one of the large flags. It smelled so delicious, and it looked so good, all those aromatic bubbling waxes, the colors so bright, and I just begged him to let me do one stripe. He finally said, 'All right, one.' So I decided it might as well be red. I stared at the painting, savoring the moment, and then I dipped a brush in the wax, getting as much on as I could, and made a stroke—right in the middle of a white stripe! Ooops! Needless to say I didn't ask again. There was just no way he could think I hadn't done it on purpose."

Johns painted a few Rauschenbergs during this time. He did a couple of gold-leaf collages, and a large canvas in the style of *Rebus*. "I thought I understood what went into his pictures, so that I could do one," he said. "But mine weren't convincing at all."

—TOMKINS.

Shaggy John Cage tells another.

❏ I dug up some hog peanuts and boiled them with butter, salt, and pepper for Bob Rauschenberg and Jasper Johns. I was anxious to know what Jasper Johns would think of them because I knew he liked boiled peanuts. I was curious to know whether he would find a similarity between boiled peanuts and hog peanuts. Most people in the North have no experience at all of boiled peanuts. People who've had hog peanuts speak aferwards of the taste of chestnuts and beans. Anyway, Jasper Johns said they were very good but that they didn't taste particularly like boiled peantus. Then he went down to South Carolina for a few weeks in November. When I saw him after he got back, he said he'd had boiled peanuts again and that they tasted very much like hog peanuts.

—JOHN CAGE, *Silence*, 1961.

Andy Warhol
(1930–1987)

Eventually, everyone who ever knew Andy Warhol will write his recollections. These reminiscences come from Emile de Antonio, an independent filmmaker who appeared in Warhol's films.

❏ He came to small dinner parties at which I served smoked salmon, Dom Perignon, and grass. Andy did extraordinary menus. I wish I had one, I always gave them to guests like David Winn or Bobo Legendre. I introduced him to a fashion model whom I later married. Andy was fascinated—he stared at her and said, "Why, D, she looks just like David. Why don't you marry David?" Andy remembered everything; he read every gossip column. He wrote fan letters to Tab Hunter. Of course, he had always wanted to be a painter. He masked his past; he denied he ever went to college; but he did—Carnegie Tech; he graduated at nineteen.

—EMILE DE ANTONIO AND MITCH TUCHMAN, *Painters Painting.*

Ethel Scull's husband Bob commissioned a portrait.

❏ Bob had asked Andy Warhol to do a portrait, which sort of frightened me, naturally, because one never knew what Andy would do. So he said, "Don't worry, everything will be splendid." So I had great visions of going to Richard Avedon.

He came up for me that day, and he said, "All right, we're off."

And I said, "Well, where are we going?"

"Just down to Forty-second Street and Broadway."

I said, "What are we going to do there?"

He said, "I'm going to take pictures of you."

I said, "For what?"

He said, "For the portrait."

I said, "In those things? My God, I'll look terrible!"

He said, "Don't worry," and he took out coins. He had about a hundred dollars' worth of silver coins, and he said, "We'll take the high key and the low key, and I'll push you inside, and you watch the little red light." The thing you do the passport with, three for a quarter, or something like that.

He said, "Just watch the red light," and I froze. I watched the red light and never did anything. So Andy would come in and poke me and make me do all kinds of things, and I relaxed finally. I think the whole place, wherever we were, thought they had two nuts there. We were running from one booth to another, and he took all these pictures, and they were drying all over the place.

At the end of the thing, he said, "Now, you want to see them?" And they were so sensational that he didn't need Richard Avedon.

I was so pleased, I think I'll go there for all my pictures from now on.

When he delivered the portrait, it came in pieces, and Bob said to him, 'How would you like . . . don't you want to sit down at this, too?" because there were all these beautiful colors.

He said, "Oh, no. The man who's up here to put it together, let him do it any way he wants."

—DE ANTONIO.

Patrick Smith interviewed Nathan Gluck, Warhol's assistant, who made Warhols indistinguishable from Warhol's.

❏ Andy had this great passion for drawing people's cocks and he had pads and pads and pads of drawings of people's lower regions. They're drawings of the penis, the balls and everything, and there'd be a little heart on them or tied with a little ribbon. And they're—if he still has them—they're in pads just sitting around. I used to wonder what his mother would do if she saw them. But, I guess, she never saw them or didn't recognize them. But every time he got to know somebody, even as a friend sometimes, he'd say, "Let me draw your cock."
SMITH: And then they would volunteer?
GLUCK: Yeah. They'd drop their pants, and Andy would make a drawing. That was it. And then he'd say, "Thank you." Sometimes three or four drawings.

—PATRICK SMITH, *Warhol: Conversations About the Artist.*

Smith also asked questions of Robert Fleisher, who was manager of the stationery department at Bergdorf Goodman when Warhol designed their stationery.

❏ I knew what he felt about movie stars or, you know, some guy. But, like, the world didn't really exist except some immediate pleasure, maybe, yet he was very poor. He was very poor. He really scrounged in the early days, and I would give him quite a lot of credit for fighting up to those things, those other things that he achieved. . . .

Andy *loved* to sketch models and very intimate sexual acts. Really! And Andy sketched us screwing a couple of times. Andy would get very, very excited. He wouldn't quite join in, but he *loved* watching. He would very often like to draw me nude and see me with an erection, but he never actually touched me. And I think that I never really put myself in a position of letting him or leading him on, or [think] that I was interested physically, because I wasn't. And at one time he said that he got so hot when he saw men with erections that he couldn't have an orgasm himself. But he started to strip that day. "And wasn't it all right if he sketched in his Jockey shorts?" And he did. And I was really upset. And it kind of *confirmed* what I had thought about Andy's personal habits in those days.

I have a feeling that this person Charles [Lisanby] took him in hand in that area and started to teach him about clothes, how to get dressed

and buy your suits at Brooks Brothers. And Andy did a *little* of that,
but, as you know, he went back to what was trendy—with black leather—
later on. And that was after I knew him, stopped being friendly with
him. But my *feeling* about his sexuality, anyway, is from what I could
gather. I *never* saw him in an actual sexual act or in a place where
homosexuals go to have sex or did. I never saw him in a bath[house]
or anything like that or at a gay bar. He *talked* about sexual experience,
somehow, that some guy's "bum"—he used to use the English word for
rear end—and he'd say, "Oh, my bum is so sore tonight because I met
this number [a good looking and young man], and he screwed the ass
off me." I never believed it. I think that—at *least* in the time that I knew
him—I *don't* think that he *ever* had an overt sexual act with another
human being.

—SMITH.

Smith asked Fleisher about Warhol and Truman Capote.

❏ FLEISHER: Oh! He had a terrible crush on him right from the be-
ginning.
SMITH: I'm told he used to write a fan letter every day for a year.
FLEISHER: Yes. He tried to call him. He wanted to sketch him. Capote,
to my knowledge never answered or acknowledged him. He did sketches
from his imagination.

—SMITH.

Fritzie Wood told Smith that Warhol sat in the Plaza lobby
hoping to be mistaken for Capote. When it happened he was joy-
ous. Smith also talked with Ivan Karp, who told him

❏ I once said to [Warhol], "What do you want? You've got every-
thing: you have crowds, hordes, young people, beautiful people,
charming people, rich people, lovely people. Nobody seems to touch
you." I said, "What do you want?" He says [Karp imitates Warhol's
whisper], "I want more fame."

—SMITH.

Warhol became the *bête noire* of painterly painters like Ad Rein-
hardt. "Warhol's ultimate product was Warhol," as a journalist
put it. In the time of the assassinations, Warhol's name was al-
most added to an illustrious list.

❏ One June day in 1968, a young woman named Valerie Solanas,
age twenty-eight, came out of the elevator at the Union Square Factory
and started shooting. She had a .32-caliber automatic pistol and a .22

revolver in her handbag. She shot Warhol twice, and Mario Amaya, a visiting critic, once, and she probably would have shot Warhol's business manager, Fred Hughes, who was down on his knees begging for mercy, if the elevator door had not clashed open again bringing more visitors; she got into it and left, to be picked up by the police a few hours later. "He had too much control over my life," she explained. She was an aspiring actress and playwright, and also the founder and sole member of an organization called the Society for Cutting Up Men, or SCUM.

—CALVIN TOMKINS, *Off the Wall: Robert Rauschenberg and the Art World.*

David Bourdon heard that Warhol was in the hospital with only a 50 percent chance of survival.

❑ As soon as he was out of intensive care I got a telephone call— Andy calling me from his room. He wanted to talk. He wanted to find out what sort of press coverage he'd been getting. He knew that I was about to do an article on him for *Life* magazine, and he wanted to know how *that* was coming along. Actually, the piece had been finished and it was in the house before Andy was shot. We had all the photographs, the layout, everything. Then Andy was shot. The *Life* editors were ecstatic. It was going to be a lead story—eight or ten pages—a major space in the following issue.

But then Robert Kennedy got shot. Andy's story was killed, and the cover story came out on the Senator . . . which was the obvious choice. The following week the Andy story was much less exciting to the editors, and they said to me, "Well, the only reason to run the story now would be if Andy . . . you know . . . died."

So Andy kept calling me up: "Are they going to run the story *this* week?"

I told him, "Andy, they're very mean. They'll only run the story if you die. I'd much rather have you alive, even if it means that my story doesn't get published."

—JEAN STEIN, *Edie: An American Biography.*

Walter Hopps remembered his first meeting with Warhol.

❑ Well, at the door was a peculiar, fey, strange-looking person. I sighed, thinking we were in for a cute time of it, and my reaction was reinforced as we went down hallways and I saw peculiar stashes of a kind of chi-chi gay taste . . . crannies full of gumball machines and merry-go-round horses and barber poles. I said, to myself, "Good Lord, this guy is a cute, rather effete decorator," which was not especially novel since public taste was already on the edge of Tiffany glass. Every-

where in this townhouse, variations on this kind of taste were collected. We went into a foyer and looked down the hall at a great collection of material that seemed to reflect this . . . a stash of forties wedgie shoes, which seemed kind of kinky. The townhouse, gloomy and large, was peculiarly unfurnished. It was more of a collecting depot, a warehouse of things. I said, "Gee, it looks like you collect a lot of gumball machines here." He was some strange, isolated figure in his laboratory of taste experiments.

—STEIN.

Capote also remembered his first meeting.

❏ It had to be in the late forties, or perhaps 1950, but certainly it was when my mother was still alive. Anyway, I started getting these letters from somebody who called himself Andy Warhol. They were, you know, fan letters. I never answer fan letters. If you do, you find yourself in a correspondence you don't want to have; or, secondly, you find these strangers turning up on your doorstep; or, thirdly, if you don't keep up with your letters to them after the first, they write hurt, vindictive letters wondering why you've stopped. But not answering these Warhol letters didn't seem to faze him at all. I became Andy's Shirley Temple. After a while I began getting letters from him every day! Until I became terrifically conscious of this person. Also he began sending along these drawings. They certainly weren't like his later things. They were rather literal illustrations from stories of mine . . . at least, that's what they were *supposed* to be. Not only that, but apparently Andy Warhol used to stand outside the building where I lived and hang around waiting to see me come in or go out of the building.

One day my mother was visiting from Connecticut. She was sort of an alcoholic. Somehow or other my mother spoke to him out there on the street and she invited him upstairs to the apartment. I walked in later, and he was sitting there. He looked then exactly the way he looks now. He hasn't changed an iota! He had been having this conversation with my mother, who was a bit looped. So I sat down and talked to him. He told me all about himself and how he lived someplace with his mother and twenty-five cats. He seemed one of those hopeless people that you just know *nothing's* ever going to happen to. Just a hopeless, born loser. Anyway, it was friendly and pleasant, and then he left.

He started calling me every day after that. He'd tell me what was happening to him, and his troubles, and about his mother and all those cats, and what he was doing. I didn't want to be un-nice or anything, so I sort of put up with it. Then one day when he called up my mother, she told him not to call any more. She was drunk at the time. Like all alcoholics, she had Jekyll-and-Hyde qualities, and although she was a

basically sympathetic person and thought he was very sweet, she lit into him. So suddenly he stopped writing or calling me.

I didn't hear from him or about him until suddenly one day D. D. Ryan bought a gold shoe Andy had dedicated to me in a show and sent it to me as a Christmas present. She told me, "Oh, he's becoming very well know, very on-coming." Even then I never had the idea he wanted to be a painter or an artist. I thought he was one of those people who are "interested in the arts." As far as I knew, he was a window decorator . . . let's say, a window-decorator type.

Then I ran into him on the street. When I had known him in his previous incarnation, he seemed to me the loneliest, most friendless person I'd ever seen in my life. He was surrounded by seven or eight people, a real little entourage around this person I had really thought quite pitiable.

Then he started sending me pictures again, including a portrait of me that if you look at you can tell I didn't sit for him.

I think, looking back, that at a very early age he had decided what it was he wanted: fame—that is, to be a famous person.

—STEIN.

Henry Geldzahler of the Metropolitan Museum:

❏ My favorite was a telephone call at one-thirty in the morning. "Henry, I have to talk to you." I said, "Andy, it's one-thirty in the morning." "We have to talk," he said. "Meet me at the Brasserie." I asked, "Is it really important?" He said, "Yes, it's really important." So I said okay; I got dressed, took a taxi, and met him at the Brasserie. We sat down at a table. "What is it?" I asked. "I have to talk to you. I have to talk to you." "Yes? Yes?" "Well," Andy finally said, "say something." That was it—a cry for help of some kind. Sometimes he would say that he was scared of dying if he went to sleep. So he'd lie in bed and listen to his heart beat. And finally he'd call me. But it was amusing, too, in its mad way. He did like to hear me talk. Sometime that year he was asked to do a radio interview at WBAI and he asked, "Can I bring a friend along?" So I joined him at the microphone. They would ask a question and he wouldn't say anything. So I'd lean forward and say, "What Andy means is . . ." and I'd answer it. Once in a while he'd say yes when the answer was no. Then I'd say, "When Andy says no he means yes," and then explain. At the end, the interviewer said, "I'd like to thank Mr. Geldzahler from the Metropolitan Museum for being with us today, and Mr. Andy Warhol." Andy grabbed the microphone. It was the first time he spoke in the whole interview. He said: "Miss Andy Warhol."

—STEIN.

From the Factory, Ondine:

❏ How he made those paintings was so helter-skelter. Do you re-
member Harriet Teacher? She was one of the queens of the avant-
garde. Very weird girl. Very small. Intense. Controlled. She always had
a dog with her—a huge dog named Carmen Miranda. One day she
came up to the Factory with Carmen Miranda and asked Andy if he
would mind if she shot his Marilyn Monroe paintings. He said no, it
was okay.
 There were about seven Monroe canvases stacked one against the
other on the floor. Harriet put on a pair of white gloves, took a pistol
out of her motorcycle jacket, aimed it at the middle of Marilyn Mon-
roe's forehead—standing about fifty feet away—and shot a hole through
all those canvases. Right in the middle of the temple. Perfectly on tar-
get. Lots of people were watching . . . Billy Name, Morrissey, Warhol
. . . no one could believe it. It was a small beautiful German pistol; it
was just lovely. After she'd fired it, she said, "Thank you," and sat down.
Warhol came over to Name and me and he said, "I didn't think she'd
do it. My God!" After a while Harriet left with Carmen Miranda. She
put the white gloves in the pockets of her motorcycle jacket. She was
very neat about the whole thing.
 Marilyn Monroe looked marvelous after she'd been shot. Just beau-
tiful. The holes in all the heads were clean. Real clean. Andy sold them,
of course. There's nothing he doesn't sell.

 —STEIN.

Warhol accepted invitations to lecture, but he did not lecture.
Alan Midgette:

❏ Paul Morrissey asked me, "Do you want to go to Rochester tomor-
row and impersonate Andy at a lecture he's supposed to give there?"
 I said, "No." I was so used to the idea of not receiving anything for
whatever I did at the Factory that the idea of doing a lecture in place
of Andy was not interesting at all until Paul said, "You would get six
hundred dollars. We'd give you half of the lecture fee. We'll go on a
tour of colleges." "Well," I thought, "six hundred dollars for one day's
work is not bad, and I'm always up for fun like that."
 The next day Paul asked how we could make it work. I said, "We'll
spray my hair silver and put some talcum power on top of that. Then
we'll get some Erase, the lightest color they have. I'll put it all over my
face, eyebrows, lips, up my nose, in my ears, and over my hands and
arms. Then I'll put on Andy's black leather jacket"—he'd handed it to
me in Max's Kansas City the night before—"put the collar up, put on
the dark glasses, and that's it."

So it worked. Paul sometimes called me Andy by mistake. He couldn't tell the difference at times. He came along with the film which was the main part of the Warhol presentation. The idea was to show it to students on this tour of colleges and they would ask me questions.

It was easy to impersonate Andy because to the questions I'd always say "Yes" or "No" or "Maybe," "I don't know," "Okay," "You know, I don't think about it," which is the way Andy would have answered the questions anyway.

So I passed. I passed at one o'clock in the afternoon on a clear, sunny day in a gymnasium in Rochester. They had a packed audience. Paul projected the film. I sat in a corner with my back to the audience. I decided that was the easiest thing to do. I chewed gum a lot, because Andy did. It gets your face moving quite a bit, so the audience couldn't tell very much about it when I had to turn around to answer questions after the film was over. The first one was: "Why do you wear so much make-up?" I said, "You know, I don't think about it." They let it go.

I think perhaps the thing began to blow up in Salt Lake City when "Andy" was supposed to talk to three thousand students. As we landed, we heard over the loudspeaker, "Please be careful getting off the plane. Watch out for your hats because it's really windy today."

Sure enough, when I got off the plane, the wind blew off all the talcum powder I'd put in my hair, just blew it right out like a puff of smoke. All these people were standing there waiting for us. I got into a car and this guy started taping me. He was very shy. Finally he said, "What is that stuff on your face?"

I said, "I have a skin condition."

He got very embarrassed, and said, "Oh, I'm sorry."

—STEIN.

Index

Topics